Handbook of Inquiry in the Arts Therapies

One River, Many Currents

Handbook of Inquiry in the Arts Therapies

One River, Many Currents

Edited by Helen Payne
Foreword by John Rowan

Jessica Kingsley Publishers
London and Bristol, Pennsylvania

The authors and the publishers gratefully acknowledge permission to reprint extracts from the following:

Eliot, T.S. (1936) *Collected Poems*. London: Faber and Faber.

Edwards, D. (1989) 'Five years on: further thoughts on the issue of surviving as an art therapist', in T. Dalley and A. Gilroy (eds) *Pictures at an Exhibition Selected Papers on Art and Art Therapy*. London: Tavistock.

Males, J. (1979) 'Is it right to carry out scientific research into art therapy?', *Therapy* 3rd May.

Weldon, F. (1988) *Leader of the Band*. London: Hodder and Stoughton Ltd/ New English Library Ltd.

First published in the United Kingdom in 1993 by
Jessica Kingsley Publishers Ltd
116 Pentonville Road
London N1 9JB

Second impression 1996

British Library Cataloguing in Publication Data
Handbook of Inquiry in the Arts Therapies:
One River, Many Currents
I Payne, Helen
615.8

ISBN 1-85302-153-9

Printed and bound in Great Britain by
Athenæum Press Ltd, Gateshead, Tyne & Wear

Contents

To Sarah, with love

Acknowledgements

First of all my appreciations go to the contributors of this book, many of whom are friends and colleagues with whom I have shared struggles with research processes. All are members of a community of arts therapists working together to develop research in the field. Thank you all for your responses to my editorial comments.

It is also important to acknowledge and thank those participants, respondents and co-researchers of the various projects described in the text: patients, children, adolescents, teachers, lecturers, nurses, students and arts therapists themselves.

Thanks to all the supervisors, both academic and clinical, who have given of their time and expertise to help the arts therapies develop a research base.

My inquiry work over the years owes much to staff and students or clients in the following special schools, centres and colleges; St Luke's School, St Albans; Whitefields School, Walthamstow; Aycliffe Regional Assessment Centre, Durham; St Joseph's Residential School, Edinburgh; New College, Durham; Child and Family Psychiatric Clinic, Hertfordshire; and Hertfordshire College of Art and Design (now the University of Hertfordshire).

Additional mention must be made of those hospitals, centres and organizations in which the research described in this book was undertaken.

Finally thanks to all those organizations who have supported inquiry in arts therapies in their settings, to the University and college departments which have provided the supervision and to all the charities and independent sponsors who have so generously funded those projects mentioned in this book.

Helen Payne,
St Albans, 1992

Foreword

In 1992 Donald Polkinghorne produced a comprehensive review of research methodology in the humanistic tradition. I hope and believe that if he wrote another one in years to come this would be one of the books he would have to quote.

The humanistic tradition insists that human existence includes unique characteristics such as self-reflection, purposefulness, language and culture, and it tries to be rigorously faithful to the full richness of human existence.

Many of the chapters in this book hold to this aim. They do so in some instances with the most difficult cases – children, the pre-linguistic deaf, self-mutilators, schizophrenics, people with learning difficulties, the sexually abused. We cannot read this material without developing an enormous respect for practitioner-researchers who have to struggle so hard.

The lot of the practitioner-researcher is generally an unhappy one, and I have written elsewhere (Rowan 1992) that it is almost impossible to carry it out. Yet here are people who are not only doing it, but are sticking with it to the very end.

Some of this research is agonisingly unsatisfactory; some of it is embryonic and incomplete. One of the most successful papers is not 'new paradigm' at all. But it all shows a remarkable spirit of wrestling with intractable material, which can only encourage and inspire future researchers who go into this field.

There is a good deal of reference to Reich and to Laban, which is perhaps not surprising. But one of the things which did surprise me was the way in which the name of Donald Winnicott kept on recurring. He seems to have said things which arts therapists find highly relevant and usable.

There is a good deal of interest here in Europe, and it seems clear that connections are being made with people in other countries.

Perhaps the most impressive part of the whole book is Part 3, where we get eighteen pages listing item after item of research which has been completed. Art therapy, dance movement therapy, dramatherapy, music therapy are all covered in a wide-ranging way.

Not all of this is research in the humanistic idiom, of course, and neither is all of the research in the main volume (Parts 1 and 2). But it does show how much is going on, and how much more has been done than anyone knew up to now.

I have known Helen Payne for many years, and always knew she would do something remarkable one day. But this book is an achievement which goes above

and beyond my expectations. It is nothing less than a physiognomy of arts therapies research in Britain today, warts and all.

John Rowan

References
Polkinghorne, D.E. (1992) 'Research methodology in humanistic psychology' *The Humanistic Psychologist* 20/2+3 pp.218–242.
Rowan, J. (1992) 'The myth of therapist expertise' (response to Katharine Mair) in W. Dryden, and C. Feltham, (eds) *Psychotherapy and its discontents*. Milton Keynes: Open University Press.

What Are the Arts Therapies?

The arts therapies comprise art, drama, dance movement and music therapies, which have each developed as distinctive disciplines in this country.

The ability to respond to the arts is in all of us. Handicap, disability, disorder, injury or illness often leaves this unimpaired. People who have difficulties in making sense of or communicating with their environment may find one of the arts therapies a pathway to a greater sense of self and expression. The arts therapies seek to engage the client in an experiential approach within one of these mediums whereby clients can be guided towards realizing their full potential. Individual and group sessions are available to those in the health, education, social and voluntary services. Some qualified arts therapists undertake additional training and practice privately. All vocational training is post graduate and most are university validated; there are professional associations and a system of registration of qualified practitioners for each therapy. Their training qualifies arts therapists to work in a variety of settings such as psychiatry, learning disability, group homes and day centres for the elderly, prisons, hospices, special and mainstream schools and colleges, and in the community. Titles for this work include therapist, tutor, instructor, technician, nurse, social worker, group worker, teacher and psychotherapist.

The arts therapies' assessment and diagnostic tools are specific to each field. Evaluation forms an integral part of the process of therapy. In each of the arts therapies a considerable understanding of and experience in the art process is essential. The common ground for all arts therapies includes the focus on non-verbal communication and creative processes together with the facilitation of a trusting, safe environment within which people can acknowledge and express strong emotions. A basic assumption is that people will use the medium in a way which reflects how they are thinking and feeling. Through acknowledging and supporting this process there may be a development and integration of hidden or forgotten parts of themselves. Each art medium encourages the client's own special language to emerge and to be used as a communication within the relationship with the therapist and others in the group. Personal language evolves, whereby therapist and client can begin to understand the nature of the unwell-being as presented. Practitioners sensitively guide clients through to the thera-peutic goals determined by the nature of the client's assessed needs.

This book is the first 'coming together' in print to document practitioners' work in the arts therapies and is another outgrowth of the increased liaison between the four professional fields of art, drama, music and dance movement therapies. The development of research and publication in each of the arts therapies has been encouraging. Dialogue between the arts therapies is becoming an important feature of their development as professions, for example, currently there are discussions between the professions and the Council for Professions Supplementary to Medicine for State Registration of Arts Therapists. There is a Standing Committee for the Arts Therapies Professions which consists of the Chair of each profession and one other representative. This committee has a wide brief to disseminate information about the inner workings of, and objectives for, each profession. There have been further developments in the area of research with the formation of the Arts Therapies Research Committee. This group aims to raise the profile of research within the professions and to act as a supportive network for arts therapists conducting research.

Another joint committee – The Committee of Arts Therapists in Education was a response to the changes in the education services and has a major task of producing an authoritative document, approved by all the professions, which will provide employers and the general public with information about how arts therapies can contribute to the education of specific groups of people.

Finally I have founded an Institute for the Arts in Psychotherapy, a proactive initiative to extend arts therapies services into private practice and the community, particularly in the light of government policies on community care.

It is hoped that the reader will find that this book stimulates their own inquiry as well as clarifying the nature of the arts therapies, their differences and their common ground in research.

Helen Payne

Part I

Introduction

Introduction to Inquiry in the Arts Therapies

Helen Payne

The purpose of this chapter is to give the reader a brief introduction to the aims and organisation of the book together with a brief overview of themes arising from the collation of material in arts therapies research represented in this volume.

This book was an outgrowth of the second arts therapies research conference held at City University, London in 1990. At first we intended to publish in book form all the papers from that conference but since there were over 40 presentations the organising committee (Arts Therapies Research) had to decide on a compromise; namely to publish all the abstracts and several shortened papers in the conference proceedings and distill a few for the limited space available in this book. It was a difficult decision to forgo the publication of so many other interesting papers.

The book seeks to place itself in what it is hoped will become a tradition of books which explore the practical, personal and social aspects as well as the outcomes of doing research in the arts therapies. This, the first of its kind, aims to stimulate thought and reflection by giving first hand descriptions of the challenges, pains and satisfactions of trying to discover what is unknown – a process not unlike therapy! It is hoped readers will be more able to assess the validity, reliability and generalizability of particular research and that the discussions of specific projects will help students and others in the arts therapies to involve themselves in conducting projects and to understand the research process more fully.

The accounts do not pretend to present the truth about research, or even about research methods, but they do offer a further perspective on the ways in which research in the arts therapies is conducted. It is hoped that these accounts of the application of research in the arts therapies and the reflections on doing arts therapies research will help the reader to look critically at research methodology. It may provide a source of inspiration to students and fellow practitioners setting out on their own research projects.

This is the first time all four arts therapies art, music, dance movement therapy and dramatherapy have collaborated on a major project like this. It is a milestone

in their development that they can now look outside their own professional boundaries and relate to another different yet complementary art form as therapy. Our learning from each other can only make us stronger in our separate and shared identities. We are, in the main, flowing along the same one river, yet have strengths in the different currents we each occupy. By co-operating, in terms of research, there is the possibility of a deeper and stronger flow to the forward motion of the river in its journey towards a common wellspring. Although initially emerging from the conference the book has evolved with a life of its own and now has become an entity with its own energy and symbolism. The chapters are based in the main on papers presented at the conference but most have developed since then and been re-worked and updated. One of the aims of this book was to present a range of views on inquiry in the arts therapies as well as addressing some of the common concerns expressed at the conference. Each of the chapters represents one of the ways in which arts therapies are struggling with inquiry. By collecting material together in one volume it is hoped that each profession can inform others in the mutuality of dialogue.

The philosophical background and practical application of human inquiry in the arts therapies are represented in the content and structure of the various chapters. As readers are open in their responses to the chapters from both an intellectual and emotional level, further messages may become available to them just as there are multi-layered messages available in our discrete art forms.

In the selection of chapters attention has been paid to both process and outcome research since this is what is currently being undertaken in arts therapies research; in this way it tries to give a snapshot of the state of the current field. Perhaps arts therapies research needs to concern itself with integrating both these approaches in the future whereby there is a complementary methodology of inquiry?

This book is transdisciplinary in that it goes beyond the limitations and confines of the separate disciplines in its intention and content. In attempting to outline the various patterns of inquiry practiced in the arts therapies, some old and recognizable others new and still struggling for emergence and recognition, the book asks what attitudes of mind predominate in arts therapies research, what are the forces which underpin it? The chapters reflect both established and newly emerging patterns of inquiry. Chapters were selected for their illustration of current thinking in arts therapies inquiry as well as their area of content such as those representative of a range of populations, for example, emotionally disturbed children, adults with psychiatric disturbance or learning difficulties, survivors of sexual abuse, autistic young people and practitioners themselves. Chapters were also selected for their diversity of settings: psychiatric hospitals, a psychiatric unit for deaf people, schools, a theatre workshop, a hospital for the severe learning disabled, colleges and institutions of higher education, and a child development centre. In addition, some chapters illuminate ideas in inquiry rather than discussing a research project, giving the reader guidance in their thinking about the process and nature of research in the arts therapies.

The book has been divided into three sections. Part I sets the scene and is concerned with introducing the reader to the book and its themes, addressing the fears practitioners in the arts therapies may have about research, and argues that there are ways of becoming a researcher without compromising your philosophical beliefs or your practice.

Part II is an account of inquiry approaches applied specifically in the four arts therapies: dramatherapy, art therapy, dance movement therapy and music therapy respectively.

Part III provides the reader with a resource directory of all the known research, both past and current, in the arts therapies. It has been listed in historical date order and with details such as name, title and location, sponsors, university departments, methodology and outcome. This directory of arts therapies research provides a reflection of the current state of arts therapies inquiry and provides invaluable source material for all arts therapists and other professionals, whether student, practitioner or researcher.

Contributors' responses to the book
(edited by Helen Payne)

Before setting out to write this introductory chapter it occurred to me that since this was a first collaboration in the arts therapies it would be helpful if contributors were to meet and talk to each other about their research ideas as a basis for an analysis of themes and issues in arts therapies research. We met for a short time one Saturday afternoon and, after some story telling based on our chapters, highlighted our responses to these in poetry, drawing, writing and speech. What follows is an analysis of these reflections contained within specific themes. Contributors saw this chapter in draft form and were invited to make comments.

The meaning of research

One of the themes to emerge from our reflections was a concern to explore the meaning of research.

Research was seen as 're-searching', a voyage of discovery to uncover meaning; but that if lacking in direction may become circular, lacking in coherence or outcome. One of the ways we looked at this was by perceiving research in the arts therapies in the form of the four elements: water, earth, fire and air which are said to be the sum total of the universe, both the positive and destructive forces. Inquiry in the arts therapies could be seen to include them all but in so doing risks becoming overwhelmed. As researchers we bring elements of ourselves to our research, realising perhaps our joy in the satisfaction of a successful outcome or our despair as things become chaotic and confusing. What is meant here is the principle of reflexivity in human inquiry which needs acknowledging in arts therapies research. The notion that we co-produce the worlds of our research knowledge rather than discover something already there, outside of us. Our own assumptions and activities as researchers must become part of the inquiry within

a process which stresses complex multiple realities informed by a belief that research and knowledge is personal, social and cultural in construction. What follows are some thoughts on the way the elements, which are in us all as liquids, solids, energy and gases respectively, may affect our research.

Water – this may represent the psychodynamic thinking which bathes the arts therapies. There are watery emotions connected to the research in which we fear we may become drowned. Yet the importance of acknowledging the feeling component, as well as the cognitive, is felt to be crucial to arts therapies inquiry. Within this liquid may lie the potential for further forms, not yet rigidly material, nor pure imaginings. This intermediary state provides for unconscious forces which could destroy or be of benefit to the research.

Earth – this element could refer to the fear that we may become too dull or frozen in our research approaches although we recognise the importance of grounding our professions through research. Unless the subjects are rendered coherent, for example in training courses, there will be difficulties in attracting students or developing secure boundaries for the professions. Research is one way of ensuring a body of knowledge and, as with the earth, this could give 'birth' to further knowledge in the arts therapies. Could research also act as a container for the development of this knowledge?

Fire – this may be to do with a fear of becoming destroyed, consumed by the hungry demands of the research, overwhelmed by the data, the amount of work and so on. It may represent the fire of enthusiasm necessary for the initial interest in research which requires careful stoking throughout the study, or the energy resulting from excitement and joy generated by discoveries on the way.

Air – this element could reveal to us our fear of remaining too airy, we may become out of touch with the reality of research. But in researching might we lose our 'butterfly' qualities of delicacy and creativity? The beauty may be diminished in the process or act of being caught.

If these elements were seen to symbolise aspects of the arts therapies researcher, and therefore the research, then it requires a tight-rope balancing act to maintain awareness. The fear of falling, losing our balance keeps us gripped. We have an inner balance which keeps us to the task of survival as a researcher and for this balance to be maintained we need awareness. Perhaps it is this very precariousness of research which attracts us? The falling, as in therapy, can be safe, learned about and survived to be integrated into a restored and different kind of balance until we are thrown off-balance again as we continue to challenge gravity. The tight-rope walker image bridges the opposite qualities of strength and fragility in a precise, co-ordinated movement. We need to connect with both these qualities in our research in order to find the point of integration.

There needs to be a balance between the process of research as an act of creation and being respectable. Research was thought to be both logical and symbolic in meaning as represented in our written thoughts and pictures. It is of benefit to the researcher personally and professionally because part of research

is about being, not just about knowing, and it is this which ultimately affects the client.

Who's afraid of the Big Bad Wolf?

This theme was concerned with how energy was used and directed in research dissemination, for example in forward bursts or a movement up and out. When the energy emanates out into the public domain others will be on the receiving end of the research. There is a fear about how others will receive it, through our language, our words. Will they understand? How can we translate our non-verbal art form into words? We represent our thoughts in different languages. To know about a dance one has to look, to have respect for its language. How do we put what is our way of being, drama, music, art and dance movement into a form that is acceptable and recognisable to the outside world? Part of this process is concerned with recognising the need to formalise public awareness of the arts therapies (and the arts in general for that matter).

Research/researcher/client relationship

The impact the research had on both the researcher and clients was felt to be harmful at times in terms of expectations and fears evoked. Having set up the research the researcher may not always be prepared for responses from clients. Sometimes these are concerned with clients' feelings about being asked to do something for the research, in this way the focus is on something quite different from their therapy. There seems to be a need to acknowledge that the research itself has an impact on others, including the researcher. Experiencing, for example, a client enjoying or finding helpful a particular form of treatment as part of the research and the researcher's mistrust of that response. The power of the researcher could lead to projections onto the non-participant observer.

The issue of having to build trust and a relationship with the research participants to counter-balance that feeling of being 'landed in it' was felt to be important to arts therapies inquiry. In particular it was noticed that there were often differing agendas for the stakeholders such as the researcher, employing authority (if there was one), sponsors and the clients. The idea of research occurring with, rather than on, clients was raised in connection with the need for self-directed action for both the researcher and any other participants, for example, clients.

The following extract from the contributors' meeting reflects some thoughts on the client's perceived sub-text in response to the text of a research project.

(Client has had no preparation, no choice in participation.) Client thinks:

> I'm going to be given a nice time,
> I don't trust
> that, I don't trust you,
> I'll muck it up, muck you about but...
> If you stay, if you wait...
> If you stay with me,

I'll stay too, participate, enjoy... maybe...

Monster as the research and researcher as monster

This final theme arising from our discussions was concerned with the differentiation lost between the 'inside' and the 'outside'. How much does your research topic become you? The interplay between the researcher's inner world and fantasies and the outside world do not remain so separate, the boundaries blur, the research getting under the skin, like a birthing process, painful.

In becoming both the 'eaten' and the 'eater' in the role of researcher, arts therapies researchers may find themselves losing some of their own identity in the role of researcher. Likened to a demanding monster by one researcher in our collaborators' meeting, it was felt the research fiercely controls the researcher's life, pushing parts of it away in order to have an affair with the researcher part. It desires a love–hate relationship and one in which the researcher could lose herself in the process. If not enthralled and gripped by it feelings concerned with being a 'bad' researcher may emerge and then the research is hated; it feels a weight, dragging the researcher down, no wonder people are deterred from doing research! Feelings of guilt may arise in the researcher because the research was not loved all the time. It is often experienced as too demanding of time and attention, taking up all the space. Here we have the scenario of the researcher as victim of the research.

What about the other part, the researcher as a monster who 'eats'? Here the researcher is hungry for knowledge and it is this hunger which drives them forward, they are now hooked on research as a way of life, the rules 'record it, write it up, analyse it' are integrated into professional practice and act as a mainstay, the researcher does all the ingesting. Eating up lousy practice, approaches, attitudes, old structures and roles; it can be an exciting and satisfying meal! Here the researcher feels in control and powerful. It's OK to hate it sometimes perhaps.

This introductory chapter has set out briefly to provide the reader with a taste of the material presented in the following chapters of the book. Hopefully they will broaden your research horizons, assist you in keeping abreast of current trends and issues in research in the arts therapies, and aid you in adapting your research idea or question to the particular needs of your clients, institution and practice. Finally, it is hoped the book will stimulate you towards innovating research projects, whether independently or by a research degree, since through embarking on such a journey it is likely your learning will increase and your practice become more effective to the betterment of your clients and the profession as a whole. A research orientation to practice – that is, one based on evidence from inquiry and systematic experimentation, observation and evaluation and not on theoretical speculation – will help the arts therapies to ascertain what works best from clinical investigation in order to contribute to a broader and deeper body of knowledge in theory and practice.

'Why Don't Arts Therapists Do Research?'

David Edwards

Introduction

The paper upon which this chapter is based[1] was originally written with the intention of clarifying my thoughts and feelings regarding my own lack of research activity as an art therapist. The question 'Why don't art therapists do research?' is, however, one which might equally well apply to other arts therapies disciplines such as music, dance movement or drama therapy. Although what I have to say in response to the title of this chapter is therefore personal and primarily concerned with issues arising out of my work as an art therapist, I nevertheless hope it will also be of interest and relevance to those who, like myself, are interested in research issues but find the actual undertaking of research problematic for one reason or another.

'Why don't arts therapists do research?'

The question 'Why don't arts therapists do research?' is, I believe, important for a number of reasons. First, because whatever we may feel about the *kind* of research that is appropriate for our particular profession there does not appear to be very much research going on. Appearances may, of course, be deceptive, and it does seem likely that the level of research activity within art therapy, for example, is greater than the number of published papers suggests. Nevertheless, it does seem to be the case that for whatever reason such research as is currently taking place within art therapy – and the arts therapies generally – does not enjoy a particularly high profile.

The question 'Why don't arts therapists do research?' is also important because if it is believed to be the case that research may further our understanding of the theory and practice of the arts therapies, then the underlying reasons for, and the implications of, this lack of research need careful consideration. Just as in our clinical work we need to pay attention to what is not being said, imagined

1 An earlier version of this chapter was presented as a paper at the Second Arts Therapies Research Conference ('The Art of Research') held at the City University, London on April 6th and 7th, 1990.

or expressed, and doing so may be helpful in developing our understanding of a person's difficulties, so too, in my view, does the lack of research in the arts therapies offer important clues as to the current state of the various professions.

Why, then, don't arts therapists do research? If my own experience of attempting to conduct evaluative research in a clinical setting is at all pertinent, then the answer is relatively simple and will be familiar to anyone who has ever sat down to write an article or a talk, let alone conduct a research project. If we experience the task, or even the idea, of writing a paper or conducting research – whatever form that research might take – as one which fills us with anxiety, it seems to me our natural response to this would be to avoid, if at all possible, doing either. Alternatively, if we find the experience of writing or conducting research rewarding, pleasurable even, then we are likely to continue doing it.

Before I begin to examine this issue in more detail, it is necessary to acknowledge that the problems arts therapists face in relation to conducting research cannot be adequately explained in purely psychological terms. That is to say, no matter how free of anxiety and inhibitions, full of questions and ideas, or committed to conducting research we might be, arts therapists are likely to face a number of difficulties and obstacles which still need to be overcome. Perhaps the most obvious of these is the chronic lack of funding and resources available for arts therapists wishing to conduct research. Unfair though it may be, at the present time arts therapists who might wish to engage in some form of long-term research activity generally receive little support or assistance from their employers, and are likely to find it necessary to fund their research out of their own resources.

If it is the case that a major reason arts therapists do not conduct research is that it is anxiety provoking, why is this so? And more importantly, what might be done to reduce the anxiety arts therapists seem to experience in relation to conducting research? It may be possible to begin to answer these questions by examining those research issues I, and no doubt others too, have found problematic. I would list these as follows:

- unfamiliarity and inexperience with research methodology;
- the complexity of conducting research in clinical settings;
- the problem of time management and the lack of control many arts therapists have over their workload;
- the fear of criticism and failure;
- low morale within the professions;
- the lack of support and incentives for research initiatives;
- and the lack of interest in research outcomes.

This list is not intended to be exclusive, and I am sure other arts therapists might wish to add to or amend it in certain respects.

In the remainder of this chapter I wish to pay particular attention to the unfamiliarity and inexperience arts therapists tend to have with research methodology, especially research methodology derived from the physical or natural

sciences and the problems this may generate. I wish to do so because my own experience has led me to conclude that this is possibly the most intractable and anxiety provoking of all the issues on the foregoing list.

Unfamiliarity and inexperience with research methodology

That art therapists tend to be unfamiliar with and, therefore, relatively inexperienced at using research methodology derived from the physical sciences should not, perhaps, be surprising, given that most of us come from arts backgrounds. Moreover, rightly or wrongly, the basic professional training art therapists receive places little or no emphasis on students acquiring such research skills. I understand that much the same applies for music, dance movement and drama therapists. This is in marked contrast to clinical psychologists, for example, whose training and professional practice often leads them to attach considerable importance to these skills as a means of evaluating and elaborating their work with patients or clients.

It is partly as a consequence of the influence clinical psychologists and others amongst our medical and para-medical colleagues have had, that within the field of mental health the word research tends to be used quite restrictively. That is to say, despite those methods of inquiry available in a field such as art therapy – methods which might legitimately cover anything from an exploration of aesthetics applied to the understanding of images produced in therapy, to an attempt to evaluate the effectiveness of art therapy as a way of treating a particular client group – the word research tends only to be applied to those which profess to be 'scientific', 'empirical', or 'objective' in orientation. In practice the word research has come to mean 'scientific' research based on objective measurements that can be put to general use.

While this view of research is in many ways unfortunate, its consequences may possibly be quite serious in so far as it is one which may act as a disincentive to arts therapists wishing to engage in research. Moreover, because statistically based research in art therapy is quite rare, at least in the UK, it may actively promote the view that art therapists do not take their work seriously no matter how eloquent our attempts to persuade others as to its worth.

One possible consequence of such a view is that those who hold it might actively undermine our attempts to help clients or patients. As Jeanne Males (1979) has previously argued,

> 'It is imperative to the service provided that good professional relationships should be established with the clinical team, and any such relationship will be enhanced if respect can be gained on the basis of a firm body of knowledge to back up the clinical skills of the therapist. Without a good relationship with one's professional colleagues, referrals may be scarce, attendances poor, opinions may not be sought and this will not serve the client well. It is vital then that objective research based on measurement be undertaken for the client's sake' (p.5).

The issue of what may or may not be legitimately defined as research, and how research should be conducted, is particularly important because as members of relatively recently established professions we are in danger of prematurely conceding the argument as to what does or does not constitute relevant knowledge in the arts therapies. It is important to note – as other contributors to this book also point out – that research strategies other than those dependent upon 'objective' measurement exist. Strategies which are arguably more sensitive to the nature of our work; and, indeed, are likely provide a better understanding of its intrinsic meaning and value. We might also find it helpful, as I have previously argued (Edwards, 1989), to pause for a moment 'to question the assumption that scientific knowledge is necessarily objective' (p.173).

However, as this chapter is primarily concerned with those factors which it may be argued promote or inhibit research activity in the arts therapies, rather than with methodological issues, I do not intend to delve too deeply into the relative merits of the numerous methods of inquiry potentially available to those in the various professions; be these quantitative, controlled clinical trials, single case studies, observational and so on. The point I wish to emphasise is that the inexperience and unfamiliarity arts therapists have with traditional forms of research methodology may give rise to uncomfortable levels of anxiety. Levels of anxiety originating in part from the increasing pressure on arts therapists (along with other mental health professionals) to demonstrate objectively the efficacy of our work.

Questions of the kind one might expect evaluative research in art therapy to address such as 'Does art therapy work?' and if it works, 'How does it work?' are not, of course, new ones; therapists, patients, clients, colleagues and employers have been asking such questions, in one form or another, for a long time now. What has changed is the importance now attached inside and outside our respective professions to our ability to answer them. Since the introduction of new management procedures into the NHS, for example, arts therapists have become acutely aware that questions regarding the efficacy of our attempts to help those in need are no longer exclusively matters of ethical or professional interest – we all like to think we are doing a 'good job' – they are personal. Our continued or future employment may well come to depend upon the kind of answers we give.

Beginning with the recommendations made in the first Griffith's report on the management of the NHS and continuing with the government's White Paper 'Working for Patients', arts therapists are expected to be able to demonstrate that their work is both valid (in the sense of being efficacious) and cost effective. The means employed to evaluate the service provided for patients will obviously vary from location to location, but there can be no doubting that the quality and effectiveness of our performance and output (the process and outcomes of our work with patients) are increasingly being scrutinised. Faced with the problem of demonstrating that art, music, dance movement or drama therapy are effective where does one begin?

Is it in fact necessary to begin anywhere? Surely arts therapists have long since demonstrated the efficacy of their work; why else would we continue to find employment? One might, after all, argue that there is nothing new about sharing one's troubles with another person in order to experience some relief from them. The same might also be said about the use of art materials, sound or the body in order to create forms symbolic of human feeling. As human beings have engaged in such activities from time immemorial as a means of externalising, making sense of and preserving experience it sometimes feels rather strange to be asked to justify the benefits this might bring. Surely these too are well known and need no further justification?

Unfortunately, the bodies of knowledge upon which the arts therapies professions are based are often at odds with the value systems which currently dominate our culture and its institutions. One manifestation of this is the notion, derived from the medical model, that those who seek psychological help have an identifiable psychopathology – an illness – which may or may not be effectively cured by a specific treatment technique such as art therapy. How we respond to questions such as 'Is art therapy effective?' will ultimately depend upon how we conceptualise our work; upon whether we think of it as a treatment technique whereby the therapist changes the patient in some predetermined manner or, as I see it, as a form of personal relationship and education – a way of helping others tell their story or learn about their feelings.

When discussing the issue of effectiveness in relation to psychotherapy the late Don Bannister (1980) made the following, and very relevant, observation.

> 'Many of our self inflicted puzzles arise from our habit of introducing into psychological discourse constructs which derive from non-psychological sub-systems. A specific example of this is our use of a construct of 'psychotherapy' which is heavily cluttered with 'medical' meaning. This becomes clearer if we substitute any purely psychological term for psychotherapy and then consider whether the kinds of questions commonly asked about psychotherapy make sense. Consider the construct of 'conversation'. If you were asked 'how effective is conversation?' you would surely begin by questioning the question. As it stands it is a nonsense. Conversation between whom? Conversation about what? Conversation to what purpose? And which of the multiplicity of meanings of "effective" is implied by the question "is conversation effective?"' (p.13).

The problems associated with demonstrating that our particular and, I wish to add, often very personal ways of helping are actually beneficial are, then, as much to do with how we – and those we work with – might define what we are doing, as with what counts as proof or evidence.

Issues such as these obviously have consequences for the kind of research felt to be permissible or acceptable in the arts therapies, particularly by those outside the various professions. For some of our colleagues acceptance of the arts therapies worth is dependent upon our ability to provide objective evidence of its utility. Until, that is, the claims we may make for our ways of working have been

subject to 'scientific' appraisal. As empirical science is primarily concerned with the accumulation of facts, facts moreover drawn – so the myth goes – from dispassionate observation and experimentation, it is facts – preferably in a statistical form – which arts therapists are expected to come up with in order to validate their work.

The problem is, finding such facts in a field such as art or psychotherapy is a notoriously difficult and complex business. Faced with the practicalities of attempting to do so one enters a methodological minefield of, amongst other things, 'rating scales', 'dependent and independent variables', 'outcome measures' and so forth. Such terms may well be meat and drink to those of a more positivist frame of mind, but I must admit to having found them bewildering and at times quite alienating.

Although I have made a number of past attempts to 'objectively' evaluate the 'effectiveness' of my 'interventions', largely as a pragmatic response to external pressure, I eventually came to realise that through doing so I was effectively trying to reduce a complex body of knowledge and experience to a rough and ready set of demonstrable facts. This is not to state that traditional methodologies are necessarily misguided or wrong, or that they have no place in arts therapies research. For example, the use of questionnaires addressing such issues as attitudes within the profession to self-employment and private practice (Edwards and McNab, 1988) may provide a wealth of interesting information. So too might a questionnaire exploring the problems arts therapists have conducting research. In clinical settings thoughtfully conducted research may reveal, amongst other things, practical and useful information regarding who gets selected for which form of therapy, from where and for what reasons. Systematically collecting such quantitative data may, for example, be done relatively simply through a carefully designed referral form[2].

Although it is possible to count, measure or calibrate statistically some aspects of our work as arts therapists, as I have previously argued elsewhere with regard to art therapy,

> 'It is... important to recognise that through emphasising the 'technical' aspects of art therapy we run the risk of overlooking much of what is fundamentally important, and in many ways radically different, about it. To attempt to validate art therapy by seeking to demonstrate the superiority of one approach in comparison with another, or to discount the possibility that the personalities of those engaged in it play a significant role in what goes on... seems to me not only to lack sense but to miss the point. As it is the personal relationship established between the therapist and the patient – a relationship mediated through images – that is central to art therapy, it is essential the subjective experience of this relationship from the perspective of both the therapist and

2 For an example of a referral form designed to gather information systematically for research purposes see Edwards (1987).

the patient be taken account of in any process of evaluation' (Edwards, 1989, p.174).

Our subjective experience of therapeutic work is also relevant to the question 'Why don't arts therapists do research?' in that it is likely to determine the importance we attach to research findings such as those which do attempt to demonstrate the superiority of one approach in comparison with another. To again quote Don Bannister (1980),

> 'the idea that we will involve ourselves in or discontinue the practice of, psychological therapy, as a result of formal evaluation research, is a public front, not, for most of us, a personal truth. Our involvement in psychotherapy [for psychotherapy read arts therapies] or our withdrawal from it.. seems most often to hinge on our individual clinical experience. If our experience of psychological therapy makes sense to us, that is to say we can see reasons why we have been of no help to this person or some help to that person and we can develop and elaborate our understanding through our work, then we are likely to continue to work in this way, whatever the literature may say. Equally, if our experience of psychotherapy is that it is a depressing confusion then we are unlikely to continue, again regardless of what the literature may say' (p.13).

Much of the anxiety arts therapists experience with regard to evaluative research in particular appears to stem from a conflict between the recognition that it is important to ensure those we work with are helped rather than harmed, and having the means available by which we might demonstrate this is the case. Having given this matter considerable thought in recent years I have come to the conclusion that although a realistic response to the pressure placed upon arts therapists to demonstrate the effectiveness of our work might well be to adapt and use what we can from traditional research methodology, I personally doubt whether doing so will, in the long term, prove very helpful in furthering our understanding of the meaning and value of the relationships we have with our patients or clients. It is my view that prior to the question 'Does art therapy work?' is the more pressing and clinically relevant question 'What factors determine whether a relationship is traumatic or healing?' (Woodmansey, 1987, p.73).

If research in the arts therapies is to be of any help at all it should concern itself first and foremost with what goes on in it. Potentially, the richest and most readily available source of information we have about this is what goes on within ourselves. I would argue that exploring and building upon this, in our clinical work, in supervision, in therapy or in the studio offers us the best hope of providing therapeutic help for those in need or distress, and need not necessarily involve our having to employ procedures derived from traditional research methodology. It might of course be argued that such an approach to understanding others is itself 'scientific' in the sense that it may further our understanding of 'the relationship between the experiment that is the... therapy session and the experiment that is the client's life outside' (Bannister, 1980, p.13).

Conclusion

In concluding this chapter I wish to make two main points which I hope will prove
to be of help in overcoming those anxieties I believe inhibit an imaginative and
playful attitude to research in the arts therapies.

The first point I wish to make is that we do not have to accept the view often
put forward by those sceptical about the 'effectiveness' of our work that 'It is
vital... that objective research based on measurement be undertaken for the
client's sake' (Males, 1979, p.5). Our work as arts therapists should, of course, be
open to critical, even 'scientific', inquiry. It is debatable, however, as Richard
Stevens (1983) observes in his book *Freud and Psychoanalysis,*

> 'as to whether the essence of science lies in adherence to a particular kind of
> method (i.e., quantification and experiment) which has proved so successful
> in the natural sciences, or whether it is in rational and systematic investigation
> of whatever kind is best likely to yield understanding of the subject matter in
> question' (p.116).

If we can accept such a view then we might feel more able to stop apologising for
being unable to do what may in any case be impossible, that is, provide conclusive
proof, supported by objective evidence, of art, music, dance movement or drama
therapy's effectiveness. We might then begin to remind ourselves that those forms
of inquiry and evaluation we bring to our work – particularly those drawn from
the arts – are neither inadequate nor inferior to those drawn from science.

Second, if as mental health professionals we believe research should be taken
seriously, and wish to be seen to be regarding it as such, then it is important
research initiatives are encouraged and supported. As individuals we might make
our own contribution in this area by sharing and debating openly, without fear,
our personal experiences and philosophies. It is also important, however, that
collectively we actively encourage and support the representatives of our various
professional organisations in their attempts to persuade employers and funding
agencies of the necessity for further research into areas which affect our work.
Without this those who wish to conduct research in the arts therapies will, quite
unfairly, be obliged to continue to subsidise this out of their very often limited
personal and financial resources. Not every arts therapist will be interested in
conducting research, however broadly we may define the word. Those who do
should receive every possible encouragement.

References

Bannister, D. (1980) 'The nonsense of effectiveness', *New Forum* (Journal of the
Psychology and Psychotherapy Association), August.

Edwards, D. (1987) 'Evaluation in art therapy', in D. Milne (ed) *Evaluating Mental
Health Practice.* London: Croom Helm.

Edwards, D. (1989) 'Five years on: further thoughts on the issue of surviving as an art
therapist', in T. Dalley, and A. Gilroy (eds) *Pictures at an Exhibition: Selected Papers
on Art and Art Therapy.* London: Tavistock Publications.

Edwards, D. and McNab, D. (1988) 'Private art therapy', *Inscape* (Journal of the British Association of Art Therapists), Summer.

Males, J. (1979) 'Is it right to carry out scientific research into art therapy?', *Therapy*, 3rd May.

Stevens, R. (1983) *Freud and Psychoanalysis*, Milton Keynes: Open University Press.

Woodmansey, A. C. (1987) 'What's wrong with psychotherapy?', *British Journal of Clinical and Social Psychiatry.*

From Practitioner to Researcher
Research as a Learning Process

Helen Payne

Introduction

This chapter argues for the development of research in dance movement therapy (DMT) specifically and the arts therapies generally. In showing how 'new paradigm' approaches to human inquiry can successfully integrate research and practice, it argues that we do not need to throw out our beliefs and practice bases in order to carry out successful research. There is often a fear of research amongst arts therapists and perhaps also an ignorance of the accessibility some methodologies offer the practitioner. Research does not need to be diminishing, reductionist, number-crunching or too academic; it does not need to be very different from practice at all.

Arts therapists' experience of the contradictions and dilemmas outlined in this chapter may have contributed to the reasons for retreating from undertaking research projects. However, the fact that practitioners in DMT and the other arts therapies are already skilled in self awareness, analysis and reflection opens up the possibility for a move into research.

Through describing my experiences in researching DMT and illustrating my personal learning process, a journey from practitioner to researcher (which is inclusive of practitioner) is documented. It particularly stresses how I changed from adopting the quantitative, traditional methodological approaches to the 'new paradigm', a more responsive, interactive and 'objectively subjective' view of research; this accompanied a shift in my ability to integrate research and DMT practice. Across the Atlantic, where most DMT research has been undertaken, the preference is still for the traditional paradigm (see, for example, the recent research undertaken by Brooks and Stark, 1989; and Berrol and Katz, 1989). It is proposed that new paradigm approaches to research, which are well documented (Reason and Rowan, 1981; Guba and Lincoln, 1981; Lincoln and Guba, 1985; Mahrer, 1985; Reason, 1988) can be particularly suited to arts therapies inquiry.

The bulk of the chapter describes six research projects, many of which were undertaken in the context of award bearing courses. The experiences fall into

three stages, drawing out the idea of the practitioner – researcher relationship and identifying some key themes from six research studies I have undertaken. The second section considers what may be learned from these research experiences, and the final section argues that practitioners and researchers of clinical practice have enough common ground to be combined in the same person: research can be consistent with practice; practitioners can adopt a less alienating research orientation to the benefit of clients.

The title 'From practitioner to researcher' might imply that I was first a practitioner and became something different, a researcher. In a sense this is true; it does concern the learning experience involved in becoming a researcher, but principally I mean that research has been intertwining with my DMT practice. I sincerely believe there is much that DMT practitioners and other arts therapists already 'know-in-action' (Argyris and Schon, 1974; Reason, 1988) which can be helpful in the research process, particularly if one uses the emerging approaches to methodology. One aim of this chapter is to give practitioners confidence that the transition to becoming a researcher can be made and that research can be seen to be less differentiated from practice than might at first appear. Furthermore, I believe we can fulfil our responsibilities to develop the profession which requires a strong research base.

There were assumptions about the perceived separateness of research from practice emerging at the first Art Therapies Research Conference in 1989. There was also a need expressed to know how to begin research and how research could be reconciled with practice (Gilroy *et al.*, 1989). What then is meant by research? One definition (in the University of London's 'Regulations for Research Funding') states 'Research is a major piece of work leading to the advancement of knowledge by original inquiry (and normally followed by publication) as distinct from course-work'. In another definition John Heron (1981) says that 'research is a process of systematic (and not so systematic) inquiry that leads to knowledge stated in propositions'. Heron talks about the nature of inquiry with people needing 'an element of observation of, or interaction with, persons in order to offer empirical evidence for the research conclusions' (Heron, 1981, p.19); and goes on to recommend that in social science inquiry the researcher needs to interact with subjects so that they contribute, strongly or weakly, to the research stages. As artists do we not also engage in a collaboration with the audience when performing our work? You may not agree with either definition but they do form a basis for dialogue. Personally, as a therapist I understand research to be concerned with systematically checking out whether in fact the values and benefits I aim to generate through my practice are more than simply my wishful thinking.

To continue this section there follows a retrospective understanding of learning and pitfalls from my attempts to conduct research, see Figure 3.1 for an overview.

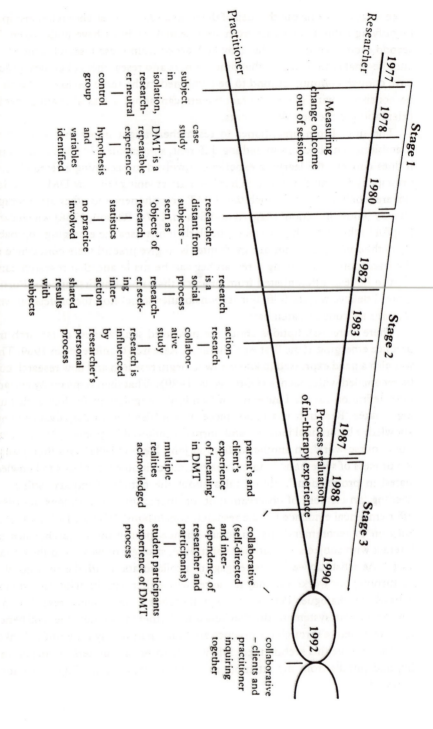

Figure 3.1 To illustrate what brought practice and research together (in chronological order)

The first stage

This stage outlines three projects and some of the early learning arising from them.

Before my first small research study (Payne, 1977) I had already been exploring the use of movement as therapy for two years in both special school and hospital settings. During a post-qualifying course I decided to request a placement in a school for the maladjusted, or EBD as they are now known, to explore whether movement therapy[1] could help with the emotional disabilities these children presented. Did this intervention I was so excited about, movement therapy, actually work? Proving its effectiveness would validate my next step, that of practicing movement therapy formally on my return to the special school which had seconded me. Then I could work as the full-time movement specialist with the added (and more exciting) task of developing movement therapy.

The purpose of this pre-post test design study was to evaluate whether there was any improvement in the children's abilities to make and maintain relationships. Teachers completed both a questionnaire and a standard psychological form about the child's behaviour with others, both before and after a short-term movement therapy programme. A second group was selected for the variables of age and sex as a control throughout the experiment. In both groups each child's movement patterns were observed by me using a schedule based on Laban Movement Analysis. These observations were then correlated with core syndromes in emotional behaviour such as hostility, withdrawal, depression or peer maladaptiveness identified by their teachers on a behavioural rating scale. Specific movement patterns were shown to correlate with particular core syndromes which, after a programme of movement therapy, changed to become less dysfunctional, illustrated by the rating scale results correlated with movement profiles.

Thus a traditional approach to research methodology was adopted, in this case measuring changes via rating scales and movement profiles in the experimental group after the intervention programme. Variables were controlled and results were tabled. By the end of the project I was delighted – my aim, to prove movement therapy worked, had been achieved – because movement patterns had been extended and relationships/behaviour with others had improved in the experimental group alone. I could now return to school and negotiate confidently for individuals and groups to be referred for movement therapy, believing that movement therapy was an objectively valid intervention. The report I wrote for my course was never seen by the setting.

So what did I learn from this first step into the unknown? In terms of the social or public nature of research I was a researcher external to the school. If the practitioner/researcher only attends the institution for research purposes the

1 At that time I was not confident enough of the dance element in the work hence the
 term movement therapy was used. Since I was a movement studies specialist it seemed a
 big enough jump from movement to therapy; the dance aspect became more evident to
 me later.

staff/clients do not see them in any other role, particularly not as solely a practitioner. Since they are aware the visitor is dependent on them for the success of her explorations into research they may use the opportunity to use control. For them, the DMT sessions need to have a point other than for research purposes. The research was dependent upon the subjects and the staff and each player had different agendas in connection with it. The aim from my perspective was to prove that change came about. To do this I needed trust and co-operation from both the institution and children. The issue of authority was evoked as material in the DMT group, for example in the theme of controller versus controlled. The research was also dependent on the staff completing forms, although there may have been a hidden agenda for them that the implementation of DMT might make their lives easier if it helped the children's behaviour.

That first small pilot study led to a second, extended piece of independent research at my then current special school setting (Payne, 1981).

This two-year project used similar methodology and tools of measurement, adding video recording to aid movement observation. My motivation was the need to prove the effectiveness of movement therapy, this time not so much to myself but to both the school and to a wider audience.

It became obvious in this second study that I was not learning anything about how the therapy worked, nor was the research contributing much towards a body of wider knowledge about human behaviour. Now I believe it is more interesting to ask different questions such as what are the processes and factors concerned with DMT practice. However, there was some valuable learning about certain aspects of research which I will now comment upon.

Supervision and the perceived need for an 'expert'

Part of the learning in this study was of a personal nature. Although the school and others in the UK found the work interesting and were generally supportive, the profession across the Atlantic, to where I kept looking for 'specialist, expert support', since DMT was more widely articulated there, seemed too bound up with their own need for acceptance of the work in the public domain to offer help to its development in the UK. For the few of us in the UK in practice at that time (the 1970s) it was a very needy period; we gained input when Joanna Harris, an experienced dance therapist from America, made frequent trips to the UK.

The lack of expert advice in DMT in this country was frustrating; if only there was someone who could give me all the answers! Now I realize there are no experts, only people with different experiences, but then I needed someone to say 'this is the way to do it' or 'you are doing it right!'. For the most part I had to rely on my own resources and an emerging kindly 'internal' supervisor. Also, although it was not possible to have a practitioner as an academic research tutor (there was none at that time anyway), adequate DMT supervision was vital. I believe DMT supervision needs to be sought from someone other than the academic tutor or confusion of boundaries may result. For example, the tutor may have a vested interest in the success of the research but know little about the requirements of

DMT practice, the case in all my projects due to the lack of DMT practitioners familiar with research. Academic tutoring and DMT supervision need to be integrated though. DMT practice sometimes dictated a particular path of action, but the research another, a conflict of interests which had to be held by the practitioner–researcher and for me it was always important to put the needs of the client before the research.

It was vital to have my own therapy as well as DMT supervision and tutorials for the research to emerge out of the apparent darkness at times. The maintenance of these boundaries enabled me to clarify the practice and acknowledge my 'need' for the research to succeed both for the field of DMT and for myself. A new understanding was growing and slowly addressing more substantial issues. With the dual role of therapist and researcher, issues emerged in a later study whereby the negative transference displayed in sessions was too great for the therapist to successfully interview the volunteers for the research. Because of this it was decided to train interviewers for the final experimental fieldwork (Payne, 1987, 1988a and 1988b).

Research in your own institution

A second learning theme from this project concerned issues of the re-searcher/practitioner researching in the setting in which they are employed.

Often practitioners will tend to select research topics which reflect their own ideological commitment and values, experience, and professional interests as well as problems in the institution itself. This gives a high motivation to the field but can confuse the research if, for example, 'critical subjectivity' fails to be employed (Reason, 1986). In not acknowledging, for example, the unconscious forces affecting the investigator as well as the investigated validity will be affected. In the emerging approaches to inquiry this acknowledgement requires the researcher to stop hiding behind their role of neutrality and to be involved as a whole person. An advantage to locating the research in one's own institution is that it may be easier to attempt a holistic view of a situation, including subjective and impres-sionistic observations rather than following a prescribed research design alone. Apart from the convenience there are more opportunities to meet people infor-mally, open up pathways for collaboration or negotiate access for data gathering. However, there may be a reluctance from work colleagues to share honest opinions – the politics of research! Familiarity with the institution may lead to a difficulty in judging what is significant and what is not in the research findings, or seeing events as exceptional rather than normal or vice versa. The negotiation of the research contract by the arts therapist in their own institution needs to be just as careful as with any other institution.

In these early projects it was apparent that my old paradigm assumption concerning the anxiety felt by 'research subjects' about giving information required me to be consistently sensitive to enable them to trust me. However, using this world view it was also difficult sometimes for me to trust them, such

as when they gave answers to pre-determined questions in interviews or ques-
tionnaires (the 'are they saying this to please me?' problem).

The third study (Payne, 1980) for a dissertation during a further post-graduate
course of study was intended to contribute to knowledge in the field of human
behaviour and dance/movement therapy (D/MT)[2] (I was working full time with
autistic and psychotic children at this time). The aim was to explore links between
body image boundary, social adjustment, self concept and self actualisation
(Maslow, 1976) (as measured by the number of observed integrated movements,
Ramsden and Zaccharias, 1991) in a group of moderately learning disabled
children, some of whom were emotionally disturbed. It occurred to me that it
would be interesting to look more closely at the idea of body image boundary and
movement patterns to try to understand why it was that in my experience
disturbed children with low self concepts had such poorly defined body bounda-
ries. It had been hoped that an argument for the use of D/MT would be made
since the healthy development of body image had been established in the
descriptive literature as one of the outcomes of D/MT. Hypothesis and quantita-
tive research methods were employed. Computer analysis tested correlations
between the four variables, relating the number of integrated movements to the
barrier and penetration scores of a body boundary test and to scores on social
adjustment battery. The movement patterns of those children falling into high
scores in barrier and penetration boundary categories were analysed by myself
and an independent analyst. Presentation of this comparative research study, with
histograms, deviation graphs and tables looked very impressive to the reader. The
research highlighted, as is normal, areas for further study and recommended a
larger sample (the sample was of 40 children) and a control group if D/MT
intervention were to be applied.

There was no need to have been a dance/movement therapist to have done
this study; any experimental psychologist trained in movement observation could
have carried it out. I learned much about how to understand and implement
statistics, became more familiar with the area of body image and developed
further movement observation skills from one of the country's leading action
profilers.

I also learned that a researcher could explore theoretical concepts of impor-
tance to D/MT without researching D/MT practice. However, the children were
subjects and numbers for the research; always distant from me, whether on the
videotape, as a recorded voice or as a written response on a sheet of paper. Rarely
was I in touch with a 'live' child, within the research context, and I learned no
more about the actual practice of D/MT. I therefore asked myself whether this
kind of research could further the development of DMT[3] practice. What could it

2 I was by now admitting somewhat to the dance, and felt the need for it to be either
 dance therapy or movement therapy, hence the slash between them (D/MT), but was
 still ambivalent about which it was that I practiced.

3 I was now understanding my work to be expressive, creative dance as a form of
 movement rather than simply dance or movement. This includes the notion of

tell us? I spent a year on the project and although it had value I felt that the researcher part of me benefited whilst the practitioner did not. Thus the roles and functions of practice and research seemed incongruent and separate. This study helped me to appreciate the need for my research to stay connected to practice in some form rather than exploring factors assumed to be important in the processes of DMT and researching them in isolation.

The second stage

This stage represents the bridging of practitioner and researcher whereby there are glimpses of the shared ground possible between them. It examines the learning arising from experimenting with action-research and then undertaking an M.Phil which used illuminative evaluation (Parlett, 1974)in its methodology.

At the start of this stage a fourth project, another independent piece of research (Payne, 1983) sponsored by the then Schools Council, provided an opportunity to test out training ideas and some of the issues inherent in action-research in a multi-disciplinary group of teachers, lecturers, educational psychologists and therapists.

This project, which began in 1981, also helped me to learn something of the problems inherent in co-operative research (Heron, 1981) such as conflict and power struggles. This is illustrative of the way personal process can affect research. The inquiry group mutually agreed definitions on notions such as 'action-research' and 'DMT', but the leaderless nature of the group was confusing and scary at times. It taught me about the importance of groups monitoring their dynamics and the need for the project initiator to have skills in the facilitation of collaborative groupwork. It also illuminated how the fears some educationalists and psychologists have around the idea of 'therapy' can be painful and difficult to work through for a multi-disciplinary group.

This project was aimed not at researching one particular DMT practice, but at how dance movement might be adapted for special needs children and young people by a number of practitioners in a variety of settings. The co-operation was in the collegial sharing of the experiences of action and decisions about the activities and processes thought to be important to our task. We would shape up ideas together, go out into our settings to apply them in practice then return to reflect together on our experiences. This resulted in an articulation of methods of delivery, design of intervention strategies and structures and ways dance movement experiences could link with the curriculum in mainstream and special schools. The clients themselves were not included in the co-operative efforts.

This project formed the foundation of a shift to wanting to use action-research within my practice and to explore DMT as experienced by the clients themselves, including their reflections on the process in some way. So when, in 1982, I decided

movement at its most basic in gesture and posture through to phrased movement generally recognised as dance. The term dance movement therapy (now the term in common usage in the UK) was adopted in response to this shift.

to take a degree in research (Payne, 1987) I was adamant that I wanted to learn and develop both as a practitioner and as a researcher. One comment I made at the first meeting with my academic tutor was 'if it has to be measured with numbers then it is probably the wrong path for me'.

For this major study my aim was initially somewhat negative – I did not wish to measure change. My tutor steered me towards material on illuminative evaluation by Malcolm Parlett (1974, 1981 and 1983; and Parlett and Hamilton, 1976). After reading some of his ideas on educational evaluation and then working with him in Gestalt Therapy I was very excited about the prospect of employing illuminative evaluation as a methodology in the research.

Reason and Rowan (1981) include illuminative evaluation in their book on new paradigm research. They refer to new paradigm as being 'a systematic, rigorous search for truth, which does not kill off all that it touches' (p.xiii). The new paradigm claims to be offering another way of doing research which does not utilize the traditional approaches. It has its roots in areas such as humanistic psychology and the clinical work of practitioners such as Carl Rogers, Ronnie Laing, Carl Jung and Wilfred Bion. It aims to include subjectivity and some aspects of traditional research in a synthesis.

Research is fundamentally a personal and social process; Polanyi (1962) argues that decisions about research processes are fundamentally subjective, in that they are rooted in personal processes. Kuhn (1970) focused on the development of research methods from a historical perspective and viewed research methods within the concept of a paradigm that develops in response to social and political pressures. The resolution of tensions created by these pressures is seen as part of a consensual process. This way of looking at research requires not only changes in methodology but also changes in what are considered to be valid areas for research.

Parlett's approach, which originated from the educational evaluation field and the emerging methodologies (Reason and Rowan, 1981; and Reason, 1988) have much in common and were important ideas in my learning, although historically they emerged from different backgrounds. They represented an opening to a new way of looking at the world; for example, the client involved as a partner in the research, or the concept of multiple realities rather than one static truth waiting to be discovered.

Perhaps it was the right time, as I became more in touch with my own femininity, to look at these concepts rather than disregard them or let an old way of thinking influence me. I began to read feminist literature which criticises the Western world as valuing male, patriarchal, mono-dimensional reality, which is hierarchical and following a linear cause and effect model of the world. The assumptions in illuminative evaluation include

1. valuing numerous different perspectives with a focus on the individual's experiences, (vivid and 'subjective' as they are);

2. recording of informal thinking;

3. gathering data as part of a system;

4. negotiating the design with participants;

5. increasing communal awareness and;

6. studying the intervention in such a way that contributes to decision-making and review of policy.

Procedures and purposes are believed to be unique to the setting, and there is an engagement with a more receptive attitude in the researcher. I had no idea where these ideas would lead but felt a real shift in my learning not only as a researcher but also as a dance movement therapist.

Research can be an intense personal learning experience as well, there being a reflexive relationship between research and the life of the person conducting it. In the early stages of the M.Phil, in my parallel life, I was learning meditation, tarot cards and becoming more attuned to intuitive, spiritual and mystical teachings. It was a process of discovering for myself the philosophical ideas which in turn informed my inquiry. I also sought interaction with and became involved in every part of the process; for example, the young people (called subjects initially then research volunteers), the staff, myself and all those who might be affected by the results. At times it all became overwhelming; too much data to make sense of, too much to contain in the material emerging in the DMT sessions and so on.

Conclusions at this stage included that human behaviour can only be understood with reference to the perceptual field of the behaving person. As a practitioner I continue to be committed to understanding client behaviour as it relates to their inner world, to their specific life experiences and to my own personal understanding. By linking these 'meanings' as a researcher a more complete knowing results.

Two themes which have emerged out of my retrospective analysis of these research experiences may be useful to mention here.

Motivations

In retrospect, the importance of recognising personal motives for undertaking research was a major outcome of the learning from all these studies. Just as it is important for therapists to understand their motivations for working in a particular medium (in my case dance movement) or with a specific client group, so it is important for the researcher to be aware of their motivations and identify their vested interest in order to validate the research.

In the early studies a lack of confidence in my own practice was always an obstacle for me. There were no UK validated trainings entitled 'Dance Movement Therapy' until very recently, so I did not have the privilege of a formal DMT education. Once I had taken the plunge to enter for the first research degree my confidence began to increase – the research helped me to develop a further understanding of the application of DMT which I doubt any formal training could have engendered.

My need for DMT to be accepted in the UK was at the root of a personal goal to establish nationally validated post graduate DMT courses. For that to be on the horizon in the UK there needed to be UK research. Undertaking research was also about my need to be accepted into the DMT world, which consisted in the main of practitioners in America.

Despite my intentions to explore a more participatory methodology much of the control remained with me in the M.Phil; the client group, young offenders, were reluctant to become too involved. They were given free and informed access to the decisions and protocol of the research and consulted on the formulation of therapeutic goals. However, it was clear that in my research, involvement of staff and young people was to a less than ideal extent. The research results were shared with the young people and the staff in the form of two specially written short reports. In retrospect perhaps there was a fear that the research would not be successful if I let go of the control; that perhaps it would not be good enough for the university, which expected a more than 'good enough' result for this unknown field of DMT.

Absence – presence

An interesting conflict arose when implementing this research project, partici-pants were sometimes absent from the DMT sessions, either because of factors such as passive resistance towards the DMT process and/or the research process, abscondance or illness. They were therefore also absent from the research, since they were in relationship with my roles as both therapist and researcher. Their consistent co-operation, as with most things for this population, was hard to seek out and maintain. This became a critical factor in the research process, particu-larly in the early stages. For example, once, no participants were present for a number of group sessions. Normally this would have been an acceptable and acknowledged issue to work with, however, in the context of the research aims the group really needed to be present at each session. As Lincoln and Guba (1985) point out, 'If the reciprocal relationship of investigator and respondents is ignored, the data that emerge are partial and distorted, their meaning largely destroyed. And of course the very existence of this reciprocal relationship depends on the willingness of the respondents to participate in it and support it' (Lincoln and Guba, 1985, p.104).

Perhaps (DMT) research should only take place with those populations who can continually be present? But which population can guarantee continual presence? In this project, with clients labelled 'delinquent' and 'in care' who frequently absconded, it was arranged to have a 'safety net' of other similarly labelled young people equally willing to participate in further DMT programmes for the purposes of the research.

The learning here was that the naturally occurring phenomena need to be studied rather than a false picture of an all-present therapy group. It seemed to me that participants in the therapy process were going to be affected by the

research process and vice versa, and that this needed to be studied as part of research.

Vulnerability

Another personal theme emerging by this time, because of sharing the research, was the issue of my vulnerability. I was open to scrutiny by colleagues, academics and other practitioners, but by being open about my vulnerabilities I was able to improve my practice and research skills, admitting to mistakes, not an easy thing to do, particularly when there is pressure from within to be the 'perfect' practitioner or researcher. At times, I felt like someone crying in the wilderness. The learning for me in this was that at times the research can be so demanding and de-skilling that it is easy to lose sight of strengths in the face of vulnerability.

As a result of the aforementioned 'sharing' in written and verbal forms there was a need to develop communication skills other than those inherent in the practice of DMT. 'In other words' (literally and metaphorically), I have had to describe the practice and the research itself, both in writing and orally. This has enabled my practice to become more real to others and helped me to clarify ideas but was not easily adopted since, naturally, my preferred form of communication is movement!

The interactive nature of research and practice

By the end of stage two I had moved from seeing research as separate from my practice in philosophical assumptions towards more of a synthesis between the two where research and DMT, as practiced by me, could move together in an interactive manner.

With reference to this, later research goals would include the exploration of clients' experience of the DMT process and its interactive nature influencing the delivery of DMT as well as what participants felt they got out of it. When exploring client's perceptions of DMT, how they arrived at 'meaning' during sessions, retrospectively, the concept of multiple realities became more important; this influenced my practice as well. In a later project (referred to in stage three) the methodology would aim to involve the client more in the design, process and analysis of the research, stressing the interactive nature of the research and DMT practice.

After the pilot stage (Payne, 1986) of the M.Phil the final fieldwork might be described as crystallization, in that it felt like I had arrived at a sort of coherent whole. The focus was clearly on the young people's perceptions of the DMT process and the meaning they created out of it. In this way their description of, for example, any interactive moments or significant issues would help me to understand their world view.

In the desire to understand the client's experience of DMT it was clear that there was more acceptance of the non-causal attitude, where the approach was more one of identification of themes and clusters of phenomena which were allowed to emerge and feeling safe with that, rather than a prescriptive measure-

ment based approach. This was tied in with my practice becoming increasingly responsive to the group's material, being able to identify suitable themes for work at the group's stages of development and so on.

The third stage

The third stage began with a new project, another beginning. There was no need to register for a PhD degree to do this research, even though the status of DMT was not yet recognised. This time I continued because of my fascination with the process of DMT, and because I have encompassed a research orientation which moved with me into the field of training as well as practice (Payne, 1990). The new project was an opportunity to explore further the collaborative approach to research as well as learn about a naturalistic methodology (Lincoln and Guba, 1985). It aims to understand the nature of students' experiences in a DMT group as part of their training in DMT and seeks to evaluate any learning they may perceive as a result in their eventual practice after graduation. It was initiated by me but sought to include the 'subjects' as co-researchers as much as they wished in a way which stressed inter-dependency rather than control and a greater incorporation of the effects of the research from the beginning, unlike stage two which did not recognise these aspects. Research tools included semi-structured interviews and group discussions together with the recording of self reflections in the journals of key participants. In addition, what I learned from those traditional, quantitative approaches enabled me to select where a questionnaire is appropriate, and where not in order to deepen an understanding of particular issues. A new aspect has been to include the voices of the co-researchers, as far as they have wished, in the research process through frequent meetings after each set of interviews. As we move towards a greater partnership, although not an equal one, in the problem-solving processes we have evolved a relationship based more on self-determination (Heron, 1981) and an inter-dependency of researchers and participants (Simons, 1991). The following quotations illustrate these notations.

> 'If the subjects are not privy to the research thinking they will not be functioning fully as intelligent agents. As a self-determining person is one who generates, or takes up freely as his own, the thinking that determines his actions' (Heron, 1981, p.22).

> 'there are inevitable constraints on the degree to which participants in a different time frame and context can contribute to the analysis... Interdependent research might be a more appropriate claim to make or aspire to than participatory research. It suggests a differentiation of roles... a two way exchange with different rewards for both groups and perhaps a better mutual understanding of the professional pressures on both' (Simons, 1991, p.113).

However, the research focuses on a DMT group facilitated by another practitioner. There is a paradox here. Whereas previously I was a practitioner doing research, in this project I am a researcher looking at practice; in this respect I have gone past the point of balance (see Figure 3.1).

In the most recent implementation of my research interest an emerging project (still at the conceptual stage) hopes to involve clients in both a self-determined and inter-dependent approach, at an early stage of the inquiry which aims to explore DMT and eating disorders.

This third stage seems different in the way it focuses on methodology as more of a specific learning experience as well as in the content of the inquiry. It seems to take account of both the personal and the social nature of research in a more significant way that reflects more accurately the nature of the process which could not be captured by an experimental design. It therefore aims at collaboration with participants as early as possible and as far as they wish.

What have I learned from these research experiences?

This section explores research-practice contradictions and connections.

Contradictions

Much like 'trying' to create a dance or a painting, I have learned something about letting go of the 'trying' in order to be more aware of the experience. Early projects found me trying very hard not to experience anything personally concerned with the research, like the disappointments or moments of disaster, but also trying to deny the social aspect, that is that anyone was experiencing anything from the presence of an inquiry/inquirer in their lives.

The traditional approaches seemed to cut me off from others, and them from me, the antithesis of what is aimed for in therapy. It is surely contact and listening or 'being with' that is the focus there. So I found a conflict being in the two roles at the same time which led to different approaches towards people. As a researcher it felt like I was wearing a symbolic white coat, like a laboratory experimenter, not able to let go of the protection (or was it a defence?), of the researcher's so-called neutral role, not acknowledging people, feelings or experiences within the research process.

Arriving at this awareness was important, difficult learning for me. It seems that it is related to my life in general rather than being a single aspect of experience (Barrell and Barrell, 1975). For example, returning to full-time practice after a period in the full-time training of others in the work has been a re-connecting with the experience of the process of DMT from a practitioner's perspective. Also I now see life more as a series of configurations, themes and patterns rather than one thing causing another in a purely linear way.

Sherman and Lincoln (1983) detail a comparison between orthodox and what is termed 'naturalistic' approaches to research. This has been a stimulus to identify several contradictions which I found myself holding during the journey towards a merging of practitioner and researcher.

As a way of thinking about these contradictions (see Figure 3.2) the left-hand side could be viewed as as practitioners' fears about research and the right-hand side as representing some common ground between research and practice (for some practitioners). In the light of this I offer the following comments.

Connections with reality

In research, as in interpreting a dance or participating in therapy, it has become increasingly clear to me that perceptions of reality are determined by the researcher and participant viewpoints. There are multiple realities not just different

Figure 3.2 Contradictions

There is one reality which can be studied independently	There are multiple realities which can be studied holistically
The researcher is value-free, neutral, has no hidden agenda or 'other' motivations. Does not need to be aware of biases.	The research is influenced by the subjects' and researcher's values, motivations and paradigm selected. Explicitly states biases
There is a cause and effect relationship	Patterns can be seen and inferences made
There is one truth to be proved	Truth is multiple and is to be explained
The context is not part of the research process	An ideographic body of knowledge is the focus
Generalizations are the focus	Nomothetic
The researcher remains at a distance from subject (object) of inquiry, administering tests, therapy, etc	Researcher seeks interaction and acknowledges the influence this has on the research process
DMT is a repeatable experience	DMT is a different process with each client group, setting, etc
Prior to the study, hypotheses can be identified and every variable defined	Scope of research can be clarified without closing research doors, becomes focused as themes emerge
The researcher is distant, withdrawn, remote from subjects and research which ensures objectivity	Total immersion of researcher
There is no need to inform subjects' of findings	Wisdom of sharing results by writing reports etc for those involved
The subject is seen in isolation	Subject is seen as part of an interacting system
The method defines the problem	The problem defines the method

views of one reality, and that what is real is actually different depending on one's perspective and ability to perceive different worlds of experience. This is a model which is more consistent with the reflective practitioner. As practitioners we may fear that research will tie us down to a conclusion that there is only one reality, one truth to be proved. Yet perhaps there is some common ground for research and practice if we can accept there are multiple truths which require explanation.

Connecting with control

In practicing therapy we probably do not see ourselves as controlling the client, rather we like to think we act as a guide to them in a shared pathway towards an understanding of their inner world.

In my current research although I am the registered researcher – it is my PhD, and as such it is me that guides the research – I am learning to let go of some of the control of the research. Co-researchers are involved, albeit in a less than ideal way, in, for example, consensus decisions concerning aspects of project management and design, in validity checks, and with the analysis and write-up. There was informed consent to decisions in the initial phases and an emerging intention to contribute to both the 'doing' and the 'thinking' aspects of the research. Unilateral control implies others have no importance so do not affect the research. Everyone (including the researcher) in the purview of a study has important interactive roles which influence the progress of the research. Perhaps as practitioners we fear the idea of the researcher treating the subject as an object, in isolation, since in therapy practice we see clients as part of an interacting system with ourselves and each other and through permitting interaction through our medium, whether it is dance, drama, music or art. By acknowledging transference and counter-transference in our therapy practice we realise the influence we have as therapist. Skills such as reflection, interpretation and relationship are common to both practice and research.

As the personal process in research is more than a matter of subjectivity, so the social process is more than a recognition of the role of consensus. Beyond this is a concern for connecting people with each other in positive, mutual interactions thus improving the quality and reciprocity of human relationships.

Research and personal process

As with the practice of DMT where the therapist's personality and philosophy determine the style of therapy, so the researcher's personality is a major determinant in any investigation. We are different with different client groups, employing varied models and approaches perhaps, or stressing particular strategies. The clients too may interact with ourselves and the medium in very different ways. The common ground here in research and practice is that the problem defines the method. We are therefore aware that the therapy to which we subscribe is not a generalisable, repeatable experience. Do we fear that in researching our practice we may stifle it and our own creativity as well, the therapy becoming simply a technique?

Similarly we choose and conceptualize our research problems and design our methods and creatively generate from our results, therefore we cannot help but determine our standards of objectivity. The common ground here for both research and practice is the acknowledgement of our subjectivity and openness to admit to contradictions in both. We do not need to assume there is a single purpose, nor need we pretend that there is a completely logical base for our research.

It is becoming more obvious to me that the 'objectivity' in the emerging methodologies come from aspects of reality as viewed on a map, where interesting patterns emerge to the researcher(s) as they analyse data through a specified screen to produce meaningful results. Objectivity here lies in the way the data are interpreted and come to be understood.

The personal process under discussion requires responsible personal inquiry but do we not already recognize this as practitioners, in, for example, the fact that we reflect on therapy sessions from a personal process view, seek regular supervision as well as engage in personal therapy? By reflecting on my practice in a way that Reason (1988) termed 'knowing-in-action', and which could be termed 'knowing-in-practice', these research studies have given me an opportunity to think about what I am doing in a rigorous way. In learning 'to make sense' of DMT, as practiced by me, at that time, with those clients, in those settings; it has helped me to explore further these patterns and understandings in my practice.

Practitioner as researcher – a distinct possibility
I feel my practice has benefited enormously from undertaking these projects. It seems more consistent with my belief system to consider themes and issues arising out of a group or individual DMT programme, to include others rather than alienate them when setting up a new programme. Since we are 'in the clients' service' as practitioners we are obliged to continue our professional development. Research is one way of doing this. It is my firm belief that research can provide us with an avenue for improving our service to the betterment of our clients.

As dance movement therapists, open and responsive to the themes and processes in our clients, we can use this awareness to allow ourselves to find and recognize those things which interest and excite us and to hold off the anxiety about 'doing research on them' so that they can develop. By preparing for our enthusiasm and engaging with it through research we can establish a solid research base in the UK.

In order to do research where both researcher and practitioner are in balance with each other it has been vital to engage in academic and practice supervision. In addition, the collaborative approach offers more support to the researcher particularly when research can be such an isolating activity. Here there can be a sharing of roles for both researcher and participants although not necessarily in identical ways.

The confidence to publish and share findings at conferences and in publications grew as I experienced more learning from first-hand 'sense making' in my

DMT practice. It needs to be acknowledged, however, that dissemination is also a personal and social process; reviewers and editors are subject to their own world view and what fails to come close to their own tradition will be unlikely to pass these gatekeepers (Spender, 1988).

Without the research alerting me to crucial phenomena in practice it is probable that I would have less grounded knowledge and thus less confidence to communicate practice. More importantly I believe clients receive a better delivery of DMT. Clients have benefited from tools used in the research, such as videotape playback of sessions, which has enabled them to become more aware of their experiences in DMT. Staff too have benefited from a greater understanding of DMT (through the research initiatives) and of how DMT can integrate with other aspects of clients' care, treatment or educational plan. But how much more satisfying if both can become empowered to feel that the research is something of theirs which they can shape and define if they so wish.

So how will research benefit DMT? Is this all so far removed from DMT practice? Do we not, amongst other things, observe/assess our clients prior to intervention? Do we not define our terms of practice, plan our action and frame our observations in the light of previous experience? Do we not also analyse and evaluate the session and/or programme of work making interpretations and speculations in relation to clients' case notes and current life experiences. My thinking here is that part of our 'good enough' DMT practice is but a step away from the beginnings of research as I currently understand it. By practitioners engaging in researching their own practice, they become connoisseurs of it and more self aware.

There is a need to describe our work in a language understandable to other professions which can help us in our development towards professional recognition. In so doing we are often forced to engage in outcome measures which are more generally understood to describe our work with clients. It then becomes research 'on' the clients instead of with and for clients. It also must be said that there has yet to be a body of research which proves the efficacy of DMT and we need to ensure our students are aware of this fact, of the limitations of outcome research and of the concept of efficacy. A sole reliance on traditional research approaches denies us access to the richness available in the processes and other phenomena intrinsic to practice. Process research, equally, could find itself using movement descriptions or technical language to describe DMT which could alienate us from our colleagues in the services in which we work.

Research itself is a process and, inevitably, the world view of the researcher is part of it. Research seems to feel one day like a devouring beast which totally takes over your life and another like an exciting, powerful magician with new spells and potions to heal the splits and provoke ideas and understanding. The puzzles and anomalies, the acquisition of new thinking and the asking of further questions (but rarely the finding of one definitive answer) are all a part of the process.

Since DMT is so young in its development, perhaps the next decade is the time for it to begin to take a good look at the possibilities for research, to see if anything can be integrated to make that transition towards an on-going research profession. DMT is amenable to research and it is crucial that it is undertaken for the development and recognition of DMT as a profession. A beginning has been made. Now the field needs to look seriously at ways of broadening its research base to help it become a profession. There are strengths in the emerging approaches to methodology not available in traditional ones. However, it is vital we remain open to all approaches and, more importantly, begin to explore them for ourselves, whenever an interesting issue arises in our practice.

So what can be done to nurture research in dance movement therapy? The training institutions need to provide a climate of support and reflection for students in training within a research ethos. For those who have been in practice for some time these institutions need to find ways of encouraging practitioners to think about registering for a research degree or undertaking an independent project. Conditions for staff need to include encouragement and support for them to embrace research and opportunities for critical debate within and across departments. A research fellowship would be a particularly important development to encourage research opportunities for dance movement therapists. The professional association (ADMT), while succeeding in providing firm foundations in areas such as standards for professional practice, needs to recognize the importance of research activities. In the light of this it needs to aim, in the future, to weave a positive attitude towards research in its policies, practice, registration criteria, professional journal policies and in any negotiations for recognition and conditions of service in the health, education and social services.

The Arts Therapies Research Committee[4] is making a strong contribution to raising the profile of research in the arts therapies and can offer support to DMT and arts therapies research. This initiative enables practitioners to engage in creative problem-solving approaches, communication and dissemination of their projects, at whatever stage of development, empowering arts therapists in their journey towards a research orientation.

Summary

This chapter has shared a personal biography of my research experience to date. Mistakes were made in the research projects but through these my views changed and new learning was acquired. The learning continues as endings arrive and new beginnings emerge in the unfolding process of research. The chapter has documented and analysed experiences retrospectively, focusing upon motivations,

4 As founder member of this group I would like to extend my appreciation to the art therapists, music therapists and dramatherapists who have supported this work. It has become an important landmark in arts therapies research development. Further details available from ATR c/o Ditty Dokter, University of Hertfordshire, School of Art and Design, 7 Hatfield Road, St Albans, Hertfordshire.

pitfalls, contradictions and themes from this dance movement therapist's perspective. It identified some of my learning patterns and understanding which, in turn, will affect my 'sense making' of any future research I undertake.

References

Argyris, C. and Schon, D. (1974) *Theory in Practice: increasing professional effectiveness.* San Francisco: Jossey-Bass.

Barrell, J.J. and Barrell, J.E. (1975) 'A self-directed approach for a science of human experience', *Journal of Phenomenological Psychology,* 6, 1, 63–73.

Berrol, C. and Katz, S. (1989) 'FAMP: a dance movement therapy assessment for rehabilitation: A work in Progress', in *Conference proceedings,* Monograph No 6, 24th annual Conference American Dance Therapy Association.

Brooks, D. and Stark, A. (1989) 'The effect of dance/movement therapy on affect: A pilot study', *American Journal of Dance therapy,* 11, 21, Fall/Winter.

Gilroy, A., Hoskyns, S., Jenkyns, M., Lee, C. and Payne, H (eds) (1989) 'Arts Therapies Research', *Proceedings of the First Arts Therapies Research Conference,* City University, London.

Guba, E. and Lincoln, Y. (1981) *Effective Evaluation: Improving the usefulness of evaluation results through responsive and naturalistic approaches.* San Francisco, CA.: Josey-Bass.

Heron, J. (1981) 'Philosophical basis for a new paradigm', in P. Reason and J. Rowan (eds) *Human Inquiry: A sourcebook of new paradigm research.* Chichester: John Wiley and Sons.

Kuhn, T.S. (1970) *The Structure of Scientific Revolutions.* (2nd edition). Chicago: University of Chicago Press.

Lincoln, Y. and Guba, E. (1985) *Naturalistic Inquiry.* Beverly Hills, CA: Sage Publications.

Mahrer, A. (1985) *Psychotherapeutic Change: An alternative approach to meaning and measurement.* New York, Norton.

Maslow, A. (1976) *The Farther Reaches of Human Nature.* Harmondsworth, Penguin.

Parlett, M. and Hamilton, D. (1976) 'Evaluation as illumination: a new approach to the study of innovatory programs', in B.V. Glass (ed) *Evaluation Studies Review Annual (vol. 1).* Beverly Hills, CA: Sage Publications.

Parlett, M. and Deardon, G. (1977) *The Illuminative Evaluation in Higher Education.* California: Pacific Sounding Press.

Parlett, M. (1974) 'The new evaluation', *Trends in Education,* 34, Innovative issues. London: HMSO/DES.

Parlett, M. (1981) 'Illuminative evaluation', in P. Reason and J. Rowan (eds) *Human Inquiry.* Chichester: John Wiley.

Parlett, M. (1983) 'Illuminative evaluation', in *International Encyclopedia of Education*, vol. 15. Oxford: Pergamon.

Payne, H. (1977) 'To examine the value of movement therapy in improving relationships for a number of emotionally disturbed children'. Unpublished study, Laban Centre for Movement and Dance, New Cross, London.

Payne, H. (1980) 'Body image boundary and its relationship to social adjustment, self concept and self actualization in a group of ESN(m) [now MLD] children'. Unpublished dissertation, Cambridge Institute of Education.

Payne, H. (1981) 'Movement therapy for the special child', *British Journal of Dramatherapy*, 4, 3.

Payne, H. (1983) 'Moving towards dance movement therapy', *Laban Guild Magazine*, 71, pp.22–5.

Payne H. (1986) 'Dance movement therapy with male adolescents labelled delinquent – a pilot study'. *Proceedings, VIII Commonwealth and International Conference on Sport, Physical Education, Dance, Recreation and Health – Dance: the study and the place of dance in society*, London: Published by E.& F.N. Sponsors.

Payne, H. (1987) 'The perceptions of male adolescents labelled delinquent towards a programme of dance movement therapy'. M.Phil thesis, University of Manchester, John Rylands Library.

Payne, H. (1988a) 'The practice of DMT with male adolescents labelled delinquent-research findings and implications for practice', *Proceedings, Fourth International Conference, Dance and the Child International*, Dance Department, Roehampton Institute.

Payne, H. (1988b) 'The use of DMT with troubled youth. Final fieldwork results', in C. Schaefer (ed) *Innovative Interventions in Child and Adolescent Therapy*. Chichester: John Wiley Interscience.

Payne, H. (1990) 'The dance movement therapy group as an integral experience in a post graduate course of study'. Paper presented at the *First Arts Therapies Education and Training Conference*, Hertfordshire College of Art and Design, St Albans.

Polanyi, M. (1962) *Personal Knowledge: Toward a post-critical philosophy*. Chicago: University of Chicago Press.

Ramsden, P. and Zaccharias, J. (1991) *Top Team Dynamics*. Aldershot: Gower Press.

Reason, P. (1986) 'Innovative research techniques: critical subjectivity and holistic inquiry', *Complementary Medical Research*, 1, 1, pp.23–39.

Reason, P. (ed) (1988) *Human Inquiry in Action*. London: Sage Publications.

Reason, P. and Rowan, J. (eds) (1981) *Human Inquiry*. Chichester: John Wiley.

Sherman, A. and Lincoln, Y. (1983) 'Naturalistic models of evaluation: their similarities and differences', *Art Education*, 25, January, pp.68–71.

Simons, H. (1991) 'Reflective practitioners, reflective research', in H. Fry, J. Maw and H. Simons (eds) *Dealing with difference: Handling ethnocentrism in history in the classroom.* University of London, Curriculum Studies Department, Institute of Education.

Spender, D. (1988) 'The gatekeepers: a feminist critique of academic publishing', in H. Roberts (ed) *Doing Feminist Research.* London: Routledge.

Part II

Application

Part II

Application

The Active Witness
The Acquisition of Meaning in Dramatherapy

Phil Jones

'The Gentleman and the foole should never sit on the Stage together.'

Thomas Dekker, *The Gull's Hornbook*, 1609

Introduction

What could Restoration theatre theory, the rewriting of *King Lear*, puppetry, social contact between young adults diagnosed as autistic and dramatherapy research have in common? Dramatherapy has developed from a number of apparently unrelated fields such as theatre, psychotherapy and educational drama. I hope to show in the following chapter that dramatherapy must utilise the broad range of disciplines it is related to in order to develop a full and effective research methodology. In doing so I intend to demonstrate how it can be useful to ask, and try to answer, questions such as the one which opens this chapter. How, more specifically, can clinical work with puppetry aimed at developing social skills benefit from the consideration of a late seventeenth century adaptation of *King Lear?*

Little work has been undertaken to try to understand and describe the 'audience' in dramatherapy. This chapter selects an area from research on meaning in dramatherapy concerning the notion of 'audience' as a way of understanding a number of processes at work within dramatherapy theory and practice. Keir Elam says that 'it is with the spectator... that theatrical communication begins and ends'(Elam, 1980, p.97). In this chapter I wish to examine whether it is possible to identify what kind of communication 'begins and ends' with the spectator in Dramatherapy groupwork.

After a consideration of current thought in the related fields of theatre and therapy concerning audience, a framework will be drawn relating to dramatherapy theory and practice. This framework will aim to examine how theatre based research can act as a way of exploring and understanding processes at work within dramatherapy practice. The chapter will then focus on a piece of action research

which looks at the issues of audience and meaning in relation to work involving puppetry in a dramatherapy group with young adults diagnosed as autistic.

Research in dramatherapy

Robert Landy in a section of *Drama Therapy – Concepts and Practices* called 'Future Directions of Research' says that research in dramatherapy should be based in theory derived from drama (Landy, 1986, p.217). The usual approach in dramatherapy which draws virtually exclusively from psychotherapy and psychology research methods is challenged by this.

Within Landy's future directions for research there is one focus which he indicates as central and which is, as yet, not adequately addressed. He forms this focus as a research directed question; what is it about the dramatic, creative process that is therapeutic? The research process he advocates has two main aspects. One concerns the formulation of questions grounded in practice which are based on the consideration of whether change occurs 'due to the fact that the therapy is dramatic' (Landy, 1986, p.228). The second concerns the need for research which validates the conceptual basis of dramatherapy. Both aspects should be grounded in the art of drama. Landy says that this implies a movement 'away from the most restrictive quantitative, behavioural research toward more qualitative, in depth methods'(Landy, 1986, p.229).

The problem I see here is one of finding a language that is meaningful for dramatherapy. In contrast to Landy I feel that there is a danger in the sole use of dramatic concepts and language in research. This would only acknowledge a part of the processes which occur within dramatherapy. There is a need to explore and develop a language and framework in research which acknowledges both key aspects of dramatherapy – the therapeutic and the dramatic. The approach would not merely utilise already existing tests of therapeutic phenomenon, but would be grounded in dramatic ideas. This dual acknowledgement of therapy and drama would aim to focus upon phenomena which are directly related to the key relationships between drama and therapeutic change which are at the core of dramatherapy work.

From Landy, then, I wish to take two of the aspects he identifies as central to research; that treatment strategies and techniques must be evaluated through trial and error within precise action research, and that dramatherapy theory must be developed. To this I add the need for a relationship to be established between dramatic and therapeutic or psychological languages and meanings. The following material will utilise Landy's two main *foci* of research by first developing a theoretical structure firmly based in dramatic and theatrical form. Second, this theory will be connected to action research which tries to find a language to describe and give meaning to change within an example of dramatherapy practice. Within this I hope to establish whether it is possible to find a language which connects dramatic, therapeutic and psychological perspectives. As I have mentioned, it is usual within dramatherapy to move to psychological or therapy based testing methods when turning to the analysis of meaning and change, conceptual

frameworks or research strategies. In highlighting the notion of 'meaning' I want to try to draw together both arts and psychological approaches.

The area of research

How drama and theatre acquire meaning has been a central concern throughout their history. Theatre practitioners and theorists from Aristotle to Boal and Brook have debated and analysed the medium from this perspective. Much of dramatherapy's thinking and approach seems to ignore this search in favour of the ways in which psychology has tried to ascertain and describe meaning. This is a serious omission. One way for dramatherapy to develop research is by looking to its dramatic and theatrical origins. The creation of the field of dramatherapy throws a new light upon theatre form. In re-examining the process of drama through the framework of dramatherapy, we can learn both about theatre or dramatic phenomenon and about the nature of dramatherapy.

On one level the problem of meaning can be considered alongside the problems of interpretation. In theatre this relates to how a particular text is taken, its possible meanings analysed and put forth. How, for example, director and performers approach a given play and take it through to performance. This apparently basic process becomes almost infinitely complex when issues relating to the production of theatre and the different perspectives of those involved are taken into account. The relationships involved in traditional Western theatre are as follows:

Author/ess	← creates →	text
Text	← realised by →	director/performers/technicians
Performers	← create →	performance
Performance	← reacts to →	audience

All the above are subject to framing by particular trends in approach, ways of working within theatre, interpretation, processes of production, morals and censorship, to name but a few factors. If this framing is acknowledged then the surface of a theatrical or dramatic product shifts to become a part of a process consisting of forces struggling to create and define a meaning.

This process is especially visible in the treatment of Shakespeare by Restoration playwrites. It is unusually noticeable due to their opposition to current methods of creating meaning in theatre. Charles Lamb spoke approvingly of Nahum Tate's adaptation of *Lear* as 'Tate (having) put his hook in the nostrils of this Leviathan for... the showmen of the scene to draw the mighty beast about more easily' (Lamb, 1903, I:107). Writing in 1681 Nahum Tate describes the meaning of Shakespeare's *King Lear* as 'a heap of jewels, unstrung and unpolished... dazzling in their disorder' (Tate and Black, 1975, p.17), as having too complex and dark a vision for the late seventeenth-century theatre audience. The meaning of the tragedy is radically shifted as Cordelia is made to survive – the rescuers arriving in the nick of time, and an inserted moral uplift ends the altered play,

'Thy bright example shall convince the world
(Whatever storms of fortune are decreed)
That truth and virtue shall at last succeed' (Tate and Black, 1975, p.95).

Goneril and Regan, in line with contemporary notions of poetic justice have killed each other by this point. The framework surrounding the play has shifted the relationship between Shakespeare's original work and his audience. Tate's adaptation takes into account changes in the meaning a society wishes to take from theatre, resulting in a rewriting and a new set of relationships between meaning, text, performers, author and audience.

This aspect of theatre and drama has been particularly brought into the foreground by recent works of semiotic research. These stress the importance of analysing and finding a language to examine the processes by which meaning occurs and can be read. So, for example, Elam refers to French and Italian traditions of analysis (Elam, 1980, p.30) which explore the way theatre produces meaning, how communication occurs. 'The information "Night falls", for instance, can be conveyed by a lighting change, a verbal reference, or, in Oriental Theatre, gesturally' (Elam, 1980, p.40). This critical school examines, as in the above quotation, the choices which are made within theatre, the process by which an act is made and gives meaning. This approach addresses the problem of how to define or understand phenomena such as a Brechtian decision to make light sources visible in a production, rather than to secrete them as a realist treatment would demand.

The example from the Restoration adaptation shows how the meaning of a theatrical act is shifted or changed according to its context. In addition it demonstrates that the context is in part defined by the purpose which is given to the theatrical and dramatic act: that the apparently simple act of producing or reacting to drama is at the centre of a complex web of meaning, production and manipulation. The semiotic study of theatre and drama process is a way of coding and describing these processes.

For dramatherapy it is important to examine the way meaning is produced through the dramatic medium. One area of this process is the way in which the audience can be understood within dramatherapy. In the same way that the shift in the use of theatre fundamentally altered the relationship between *King Lear* and the audience, what shifts in the audience's relationship to drama can be identified within dramatherapy groups?

This is the central area of examination. The first task is to research into theatre history and semiotic interpretation of theatre to create the theoretical framework which Landy advocated in a way which can be used as a way of describing and understanding dramatherapy process concerning the 'audience'.

The audience

By researching into the history of theatre theory and form it is possible to identify specific aspects of the processes involved within theatre and drama concerning the audience. These may be relevant to the therapeutic use of drama. This focus

can help to develop a critique and an understanding of dramatherapy theory and practice.

Elam notes that the scope of spectator-performer signals is restricted (Elam, 1980, p.96) and can be considered within three key areas; space, relationships and intertextuality.

Space

There is usually a cognitive division between audience and spectator. A semiotic approach sees this in terms of its potential to create meaning: to allow a more precise definition of what is included in, and what is excluded from, the theatre area in space and time. It is interesting to contrast our contemporary unwillingness to allow audience invasions and interruptions with the lack of such division within Restoration theatre. Audience members could sit upon the stage area and the acted material had to battle with constant physical and verbal interruption, 'there are no guards and police; and hisses, cries, laughter and invectives resound from all quarters' (Nagler, 1952, p.280). Within contemporary notions of theatre, however, the semiotic notion of theatre space is that it demarcates a division between 'performance' and 'non-performance', the relationship between the two enables a heightened attention or focused meaning to be created on the area designated as performance space.

Relationships

The ways in which actors position themselves and communicate in relation to each other, standing at an angle so that the audience can see and hear, implies a consciousness of the audience. Their relationship is altered in recognition of the fact that observation occurs. This indicates a shift in relationship within interactions when an audience is present. It also indicates a key factor within semiotic understanding of audience process, that of a special kind of permission given to actors by the audience. William Dodd says that the audience 'delegates, so to speak, the communicative initiative to the actors onstage, making a contract whereby the actors are conceded a superior degree of articulation' (Dodd, 1979, p.135). Here are two factors crucial to the development of a frame for dramatherapy concerning audience. One is the notion of a special kind of relationship created between people within a theatrical frame which differs from that outside the theatre. The other is that the audience permits a 'superior degree of articulation' in their relationship with the performers – a special set of permissions concerning communication not available in everyday life – a heightened awareness.

Intertextuality

The frame of theatre is seen as 'intertextual'. This means that the audience's experience of theatre relies upon their ability to relate the kinds of interactions they experience elsewhere to the theatre or performance situation. 'Text' here is used by a semiotic approach to refer to the different aspects of experience an

audience member brings to their viewing of a performance which helps them to understand the form and content of a play. These texts may be other plays, or may be experiences from life. Thus the understanding of any play relies upon the audience members' ability to link their life experience to the theatre performance: this is intertextuality. Implicit in this notion is the intimate connection between life experience and theatre performance – and the audience members' ability to make sense of one through the other.

The active witness in dramatherapy

I will now explore these notions of space, relationship and intertextuality further. We may, as audience members, identify with the characteristics of one of the persona on the theatre space or stage either through motivation, experience or attitude, for example. Accompanying this may be a projection. We project our own motivations, feelings and experience into the mould the actor/actress provides for us. This need not be a simple passive/active relationship with the only dynamic being the performers becoming recipients of our projections. The text, giving events, things which happen to and for the personae, the interpretations given to the roles by actress/actor or director, all may act as a resistance to the projection. For example, I may project my own feelings or situation into a character or scenario occurring on the stage. To satisfy my projected feelings I may desire the characters or the narrative to develop in a certain way; to act in a certain way, to follow a certain course of actions. However, the interpretation or narrative may frustrate my projected desires. Hence the activity on the stage, once my projections are involved, may develop a dynamic relationship with the parts of myself I am projecting, and may shift my relationship with the projected feelings during, or after, the engagement with the performance. This may, in turn, affect the way I understand and feel about the parts of myself which have been engaged with the projection.

The nature of the theatre space is such that it creates a frame, the stage, for the audience to project possible or potential selves or aspects of the self. The intertextuality which semioticians indicate as crucial to our finding meaning in theatre acts as a way of understanding the connecting of theatre actions to those in reality. At the same time the two aspects of 'relationship' which the semioticians highlight means that the frame creates a heightened representation of reality with particular permissions which would not be granted in everyday life. Wilshire acknowledges a part of this when he talks of viewing theatre as, 'To see what one actually is to see this as only an instance of the possibility projected by the fiction' (Wilshire, 1982, p.51).

The essence of the act of witnessing, or being a member of the audience in dramatherapy, might be said to refer to the shift in meaning which can accompany a shift in perspective. It is analogous to the process which can occur in theatre: as an audience member views an actor or actress a number of processes occur which seem to both involve and disengage them concerning what is happening on the stage.

As discussed above, we 'stand in with' the character and at the same time 'maintain a distance' as an audience member. This is as true in a theatre setting as it is in a dramatherapy session. In dramatherapy individuals can identify with others involved in enactment, they can act or take on a role. At the same time, however, they can remain themselves or the aspect of the self that is an 'audience'. A theatre in miniature is created within the group and within the self. The actor or actress in dramatherapy can take on a heightened representation of themselves. Through the notion of intertextuality we can see that an audience member brings their life experiences or life texts to understand the theatre events they witness. In dramatherapy the intertextuality of theatre enables the client to bring together texts from their lives with the new text of the enactments created within the group.

I have pointed out elsewhere that the notion of 'audience' is one of the most undeveloped areas of dramatherapy thought and practice (Jones, 1991). Much consideration has gone into the dramatic work which occurs for those involved in the enactment, but much less has gone into the consideration of the audience notion in dramatherapy. Key theoretical texts such as Schattner and Courtney's *Drama in Therapy* in both volume I and II (1981) or Robert Landy's *Drama Therapy* (1986) have no index entry under 'audience' whilst role, props, acting, catharsis, chorus, play, theatre games, costume, scenery are all included. So, is the aspect of the theatre phenomenon which gives it its 'fundamental meaning' as absent as these indexes would suggest? I would argue that the function of the audience, or witnessing is present and crucial within dramatherapy groupwork, but that it manifests itself differently and has a different function from a theatre audience process. I would not say that dramatherapy, by remaining in a closed group situation, misses the 'heat' of the central encounter of performer and audience member which Brook assigns to be the essence of formal theatre (Brook, 1988, p.236). Rather I would argue that it is present in a number of ways, and provides an important function in the efficacy of dramatherapy and the work of therapeutic change within a group.

The act of witnessing in dramatherapy is that of being an audience to others or to oneself within a context of personal insight or development. In dramatherapy both aspects of audience – witnessing others and the opportunity to witness oneself – are of equal importance. Within much theatre work there is a shift in these areas from the rehearsal phase to the performance phase. In the first phase the actors, actresses and director act as an audience to their own work, the future audience being present as an anticipation. In the performance phase there is a shift whereby the main response is that of the audience present at the performance. Within dramatherapy work this shift does not occur in such a marked fashion, except in cases where a performed piece is part of the therapy. In ongoing dramatherapy work it is unusual for there to be an audience called in to witness the work. What occurs in dramatherapy is that the audience phenomenon is present in a series of possible interactions between group members, and between group members and facilitator. Both aspects as outlined above – that of the rehearsal phase and of the performance phase are paralleled within these inter-

actions, but their form and effect shift. Most dramatherapy breaks the traditional rule of audience cited by Goffman, 'the central understanding is that the audience has neither the right nor the obligation to participate directly in the dramatic action occurring on the stage' (1974, p.125). This results in a shift from the usual means to demarcate dramatic from ordinary reality – it is crucial for the therapist to recognise this shift.

Witnessing in dramatherapy can take place briefly, as one person observes an improvisation of another, or others. It can also take place as the group witnesses the improvisation of a small group or pair, or in a more sustained way during an individual's work, when group members and the therapist become audience to the role play or enactment which emerges.

For the client within dramatherapy:

1. The client can function as a witness or audience to others' work.

2. The client can become a witness to themselves: for example by the use of doubling or role reversal, or by use of objects to represent aspects of themselves.

3. The client can develop the 'audience' aspect of themselves in response to their experience, enhancing the capability to reflect upon and engage differently with themselves and their life events.

4. The experience of being witnessed within a dramatherapy session can be as being acknowledged or supported.

5. The projection of aspects of themselves or aspects of their experience on to others who are in an audience role (for example other group members or the dramatherapist) can help the therapeutic process by enabling the expression of problematic material.

The degree of consciousness of the role of audience can vary greatly within dramatherapy. It does not have the formality of many theatres where the audience area is clearly demarcated, separated off with curtains, seated in rows etc. It may change from moment to moment: the client in dramatherapy is a participant–observer to themselves and to others. At one moment the client working on material may be at the centre of an enactment, the next they may be in an audience role, or doubling. Similarly someone as an audience member can find themselves shifting as they are suddenly asked to double or to play a role in someone else's enactment. The client is called upon to act and at the same time to witness: at the same moment they are the audience and yet are not the audience to themselves. They become an 'active witness'.

The audience–performer relationship can be slight, no 'stage' areas being clearly demarcated or roles such as 'spectator' or 'actress' being clearly defined. Alternatively, the role of audience member can be clearly delineated within dramatherapy, the area in which the clients who are to engage in enactment being clearly marked, roles clearly differentiated. This creates a different relationship between those who are engaged as actors or actresses in drama and those in an

audience position. In the latter situation more distance is created between one state and the other, the act of witnessing is made more visible. This can serve a number of purposes; the creation of safety, the enhancement of boundaries concerning being in and out of role or the enactment, to heighten focus and concentration, to heighten the theatricality of a piece of work. The shift from audience to actress/actor can act as a pivot for change – enabling perspective and insight.

The analysis of theatre and audience from a semiotic point of view in terms of space, relationship and intertextuality has thus served as a useful framework to help identify a number of key processes within dramatherapy. Before considering the research project on the use of puppetry with a group of autistic adolescents I will briefly summarise the key points.

1. Active witnessing is the act of being an audience to others or to oneself within dramatherapy. Both aspects are of equal importance.

2. The audience in dramatherapy is interactive and has little of the formal demarcation of place and continuity of role of traditional Western European theatre. Within one session the client can experience both audience and performer roles and functions.

3. The audience performer relationship in dramatherapy consists of a series of possible interactions, e.g.:

 • of being witnessed by other group members or by the facilitator;
 • of witnessing others;
 • of the client witnessing him or herself (e.g. through video, role reversal or being represented by objects).

4. The audience can play an important part in the processes of dramatic projection, the dynamics of the group and in the creation of perspective and support.

The puppet and the active witness

I now wish to explore the ways in which this theoretical framework concerning the audience and active witnessing in dramatherapy can be used in an action research setting as a framework to understand what occurs within practice. In doing this I will refer to work with a group of three autistic young adults. I will not present the results of the assessments which we made in detail. For the purposes of this chapter I intend to focus upon the issue identified earlier – of trying to establish a language which brings dramatic and therapeutic approaches together. I will use the material from the group to illustrate the approach and attempt to establish this language.

The aim was to use the medium of puppetry to enable clients to become involved with the 'small actors' they created, becoming audience–participants or active witnesses to themselves. Here the key question relates to the issues of

meaning which I have raised during this chapter. How could we be sure of the meaning and effect of the work?

More specifically, the work aimed to increase the client's range and frequency of interactions with others through the use of puppetry and improvisation. We wished to see whether the use of puppets would enable the three individuals involved to experiment with and use interactions in a way which was different from their usual modes of behaviour. G.P. Stone's comments on the relationship between projection and drama make an interesting link to the semiotic theatre framework concerning audience in dramatherapy, 'To establish a separate identity... the child must literally get outside himself and apprehend himself from some other perspective. Drama provides a prime vehicle for this. By taking the role of the another, the child gains a reflected view of himself as different from but related to that other' (Stone, 1971, p.113). Here he echoes many of the issues touched on; the notion of the child witnessing themselves, the creation of perspective, the establishing of identity through empathy and distancing in enactment. The aims of the action research reflect the theoretical frame I have drawn up. They connect with the key theoretical areas of creating a dramatherapy space in which altered relationships are made possible due to witnessing, and which relate to real-life situations through intertextuality.

As a projective device within dramatherapy the puppet can be used in a number of ways. The puppet can be seen to parallel the use of objects or toys in dramatherapy. The physical and imaginative properties of the puppet invite an involvement which lies between the use of objects in play processes within therapy and the use of improvisation. The puppet may be seen as a progression from the symbolic use of objects in play. In projective use, the puppet can be seen as a progression from object usage, rather than a completely different area of practice.

Having said this, there are important differences. The body of the client may be engaged physically: for example, with a glove puppet, by the hand. In using glove puppets, the physical act of having the hand inside the puppet will engage the operator in an intimate relationship which enhances empathy between operator and puppet. In contrast the use of rod puppets, with their rods attached to the puppet's limbs, means that the manipulation is constantly visible and the manipulator has a clear statement of their power to shift limbs whilst maintaining physical distance. This creates a mixture of feelings regarding empathy and distance, but could be seen to be less encouraging of an empathic relationship for the user. As I wished to encourage empathy between the clients and the puppets, I decided on the use of glove or hand puppets. Life size or larger than life puppets can offer potential projections involving being overpowered, I wanted the clients to feel at ease in operating the puppets, so the small size of the glove puppet suited this purpose also.

The puppet, then, within dramatherapy work can be seen as a form which invites strong empathy, which inherently invites less distance than object play, which involves dramatic possibilities and which carries with it a clear process of

physical relationship (e.g. hand, rod, shadow) all of which affect the projective relationship.

Case study: the active witness and autism

With the group of autistic young adults the puppets were used as a medium to test whether empathy would be possible between the client and a made object. In addition the work would explore whether the client, in being able to play audience to themselves as represented by puppets, might permit distancing in that they were both identified with, yet separate from the puppet representation. We aimed to see whether this relationship meant that behaviour and relationships which proved difficult within actual encounters might be made possible if the clients were audience to representations of themselves. A further element of research was to see if the work undertaken with puppets in dramatherapy would have an effect on the clients' relationships outside the group.

To this end the project was co-worked between myself and Rosemary Sanctuary, who had a background in experimental psychology. Together we designed a programme of dramatherapy along with a testing system.

As stated above, we were looking to see if dramatic involvement would create a differing set of relationships between the clients. This especially concerned the reduction of stereotyped and withdrawn behaviour, along with an increase in areas identified as being positive social behaviours. Video tapes were made of the students in various situations. From this material a series of areas and behaviours were developed by Rosemary Sanctuary based on Parten's (1927) study of young children. Along with these categories others were created which the therapeutic programme aimed to develop, though there was little evidence of these behaviour categories within the relationships which the clients used and displayed. These areas included 'Initiated' 'Helping' and 'Parallel Activity'. A continuum was created from this material, ranging from withdrawn to active and pro-social behaviours and interactions.

Table 4.1 Continuum

1. Stereotyped: including

 (i) Vacant smiling or laughing

 (ii) Finger movements and/or handflapping

 (iii) Circling or dancing from foot to foot

2. Unoccupied/withdrawn: including

 (i) Staring into space

 (ii) Watching others or looking round

 (iii) Playing with own body or clothes

 (iv) Getting on/off chair

3. Solitary: including

 (i) Reading or looking at magazines alone

 (ii) Studying an object

 (iii) Drinking

 (iv) Smoking

4. Responsive: including

 (i) Smiling or laughing in response to another

 (ii) Answering when addressed

 (iii) Maintaining conversation

 (iv) Maintaining eye contact for at least one second

 (v) Handing or passing objects in response to another

5. Aggressive: including

 (i) Initiating e.g. Hitting, scratching or pushing

 (ii) Maintaining in response to another

 (iii) Ending aggressive encounters

6. Initiated: including

 (i) Addressing other by name

 (ii) Waving at other

 (iii) Touching other non-aggressively

 (iv) Starting conversations

 (v) Requesting objects or help

7. Helping behaviour: including

 (i) Passing or giving objects spontaneously

 (ii) Moving to accommodate others

8. Parallel activity: including

 (i) Looking at books or magazines together

Source: Sanctuary, 1984, p.17.

This was time sampled for two weeks before the dramatherapy group, during the dramatherapy group, and immediately after the work with a follow up two weeks after that.

The group met once a week for an hour. Nine weeks were spent by the clients making puppets and preparing. There was then an intensive period of nine

sessions over two weeks – which consisted of free play, structured activity, video playback and role playing using the puppets.

Preparation involved mirror-based identification of body parts and face, face paints and life-sized body drawing. These were used as plans for masks and for the puppets. Students drew paper patterns and sewed their own puppets. The aim in doing this was to heighten their involvement in the puppets. The mirror work was intended to test and enhance the students' ability to recognise themselves and develop an image of themselves. Each student made a mask of him or herself, based on close work with mirrors. The masks were created to develop the clients' capacity to witness, and to encourage and test self projection. An amount of time was spent in clients identifying their own masks as distinct from others and in recognising the identity of the other clients' masks.

Clients were able to identify their own puppets and to respond to the question, 'Who is that?' directed towards the puppet with their own name, and would verbally identify the other clients' puppets by the clients' names.

In the initial session after the puppets were completed they were left in the room during the dramatherapy group and free time was given. As the work progressed possible frameworks for interaction were introduced to the students. These were to initiate responsive behaviours, parallel behaviours, (such as walking, dancing, climbing, waving) and to initiate helping behaviours (such as making and drinking tea, putting the puppets to bed, overcoming physical obstacles). Students were also able to view themselves operating the puppets on video playback and asked to point and indicate who they were and who the puppets were.

The nine sessions varied between initial introductory work as described above and the giving of time to see how, and whether, clients would relate to the puppets and each other.

Within the sessions, monitoring indicated that clients showed evidence of being able to project themselves into the puppets: for example, moving towards each other and greeting each other's puppets by naming the operator whilst engaging eye contact with the puppets. Relationships developed: for example, when one of the clients had her leg bandaged, a play situation occurred whereby one of the clients' puppets bandaged the leg of the other client's puppet. The puppet was taken to lie in bed. There was some withdrawn behaviour, such as withdrawal from activities following an initiated action from another.

Whilst much change in the areas of behaviour was noted during the sessions, only minimal change was monitored during the observation periods outside the sessions.

A time sampling approach was adopted, clients were regularly observed during identical time periods throughout the process. The frequency of behaviours within the categories were recorded. A baseline was set over a two-week period prior to the work. Recording also took place during the period of intervention, whilst the dramatherapy group was running, immediately after the ending of the group for

one week, and after a two-week interval the follow-up recording occurred for one week.

As facilitators we monitored the work during the group. In the testing of whether the puppetry work had effects on the clients' behaviour outside the group, two staff members utilised the categories to record and monitor behaviour. The number of occurrences of each category was totalled and a percentile of the individual's total behaviour was calculated. Table 4.2 is a sample of the kind of material which was gathered.

Table 4.2 Client 'AC'

Behaviour	Observation period			
	Baseline	Intervention	Post-treatment	Follow up
Stereotyped	13.2	6.23	4.17	12.5
Withdrawn	59.29	38.69	34.83	51.2
Solitary	19.4	11.8	26.88	7.7
Responsive	6.19	35.08	28.41	24.25
Aggressive	0.0	0.0	0.76	0.45
Initiated	1.88	8.2	4.52	3.65

We used this information to compare the clients' range and mode of interactions before, during and after the dramatherapy work.

What is of interest here is both the positing of a model of change due to the process of active witnessing, along with the attempt to achieve a language of meaning to describe the clients' change in relation to the dramatic work within the dramatherapy session.

Conclusion

In this work Rosemary Sanctuary and I attempted to utilise the language and method of psychological testing to look at phenomena which were firmly rooted in dramatic thinking. The therapeutic programme clearly reflects the areas of theatre and drama theory concerning the audience, developed into the notion of the active witness in dramatherapy. Research into theatre history and theory provide a clear framework to identify and understand the processes at work within the practice. I would argue that this satisfies one area of the criteria set out by Landy to describe a model of dramatherapy research – the analysis of dramatherapy from a sound theoretical base derived from research grounded in theatre and drama.

As stated in the introduction to this chapter, I am also concerned to find a way in which the languages of drama, psychology and therapy can be usefully connected in dramatherapy research. I feel that in adapting a psychological testing form, linked to the dramatic processes of the active witnessing work with puppets, a mutuality was achieved: one area serving to clarify the other.

There are, of course, problems attached to this method of testing. We clearly set out to look only at specific areas of the client's experience, their behaviour towards others, whilst we did not even attempt to deal with other aspects of their experience of the work. In addition the nature of the clients' autism was such that it was impossible to gain direct verbal or pictorial feedback from them regarding their reflections on the work. The best mode we felt was to accept the communication as seen in their behaviour and relationships.

In conclusion, I hope that the above material demonstrates an approach which can be adopted in dramatherapy research. I would define this approach as emphasising three things: the relevance of theatre history and theory to the development of dramatherapy research; the need to establish a relationship between the languages and forms of drama, psychology and therapy in research; and the importance of linking research in theory to research in practice. That, indeed, the future of dramatherapy research lies in bringing *Lear* into contact with the clinical setting.

References

Brook, P. (1988) *The Shifting Point*. London: Methuen.

Dekker, T. (1609) *The Gull's Hornbook*. London: Arnold.

Dodd, W. (1979) *Misura per Misura*. Rome: Il Formichiere.

Elam, K. (1980) *The Semiotics of Theatre and Drama*. London: Methuen.

Hoffman, E. (1976) *Frame Analysis*. Hamondsworth: Penguin.

Jones, P. (1991) 'Dramatherapy: five core processes', in *Dramatherapy, Journal of the British Association for Dramatherapists*, 14, 1.

Landy, R. (1986) *Drama Therapy – Concepts and Practices*, Illinois: Thomas.

Lamb, C. (1903) *Works*, E.V. Lucas (ed). London: Oxford University Press.

Nagler, A.M. (1952) *A Source Book in Theatre History*. New York: Dover.

Parten, M. (1927) cited in D. Irwin and M. Bushwell (1980) *Observational Strategies for Child Study*, New York: Holt, Rinehart and Winston.

Sanctuary, R. (1984) 'Role-play with puppets for social skills training'. Unpublished report for University of London.

Schattner, G. and Courtney, R. (eds) (1981) *Drama in Therapy*, Volumes I and II. New York: Drama Book Specialists.

Stone, G.P. (1971) 'The play of little children', in R.E. Herron, and B. Sutton Smith *Child's Play*. New York: John Wiley & Sons.

Tate, N. (1975) *The History of King Lear* (Edited by J. Black). Nebraska: University of Nebraska Press.

Wilshire, B. (1982) *Role Playing and Identity*. Indiana: Indiana University Press.

I would like to thank Rosemary Sanctuary for permission to refer to her research and unpublished report.

Research into Dramatherapy Theory and Practice
Some Implications for Training

Lucilia Valente and David Fontana

Introduction

The research discussed in this chapter forms part of an extensive investigation we have been conducting into the theory and practice of dramatherapy as currently conceptualised by dramatherapy practitioners in the UK. In our investigation our interest has been to answer such questions as what influences go to shape dramatherapy? what techniques, skills, professional qualities and role functions are considered of greatest professional importance by dramatherapists? and what criteria are used to determine respectively client suitability for dramatherapy, the nature and extent of client progress while in therapy, and client assessment on termination of therapy?

The overall aim of our research has thus been to build up a comprehensive picture of how dramatherapy is used today, in order both to help formalize thinking within dramatherapy itself and to inform the attitudes of psychologists, psychiatrists, educationists and the caring professions in general towards the subject. It is our hope that work of this kind will assist dramatherapy to take its rightful place within the family of fully recognized psychotherapeutic practices.

Aspects of our research findings, together with some of the conclusions that stem from them, have been discussed in a number of places elsewhere (e.g. Fontana and Valente, 1991; Valente and Fontana, 1991; Valente, 1991), and in the present chapter we want to turn our attention to the implications of certain of these findings for the professional training of dramatherapists. Based as they are upon the experience of dramatherapists actually at work in the field, such findings necessarily provide important guidelines on what trainee dramatherapists most need to know if they are to be properly equipped to meet the challenges that await them in professional life.

Research methodology

Before proceeding to these guidelines, however, a brief summary is needed of the research procedures from which they arise. The first of these procedures was to conduct semi-structured individual interviews with a panel of 12 leading British dramatherapists (the *panel of experts*), during which we put to them a series of questions derived from a study of the literature (e.g. Schattner and Courtney, 1981; Landy, 1986; Jennings, 1987), and designed to elicit information relating to the research objectives outlined in our first paragraph above. In reply, the panel of experts supplied such a wealth of information that, when the tapes of the interviews were transcribed and the responses codified, we were in possession of an Item Bank consisting of 354 categorical statements on dramatherapy relevant to these objectives. This Item Bank was then referred back to the panel of experts for refinement, for clarification of wording, and for comment and additions.

At the conclusion of this exercise, item analysis showed that the statements contained in the Item Bank could be codified under the headings respectively of *The Theory of Dramatherapy* and *The Practice of Dramatherapy*, with a number of sub-headings grouped under each. Our next step was to take the issues identified by these statements and devise questions designed to:

1. gauge the extent of agreement amongst dramatherapists on the importance of these issues for theory and practice;

2. gather data on the frequency with which the practitioners employed the techniques, skills, assessment methods, and so forth, to which the issues referred.

For reasons of length, sub-sections and individual items in the Item Bank were amalgamated where appropriate, yielding a questionnaire of seven sub-sections and 273 questions, with responses to the latter scored on a four-point equal-interval scale (from 'most' to 'least') for the variable concerned (e.g. 'degree of importance', 'frequency of use'). With the support of the British Association for Dramatherapists, the questionnaire was then circulated to all full and associate members.

After follow-up letters, a respectable response rate of 56 per cent overall was achieved, containing within it an excellent 86 per cent of those actually holding dramatherapy qualifications. In the event, statistical analysis of results revealed no significant differences between the responses of these qualified dramatherapists to questionnaire items and the responses given by unqualified members of the Association, and accordingly the results yielded by the two groups were pooled and all responses treated homogeneously. We are most grateful to all respondents for the time and thought they gave to the questionnaire, and of course particularly grateful to the panel of experts who offered so generously of their expertise during the construction of the Item Bank.

Results of the questionnaire

Questionnaire responses revealed a picture fully indicative of the rich and stimulating nature of dramatherapy as at present constituted, and although there was evidence of both controversy and consensus, the latter significantly predominated. All seven sub-sections of the questionnaire have implications for professional dramatherapy training, but due to limitations of space we propose to focus upon three of the most relevant, namely the role of the dramatherapist, the qualities of the dramatherapist, and the theoretical influences upon dramatherapy.

In analysing the results, we placed the issues contained in each of these three sub-sections in rank order according to the mean importance attached to each of them by respondents on the 4-point scale, with a mean score of '1' indicating 'most important' and a mean score of '4' indicating 'least important' (the Kolmogorov-Smirnov one-sample test showed the inter-rank differences were sufficiently significant to justify this procedure). The resultant hierarchies thus gave us insight into the *relative* importance attached by the sample to each of the issues in the respective sub-sections, and from the point of view of professional training it is clear that those issues accorded the most importance should form the basis of teaching objectives and syllabus content. We can now look at the issues identified as of greatest importance within each of the three sub-sections, and comment on what they might mean within the training context.

Role of the dramatherapist

The issues in this sub-section related to those role-skills which the dramatherapist uses when relating to clients, and the hierarchy revealed by the research is set out in Table 5.1.

An interesting feature of Table 5.1 is the prominence given to the passive role-skills of *listening* and *observing* (the latter probably linked to *identifying issues*, which is also well placed) as opposed to the more active ones involved in *taking a role, confronting, interpreting,* and *guiding*. These passive role-skills are of course basic to Rogerian client-centred therapy, and it is not surprising, therefore, that Carl Rogers appears as one of the authorities with most influence upon dramatherapy (see Table 5.4). Prominence is also given in Table 5.1 to *supporting* and *accepting uncritically*, which are also features of the Rogerian approach.

This indicates the strong need for dramatherapy students to be well-schooled in taking passive roles, and raises the question of how the skills concerned might best be taught within the dramatherapy course. Rogerian training involves assimilating, through direct participation, not only a set of counselling role-skills but also an attitude towards the client characterised by empathy, non-confrontation and unqualified acceptance. Further, it involves a letting-go by the therapist of ego-projection, of dissimulation, and of strategies of social control and manipulation.

At face value, the personal/professional role-skills cultivated by the Rogerian therapist would thus seem to sit oddly with those associated with drama, which

Table 5.1: **The hierarchy of role-skills**

Role-skill	Rank order of means
1. Listening	1.212
2. Observing	1.424
3. Supporting	1.504
4. Identifying issues	1.523
5. Staying calm in crisis	1.554
6. Accepting uncritically	1.635
7. Facilitating change	1.636
8. Experience in therapy	1.695
9. Having supervision	1.715
10. Believing	1.768
11. Creating atmosphere	1.837
12. Guiding	2.038
13. Questioning	2.078
14. Confronting	2.481
15. Experience in theatre	2.617
16. Taking a role	2.688
17. Interpreting	2.803
18. Provoking	2.913

is often a highly active medium (Fontana and Valente, 1989), with confrontation the very stuff of inter-personal interaction, and with projection, dissimulation and social (audience) control the very stuff of the dramatic actor. Nevertheless drama, by virtue of its ability to reflect life, also contains the passive, client-centred Rogerian role-skills, and the challenge to those responsible for dramatherapy training is to emphasize these without curbing the full range of dramatic expression upon which the dramatherapist needs from time to time to call.

A command of this full range of skills is important because in the context of the issues listed in Table 5.1 the dramatherapist is faced with two operational tasks. On the one hand he or she has to manifest through personal behaviour those *passive* skills identified in the table, while on the other he or she has to encourage clients to express those *active* aspects of personality which have been repressed or otherwise denied access to consciousness. Dramatherapy recognizes that it is the inhibition of these aspects that lie at the heart of many of the client's psychological problems, and the understated atmosphere which can characterize Rogerian therapist–client interaction is often not the best context within which to encourage the dramatically facilitated release of such inhibitions.

Personal example by course tutors is a prime factor in helping students identify what this balance of skills means for them personally. Psychological research demonstrates clearly the importance of role models in such identification, and the greater the prestige of the role model, the more he or she is likely to influence the behaviour of students. Another necessary skill is the ability to observe one's

own behaviour and to recognize the extent to which it approximates to that of the role model. Self-insight is listed in Table 5.2 as an essential quality of the dramatherapist, and this self-insight – in the form of self-criticism – essentially requires that the therapist directs towards him or herself the very skills of listening, observing and identifying that Table 5.1 shows should be directed towards clients.

In all areas of training – such as dramatherapy – which carry a psychological component, an essential feature of students' training is to encourage them to apply to themselves the procedures and skills which they are expected to extend to clients. Within the therapeutic encounter, this means that the therapist must focus upon him or herself the same degree of scrutiny directed towards clients. A simple way to develop this self-scrutiny skill in students is to request them to complete a simple check list of personal behaviours at the conclusion of the therapy session. For example 'Did I manifest each of the following ... ?', 'Did I avoid each of the following ... ?' The self-ratings supplied by students in response to these questions can then be opened for debate within the group, with a view to seeking non-judgemental observations from peers on their perceived accuracy.

Another point of interest raised by the emphasis in Table 5.1 upon Rogerian role-skills is the difference between counselling and psychotherapy. The Rogerian approach is very much that of the counsellor, whereas the Jungian and Freudian approaches which emerge strongly in Table 5.4 are those of the psychotherapist. The difference between counselling and psychotherapy is a subject of some debate within psychology, but there is a consensus that whereas the former deals with what is *already there* in the conscious life of the client, the latter deals with *what is hidden* or with what needs to be acquired. Space does not allow an extended discussion of this difference, but it is a radical one, and the student needs to be clearly aware not only of it but of the implications for practice which arise from it.

Qualities of the dramatherapist

Table 5.2 gives results relating to those personal qualities of the dramatherapist considered most important by the sample.

These results show that particular emphasis should be placed during training on the development in students of appropriate levels of both self-awareness and other-awareness. *Self-insight* implies the ability to recognize personal strengths and weaknesses and their underlying causes, while *empathy* and *sensitivity* imply the ability to recognise these variables in others. Only by virtue of such abilities can the dramatherapist respond adequately to the needs of clients, and provide the understanding and support necessary for their psychological growth effectively to take place.

The development of these abilities should, of course, feature prominently in the course objectives set before students on their entry into dramatherapy training. In all work at this level students only assimilate such personal development objectives if they are clearly communicated to them and clearly defined. In the light of this it was re-assuring to find that when, as an additional aspect of our

Table 5.2: **Hierarchy of personal qualities desirable in the dramatherapist**

Personal qualities	Rank order of means
1. Self-insight	1.258
2. Motivation	1.321
3. Empathy	1.328
4. Sensitivity	1.359
5. Spontaneity	1.385
6. Contact with own emotions	1.417
7. Imagination	1.420
8. Energy	1.426
9. Intuition	1.438
10. Openness	1.523
11. Humour	1.558
12. Reflection	1.597
13. Clear thinking	1.651
14. Body awareness	1.785
15. Humility	1.953
16. Generosity	2.108
17. Deep feelings	2.302
18. Sociability	2.336

research, we circulated our questionnaire to students following each of the recognized professional training courses in dramatherapy in the UK, their responses accorded quite closely with those shown in Table 5.2. However, when we asked one of the course directors which in her view was the most important of all the qualities in Table 5.2 she placed humility in first place, while the students placed it last (practitioners also gave it a lowly rating). This perhaps suggests that the true value of certain of these qualities only becomes apparent after lengthy experience in the field.

Incorporating these qualities into course objectives is one thing, actually teaching them is another, and more difficulties are likely to be encountered here than in the teaching of actual therapeutic techniques. However, role play and simulation exercises are standard practice – both within psychology and within dramatherapy – for encouraging the kinds of development of which they are an integral part. Such exercises not only allow the individual to observe personal weaknesses (as revealed for example in the inability to take on certain roles, or to take them on with the necessary restraint) but also, through projection, to understand better the problems and feelings of those located permanently within these roles.

Written work, in which the individual describes him or herself in the third person, or explores how he or she would respond to particular situations, is also of great value, as are psychological tests. Such tests, which assess aspects of

personality, social skills, attitudes and other relevant psychological variables, provide the individual with a personal profile which acts as a matrix for identifying where further development is needed. Of particular value amongst the extensive battery of tests available are the repertory grid on the one hand and projective techniques on the other, since the former provides extended access to the individual's personal construct system, while the latter gives insight into unconsciously held prejudices, motivations, anxieties and the like.

Theoretical influences upon dramatherapy

Our panel of experts indicated in the initial interviews that the influences upon dramatherapy, both from within drama and from within other therapies and cultural processes, are indeed extensive, and they nominated 28 such influences embracing both techniques and systems of thought. The ratings given to these by the sample are shown in Table 5.3.

Table 5.3: **The hierachy of theoretical influences**

Theoretical influences	Rank order of means
1. Group dynamics	1.264
2. Psychotherapy	1.566
3. Theories of play	1.643
4. Theories of creativity	1.787
5. Child development	1.852
6. Client centred therapy	1.953
7. Theories of imagination	2.024
7. Psychodrama	2.024
9. Ritual	2.048
10. Disabilities	2.048
11. Child drama	2.203
12. Theories of theatre	2.274
13. Educational drama	2.276
14. Psychoanalysis	2.287
15. Social psychology	2.289
16. Object relations play	2.400
17. Gestalt psychology	2.403
18. Anthropology	2.496
19. Analytic psychology	2.610
20. Sociology	2.648
21. Cognitive psychology	2.950
22. Philosophy	2.959
23. Behaviourism	2.976
24. Existentialism	2.991
25. Yoga	3.225
26. Theology	3.231
27. Bioenergetics	3.267
28. Alexander Technique	3.426

Factors relating to *group dynamics* emerge as clearly the most important of the 28 nominated influences. This is not surprising in the light of the fact that our research showed elsewhere that most dramatherapists consider that, although they can work with individual clients, dramatherapy is essentially a group exercise. Second to group processes comes *psychotherapy*, again a predictable finding (though 'psychotherapy' is a portmanteau term without precise meaning). Also well placed are *theories of play, theories of creativity*, and *theories of child development*, which is encouraging since these areas are inter-dependent and clearly of importance for those dramatherapists (and other areas of our research show them to be numerous) who also practise play therapy. The strong showing of *client-centred therapy*, in view of the comments made about Rogers in connection with Table 5.1, is equally welcome.

Also well placed on the list is *psychodrama*, which some dramatherapists now see as a sub-division of dramatherapy, but *psychoanalysis* occupies a lowly 14th place, which is surprising in the light of the prominence given to psychoanalytical concepts – and to psychodynamics in general – in the dramatherapy literature. Even more surprising is the 19th place occupied by analytic – Jungian – psychology when one notes the premier position given to Jung in Table 5.4. It is clear of course that both psychoanalysis and analytic psychology, as sets of practical techniques, cannot be taught within the dramatherapy training programme, but a theoretical knowledge of what these techniques involve would seem to be essential if the concepts to which they refer are to be properly understood.

Similarly, it would appear that, in the light of the emphasis placed by dramatherapy upon group work, both *social psychology* and *sociology* should be accorded more emphasis than is apparent from Table 5.3. *Cognitive psychology* would also seem to be undervalued, since a knowledge of cognitive processes, and of the way in which they produce the thoughts which trigger psychological problems (see, for example, Fontana, 1992) is essential for all those involved in psychotherapeutic work.

One might conclude from this that there is some need for dramatherapy to examine modern psychology more closely, and to identify those aspects of it which provide an essential underpinning for both its theory and practice. Such aspects could then find their rightful place within the dramatherapy training programme.

Authorities relevant to the understanding of dramatherapy
Our panel of experts nominated 18 individuals as important to an understanding of the theory of dramatherapy. Questionnaire results showed that these 18 individuals were placed in the order shown in Table 5.4.

It will be seen that Jung emerges in first place, followed by Winnicott, Rogers, Stanislavski, Peter Brook, Murray Cox, Freud, Bruno Bettelheim and Bertold Brecht in that order. This provides an interesting blend of expertise from within both psychology and experimental drama, but it is relevant to note that Wilshire comes bottom of the list (and is missing altogether from Table 5.5), a curious finding in that Sue Jennings, in one of her most recent books (Jennings, 1990),

Table 5.4: **The hierarchy of authorities relevant to
the understanding of dramatherapy**

Relevant authorities	Rank order of means
1. Carl Jung	1.961
2. D.W. Winnicott	2.025
3. Carl Rogers	2.116
4. Constantin Stanislavski	2.254
5. Peter Brook	2.264
6. Murray Cox	2.321
7. Sigmund Freud	2.323
8. Bruno Bettelheim	2.380
9. Bertold Brecht	2.442
10. Melanie Klein	2.542
11. Jerzy Grotowski	2.592
12. Jean Piaget	2.650
13. Abraham Maslow	2.660
14. Ervin Goffman	2.796
15. Antonin Artaud	2.945
16. Victor Turner	3.050
17. Margaret Lowenfeld	3.119
18. Bruce Wilshire	3.434

lists him amongst those who provide the basis for a theoretical knowledge and understanding of dramatherapy. Wilshire was in fact crossed out in the question-naire (in response to a rubric which requested elimination of all names with which respondents were unfamiliar) by many people, showing that they had never even heard of him. This may indicate the existence of a gap between dramatherapy theory and practice, and perhaps argues that trainee dramatherapists should be given greater contact with theoretical issues.

The presence of Jung in first place is of great interest, and reflects the value not only of his contribution to psychotherapy but also to the psychological study of myths, rituals and symbols, all of which feature strongly in dramatherapy work. Winnicott's high position reflects his concern for children and for play (as does the high placing of Bettelheim), while Rogers' prominence reflects once again the relevance to dramatherapy of client-centred therapy. However, as mentioned earlier, the strong showing of both Jung and Freud sits oddly with the relatively lowly placing of analytic psychology and of psychoanalysis in Table 5.3, and raises again the issue of how closely dramatherapy scrutinizes psychology in order to tease out the strands most relevant to it, and to ensure their incorporation into its programmes of professional training.

The emphasis given to Jung and Freud brings us face-to-face with a further consideration, namely to what extent can trainee dramatherapists be given true insight into the work of such profound thinkers. Both Jung and Freud were

voluminous writers (the collected works of each run to over 20 large volumes), and there is a risk that students may obtain only a superficial grasp of their psychological theories and therapeutic practices. Our research makes it clear that dramatherapy looks more to psychodynamic psychology than to either cognitive or behavioural psychology in its search for appropriate psychological models, and it is precisely psychodynamic psychology that is often hardest to understand, is most open to misinterpretation, and is least supported by research evidence. This is not a plea for dramatherapy to abandon psychodynamic models, simply for it to recognize the intricate nature of these models and understand the need to approach them critically.

A further important point is that both Jung and Freud, since each based his work upon case histories rather than upon experimental or survey data, are evolutionary in much of their thinking. This means that their later work sometimes contradicts or corrects their earlier, or conversely that their later ideas are sometimes abandoned in favour of earlier formulations. It follows from this that the therapist who wishes to make use of their insights must have acquaintance with a broad sweep of their writings, rather than with limited ideas scattered here and there. He or she must be also aware of the way in which Jung and Freud diverge from (and disagree with) each other, and of how their respective work translates into subtly (but crucially) different therapeutic skills.

This is a tall order in a course of initial dramatherapy training, especially for those who have had little previous contact with psychodynamic ideas. It also places pressure upon tutors, who will already be hard-pressed to cover syllabus requirements in other areas of the course. But once relevant objectives are identified and formalised, the necessary expertise can be acquired or bought in as appropriate. In whatever way this is done, the important thing is to avoid a situation in which newly qualified dramatherapists are using psychodynamic concepts and practices without fully understanding what they involve. Of all psychotherapeutic techniques, those based upon psychodynamics are the most powerful in bringing repressed material into consciousness, and unless properly handled by therapist and client such material can prove highly damaging to the latter in both the short and the long term.

Individuals currently important in dramatherapy

During the initial interviews, we also asked our panel of experts to name individuals they regarded as important to the current practice of dramatherapy, and 16 names were put forward. The mean ratings given to these by practitioners in response to the questionnaire are shown in Table 5.5.

Of the 16, Sue Jennings heads the list followed by Moreno, Heathcote, Sherborne, Courtney, Peter Slade and Robert Landy, in that order. When asked through the medium of the questionnaire to nominate the individual who had been of most influence upon the *personal* practice of respondents, Alida Gersie emerged in first place, followed by Sue Jennings and Jane Puddy.

Table 5.5: **The hierarchy of individuals currently important in dramatherapy**

Individuals currently important	Rank order of means
1. Sue Jennings	1.594
2. Moreno	2.076
3. Dorothy Heathcote	2.219
4. Veronica Sherborne	2.373
5. Richard Courtney	2.406
6. Peter Slade	2.435
7. Robert Landy	2.490
8. Dorothy Langley	2.606
9. Gertrude Schattner	2.644
10. Rudolf Laban	2.761
11. David Read Johnson	2.872
12. Brian Way	2.897
13. Gavin Bolton	2.978
14. Viola Spolin	3.065
15. Marian Lindkvist	3.110
16. Audrey Wethered	3.127

The implications of these findings for dramatherapy training are relatively clear. Those who feature on the list, and perhaps particularly those at the head of it, all appear in their different ways to *define* dramatherapy. One of the dangers faced by the subject is that its very richness and the very breadth of its scope can lead to a rather amorphous therapy which has no clear rationale and no clear boundaries between it and other psychotherapeutic approaches. The individuals on the list have all attempted to say what dramatherapy is and what it is not. They have tried to clarify the differences between dramatherapy and drama, between dramatherapy and psychodrama, between the role of the dramatherapist and the role of the drama teacher, and between dramatherapy and the other creative arts. In short they have endeavoured to give the subject its own identity, its own territory and its own integrity, and to show how it can be used either in its own right or integrated into the work of fellow professionals who have received dramatherapy training.

Conclusion
The panel of experts and the practitioners involved in our research have identified clearly those skills, personal qualities and areas of knowledge into which dramatherapists should be initiated during their professional training. Our findings therefore provide some of the scaffolding around which the dramatherapy training course should best be constructed. We do not pretend that this scaffolding is complete, but we trust that, at the very least, it will provide stimulus towards discussion and debate within the vital area of professional dramatherapy training.

References

Fontana, D. (1992) *Know Who You Are, Be What You Want London: Collins/Fontana.*

Fontana, D. and Valente, L. (1989) Monitoring client behaviour as a guide to progress in dramatherapy. *Dramatherapy* 12, 1, 10–17

Fontana, D. and Valente, L. (1991) Drama as pre-therapy. *Speech and Drama* 40, 1, 35-40.

Jennings, S. (1978) *Remedial Drama.* London: Adam & Charles Black.

Jennings, S. (1987) (ed.) *Dramatherapy: Theory and Practice for Teachers and Clinicians.* London: Croom Helm.

Jennings, S. (1990) *Dramatherapy with Families, Groups and Individuals: Waiting in the Wings.* London: Jessica Kingsley.

Landy, R. J. (1986) *Drama Therapy: Concepts and Practices.* Springfield, Illinois: Charles C. Thomas.

Schattner, G. and Courtney, R. (1981) *Drama in Therapy.* New York: Drama Book Specialists (2 Vols.).

Valente, L. (1991) Therapeutic Drama and Psychological Health: An Examination of Theory and Practice in Dramatherapy. Unpublished Ph.D., University of Wales, Cardiff.

Valente, L. and Fontana, D. (1991) Dramatherapy and psychological change, in G. Wilson (ed) *Psychology and Performing Arts.* Swets: Amsterdam and Zeitlinger.

Grateful acknowledgement is made to the Junta Nacional De Investigacao Cientifica E Tecnologics (JNICT), Lisbon, Portugal, for the financial support given to this research.

On 'Being the Thing I Am'
An Inquiry into the Therapeutic Aspects of Shakespeare's *As You Like It*

Brenda Meldrum

> 'Twas I, but 'tis not I: I do not shame
> To tell you what I was, since my conversion
> So sweetly tastes, being the thing I am.'
>
> (Oliver, *As You Like It*, IV. 3; 136–8)

Introduction

Between September and the end of December 1991 a pilot study was carried out looking into therapeutic aspects of Shakespeare's *As You Like It* and was conducted with a small group using new paradigm research techniques (Reason, 1988). The impetus for the study came from the work of The Institute of Dramatherapy's Laboratory Research Group into the nature of theatre and therapy. The two dramatherapeutic models underlying the research plan were the Embodiment – Projection – Role model (EPR), (Jennings, 1991) and the Role Generation model (Landy, 1986). A distinction was drawn between 'therapy' and 'therapeutic' (Irwin, 1979). The aim was to explore the therapeutic qualities of working on the text using techniques from drama and dramatherapy. In this chapter, I shall give a brief description of the two models and of the basic principles of new paradigm research, followed by an analysis of themes from *As You Like It* used in the study. I shall then give an account of the processes involved in the sessions. In the conclusion, I shall discuss the findings and I shall speculate on the lessons learned in this pilot study.

The Laboratory Research Group

Dr Sue Jennings, Director of the Institute of Dramatherapy, formed the Laboratory Research Group in 1989 with the overall aim of examining the nature of dramatherapy itself. The group met from September 1989 to June 1990 and I was a participant observer. This interesting research project was by its nature structureless. While some members felt liberated by the freedom from restrictions

and able to take risks and explore aspects of drama, theatre and therapy, others felt troubled by what they perceived as the lack of clarity in the aims and goals and the leaderless nature of the structure. When Dr Jennings' research project was completed and the findings written up (Meldrum, 1991), I set up a pilot study based on the Laboratory Group's work but independent of the Institute of Dramatherapy, using the recognised technique of new paradigm research as a structure.

New paradigm research

John Rowan's keynote address at the Second Arts Therapies Research Conference in April 1990 was the spur which led me to attempt the new paradigm research method, which is a non-directive approach, allowing for co-operative venture, with all group members contributing to the direction of the research. The methodology is taken from the ideas of Peter Reason (1988). In his preface, Reason argues that orthodox research methods are inadequate for the study of persons, because they undermine the self-determination of their subjects. What distinguishes the human being is her ability to choose how to act, to give meaning to her own experience and actions and to give meaning to the actions of others. New paradigm methodology involves all the actors in self-directed, collaborative research, where all contribute to both the planning and the activity itself. The minimum requirements for such co-operative research are:

(a) that the involvement of all participants should be openly negotiated;

(b) that all should contribute to the creative thinking;

(c) that relationships should aim at being authentically collaborative.

Models from dramatherapy used in this research

As a dramatherapist, Robert Landy works through the medium of drama to achieve therapeutic goals by making explicit those aspects of the creative process which are implicitly healing and to translate them into specific concepts and practices (Landy, 1986). The basic building blocks of his model are 'self', 'role' and 'other', where the self (one's essential uniqueness), relates to the other (the representative of the social world), through the role. Landy's theory is informed by the symbolic interactionism of G. H. Mead (1934) and the sociological analysis of Erving Goffman (1959), which puts his model of humanity outside the psychodynamic models of Freud and Jung and into social psychology. Landy bases his work on the nature of role.

Sue Jennings (1990) believes that the roots of dramatherapy lie in the theatre and not in the clinic. What Jennings calls the 'true' dramatherapy model is one that is based on an understanding of the healing properties of the drama itself. Jennings uses various techniques, including text and theatre skills to observe the development of the group member through embodiment, projection and role. In embodiment, the person uses her body or parts of her body in a predominantly non-verbal way, expressing the emotional response to the task or the text of the

drama. In projection the person expresses her emotional reactions in an indirect fashion, which often leads to insight. In role, the person is able to explore her own various life roles through drama and to take on others which she has never played (1991). Using a text allows a person to bring her own emotional memory to the qualities of the character in the play.

The distinction between 'therapy' and 'therapeutic'

A therapeutic experience is one through which a person comes to feel a greater sense of herself and her abilities, while a therapy is a specific form of intervention in her life whose aim is to help bring about change, (Irwin, 1979). The word 'therapeutic' was used in this pilot study, which was not designed to examine specific forms of intervention. Many who argue that theatre is therapeutic, would not consider it a *specific* form of intervention for psychological or behavioural change.

Hypothesis

The general hypothesis was posed in the form of the question: *Is the nature of the theatre process intrinsically therapeutic?* The aim was to work with text assessing the techniques of drama and dramatherapy, using the models of Jennings and Landy with a new paradigm research approach.

The formation of the group

From July 1990 I approached people in the fields of dramatherapy, drama and psychology to see if they were interested in participating in the study and advertisements were placed in the newsletter of the British Association for Dramatherapists and at the Actors' Centre. The aim was to form a group of about ten people. This aim was not achieved; the group was never more than seven people. The formation of the group itself was the most difficult part of the endeavour and the problems in collecting together a like-minded group of people, who were interested in drama, therapy and collaborative research were not solved. But the lessons learned in the process were invaluable, as I discuss below.

The groups met for eight sessions at The South Place Ethical Society's building in Conway Hall on Thursday evenings from September 1990 to December 1990. Group members shared the cost of the accommodation.

The text: *As You Like It* (1968)

I wished to work on a play of Shakespeare's because of a research project I was planning, for which this study was to be the pilot and which required a Renaissance drama. I chose *As You Like It* because of its themes, which I discuss below. Before the group met, I conducted a literature search.

As You Like It is a satire on the popular pastoral plays of the Renaissance in which lords and ladies reject the artificialities of the Court and join in the pastoral life of happy shepherds and shepherdesses in an idyllic countryside or 'Never Never' land. Shakespeare's source was the escapist literature of the time –

specifically, Thomas Lodge's *Rosalynde*, published in 1590. This was a completely artificial story and Shakespeare, while retaining the artifice of the original, revealed its conventionality and unreality (Oliver, 1968). The following themes emerged.

The theme of time and the inevitability of decay

In the forest scenes time appears to be at a standstill, but in fact there is a steady forward motion. Thoughts of inevitable decay are expressed in the characters of Jacques and Touchstone: man's life is linked with the seasons and the process is one of decay – a very self-conscious, stylistic and posing view. The second is a less mechanical, less self-conscious attitude to time and is embodied in the movement of the play. The early scenes are dominated by the loss of the old order, an idealisation of the past in comparison with the corrupt present. The longing for a past golden age is curiously linked with fathers – with Orlando's father, and Rosalind's father. But all changes when Rosalind, who finds her own father Duke Senior in the Forest, says: '"But why talk we of fathers when there is such a man as Orlando?" The characters then turn from nostalgia for the security of a father-dominated world to the decision to create their own kind of order in marriage' (Leggatt, 1973, p.210). All the songs in the play talk of a transition from winter to spring and fertility and the human actions are connected with the rhythms of nature.

The theme of sibling rivalry

The opening scene, which shows the unhappiness of Orlando at the hands of his brother, Oliver, gives us a picture of a villain. Oliver the wicked brother, is quickly followed by Frederick, the wicked uncle. And yet, are they the cardboard characters they may seem at first reading? And is there something in the text that will give a clue to their rapid conversions?

The themes of female friendship and of sexuality and sexual transformations

> Any actress embarking on a production of *As You Like It* is embarking on a voyage of discovery (Shaw and Stevenson, 1988, p.55).

In the relationship between Celia and Rosalind, Shakespeare wrote about female friendship – an unusual relationship in Renaissance literature. Their lives at the court are totally dominated by men and male values where, as Fiona Shaw said in a radio interview, the prevalent idea of a good time is to watch a wrestler trying to kill young men. When they talk of devising sports, Rosalind says: 'What think you of falling in love?' (I.2.24), thus betraying a readiness and ripeness which comes to fruition when she falls in love with the Orlando, a young man as isolated and as unhappy as herself. To the Renaissance audiences, however, there are subtle messages behind the transformations of girl into boy and back again. In the Renaissance, female parts were taken by boy actors. There is an assumption among modern directors that this was accepted as 'verisimilitude' by the Elizabethan audiences, but Lisa Jardine's research (1983) suggests that this was not

so. Sexuality, it was said, misdirected towards a boy masquerading in female dress is 'stirred' by the attire and gestures, leading to male prostitution and perverted sexual activity. When Rosalind adopts the male attire, she takes the name of Ganymede, who was Jupiter's boy lover. Androgyny in the Renaissance was the sexuality associated with the effeminate boy – the female wanton boy, whose characteristics were stereotyped as submissive, coy, dependent, passive, blushing and willful. A boy 'vibrant with erotic interest for men', as Jardine (1983, p.29) says. These themes were discussed at the first session.

The working process

There were eight two-hour meetings. The following is a report of the processes involved in each session.

Session 1

Five people attended this first meeting; one was a dramatherapist, another a trainee at the Institute of Dramatherapy, the third a drama consultant, the fourth an arts therapist and the fifth an actor. As the instigator of the research, I explained the nature of the study to the group: that the inquiry was to examine the therapeutic nature of the theatre process through the experience of group members, using the text. The ideas behind the nature of co-operative enquiry method were examined, elucidating both the logic of the method itself, which requires that all are involved in the work as both researchers and subjects and to emphasise the personal involvement of group members in the inquiry. I explained that this personal involvement has demands: that power and responsibility are shared. I stressed that this was not a dramatherapy group, but a creative drama research group, whose brief was to look at the therapeutic aspects of the work.

Although members were enthusiastic about working co-operatively, no-one wished to facilitate the groups. It was agreed that I would facilitate the meetings of the pilot study until the New Year, and that a quarter of each session would be dedicated to a detailed examination of the processes involved in a spirit of joint research. The group discussed the theories of Jennings and Landy at length and agreed with readiness to compare and contrast methods and techniques from drama and dramatherapy. I put before the group the various themes which I had culled from the literature. The group made the following decisions:

(a) to continue the first session by linking the role definition exercises of Robert Landy with the emotion of jealousy;

(b) that the second session would look at the theme of time and decay comparing drama exercises with projective techniques from dramatherapy;

(c) that we should reassess at the end of the pilot study sessions and plan the content of further meetings depending on the group membership.

In trying to make a link between theatre and therapy, Landy uses the concept of *role*, which is common to both. In this role exercise, the task was to bring into consciousness an image of various characters in turn:

(a) a character in a book;

(b) a character from the cinema;

(c) a character from a TV show;

(d) a character from the theatre;

(e) someone from real life.

For this exercise, group members were asked to visualise characters in the different genres, who were jealous types of person. In pairs, members took the roles of the characters they most and least identified with and the session ended with a whole group improvisation. In the group evaluation, members discussed the question: 'Is this a helpful way for an actor to get into role?' in a positive way. They felt that the exercise helped to focus on the individual character and her feelings. The visualisation of the character was found to be very useful. This exercise was an important extension of Landy's generation of roles – an exercise which he uses for therapy – into theatre. By linking particular roles with an emotion and working with movement, actors were able to come into both the physicality of the character, as well as into their emotional memory.

Session 2

Two more members (dramatherapy trainees) joined the group making seven in all. The aim was to look at the theme of *Time and Decay*, using Jacques's famous *Ages of Man* speech, using different techniques and comparing them: first, drama workshop techniques and secondly, a projective technique from dramatherapy. The drama techniques used were taken from Cicely Berry (1987), in order to give physicality to the text. Then the whole group performed an improvisation on the themes in the speech, using movement and sound. The technique from dramatherapy was the stepping stone exercise adapted to Jacques's Seven Ages. Members were asked to relate to roles in their own life, via the stepping stones. In the evaluation period, members commented on the power of this technique in getting them in touch with personal memories. They addressed the contrast between the drama techniques and the dramatherapeutic exercise and concluded that working with text and improvising was far less emotive than the stepping stone exercise.

Session 3

The aim of this session was to use the text to look at the 'villains'. Are Oliver and Duke Frederick all bad or is there some psychological complexity in each of their characters which presages their rapid conversion and reformation? Once again, a combination of drama and dramatherapeutic approaches was used and compared. The role and characterisation drama exercises were based around non-ver-

bal reactions to role stereotypes and the text was used for the characters' motivations and backgrounds. The dramatherapeutic exercises approached role characterisation using visualisation and movement to different types of music: mournful Elizabethan symbolising the envy, jealousy and unhappiness, and cheerful Bach symbolising emotions after the conversion. Members agreed that this use of music added to the visualisation and had a powerful effect. The group improvisation evolved like a frieze in a Jacobean tapestry, full of fluid movement. The session had demonstrated that dramatherapeutic techniques can readily inform drama work.

Session 4

This session had the major theme of hostility and fighting. The object behind the use of the drama games was first to foster a group feeling and then to foster competition. Dramatherapy techniques were used to look into members' perceptions of aggression and hostility within themselves. Three dramatic 'fights' were compared:

(a) Orlando vs Charles from *As You Like It*;

(b) the opening scene of ritual combat from *The Love of the Nightingale* by Timberlake Wertenbaker (1989);

(c) Eddie vs the Cafe-owner from Berkoff's *Greek* (1989).

After reading the three scenes, the group chose to work on the Berkoff. It was obvious that the energy contained in the text informed the movement of the group; the text made the actors feel that movements of a staccato and aggressive nature were called for. The discussion afterwards centred around the role of the facilitator. It was agreed that when the 'mother' facilitator leaves the group on their own to devise an improvisation, it takes some time for the group to come together to agree on different ways of working with a piece of text, knowing, however, that something will happen in the end. The members agreed that movement was a very good way to connect with the emotions in the text and was a technique appropriate to both drama and dramatherapy. Examining the group dynamics in the evaluation, members agreed that people of different backgrounds used the drama to co-operate, which gave them a feeling of satisfaction. The group worked well on its own, but support from the facilitator as an audience was important.

Session 5

Using Rosalind and Celia as models in the text (I,2.1–41) the theme of adolescence was explored. The approaches used were dramatherapeutic, structured in terms of Embodiment, Projection and Role (Jennings, 1991). Through movement exercises, relaxation and guided fantasy, members imagined themselves back in adolescence. In the process afterwards it transpired that all, without exception, had felt able to project deeply painful personal experiences on to the characters in the improvisations. Members agreed that the sequence of embodiment through

movement, the use of the projective technique of the magic pool and the enactment of their adolescent selves in role was an excellent way of touching emotional memory.

Session 6

This session dealt with the theme of first love – the love at first sight that strikes Rosalind when she sees Orlando. Once again, the techniques used were Embodiment, Projection and Role (EPR). In the evaluation, the group agreed that through movement, they were able to get in touch with feelings of youth and love; the projective technique of using felt pens, allowed them to tap their feelings of pain, fear, joy and inadequacy of their own first love. The role play and the use of text (the wrestling match in front of the Court (I.2.152–250), brought an understanding of Rosalind's identification with the boy as another outsider like herself, disinherited and unhappy. The group improvisation, demonstrated to us all how successfully dramatherapy exercises and drama exercises can be used to look at text.

Session 7

This session looked at Rosalind's declaration of love for Orlando and her rejection by her uncle, and of Celia by her father, Duke Frederick (I.3.1–87). We used the dramatherapy techniques of 'sculpting' and 'consciences' and the drama technique of 'hot seating' the protagonists. The group found that all techniques interacted to give them a far greater insight into the complexities of the characters' reactions.

Session 8

In this session the group addressed the girls' decision to travel to the forest of Arden in disguise: Rosalind as a boy taking the name of Ganymede and Celia as her sister, Aliena. After reading the text (I.3.87–end) we discussed the androgynous nature of the original where a boy actor would play the woman playing the man whose name, Ganymede, would be well known to Shakespeare's audience as the boy favourite of Jove. Discussion of the text pointed out that it seemed as though the whole journey were unreal – a pantomime, made all the more telling by the androgynous nature of Rosalind's transformation bringing in complex interactions with homosexual connotations. The discussion centered around the nature of the ambivalence in the friendship of the two girls and the alteration of the power roles from Celia to Rosalind, which the group felt was increased in power by the fact that Rosalind took the 'man's' role. The depth of the discussion and the therapeutic nature of the personal disclosures was a good ending to these pilot sessions. It showed how powerful a mingling of techniques could be in the development of trust in a committed group using text with a shared task.

Conclusions

The overall question: '*Is the nature of the theatre process intrinsically therapeutic?*' was addressed in this pilot study through the group's evaluation of their process through the work. From the discussions and feedback after every session, group members were able to express their emotional reactions to the text and to the various methods and techniques used to explore the text.

The models of Landy and Jennings were used in a productive way. Each session used Jennings's EPR model; there was a physical embodiment of the theme, a projective technique to bring emotional memory to bear on the underlying emotions and role play, usually in the form of improvisation. Landy's model was used explicitly in Sessions 1, 2 and 3 where his role generation model was fruitfully expanded to bring about the emotional aspect to bear on the social role.

The aim of the study was fulfilled to the extent that both theatre techniques and dramatherapeutic techniques were used effectively together and in interaction at each session. The combination of the two helped to illuminate the text and to draw from the members very useful insights into themselves and the roles they were playing. Drama techniques exploring the physicality in the text were extremely helpful. Indeed, movement and visualisation allied with music in Session 3 illuminated the characters of Oliver and Duke Frederick in a more powerful way than a simple analysis of the text could achieve alone. The projective techniques, such as the stepping stone exercise in Session 2 and the adolescent's magic pool exercise in Session 5, made a direct impact on members' emotional memory which they were able to bring to Shakespeare's characters in a most productive way. Overall, there was a balance in the usefulness of the techniques from theatre and therapy. The theatre techniques, because they use body and voice, bring to the person a deeper awareness of her body and its importance in drama. On the other hand, dramatherapeutic techniques can give people the opportunity to express their underlying feelings in an indirect way, which can only enhance appreciation of the characters' roles and conflicts. The notion of role is common to theatre, therapy and to the human condition, as workers in social psychology, sociology and anthropology from G. H. Mead (1934), to Goffman (1959) attest.

There were, however, problems with the aim of using new paradigm research techniques. First, I found it very difficult to recruit a group from different disciplines of the desired number of ten people. I was looking for members to join neither a drama group, whose aim is performance, nor a dramatherapy group, whose aim is to help the personal development of the members, but a co-operative venture looking at the therapeutic nature of theatre itself. I have no evidence to support the speculation, but it may be that this study fell between the two stools of drama and dramatherapy. My own view is that I was mistaken in trying to set the group up on my own. Had there been a core group of myself and one or two others working with the same enthusiasm, we might have been able to recruit more members and to have achieved a stable group of ten people.

Second, the theatre model, which underlay the initial concept, may not lend itself readily to co-operative research. The theatre model, projects an image of director, actors, stage management, text, space and audience, while new paradigm research offers equality and the sharing of responsibilities. The dramatherapy model, on the other hand, projects an image of a facilitator and an individual or a therapist and a group, where once again, the responsibility is unequal. While there exist theatre groups with no director and co-counselling groups with no therapist, in order to explore the other aims (of comparing the different techniques and working with two models) it seemed that this type of research required a facilitator. The members of the Institute of Dramatherapy's Laboratory Research Group expressed a wish for a defined leader and the members of this pilot study did not want to facilitate, but rather wished to be participants only. However, as Reason points out, 'facilitating roles are of particular importance' (1988, p.27). Furthermore

'Of course, if the facilitators get stuck in their role as facilitators, then they will no longer be participating members of the inquiry group, and this may be regarded as a problem' (Reason, 1988, p.31).

Reason suggests that there are two possible ways of coping with this problem: first, 'to accept that facilitators are facilitators and just that' (1988, p.32), or to take the second possibility:

'... more in keeping with the idea of the co-operative inquiry model, is for the facilitators to aim to work themselves out of a job... and at an appropriate stage pass the facilitation over to group members and to become ordinary group members themselves. Again, this is easier to say than to do' (1988, p.33).

I should certainly have liked the group to progress in this way, but I feel that the way I originally set up the pilot study mitigated against this outcome. I began with an idea to look at the therapeutic nature of theatre by exploring a specific text; in hindsight, I feel I should have had more response had I allowed the group to decide on the text, or, indeed, to have had no text at all.

However, there was considerably more discussion and analysis between group members and facilitator than is usual in the normal theatre or therapy group and to this extent new paradigm research methods usefully informed the work. Indeed we, as a group, succeeded in what Reason calls 'the whole point of the inquiry process which is to move between, and systematically contrast, reflections and experience' (1988, p.33). I think this was a considerable achievement since none of us had had any prior experience of new paradigm research. All members agreed that participating in this pilot study was interesting, useful and great fun! To quote Reason again:

'... co-operative inquiry starts with a paradox: the label implies equality and a democratic process in which we can all engage; yet it is not a casual and unstructured process and to do it well demands intense commitment and subtle skill of those who undertake it. These skills can only be learned through

doing.... It is therefore helpful to regard co-operative inquiry as an essentially *emergent* process' (1988, p.19).

This pilot study taught me many valuable things, but the greatest lesson I learned for myself, was that I should not in future try to carry out such an ambitious project on my own. It would have been much more productive to have planned the project, recruited the members and facilitated the study in tandem with one or two others as interested as I in the therapeutic nature of the theatre process. A core of two or three like-minded people may achieve more than one person on her own and the problems of shared facilitation would have been partially solved at least. The traditional theatre model of director, actors and audience and the dramatherapy model of therapist and client group could then be more readily be adapted to a more truly co-operative venture.

References

Berry, C. (1987) *The Actor and his Text.* London: Harrap.

Berkoff, S. (1989) *Decadence and Other Plays.* London: Faber and Faber.

Goffman, E. (1959) *The Presentation of Self in Everyday Life.* Garden City, Doubleday.

Irwin, E.C. (1979) 'Dramatherapy with the handicapped', in A. Shaw and C.J. Stevens (eds) *Drama, Theatre and the Handicapped.* Washington D.C.: American Theatre Association.

Jardine, L. (1983) *Still Harping on Daughters: Women and Drama in the Age of Shakespeare (2nd edition)* London: Harvester Wheatsheaf.

Jennings, S. (1987) (ed) *Dramatherapy: Theory and Practice for Teachers and Clinicians, 1.* London: Routledge.

Jennings, S. (1990) Dramatherapy, public seminar, Institute of Dramatherapy, 6 March (unpublished).

Jennings, S. (1991) (ed) *Dramatherapy: Theory and Practice for Teachers and Clinicians, 2.* London: Routledge.

Landy, R. (1986) *Drama Therapy: Concepts and Practice.* New York: Charles Thomas.

Leggatt, A. (1973) *Shakespeare's Comedy of Love.* London: Methuen.

Mead, G.H. (1934) *Mind, Self and Society.* Chicago: University of Chicago Press.

Meldrum, Brenda (1991) 'Drama and Dramatherapy – How are they linked?' *Theatre and Therapy,* 2, 1, 11–19.

Oliver, H.J. (ed) (1968) Introduction to: *As You Like It.* New Penguin Shakespeare; Harmondsworth: Penguin Books.

Reason, P. (1988) *Human Inquiry in Action: Developments in New Paradigm Research.* London: Sage.

Shaw, F. & Stevenson, J. (1988) Celia and Rosalind in *As You Like It*; In: R. Jackson and R. Smallwood (eds) *Players of Shakespeare 2.* Cambridge: Cambridge University Press.

Wertenbaker, T. (1989) *The Love of the Nightingale and The Grace of Mary Traverse.* London: Faber and Faber.

Dramatherapy Across Europe – Cultural Contradictions
An Inquiry into the Parameters of British Training and Practice

Ditty Dokter

The following quotations show the influence of anthropology on dramatherapy as justification for the use of drama in healing, as well as providing some sources as to the form and content of its practice.

> 'Drama is not a newly discovered activity. It has been an essential part of man's development from the earliest days, as is apparent from archeological and anthropological research' (Jennings, 1964, p.1).

In more recent publications:

> 'Anthropology also serves as a source for dramatherapy, particular in its attention to ritual, magic and shamanism as practised in various cultures. To fully understand dramatic play, it is imperative to look at these anthropological practices...' (Landy, 1986, p.67).

> 'It has been accepted that dramatherapy shares important formal similarities with ritual. Both dramatherapy and corporate ritual are ways of implementing interior change, in that they have regard for the actual shape of events, interior and exterior, which symbolise the reality of such changes' (Grainger, 1990, p.123).

As both a dramatherapist and an anthropologist I am concerned about this easy connection between dramatherapy, ritual and shamanism. Without reference to the cultural context of the practice, it could fall into the same ethnocentric trap that psychoanalysis fell into, with an underlying evolutionary assumption and romantic longing to the 'natural' state of the 'noble savage'.

I decided to make use of social anthropology to study dramatherapy in an attempt to determine some of the parameters of British training and practice. For my research I formulated the hypothesis: 'Cultural concepts of drama and therapy will influence the practitioner of dramatherapy.' Linked to this was the philosophy

that the ascribing of meaning is important, especially that ascribed by the participants in that culture (Geertz, 1975). This in turn was supported by a concept of drama formulated by Bruce Kapferer (1983) which for me formed the bridge between the hypothesis and the philosophy. This theoretical framework was then applied to a piece of fieldwork. I interviewed, with the aid of standardised questionnaires, a group of previous dramatherapy students. This particular group came from the Northern Mediterranean to study dramatherapy in Britain and consequently returned to their country of origin to practise. The contents of this chapter mirror this process. I consider some anthropological concepts about drama and therapy and explore how they were applied in the fieldwork. This is followed by some reflections on the methodology of that fieldwork. The conclusion makes some tentative suggestions about the parameters of British training and practice as well as indicating some further areas of study.

Drama and therapy as in dramatherapy

The four important anthropological concepts regarding drama and therapy which I applied to dramatherapy are:

- the bringing together of differing realities
- drama and therapy as ritual
- the concept of reflexivity and the transformation of meaning
- the different orientations in the systems of therapy

The relevant theorists were Victor Turner (1982) on 'social drama' and Bruce Kapferer (1984) on the role of drama in Sinhalese exorcism ritual. According to Kapferer drama brings the everyday reality into the supernatural reality of the ritual. He quotes Bateson: 'It is in the nature of drama that it opposes and interweaves different realities' (Bateson, 1973, p.193).

These differing realities are then linked to the concept of reflexivity. Kapferer says that rituals promote reflexivity by enabling individuals to objectify their action and experience in the context of the rite. They can stand back and distance themselves from their action within the rite, so that they can reflect on their own and other's actions and understandings. Turner lodges reflexivity in the processes of redress in social drama suggesting that in Western society these means of redress have moved out of the realm of religion into those of the various arts and especially theatre. He based his social drama theory on his work with the Ndembu in Zambia (Turner, 1967) and stresses the importance of performance in experience. He defines performance as an act of creative retrospection in which meaning is ascribed to the events and parts of the experience; both living through, thinking back and projecting into the future by setting goals. Meaning arises in memory, in cognition of the past and is concerned with the fit between past and present.

The original definition of the word therapy is 'alternative ritual'. Different anthropological concepts support the link between mental illness, its treatment and ritual. Those concepts such as the treatment of illness and illness itself as a rite of passage, the enactment of the 'sick role', the different perspectives of

patients and healers (the professionalisation and power aspects are linked to this), the differing realities, i.e. 'normal' as opposed to 'pathological', and the overlap of the secular and the religious both in treatment and perceived aetiology. The net result of this seems to be that all systems of psychotherapy and healing are seen as having some common elements regardless of the cultural context in which they occur (Marsella and White, 1984). Depending on the cultural context certain elements may be more emphasized and utilised than others. Basically however, the different systems can be grouped around four orientations: physiological, psychological, social and supernatural.

Results

Applying these concepts to dramatherapy in Britain and the Northern Mediterranean countries produced some interesting results.

First, the bringing together of different realities. In a group therapy context different realities can be distinguished. There are, for example, the group reality and the individual reality, the 'abnormal' and 'normal' reality, the unconscious and conscious reality, the past and the present reality as well as the differing realities of the individuals within the group, including those of the therapist. I stressed the group aspect because most dramatherapy occurs in a group context and the British training is also geared towards working with groups. With regard to the different realities in drama I wanted to stress the linking of dramatic and everyday reality, the realities of actor and audience. So, in combining drama and therapy different realities are certainly brought together with the aim of mutual reinforcement. Turner's concept of a universal social drama appears to imply that dramatherapy under those circumstances should be universally applicable, whatever its societal context. However, Turner (1982) also states that there is an interdependent relationship between social dramas and genres of cultural performance in each society.

Applying this concept of drama to the northern Mediterranean countries, the different genres of cultural performance certainly affected how and if drama was seen as part of everyday life and reality, or in a separate aesthetic sphere. In Greece, the theatre is seen as very separate, part of the entertainment industry, something done by professional actors. The fact that drama is not seen as part of everyday life and the role education can play in that, is mentioned by the Greek informants. This makes the concept of drama as therapy difficult to accept. This same point is made in Spain and Portugal, although there drama is seen as having a social importance. In Galicia, a province in North West Spain, it is part of the attempt to keep a minority culture alive and with that the language. Music is the genre of cultural performance which is important for everyday life.

In Portugal, drama was seen as having been important in the period before and after the revolution. 'Revista', a specific form of Portuguese political theatre, served to keep the opposition alive, saying the unsaid before the revolution. After the revolution it served to establish the new independent identity of the republic in a larger world. To that end the government invited outside directors and

companies from politically similar countries, to influence the public, indicating 'this is the direction we can take'. Drama was also not seen as valuable to the individual. This, combined with a strong emphasis on individual therapy rather than group therapy made dramatherapy as a concept difficult in these countries.

Then came the concepts of drama and therapy as a ritual and whether consequently dramatherapy can be considered as a ritual. Turner's definition of ritual certainly could not be extended to such a secular ritual. Kapferer's (1983) definition of a ritual could possibly be extended to drama, therapy and dramatherapy.

> 'A multi modal symbolic form, the practice of which is marked off (usually spatially and temporally) from, and/or within the routine of everyday life and which has specified, in advance of its enactment, a particular, sequential ordering of acts, utterances and events, which are essential to the recognition of the ritual by cultural members as being representative of a specific cultural type' (p.3).

The problematic area may be the recognition of the ritual by cultural members. Is dramatherapy enough of a coherent and sequential ordering to be called a ritual? Also, how culturally determined is it to Britain? When looking at the historical and theoretical development of dramatherapy in Europe different cultural and theoretical influences can be seen. Even within dramatherapy in Britain different emphases in training can be found. An important element here might not be just the nature of drama in the 'genre of cultural performance', but also where therapy is placed within the four orientations of physiological, psychological, social or supernatural. As will become clear in the following description of the development of dramatherapy in Britain within the Northern European context, the psychological and social orientation predominated.

Drawing on sources from literature, Hilarion Petzold (1983) links the emergence of dramatherapy in the late nineteenth and early twentieth century to certain developments in theatre and society. It could only gain validity if the play was not just an expression of fate, but as personally experienced scenes and lived through reality. This reality is not scripted by others, but self written by the individual or, according to the playwright Brecht, the expression and part of societal change processes. Within the context of many developments in theatre and therapy in Europe in the 1960s dramatherapy in Britain started to emerge from two sources. Its emergence was related to the more action orientated forms of therapy at that time as well as certain developments within the theatre, especially theatre in education and remedial drama. One dramatherapy development came from special education, the other from the professional theatre, actors moving into hospitals to work with patients, believing in the healing power of the art form.

After a decade of working and promoting, training courses were set up to train people in, respectively, dramatherapy and drama and movement in therapy. Dramatherapy has, in Britain, continued to identify itself both with (special) education and the mental health field. Drama as an intrinsically healing art form

linked to the creative process and dramatherapy as a form of psychotherapy, more aligned with psychodrama and group analysis, have continued to co-exist. The British Association for Dramatherapists, set up in the 1970s, shows this uneasy alliance in the definition of dramatherapy as: '... a means of helping to understand and alleviate social and psychological problems, mental illness and handicap; and of facilitating symbolic expression, through which man may get in touch with himself both as individual and group, through creative structures involving vocal and physical communication' (Landy, 1986, p.58). In the northern Mediterranean, dramatherapy as a form of psychotherapy raises difficulties, whereas dramatherapy as a creative expressive medium finds easier acceptance, although with some reservations: 'The word therapy is difficult. Dramatherapy can be creative work and play, but not therapy. People think it has to do with illness, bad luck, being cut out from and not accepted by society' (direct quote from a Greek informant).

When talking about how therapy was seen the informants stressed the differences between rural and urban perceptions. In the Greek rural areas, where the sense of community is still very strong, the community is seen to support the individual. If mental health difficulties occur, the church in the form of the local Greek Orthodox priest, is the first to be consulted. Only as a very last resort, under the penalty of strong stigma, is therapy from outside considered. This is then in the form of hospitalisation in a psychiatric institution and treatment with drugs. Although not explicitly stated this seems to support an initial supernatural or social orientation, followed by a physiological orientation in the systems of therapy. Psychotherapy in the form of psychoanalysis is available in urban areas, privately. Psychodrama as a technique used in analysis is known, introduced by American trainers.

In Spanish rural Galicia, in contrast with urban Madrid, people do look for therapy first from traditional healers in the (often very isolated village) communities, or from the Roman Catholic church. The people looking for therapy are often from the urban areas. The psychoanalytic school is strong, and psychodrama is known as a technique within that. Only individual therapy treatment is available and some state financial support for that can be obtained.

In Portugal, therapy is confined to the urban areas. One of the informants stressed the importance of a television series, a Brazilian 'soap' drama series, in creating a more generally accepted atmosphere for therapy. The series is watched by a very large proportion of the population, also in the rural areas. The Catholic church and psychoanalysis were quoted as sources of healing. Here though, the emphasis in the treatment orientation seems to be less physiological, more educational (re-training, a heavy emphasis on integration). There is still a leaning towards individual rather than group therapy. In Portugal, the therapy has been strongly influenced by Latin America through ex colonial links. Argentinian refugees introduced psychoanalysis, for example.

The above data were used to explain the difficulties in the acceptance of dramatherapy practice. I also wonder, looking at the historical development of

dramatherapy in Europe, where the importance of the changing relationship between church and state was stressed, whether the contrast between rural and urban acceptance of therapy can in part be due to this relationship. In several of the Mediterranean rural areas therapy is not an alternative ritual to the church healing ritual; there is a religious or supernatural, rather than physiological or psychological treatment orientation : 'We have religious informal psychotherapy' (Greek informant) and 'The role of the traditional healers is important in Galicia, they use their own rituals. The Catholic religion has also many places, where people can go for healing' (quotation from a Spanish informant).

When talking about the more acceptable expressive, creative qualities of drama some other interesting issues were raised. The main one was that of non-verbal communication, drama as an aid to this such as touch and physical expression, especially for adults, but also for children. In Greece touch was seen as more frequent and easier, leading one informant to the proposition that drama might be less necessary in Greece, the other to emphasize the need for creativity. The aspects of creativity and play were both seen as important by all informants.

Linked disciplines in Spain and Portugal are psychomotricity and 'expression corporel' (bodily expression), imported from France. Both had an important period in the 1970s, but are now seen as on the decline. In Portugal, informants are using 'expression corporel' and can gain acceptance for their practice by emphasising expression through drama and movement. The embodiment of action seems to be given importance and acceptance. This could be a further possible cultural determinant, in Spain for example, regional differences were stressed; a North-South divide about the acceptability of, and ease with, physical expression.

The third anthropological concept, that of reflexivity, expands the debate about dramatherapy as a recognised and recognisable ritual. Turner's third phase of social drama, 'processes of redress', and Kapferer's identification of two ways in which rituals promote reflexivity show how dramatherapy, as the combination of drama and therapy, can be called a ritual. Dramatherapy certainly seeks to enable the participants to objectify their action and experience in the context of the sessions. It allows people to stand back and distance themselves from their action, reflecting on their own and other's experience both inside the context of the session and the social and cultural world from which it emerges. It is this reflexivity, inherent in the performance, which enables the transformation of meaning and context. Performance in this context means an act of creative retrospection in which meaning is ascribed both to the events and to part of the experience.

These anthropological concepts connect with the specific dramatherapeutic concept of distancing. 'Aesthetic distance' is the point where the individual both remembers and relives the past and catharsis can occur (Landy, 1986). They also connect with the psychoanalytically influenced concepts of reflection and transference (renegotiating the perceptions of the past into the present). Although this all seems to justify the notion of dramatherapy as a universal social drama, a ritual,

Kapferer's point of recognition by cultural members remains relevant to my query regarding the informants from the Mediterranean. As discussed above the recognition of a British ritual by a Mediterranean audience is not only influenced by their perceptions of drama and therapy, but also by the issues of reflexivity and professionalisation.

The concept of reflexivity is necessary to dramatherapy. When translating the function of reflexivity in therapy as understanding bringing a cure in mental illness, this concept does seem to exist within Greece, Portugal and Spain, for example, the availability of psychoanalysis from which the concept is derived. Differing medical and healing systems co-exist, although each with a different treatment orientation based on a different concept of illness. The dramatherapeutic treatment orientation lies in the linking of reflexivity in drama and therapy. Reflexivity in drama is difficult, however, in Greece, where the dramatic reality is seen as a separate aesthetic reality.

In Spain and Portugal drama is seen as more part of cultural and political group identity, but still not linked to the everyday reality of the individual. Given this different concept of drama, the acceptance of drama as therapy would be problematic. In its treatment orientation it might have to come closer to psychotherapy, rather than the educational field, as drama has no base in education. This could lead to a link up with the analytic orientation but the professionalisation process is an inhibiting factor.

Dramatherapy in Britain has mirrored the medical profession in its striving for professionalisation (Parry and Parry, 1987). Professional or academic qualifications are required as a pre-training and courses were developed at postgraduate level, thus limiting access. It founded a professional association to negotiate for recognition by academic, medical, educational and ministerial departments and has now also instituted a code of practice with disciplinary procedures. The association is attempting to join the larger body of psychotherapies, which, in the form of the United Kingdom Standing Conference of Psychotherapies (UKSCP), is trying to formulate recommendations to the government about the statutory registration of psychotherapists. It is also pursuing a second road to national registration via the Council for Professions Supplementary to Medicine.

Medical anthropology has shown that this whole process of professionalisation is a result of very specific circumstances (Last and Chavunduka, 1986). When new systems of medicine are developed there are moves by the old established systems to prove differentiation from other competitors below; the status game. The consequence of professionalisation is the dispute about access; who can and cannot join. This influences the training systems. Theory in a new field cannot be developed quickly enough, so theories from related fields are drawn in. This can certainly be seen in the development of dramatherapy as a profession. The process of professionalisation itself transforms the system of medicine concerned. It becomes more rigid and there is a debate whether it is also rendered less effective due to reduction of the placebo effect. The professional status of the healer influences the patient–healer relationship, both by reinforcing the placebo effect

through status expectations, but also potentially emphasizing the different perspectives and experiences of both (Friedson, 1980).

Kapferer's different perspectives of healer, patient and audience in a Western European context should take into account the effect of the professionalisation process. The effect on training should especially be considered, if the training is obtained abroad and then used to practise in the healer's country of origin. In my conclusion I will go into this in more detail.

Within dramatherapy in Britain the professionalisation debate still continues, not only about the 'how', but also about the 'whether' and the 'how far'. As seen in medical anthropology different medical systems can co-exist without integration of one into the other. In a plural health system any healing mode can be dominant at a particular time. When looking at issues of status and hierarchy it is important to look at the whole range of healers. It is important to look at the range of clients the healers work with because status and class are also invested in the patient and these cultural attitudes about the patients affect the cultural attitude about the healers (Littlewood and Lipsedge, 1982). This is particularly relevant when looking at mental health: the patient/client's aetiology will influence the type of healer chosen, when and in what sector. In Britain dramatherapy practitioners work in both the statutory sector and the independent sector with a variety of client groups. The training is more geared towards the statutory sector in its theory and practice teaching.

When looking at the informants in the Mediterranean it was important to consider the client groups they work with as well as the setting in which their practice took place: regulated or the independent sector. What is the process of medical professionalisation like in their country of origin and how does that compare with the British situation? What are the relative status positions?

Of the sixteen informants, fourteen were using their training in some form or another, the majority worked in urban areas, four excepted. Most of the informants had come from and were now working in the special education field. Their later practice has not necessarily been in the same place of work. If, however, they have wanted to change, this has often had to occur on a freelance basis or through manoeuvring to change role or duties within their place of work. The professionalisation issue has affected them by proving access to different fields of work difficult in an official capacity, also because of different recognition by the various ministerial departments. The medical field has been difficult to enter, but many applicants did not come from this field, illustrating the importance attached to their previous professional qualification.

Summarising, it is clear that the application of anthropological concepts regarding drama and therapy, certainly indicates cultural determinants and parameters for British training and practice. Before elaborating on these though, I want to discuss some of the methodology used in the fieldwork. This may help to put the results of the northern Mediterranean fieldwork into context, prevent too wide a generalisation and indicate areas of further, more detailed study which are required.

Some reflections on fieldwork methodology

This particular small piece of fieldwork was intended as a pilot study for further, more in depth work. Keeping that in mind, I opted for a broader qualitative approach. Individuals were interviewed about their views and opinions, and observed in their places of work, where possible through participant observation. Available biographical information was studied as well as the cultural nature of the theatre and the health systems in the countries concerned. I wanted to compare these data with similar information in Britain, both historical and current, in order to start to determine certain cultural factors inherent in a British training which could influence the possibility to practise in the country of origin. I opted for questionnaires as a means of standardising interviews where possible, but allowing for the fact that not all informants may be interviewed face to face, having to interview by telephone or rely on the post for gathering the data. Indeed, out of a pool of sixteen informants, five had to be approached by post of whom three responded. One other was interviewed by telephone.

It was possible to interview four people at their places of work; the other six were either interviewed at their own home (three) or in a public place chosen by the informant. One informant refused the questionnaire so an unstructured interview took place. From the above breakdown it is clear that the fieldwork, as usual, did not run smoothly along standardised lines in a clearly controlled situation. This was due to logistics, the informant's arrangements about where to meet (I was a visitor in an unfamiliar environment) and the pre-interview relationship I had with the informant (of the fourteen informants seven had previously known me as a trainer) which needed an adjustment in their relationship to me as a researcher. This situation highlights the problem about participant observation, in that researchers 'are never merely observers, they are also an integral part of the field of study' (Ellen and Hicks, 1987). As arts therapists researching our own practice and training, this certainly is the case.

Geertz's 'web of significance' (1975) teaches that the search for meaning is not so much a matter of fact or concerned with an objective representation of reality, but with the perception, cognition and expression of that reality. Through the interviews I hoped to talk, think and understand some of the idiom of the informant, then experience some of that reality in their place of work and look at some of those perceptions. Given the nature of my fieldwork any quantitative, comparative approach would not be viable, and given the inherent bias only description would do justice to the data. However, these descriptive data could be set both against the hypothesis and the legal and historical framework in which dramatherapy evolved. Additional, potentially useful, information was biographical detail and earlier student perceptions of their training. It was necessary to look at possible inherent bias in that information, which was collated by someone else for different purposes. It was also important to look at what might not be said, for example, because it is part of the informant's taken for granted reality. The asking of open questions in the study's questionnaire tried to address the issues of researcher bias and the informant as competent actor. The latter takes into

account that the informant ascribes their own meaning and is able to ascribe significance when they describe and make sense of their reality. I attempted to grade the questions and elicit some of the informants' values further by focusing on the informants' opinions. I started to ask about their opinions and experiences after and during training before broadening out to their opinions about drama, theatre, therapy and dramatherapy in their own country and Great Britain. This was another attempt to take into account that questionnaires reflect the norms and value system of the researcher (Reason and Rowan, 1981) and that conclusions may be distorted if the respondent's values are not considered (Kersner, 1990). It was for these reasons that I used a descriptive approach to data gathering, with an emphasis on open questions, opinions and motivations regarding meaning to both elicit and process the data and bias.

Conclusions: implications for training and practice

Drama and therapy, as in dramatherapy, looked at from an anthropological perspective and applied to a pilot study of northern Mediterranean ex-students of the subject, indicates some interesting possible parameters of British training and practice.

With regard to drama, important cultural determinants were the genres of cultural performance; for example, what place did drama and theatre take up in the community and how were they perceived by the members of that community? It was especially important to note whether drama was seen as a part of everyday reality, or as a separate aesthetic reality. Connected with that was whether drama was perceived as valuable to the individual. One area where this was generally recognised, was that of creativity and play. Bodily expression was another factor, but the possibility of some cultural determinants regarding the embodiment of action and ways of non-verbal expression, were also raised.

The issue of the individual versus the group, was connected with the cultural determinants regarding therapy; is therapy seen as an individual or group treatment? That is, is it connected with the different treatment orientations of the therapy systems: physiological, psychological, social or supernatural? Distinguishing between the urban and rural context is important here, as well as looking at how the different treatment systems co-exist or are integrated.

In Britain dramatherapy allies two directions; dramatherapy as an intrinsically healing art form and dramatherapy as a form of psychotherapy. In both directions it is relevant that the dramatherapeutic treatment lies in the linking of reflexivity in drama and therapy.

If the concept of reflexivity in drama is problematic, the acceptance of dramatherapy as a therapeutic medium seems to be equally so. Finally, the process of professionalisation, both in its influence on accessibility for practitioners and its effect on patient–healer relationships, will need to be addressed. If one looks at the applicability of dramatherapy in differing cultural contexts. The implications for dramatherapy training and practice could be several.

First, in training, the teaching of drama needs to be linked to the genre of cultural performance where the student is likely to practice; a placement in the country or community concerned would be useful, so that application and adaptation could be discovered and explored during training.

Second, the healing nature of dramatherapy in the model taught, whether as a form of psychotherapy or a creative healing art form in itself, could be explicitly explored with reference to the cultural context of practice. The notions of access and professionalisation are important here, showing the importance of links between professional bodies and training across Europe. This applies in practice as much within a multicultural Britain as across Europe, both for the client and the practitioner: what are the understanding and orientations of drama and therapy in different countries and communities? To claim universalism is easy but to look at specific differences and applications can lead to an enrichment of our profession and training as well as better access for clients.

Finally, from an arts therapies research point of view, the application of a different field of knowledge may allow us to gain enough distance from our subject to engage with the inherent difficulty of participant observation and bias. It is important that as arts therapists we develop our own research methodology, but do not lose sight of other disciplines which can elucidate a possible ethnocentric bias.

References

Bateson G. (1973) *Steps to an Ecology of Mind.* Hertfordshire: Paladin.

Ellen R.F. and Hicks D. (1987) *Ethnographic Research.* London: Academic Press.

Friedson E. (1980) *Patient's View of Medical Practice.* Chicago, Ill.: University of Chicago Press.

Geertz C. (1975) *The Interpretation of Cultures.* London: Hutchinson.

Grainger, R. (1990) *Drama and Healing: The Roots of Dramatherapy.* London: Jessica Kingsley Publishers.

Heron J. (1981) 'Philosophical basis for a new paradigm', in P. Reason and J. Rowan (eds) *Human Inquiry.* London: John Wiley and Sons Publishers.

Jennings S. (1964) *Remedial Drama.* London: Pitman.

Kapferer B. (1983) *A Celebration of Demons Exorcism and the Aesthetics of Healing in Sri Lanka.* Indiana: Indiana University Press.

Kapferer B. (1984) 'First class to Maradana: secular drama in Sinhalese heaing rites', in S.F. Moore and B.G. Myerhoff (eds) *Secular Ritual.* Assen: Van Gorcum.

Kersner M. (1990) 'Are questionnaires a useful tool for arts therapy research?', in *The Art of Research: proceedings of the Second Artstherapies Research Conference.* London: City University.

Landy R. (1986) *Dramatherapy.* Illinois: Charles C. Thomas Publishers.

Last M. and Chavunduka G. (1986) *The Professionalisation of African Medicine.* Manchester: Manchester University Press.

Littlewood R. and Lipsedge M. (1982) *Aliens and Alienists.* Harmondsworth: Penguin.

Marsella A.G. and White G.H. (1984) *Cultural Conceptions of Mental Health and Therapy.* Dordrecht: Reidel.

Parry N. and Parry, J. (1987) *The Rise of the Medical Profession.* London: Croom Helm.

Petzold H.(1983) *Dramatische Therapie.* Stuttgart: Hippokrates Verlag.

Turner V. (1967) *Forest of Symbols.* London: Cornell University Press.

Turner V. (1982) *From Ritual to Theatre, the Human Seriousness of Play.* New York: Performing Arts Journal Publications.

The Retrospective Review of Pictures
Data for Research in Art Therapy

Joy Schaverien

'We do not apprehend the real by attempting to attain it step by step over the painful detours of discursive thinking; we must rather place ourselves immediately at its centre. Such immediacy is denied to thought; it belongs only to pure vision' (Cassirer, 1957, p. 35).

In the daily practice of the art therapist there are many processes which are regularly performed without question. If these are scrutinised we may find that there is an integral system on which research may be founded. The art works, made during the art therapy process, offer a unique means for 'placing ourselves immediately at its centre' (Cassirer, 1957, p. 35). They offer a specific means for evaluating and monitoring therapeutic interactions. The concrete and continued existence of the pictures and other art works made in therapy offer a research tool of a particular type.

In common with other art therapists I began my career as an artist, only later becoming an art therapist. It is for this reason that certain elements of art, art theory and art history contribute to my understanding of art therapy. The pictures made by my patients have formed the basis of my research. Now, when asked to write about the research process, I have decided that the implications of this are not necessarily self evident. It may be useful to spell out how an understanding of certain aspects of art, gained from a fine art background, influence both my practice and my research.

In a chapter in *The Revealing Image* (Schaverien, 1991, pp. 75–77) I began to develop links between the idea of the retrospective exhibition for an artist and the review session for the patient in art therapy. In this chapter I intend to develop the research aspect of this connection. I shall discuss two different types of application of pictures as the data for art therapy research; the record and the review. Precedents will be drawn from: a) art books based, retrospectively, on the life and work of a single artist and; b) the illustrated psychoanalytic case study. Finally I shall discuss the use of the case study in art therapy research. I shall draw on the case study which formed the final chapter of *The Revealing Image* (Schaver-

ien, 1991, p.154). This chapter consisted, in part, of a retrospective review of the pictures of one patient. These pictures were shown, analysed and described along with the context in which they were created. These two pictures demonstrate some of the processes concerned but in a full length case study there is opportunity for a more complex understanding to emerge.

In this chapter I attend to two basic themes in which the art objects, made within therapy offer data for research:

1. *The art work as record*

The art works provide a method of recording the patient's experience of the session. They aid the therapist's memory of the state of the patient at a particular time and enhance notes which may have been made after the session. To the therapist's record they add that of the patient.

2. *The review*

The retrospective review of the series of pictures demonstrates progress and changes which have taken place over days, weeks, months and even years. This is useful within therapy and reflects an interaction between patient and therapist. It is also useful for the art therapist researching the process of therapy in retrospect. Often the research process in art therapy consists, in part, of a retrospective analysis of the pictures combined with notes made by the therapist during the therapy.

Art therapy research may involve a systematic analysis of the colour, shapes and form of the marks in the picture. It may include observation of the changes which take place in the use of certain figures in a series of pictures. Sometimes the patient's comments on the pictures are available and this enables a comparison between the therapist's experience and that of the patient. Validation takes place, as with any interpretation made within psychotherapy, through the movement which is effected in the patient. This is sometimes observable in the imagery as well as in the changes in the state of the patient. Whilst art therapy case studies are similar to those of other forms of single case study research there is a difference. This lies in the concrete nature and continued existence of the pictures.

An essential foundation for both the record and the review in art therapy is the fact that the work of art lasts. This means that there exists material evidence of the marks made by the artist. It is this which distinguishes art therapy from other forms of psychotherapy and also from drama, dance movement and music therapy—art therapy is the only form of therapy where there is a series of lasting objects created by the patient. This offers data and the potential for a very particular type of research investigation.

The pictures have long been used as a method of recording sessions in art therapy. Some art therapists make notes on the backs of pictures to remind themselves, and the patient, of what was said in the session. Others make separate notes about the other aspects of the session, whilst some rely totally on the pictures to remind them of what took place. Pictures are usually dated and stored in

individual folders or spaces in the art room. Thus in art therapy practice there is a built-in storage of the data for potential research.

Within the course of therapy the pictures which have been stored in this way provide a way for patient and therapist to return to the material of a past session. The pictures provide an instant recall of part of the session. As far as I know, neither of these methods of working has previously been discussed as a legitimate form of collecting research data.

The retrospective exhibition

In a retrospective exhibition, held in an art gallery, the work of one artist is exhibited in chronological sequence. In such an exhibition all the work of a single artist is viewed in one place and at the same time. Works which were created on different occasions and at different stages in the artist's career are all gathered together. In this way fragments of the artist's life from different periods are assembled in one place. This offers the opportunity for both the artist and the public to review progress retrospectively. Seen in sequence, links may be made between pictures and it is possible to re-evaluate the meanings of particular works in the context of those which both preceded and succeeded them. When linked with the artist's biography all kinds of new understandings emerge.

It is similar with the work of a patient, especially when the therapy is long term. Here the work, reviewed in sequence and combined with the life history of the patient, offers unique insight into aspects of the person which may have been previously hidden or unconscious.

In art history the written biography of the artist has a similar effect to the retrospective exhibition. A photographic record of all the work is gathered together in one book and shown in sequence. The commentary in such books may tell about the life of the artist. I will give a brief example of the use of the biography of the artist Edvard Munch in a book primarily about his paintings. My aim is to demonstrate how the art historian may use such data as a basis for research. The history of the artist's life enriches our knowledge and understanding of the artist. It also enhances appreciation of the pictures. This can be seen as offering a precedent for art therapy research.

In the book on *Munch* (Benesch, 1960) the artist's life is described in conjunction with a chronological review of a selection of his art works. The book begins with an overview of the time into which Munch was born, his family and the major traumas of his childhood. It continues to weave the artist's life story with those of his contemporaries, discussing those with whom he would have been associating at the time certain pictures were painted. The pictures are analysed in detail, they are described and then discussed. Connections are made between certain incidents in the life of the artist and pictures or themes which he regularly painted. There is speculation about the artist's relation to these themes.

Such a method has been used by art therapists often, only partly conscious of the tradition in which they follow. It is not merely the psychoanalytic case study

which influences the art therapist but also the art historian investigating the influences of the artist's life on his work.

There are other types of art historical study of the work of the individual artist but I do not have space to discuss these here. My aim is to point out that the pictures made by Munch form a lasting record of his life. The book which is written about him is based on a sequential review of the paintings. His life history is told to inform the viewer of other dimensions to the pictures and the pictures reciprocally add a dimension to the story of his life. The research involved the writer in investigating the artist's life, analysing the pictures and then making philosophical and theoretical connections between these different facets.

Psychoanalytic approaches to the illustrated case study

In considering precedents for the illustrated case study as the basis for research one comes across many examples from psychoanalysis. Rarely is it stated as a method of research, and yet the pictures are clearly used as data. They demonstrate processes which the writer wishes to convey to the reader. I suggest that these pictures are not merely illustrations. They demonstrate a means of recording and investigating the processes which take place in psychotherapy. Whilst this might be viewed as evidence of outcome rather than a conventional research method I am suggesting that the pictures are often a starting point for the analysis of the therapeutic process. The temporal existence of the pictures provides a lasting record of the therapeutic work. In order to substantiate this claim I refer to certain psychoanalytic books. In this section I pay particular attention to what the writer has stated with regard to the aims and objectives of using the pictures. Examples include Jung (1959), Milner (1969), Winnicott (1971) and Edinger (1990).

Jung (1959) writes:

> 'The unconscious produces dreams, visions, fantasies, emotions, grotesque ideas, and so forth... The only question is whether the hypothesis of a dormant and hidden personality is possible or not. It may be that all of the personality to be found in the unconscious is contained in the fragmentary personifications mentioned before [archetypal images]. Since this is very possible, all my conjectures would be in vain—unless there were *evidence* of much less fragmentary and more complex personalities, even though they are hidden.

> I am convinced that such evidence exists. Unfortunately, the material to prove this belongs to the subtleties of psychological analysis. It is therefore not exactly easy to give the reader a simple and convincing idea of it' (pp. 283–4, emphasis mine).

Having stated this Jung then goes on, in the next chapter, to give a detailed illustrated case study which he calls 'A Study in the process of Individuation'. It seems, by the sequence, that there is an implication that the case study and the pictures are the evidence to which he refers above; but this is implied rather than stated.

The chapter is the story of the analysis of one woman who used pictures as a means of coming to realise the images of her unconscious. He says 'Before coming to Zurich she had gone back to Denmark, her mother's country. There... unexpectedly there came over her the desire to paint—above all, landscape motifs. Till then she had noticed no such aesthetic inclinations in herself, also she lacked the ability to paint and draw' (Jung, 1959, p. 290).

Jung appears to be making the point that the pictures came from an inner need to externalise the process which had begun before the therapy started. The pictures are shown as if they make evident the material which he has been discussing in the previous chapter. He does not state that they are the method and yet this seems to be implied; it is fairly clear that this is what he intends. Furthermore I suggest that these pictures are the basis of some of the ideas which are elaborated in the book. This process of the link between Jung's use of the pictures in the therapy and his writing has been established by Edwards (1985) through unpublished research conducted in the Jung archives in Zurich.

In 1969 Marion Milner published *The Hands of the Living God.* The entire book is devoted to a lengthy case study which traces the 16-year analysis of a woman patient. Regarding her method of research and recording Milner says:

'As for the method of writing the book, I had intended, in the beginning to use my own diary notes of the experiences with this patient, together with her drawings, as the basis for a descriptive account of what had happened between us. Soon however, I found that the problem of selection from verbal material collected over very many years was too difficult; so I decided to make the account centre on the drawings, since I did come to look on these as containing, in highly condensed form, the essence of what we were trying to understand. In fact I came to see them as my patient's private language which anyone who tried to help her must learn how to read – and speak.

However there were still difficulties, even with this plan, for I soon found that my ideas about what happened were continually developing, in the course of the writing, as also the aim in my writing. Thus I soon discovered that there was another aim, other than the one I had first given myself.. I realised that there were certain ideas that I had an imperative need to try and formulate in order to clarify them for myself; I saw that what had started as an attempted therapy, told to demonstrate what this kind of patient needs from society, had also become the study of what happened to my own way of seeing the experience when I tried to write about it' (p. xxi).

There are two important points here which link to my theme. The first is the method of recording; selection from the notes became too difficult and she resorted to using the pictures as the centre of the account because these were the patient's own language. This demonstrates the importance of the pictures as data; they are a lasting record left by the patient. The second is that Milner's description of her own process gives an impression of how the research develops and changes for the researcher as it progresses. This demonstrates an important distinction between the research process, the writing of which usually takes place after

therapy has terminated, and the understanding on which interpretations are based during treatment. A third point, which comes through later in the book, is that Milner and the patient together review the pictures during the course of the therapy (Milner, 1969, p. 409). The pictures then have a dual function; they enable retrospective review sessions to take place during the therapy and they offer an opportunity for retrospective analysis of the pictures after termination.

Winnicott's publication *Therapeutic Consultations in Child Psychiatry* (1971) is a series of mini case studies using what has become well known as his squiggle technique. Again this is a type of free associating on the paper which is not unfamiliar to artists; it offers a playful way of beginning to fill the space. Here he too uses the illustrated single case study as evidence of the process of treatment. Combined with his hypothesis and discussion of the interactions with each child the drawings help the reader to understand the course of the therapy. This is different with each of the children and the outcome of the treatment of each case is described. It is clear that frequently it is the process of revealing the problem in, and through, drawing which has enabled the analyst to develop an understanding of the source of the problem. It is also this which seems to enable the child to feel seen and understood which often seems to be the factor which induces psychological movement.

Winnicott draws with his child patients, often on the same sheet of paper; thus he alters and influences the development of the drawing. Winnicott does not discuss the inevitable countertransference effects of his interventions. As a research method this could be seen as contaminating the situation. However, it could also be seen as a form of participant observation (Reason and Rowan, 1981). Unlike most art therapy cases, the children in these studies are never merely left to make their own unsolicited pictures. However, in the more analytic studies by Winnicott this does happen, for example *The Piggle* (1977).

It seems that the method of research revealed in this book is one adapted to a particular clinical situation. The data of the sessions comprises the pictures and notes made after sessions. Sometimes there is a gap of several years between sessions but it is made clear that the pictures remain as a link for the child and for the therapist.

In terms of a research method it is likely that art therapy research and psychotherapy research is of necessity a form of participant observation. This is because a psychotherapist can never be totally objective about any therapy which he or she has conducted.

Two other psychoanalytic books merit mention in this context, both are illustrated with pictures exhibiting the processes described in a case study. In both books it appears that the pictures were apparently an integrated part of the analysis. In *Narrative of a Child Analysis* Klein (1961) uses pictures, made by a child patient, to illustrate their work together. One might take issue with some of the interpretations Klein makes about the drawings. Her interpretations of the aesthetic responses of the child to the other pictures viewed by him reveal a reductive approach to the aesthetic experience. However, the method of including

a series of pictures, in sequence, to illustrate a case study is clearly demonstrated here. Klein does not state that this is data for research although I would suggest that it is.

The book *The Mythology of the Soul*, (Baynes, 1940) is derived from the case material and the drawings and paintings of his work with two patients. This book takes a Jungian approach and the illustrations form an integral part of the work. Because of the pictures and its open approach to images it had a considerable influence on many early art therapists in Britain. Again the pictures are used as evidence but their role is not spelled out as such.

In a recently published book the Jungian analyst Edinger (1990) tells the story of a ten-year analysis almost entirely through the pictures made by the patient. The patient's pictures and his own comments are given priority over those of the analyst. The book is laid out so that on the left-hand side of a double page is a picture and on the right is a paragraph with the patient's description of the meaning for him of the picture. This is followed by a comment by the analyst on his impression of the implications of the subject matter of the picture. The patient was an artist who chose to bring his pictures to therapy. Here the patient's own familiar language of art influences and dictates the shape of the therapy. In his introduction Edinger describes his intention:

'There are only a handful of published case histories which illustrate the unique approach of Jung to the human psyche... Nevertheless, such data on individual cases must be accumulated if the larger worlds of psychiatry and psychotherapy are, belatedly to realize Jung's massive contribution... It is an impossible task to condense the analytic efforts of ten years into a coherent whole without some unifying thread. Fortunately in this case the unifying thread is provided by a series of pictures that touch all the major themes of the analysis' (Edinger, 1990, p.xiii).

Edinger states that the research data is the pictures but, although there are interpretations about the pictures, many questions remain unaddressed. As a method of research this book lacks a critical edge to interpretations made about the pictures. It is not as rigorous nor as questioning about the style, use of colour and form and I would expect for a study where the art works were being investigated. I would have liked to know more about how the parts of the picture were viewed in relation to the client. The story is left to tell itself and sometimes this leaves too much to the imagination of the reader. Due to the fact that the patient is an artist, the quality of the art work in this book is formally good. However, there is little distinction between the images which merely illustrate and others which may be seen to embody the transference. This is a distinction which I have made elsewhere (Schaverien, 1987 and 1991). Thus although there is much potential for research in this study I consider that it is a presentation of the data rather than a research document. The psychological and philosophical questions raised by the data are, in the main, left unaddressed.

Art therapy case studies in art therapy research

In art therapy the case study is, and has always been, the main data for research. A review of the art therapy literature is not within the scope of this chapter but if one picks up any book about art therapy it is likely to be illustrated with the work of patients. Sometimes these are lengthy case studies, more often they are brief illustrations of the story of the treatment. In either case it is clear that the art therapist treats the pictures as data and this is often in a similar way to the art historian writing about the artist.

In *Working With Children in Art Therapy* (Case and Dalley, 1990), almost every chapter contains pictures. These convey a point, or series of points, about art therapy, that the writer needs to show rather than just explain. In a chapter in *Images of Art Therapy* pictures are shown as the basis of the research carried out by Nowell Hall (1987). Here investigation of the pictures was combined with the comments of the patients. These were based on follow-up interviews conducted ten years after termination of therapy [illuminative evaluation was used in this study – Editor's note]. Analysis of the style of pictures made in therapy has been conducted and written about by Simon (1992), whose book is richly illustrated.

In their training all art therapists in Britain are required to write a case study. This is based on a clinical placement and is the report of treatment, by the student, of a single patient or a group. There is a fairly standard form to these studies. They contain a description of the patient's history, the presenting problem and the aims, process and outcome of therapy. These case studies are expected, where possible, to be illustrated with art works made by the patient(s). The pictures and the treatment process are described and analysed by the student therapist.

In view of this practice it is surprising that, much later in their careers, when experienced art therapists come to write their Master dissertation, they are often troubled when asked about their research method. They immediately think that this means scientific proof that art therapy heals and so they feel inadequate. Cassirer (1957, p.35) writes 'Is all reality accessible to us only through the medium of scientific concepts? Or is it not evident that a thinking which, like scientific thinking moves only in derivations and in derivations from derivations can never lay bare the actual and ultimate roots of being?'

The illustrated case history creates a particular form of evidence for research. This is based in traditions of art and so has a reputable history. It is in the pictures that the roots of art therapy are 'laid bare'. This is only the beginning; it is also necessary to find a way to talk about the pictures within the therapeutic relationship and the research process can help to make this possible.

Illustrations

In the last part of this chapter I shall discuss two of the pictures which illustrated my PhD research. They are extracted from a case study which is published in *The Revealing Image* (Schaverien, 1991, p. 154). In showing these pictures my aim is limited. I wish merely to demonstrate how two pictures, shown in the sequence in which they were made, reveal changes in priority and relationship of certain

figures within the picture. This gives only a fragment of a retrospective review. It offers only a tiny percentage of the potential of seeing all the work, made over a longer period of time, in sequence. The full retrospective review presents a very particular context in which pictures are viewed. This context offers a way of limiting and locating meaning.

When I commenced my research I conducted a review of these pictures. They were made approximately fifteen years previously. There were over 200 pictures made over three years and any comments or observations I make here are necessarily influenced by the context of the full case study. I examined them all and divided them into themes and groups based on the subject matter, the art materials and types of marks that had been made. There were certain identifiable themes in the series such as: the dancers, couple's heads, male figures and female figures, summary pictures. Here there is not space to enter into discussion of these themes, instead I will draw the reader's attention to certain elements in these two pictures in order to point out movement. It is my premise that these demonstrate unconscious processes which reflect movement in the inner world of the patient.

The pictures 1 and 2 (see Figure 8.1) were made on two consecutive days. This was one month after the artist, Harry, had been admitted to the NHS day hospital where I was the art therapist. They were number 27 and 28 in the series. Although he had not painted since he had left school, Harry had a great need to externalise his inner images and every day he made at least one or two pictures. Both of the pictures, illustrated here, are drawn in felt tip coloured pens on white cartridge paper measuring 38 x 56 cms. I do not intend to discuss the artist here, but rather to attempt to demonstrate how the pictures provide a record of sessions which, when reviewed in sequence, reveal multiple layered potential meanings.

I shall describe what is apparent in the pictures, I draw attention to the development of certain figures which seem to change position or to make progress from one picture to the other. I propose that these pictures facilitated the emergence of depth processes which came to light uniquely through the visual images.

Picture 1

A young man in the centre of this picture is immersed up to his shoulders in deep water. His position appears to be ambiguous, he could be behind the horizon and so, enormous in relation to his surroundings. Immediately above his head a star shines. On either side of him is a cloud; the sun appears to rise above the cloud on the left; from the one on the right pink droplets fall like rain. To the left of the picture the sea gives way to land, from which a tree grows. The tree is light on the left side and dark on the right. In the sky black birds fly and to the right side of the man a black swan swims away from him and towards the edge of the paper. In the foreground, in the right corner rises a coloured shape, like a phallus. It is drawn in many colours the pink inside and the black outside.

For the purposes of this paper I would draw the reader's attention to certain figures in the picture. The swan, the tree, the male head, the sun and the clouds.

Figure 8.1a

Figure 8.1b Pictures drawn on consecutive days

Each of these images reappears in the second picture but in a different position. It is the change in priority and placing of the individual parts of the pictures which alters the relationships within it. The implications of the positioning of these elements is not a fully conscious process for the artist. I propose that this demonstrates the value of the pictures as a record which offers insight. I am suggesting that the changes which are seen to take place in the pictures echo those taking place in the inner world of the artist/patient.

Picture 2

This picture was one of four made the next day. It shows a couple side by side facing the viewer. They too are submerged in water which appears to be deeper and rougher than its surrounding sea. Immediately in front of the pair the water is green and turbulent. This water, drawn in green and yellow, could also be land, green and yellow are colours often associated with the earth (Hillman, 1989). When compared with picture 1 this could be the same land as is depicted on the left-hand side of the lone male figure. In picture 1 the lone male figure seems to emerge from behind the horizon, but here there is a couple who appear in the midst of the sea. In front of them, and towards the viewer, is what appears to be a floor or a stage on which a cradle with a baby in it rests. This is surrounded by a black crate, square and barred. Above, and between the couple, a tree rises; the same half light/half dark tree as in picture 1 but its position has changed; here it is placed above the heads of the figures perhaps replacing the star in the first picture.

The male figure could be the same person as depicted in picture 1 but, if so, his hair has grown. This might denote the passage of time, as might the changes in the black swan. The swan has matured, the plumage on its wings shows signs of beginning to turn white. In later pictures the swan is depicted in full white plumage. The position of the swan in the picture here is different; it swims into this picture from the left edge. The sun has also changed sides, it is no longer behind a cloud and, as in the last picture, it is diagonally opposite the swan. This would seem to indicate that these two figures, the swan and the sun, may hold some kind of a tension; perhaps they are the opposite elements. Their position and their colours, black and yellow respectively, seem to denote polar roles within the pictures.

There are many points about these pictures which could be developed but I intend to keep my focus on the theme of this paper. It is the relevance of pictures as data on which art therapy research may be based which I am attempting to demonstrate. Pictures such as these offer the opportunity for a sequential review of the position of each of the elements in the picture. They offer the material from which hypotheses may be drawn. They indicate a certain progression in the state of the patient. In addition they reflect the transference to the therapist.

To simplify a complex set of processes, which I have written about elsewhere, we could see the first of these pictures as showing a part of inner world of the patient alone in the sea of the unconscious. In the second picture he is no longer

alone, a feminine aspect has joined the lone male. It seems that from their union a child has come forth. The baby is held, as yet in a barred square, in later pictures it emerges free of such constraints.

The tree could be understood to be a symbol of the union with the feminine aspect and so in picture 2 it has moved to the centre. The sun, the solar aspect could reflect the male principle; this is demonstrated by the second picture where the tree reflects the light on the male side despite the sun having moved to the side of the woman.

The problem with these comments is that they potentially fall into the category of unsubstantiated claims. I suggest that they can be validated; firstly through viewing the pictures in the context of the sequence of the set of pictures. Secondly through asking the artist what they meant for him. A third way is to attend to the art therapist's impressions and analyse the pictures beside notes and memories of the therapy. The therapist's memory, woven with application of theory and speculation, may also offer insight into the ways in which the process of art therapy effects a change in state of the artist/patient.

Conclusion

These pictures remained as a record of the sessions long after therapy terminated. When I studied them I found that they reminded me of what had passed between the patient and myself. Through their aesthetic quality I could recall the aesthetic response I had had to them at the time they were made. They brought into the present the memory of the state of the artist at the time he made them. They re-awakened some of the countertransference feelings which I had experienced when we were working together. Thus the pictures were effective in a way that case notes cannot be. They re-evoked the countertransference from a past time and brought it live into the present.

They also have the power to re-evoke the transference as Harry explained when one day he had considered visiting me. He told me that, as he was with members of his family, he had not come to see me because he would have wished to see his pictures. He felt that he would be touched by the pictures if he saw them again. He could not bear for this to happen when he was with his family. Although this may have included feelings about seeing the art therapist again, it was expressed in terms of the pictures. I think it is important to understand that, through the power of the pictures, affect from the past can be carried live into the present.

The concrete and temporal existence of the art works offer a unique opportunity for retrospective research. The pictures also offer a way of recreating the therapy for the viewer or reader. They are a record of the therapy, providing a particular kind of research data.

In this chapter it has been my intention to offer a new way of viewing an old established practice of art therapy. It is intended that considering the illustrated case study as research data may offer art therapists renewed confidence in the foundation of our own research processes and methods. It invites further critical

exploration of the data of our clinical work. The pictures, drawings and sculptures made by our clients, offer a unique opportunity for studying the psychotherapeutic application of art. The sequence of pictures offers the potential for investigation of many aspects of art therapy and art psychotherapy.

References

Baynes, H.G. (1940) *The Mythology of the Soul.* London: Routledge, Kegan Paul.

Benesch, O. (1960) *Munch.* Translated by J. Spencer. London: Phaidon.

Case, C. and Dalley, T. (1990) *Working With Children in Art Therapy.* London: Routledge.

Cassirer, E. (1957) *The Philosophy of Symbolic Forms. Volume 3, the Phenomenology of Knowledge.* Connecticut: Yale University Press.

Edinger, E.F. (1990) *The Living Psyche.* Wilmette, Illinois: Chiron.

Edwards, M. (1985) Paper given at the conference 'International Review of the Arts in Psychotherapy', Goldsmiths College, University of London.

Hillman, J. (1989) 'The yellowing of the work' Paper given at the 11th Annual Congress for Analytical Psychology, Paris. Forthcoming in the Proceedings of the Congress, Ensiedeln, Switzerland, Diamon.

Jung, C.G. (1959) *The Archetypes and the Collective Unconscious. Collected Works Vol 9 Part 1.* Princeton: Bollingen.

Klein, M. (1961) *Narrative of a Child Analysis.* London: Hogarth.

Milner, M. (1969) *The Hands of the Living God* London: Hogarth.

Nowell Hall, P. (1987) 'Healing the Split', in T. Dalley *et al., Images of Art Therapy.*

London: Tavistock.

Reason, P. and Rowan, J. (1981) *Human Inquiry.* London: Wiley.

Schaverien, J. (1987) 'The Scapegoat and the Talisman: Transference in Art Therapy', in T. Dalley *et al., Images of Art Therapy.* London: Tavistock.

Schaverien, J. (1991) *The Revealing Image: Analytical Art Psychotherapy in Theory and Practice.* London: Tavistock/Routledge.

Simon, R. (1992) *The Symbolism of Style, Art as Therapy.* London: Routledge.

Winnicott, D.W. (1971) *Therapeutic Consultations in Child Psychiatry.* London: Hogarth.

Winnicott, D.W. (1977) *The Piggle.* London: Hogarth (1980 edition Penguin).

The Art of Science with Clients
Beginning Collaborative Inquiry in Process Work, Art Therapy and Acute States

Sheila McClelland, Ann and Pat

Introduction

The focus of this chapter is on beginning research. It is about beginning a particular sort of research which is concerned with *reflection in action,* and with collaboration with people, that is, doing research *with* and *for* people, versus on them (Reason and Rowan, 1981, 1988). What is being researched are aspects of process oriented psychology (Process Work), (Mindell, 1988) as a model for working with radically altered states of consciousness (ASC) associated with acute states in psychiatry.

What I am primarily trying to do is demonstrate some of the strands that are around beginning this type of research, and some of the responses of myself and my co-researchers – how interesting and exciting, how confusing, difficult, chaotic and painful it is. Also, how vulnerable one can feel around both engaging in research, and in reporting it at such an early stage.

I also want to show something about the theoretical building blocks on which this project is based and the type of care and rigour which need to go into the preparation of the researchers and also the context in which the inquiry takes place.

Theoretical underpinnings

As initiating researcher, I came to undertake this project from training in a humanistic and phenomenological orientation to art therapy, and in the personal construct psychology of G.A. Kelly (1955). In 1982, the writings of Dr Arnold Mindell (1982) appeared to me to address what was and is a burning issue for psychotherapy in the humanistic models. How to enter into communication, and communicate with, clients who express themselves in communications other than verbal, that is, pre- or non-verbal construing. Therapeutic models in which I had been trained suggested that if therapists could establish communication using the

client's mode of expression, and enable awareness to be brought into these states, the states would be amenable to change.

Process work increasingly appears to be at this growing edge, (Mindell, 1985, 1988) with its solid foundation in modern communications theory and its elaboration of very practical tools for enhancing awareness in a wide spectrum of perceptual, experiential channels. Having trained since 1987 with Mindell and his close associates now causes me to regard myself as a process worker who also uses art therapy, albeit extensively, because my experience is that one can most usefully address people in acute states by developing as multi-channelled a technique as possible, and not being too bounded by professional delineations.

In terms of research methodology, Reason and Rowan's publications introduce a series of approaches which, as with the above, emphasize clients' ways of making sense of the world and their experiences as the only valid point of departure for both social research and therapeutic intervention.

The conduct of a co-operative inquiry project is underpinned by careful preparation of the researchers and the 'field' in which the inquiry is to take place. Co-operative inquiry is a very personal process. The inquirer is required to consider her personal investment and motivations in her particular field of research. For me, the challenge of pioneering in uncharted territory is important, coupled with the satisfaction of seeing people emerge from distressing and destructive states, and wonder at how, if accurately accessed and skilfully supported, such states contain the 'spark' to ignite and unfold themselves. I have also an investment in people forming their own, unique knowing, out of their own experiencing. I guess that this is related to my own character structure. In my personal history I was educated into what values, religious and otherwise, I must adopt, in a mode that firmly split 'head knowing' from 'body knowing'. In fact, there was little room for any form of strong personal knowing, resulting in a shy, but very inwardly rebellious young adult, who was bound to react to imposed knowledge, the later development of which is to strive for a creative dialogue between both domains of knowing.

In addition to ongoing exploration of personal patterns mirrored in the inquiry, the inquirer needs also to be committed to ongoing personal development. The method which will shortly be outlined demands development of various kinds of high quality, multi-levelled awareness, in addition to other skills specific to the model of collaborative inquiry chosen. Prior to formal registration for PhD research in 1990, my training in process work involved rigorous discipline in developing fluency in working in many perceptual channels and in working on my own processes in areas as diverse as body symptoms, dreams, altered states of consciousness, relationship issues, and conflict resolution.

Preparation of the field of inquiry in this model is 'that process by which one allows for sufficient time to practice, communicate about practice, obtain feedback and revise practice' (Cunningham, 1988). The 'field', in my case, is the acute psychiatric unit of a large hospital complex. Since 1987 my practice involved developing and studying process work interventions with a wide range of clients,

in both psychoneurotic and psychotic categories and currently involves formal cycles of inquiry with some of the clients. Many of my clients were considered to be in the 'at risk' category: many had been exposed to a wide variety of therapeutic interventions. During this time I also explored a process work orientation to my practice as an art therapist (McClelland, 1992), in particular with its potential for dynamic, brief therapy.

My communications about my practice involved co-working with colleagues, teaching process work theory and practice, engaging in experiential exercises and often using video tape recording (VTR) of actual interventions with clients, and organizing major seminars and supervision on site. Clients also learn the methods of process work in the course of their therapy, and despite challenges from colleagues to the contrary, I hope to show this prepares them as potential co-researchers who can develop degrees of awareness even in the midst of radically disturbing states. Many clients agreed to VTR, and participated in review of their therapy sessions as a potential for integration of emerging processes, and an assessment of change.

Feedback from professional colleagues included comments that the method appeared to address a wide range of client difficulties which had previously been deemed intractable. There was confirmation that much training would be needed in order to develop sufficient levels of skills necessary for observation and unravelling of multidimensional, often minute signals in acute states. With colleagues, an important inquiry was into noticing the ways in which this very different paradigm was interfacing with their respective models of training. All reported that some process work attitudes and skills were immediately learnable and useful.

Why process work, why research?

My decision to start formal research when I did, despite the fact that the introduction of process work into our context was demanding enough, merits explanation.

A primary consideration in undertaking this type of research is *its potential value:* what is in it for *me,* as initiating researcher; for *us,* those who choose to collaborate with me; and for *them,* the academic and professional community, and employer.

For *me,* I've already stated some personal motivations – the satisfaction of experiencing clients move from positions of desperation and suicidal intent back into life, following even a small intervention based on accurate perception of the communication mode of their acute state. Very few indeed have been readmitted.

Conversely, I experienced considerable isolation. Process work is new in this country, and proponents few and far between. Pioneering involves risk. In this situation I judged that visibility, accountability, and the creation of some peer review mechanisms would both enhance learning and provide a safety factor. Registration in an accredited institution, in my case in the University of Bath, with the inestimable advantage of becoming a member of a co-operative inquiry

group facilitated by Dr's Peter Reason and Judi Marshall, seemed increasingly urgent and necessary, offering a milieu wherein I could learn skills, both theoretically and experientially for organizing and managing research aspects of the project.

For colleagues, the feasibility of learning a range of interventions in pre- and non-verbal states as a counteraction to feelings of professional failure, hopelessness and, at worst, cynicism as many of our interventions fail to appropriately address these states. In addition there was the possibility of creating a community of inquiry (Torbert, 1987) on site to support the development of our learning. Many clients seemed eager to participate when they realised that we had been inquiring quite naturally. Many stated that they would welcome an opportunity to make what had been an awful experience, useful in some way to others.

For employers, research might act as a form of quality control. One in which ideally, clients, *and* the team as a whole learn to monitor congruency between aims, methods used to achieve them, and outcomes.

For the academic community, research could provide an increase in the knowledge base around working with extreme states in a way that might enrich all concerned.

Beginning research: why not reported?
The first part of this chapter has been principally authored by myself. By mutual agreement, however, it was co-edited by my co-researchers/co-subjects. From the report on cycle 1 it has been co-written by all.

We are excited about reporting what feels as if it is potentially important and novel experimentation in collaborating in inquiry around radically ASC. It seems right to communicate this early stage while still close to it, rather than retrospectively portraying it, almost like some vital 'knowing' might not get developed if we did not report it, or would be suppressed in the refinement stages. Yet, precisely because we feel so close to it, we find that there are issues we cannot include at this stage because to do so would make us feel extremely vulnerable, and could even be dangerous for us in various ways. In spite of this, we have attempted to identify some difficult issues.

It was put to me that the beginning stage of inquiry frequently resembles a 'firecracker'! A whole mass of loaded material literally 'explodes', ideas, feeling are thrown up, scattering in every direction. This was indeed the case! We appeared to touch upon everything, yet deepen nothing. We cannot yet foresee the place which these issues may occupy in the research as a whole, nor which will prove of real value. Some of the material is highly 'charged', and at this stage remains largely unprocessed. If we try to balance this data too much, we may lose potentially vital information: yet we also feel that we may offend others, and leave ourselves open to being misunderstood and even isolated.

A huge difficulty for me is that, contrasted with the rigour of preparation, years of study, personal engagement and experimentation, the project may at this stage, appear 'chaotic', unbounded. However, the rigour and care demanded in both

process work and collaborative inquiry are formidable, but of a different order than more conventional paradigms. One example is that in contrast to traditional research which commences with clear-cut hypotheses, at the beginning of collaborative research hypotheses are held tentatively, and are continually open to negotiation and change in the course of the collaborative process. Divergence is welcomed at the beginning of inquiry, but can feel tantamount to chaos, as the initial intent of the initiating researcher is pulled this way and that by her co-researchers!

An example of one kind of containment which process work offers for allowing vital issues to emerge more organically, is that chaos is deemed a function of our inability, for one reason or another, to perceive the underlying process pattern. We, as therapists, are encouraged to model an ability to 'swim' in chaos, trust it for long enough so that a 'pattern that connects' (Bateson, 1973) may emerge out of our collaboration.

Probably my most vulnerable area is in reporting early stages of experimentation with the therapist role as it might look in a collaborative versus a more hierarchical model. My customary style is one of very active involvement. In the subsequent account of our inquiry, my early experimentation with a more facilitative, democratic style threw me into a very unfamiliar role in relation to two ex-clients who had agreed to co-inquire. This evoked strongly polarized reactions, both supportive and challenging. In fact, I had implicit trust that we had developed together sufficient resilience and skills to support such experimentation. But I am aware that I may be criticized for not providing enough containment and support to my newly designated co-researchers during the transition period, and for relinquishing my skills as therapist to too great a degree.

Process work

Process work and psychiatry

In a publication on process work in psychiatry Mindell (1988) appreciates the value of the biomedical and associated models in psychiatry in terms of their management of many acute states, but also suggests that the diagnostic categories of, for example, the Diagnostic and Statistical Manual of Mental Disorders (American Psychiatric Association, 1987), often fail to meet either their implicit or explicit healing goals. These approaches and the associated use of pharmacology aim principally to alleviate symptoms, and are in some instances used as an adjunct to psychotherapy. Mindell supports the use of medication when it is experienced as useful to the client. Mindell's own model seeks rather to develop a phenomenological language to describe events, and assumes that if the actual details of a wide spectrum of a person's behavioural signals are observed, a pattern of meaning which will make that person's life more worthwhile, will emerge.

Philosophical base

Concepts of change in process work are related to philosophies which regard constant transformation and change as a tendency which is innate in all things

and situations (Mindell, 1985). Arising from this concept, a most radical notion for psychiatry may be that the acute state, however distressing or dangerous, is, paradoxically, a change which is needed, trying to happen. The state is also said to contain the seeds of its own evolution and resolution. Yet many states cannot complete themselves, and are said to 'spin' – fail to ground themselves, or likened to a frozen part of a larger experiential pattern, presenting in terms of, for example, relationship problems, neuroses or psychoses.

Theoretical base

Enabling an acute state to complete itself is a complex business. The prospective process worker has to learn a wide spectrum method of perceiving, differentiating and enabling human communication signals to unfold, in a communication mode adapted to the nature of those signals. This highly discriminative observation and methodology is what distinguishes the method from other 'process' psychologies. To this end, Mindell and associates have invented a system, based heavily within modern communications theory. What we observe and experience is differentiated according to 'channels', for example, one can feel something in the body such as pressure or tension; hear tones and content of speech; experience dreams in inner vision.

Mindell describes six major 'channels' of experiencing and communicating: visual, auditory/verbal, movement, proprioception (body-felt sense), relationship and world (Mindell, 1985). Furthermore, these channels are said to be either occupied or unoccupied by a person's awareness. Occupied channels are used with fluidity and control: unoccupied channels are host to a range of disturbing processes of which the person typically feels a victim.

Mindell proposed a structure by which the therapist can perceive processes. He describes all those experiences, images, ideas, feelings, sensations, relationships, world events, with which a person identifies as 'primary processes', and all those with which she claims do not belong to her and are typically described as 'happening' to her as 'secondary processes'. For example, the major problem for change is said to lie in the conflict between the way in which a person identifies and does not identify herself. That conflict is said to be maintained by that person's system of value laden concepts about self and the world. In process work terms, that boundary between I and not I, the limits of that which is relatively known and what is unknown, is graphically termed the 'edge'. This loosely corresponds with the concept of resistance in psychotherapy, or that point where the person indicates, explicitly or implicitly, 'that, I cannot, or will not do!' In psychiatry, edges are usually huge. The distance between how the person describes themselves, and what is emerging is usually vast, the conflict most painful.

Both primary and secondary processes are only partly conscious. 'Consciousness' is a term which Mindell reserves for the process of reflective awareness, or the existence of a 'meta-communicator', one who can communicate about her experiences and perceptions.

Task of the process worker

In this short account, no adequate account of the theory or methodology of process work with acute states can be given. The general goal of the process worker is to understand and unravel processes. The initial aim is to determine the momentary process pattern, that is, how the client is identifying or not identifying herself, channels which are more or less occupied by awareness, and major edges to these processes.

The next stage is the confrontation of awareness with processes that are trying to unfold. A primary tool here is that of amplification, which refers to that process which strengthens and vivifies signals, thus assisting them to cross that person's threshold of awareness. Focusing on states enables them to 'ignite', and begin to unravel: they contain their own 'spark'. But when processes are amplified, the person usually comes to an edge. One then works on what value system is against the information trying to manifest, appreciates this, yet also tries to assist the person to integrate some of the emerging information into their life and identify with it. However, because of the often dangerous and even life threatening nature of these states, much care and patience is needed in creating sufficient containment, teaching skills with which to manage the states, and giving minute attention to the implications of change in that person's life.

Concepts of 'pathology' and altered states

There is no *a priori* concept of illness in the process work paradigm. Being 'sick' is a primary process opinion about a secondary process which is disturbing. Mindell has explored the diagnostic categories of psychiatry in terms of their typical process patterns, (Mindell, 1989) but he chooses to term disturbing experiences, 'Altered States of Consciousness' (ASC), that is, states which are altered from the way in which that person normally identifies themself. We all have them; for instance, a normally calm person finding themselves gripped by a rage, and momentarily unable to communicate about it. What distinguishes this type of everyday experience from acute states are the latter's duration over time, intense level of conflict between primary and secondary process, and their occurrence in channels in which that person has very little awareness, fluidity, or sense of control. Mindell describes psychosis as an 'extreme' state, where the person has literally no ability to meta-communicate about different aspects of her process, but simply 'flip-flops' from one to the other.

Art therapy

Process work has a number of radical implications for art therapy. Among these is that art making may be regarded as a potentially complex, multi-channelled process (McClelland, 1992). My own preference is for a wide range of tools for assisting processes to flow in channels in which they are momentarily presenting, without necessarily using art materials. But I will just as readily interweave them. Perhaps a couple of examples may best illustrate my orientation. As much of the disturbance and 'stuckness' of ASC is said to be due to their occurring in channels

which are unoccupied by awareness, an important way of assisting a person to complete and integrate a secondary process is to help her process the disturbing content in a channel in which she is more fluid. For example, a person who is experiencing a very disturbing feeling in an unoccupied proprioceptive channel could, if visually oriented, be invited to visualize and/or to make an image to represent the internal process.

Alternatively, imagine a person experiencing a panic attack as 'shaking inside'. Her proprioceptive channel is unoccupied, but she begins partly to change channels by making small movements while describing her inner experience. In order to amplify the secondary process expressed now in her movements I might offer materials such as clay, which could be sculpted by the movements, or finger paint to 'shake' with. If her movement channel is also very unoccupied, she may not try this, but I've frequently seen clients with strong edges to powerful, aggressive movement, enabled to channel and unravel these processes, when offered materials which offer enough resistance and containment. I am emphasizing that art making can engage movement, vision, feeling, the feedback from an externalized object, plus much more.

A developed awareness of channel occupation, from moment to moment, is vital. If a client has been exploring over her 'edge' in 'foreign' channels, and the current need is for increased control, to facilitate her in materials which may plunge her yet again into a largely unoccupied channel may not be at all useful.

While acknowledging issues of professional boundaries and length of training, to be truly client versus profession centred suggests that arts therapists of all disciplines need to consider how our current practice within various channels may be elaborated, and how our professions may interface to assist the flow of our client's 'current', without requiring her to adapt to, and swim in, ours.

Research model: collaborative inquiry

In beginning research, the most important decision one makes is the choice of research model. The best is one which is most philosophically and theoretically congruent with what is being researched, and best capable of registering it.

As initiating researcher, my choice was for collaborative research methodologies as described in Reason and Rowan (1981, 1988). The primary statement of these new models of scientific research is that valid social knowledge depends on the development among persons of a new politics based on a shared commitment to research their everyday lives together (Torbert, 1981). In these models, the 'subjects' of the research contribute not only to the activity that is being researched, but also to the creative thinking that generates research propositions, research designs and management, and draws conclusions from the research. So all concerned are both 'co-researchers' and 'co-subjects'.

Various approaches within the model emphasize different aspects of the collaborative process. I am currently implementing a combination of two models, action science (Torbert 1987, 1992), and experiential inquiry (Heron, 1988) which I will briefly describe.

Action science

My primary choice is for an action science approach. Developed by Bill Torbert, its principal aim is to create knowledge in action, and for action. The overall aim is to create self-reflective individuals and organizations, with the potential to transform self, society and scientific inquiry.

The model of action science begins from the assumption that research and action are inextricably intertwined in practice. Knowledge is gained *in* action and *for* action. The question of validity of social knowledge is how to develop genuinely well informed action versus a reflective science about action.

In order to develop action science, all participants in the action need to cultivate a complex, high-quality interpenetrating attention, the span of which embraces the translations back and forth among four major research modes of human experience:

> *Intuitive purpose,* or intention which is capable of assessing qualitatively issues most worthy of attention, which is capable of clarity in framing, and alive enough to possibilities of reframing if more vital issues emerge;

> *Theoretical strategies,* the conceptual frameworks pertinent to the inquiry, the sense we are making of all this;

> *Behavioural strategies,* methodologies which are fluid in the sense of using wide, multi-channelled modes of experiencing and action appropriately and with awareness; and

> *External effects,* or the feedback from others and the world as to the effects of our actions. The collection, analysis and feedback of this empirical data focuses on the degree of congruence/incongruence across the four qualities of experience.

Only a brief indication can be given here of the complexity of Torbert's ideas. However, he stresses that the *primary* medium of research is 'an attention capable of interpenetrating, of vivifying, and of apprehending simultaneously its own ongoing dynamics and the ongoing theorising, sensing, and external eventualizing' (Torbert, 1972). Only such an attention makes it possible to assess whether effects are congruent with purpose.

The above research modes are regarded as being in constant interplay, interacting with and affecting one another, and all persons concerned are both committed participants in the action and observers of the level of congruity between their collaboratively determined purposes, strategies, behaviours and their outcomes.

Experiential inquiry

The second approach, experiential inquiry, developed by John Heron, shares many of the dimensions of action science, such as kinds of knowing, and the maintenance of high-quality awareness of purpose. But, whereas action science emphasizes the development of reflection *at the point of action,* Heron's model emphasizes the phase of reflection *on* action.

The essence of co-operative experiential inquiry is 'an aware and self critical movement between experience and reflection which goes through several cycles as ideas, practice and experience are systematically honed and refined' (Heron, 1988).

Proponents of this method have developed a variety of practical structures, based on validity issues, for conducting cycles of inquiry. We refer the reader to Heron's examples of stages a co-operative inquiry needs to go through (Heron, 1988). For our project we employed in a very concrete way, five of his validity procedures.

Why process work, art therapy and co-operative inquiry together?

Many strands draw these three models together. I shall touch on just a few. A most important reason for choice of participatory, democratic models of inquiry was my belief, based on experience of doing process work with people experiencing radically ASC, that *they* must be considered most expert in their states, and our potential teachers. Most clients referred to me had experienced failure of methods which repressed their states, and were ready to try the opposite – exploring the nature and possible purpose of ASC. Participating as process worker, I experienced qualitative, vivifying, and emotionally moving experiences of radically ASC. The practice of process work and art therapy increasingly seemed as much a conjoint process of therapy *and* inquiry as we together entered into 'mapping', in images, movements, stories, and other multi-channelled descriptions, how ASC were manifesting themselves, unravelling themselves, forming and reforming patterns. To co-inquire seemed logical, empowering, and more valid.

This leads to a second strand. The tools of awareness which process work teaches clients correspond to some of the qualitative, fluid type of *multi-channelled awareness and behaviour* which is a prerequisite for action science. In the very moment of action, the client is invited to bring awareness into exactly how various states are expressing themselves, experience with awareness in that channel, notice and if possible communicate this. For example, a client may be asked, 'how, *exactly* are you experiencing that fear, really bring your awareness to the body-felt sense of it, is it a shaking, queasiness, or what? Could you make a small movement to represent it? Could you make an image so precise that I could begin to have that experience?' It will be clear that this process not only develops powers *which broaden* and *deepen* attention, but also *focus* attention. Process work has its own kind of inbuilt action science.

A most important strand is the role which the 'in the moment' attention to, and communication of perceptions around congruity or incongruity of purpose, strategy, behaviour and outcome may have in developing the role of the meta-observer and communicator, as these roles are described in process work. That is, the ability to develop a more all embracing awareness for both one's own communications, the interpersonal network in which one 'swims', and the ability to monitor constantly the effect of our behaviours.

Client to action scientist

In this cycle of inquiry, I wished to initiate as full a collaborative process as possible. Two clients I had formerly worked with, Pat and Ann, struck me as people who had developed considerable skills of awareness and reflection through their process work therapy, which had effected very constructive movement in their lives. When I invited them to co-inquire and to contribute to the writing of this chapter, they were interested. They wished the type of radically ASC which they had experienced to be *taken seriously*, which for them meant that to suppress the ASC, by whatever means, had not been effective for them. They both affirmed the eventual value which unravelling the meaning their states had for them. Further, they wished to contribute to improvement of professional practice in a process work mode. I must stress that at the time of the inquiry our formal therapy contract had ended but both people still experience, on occasions, radically ASC connected with eary traumatic experience which we shall describe.

Both Ann and Pat had been subjected to extensive and violent childhood sexual and physical abuse. Prior to their process work therapy, the lives of both had been completely disrupted by extremely disturbing ASC. Both were considered 'at risk'. Pat had made a number of suicide attempts, resulting in repeated hospitalizations, as she could no longer bear the distress and loss of competency occasioned by the states. Ann had come close to suicide. Pat was referred for process work after prolonged therapy failure. Ann was referred from the psychology department because she was communicating more by drawing than verbally, and behavioural approaches to her obsessional, agaraphobic and bulimic states were not proving effective.

Design

The requirements for the prospective action scientist are daunting, both in terms of personal development and associated research skills. Yet there was a sense that we could only learn, develop and hone these skills by launching into action. Paradoxically, the skills needed to start out are precisely those which engagement in the inquiry actually develop – a 'chicken/egg' situation.

We embarked on the research feeling competent enough to engage. The project as a whole was grounded in four years of fieldwork. We had developed various attentional skills, for example, locating the channel in which ASC were manifesting, focusing and amplifying those signals, changing channels in order to flesh out a process – all requiring rigorous discipline, both of feeling and thinking while in action.

For our first meeting, we agreed an overall goal of beginning to study Torbert's four dimensions of research. I also introduced Heron's structures for enhancing validity, and we recognized several dimensions that seemed to be most relevant to our situation. On the basis of these, we were to outline a research design plan.

Having arrived at an agreement about our purpose and issues we considered most valuable, we decided to test our hypothesis, that radically ASC, however awful, contain information that is vital to that person's development; that process

work and art therapy can assist their natural unfolding, and also contribute to their containment and management. We also wanted to explore why art therapy had been such a vital tool in processing Ann's ASC, while for Pat, art therapy had been peripheral. What method we might use to explore this was not clear, but I had an instinct that somehow Ann would come up with something.

We reviewed our personal understandings about process work, and then looked further at co-operative inquiry theory. We considered skills we'd need to develop, and problems that might arise. One example of the latter was Ann's dyslexia, and despite reassurances that her verbal and artistic fluency, coupled with excellent reflective capacities constituted research skill, we realised a need to find as varied ways as possible to record our experiences. The distress she experienced just then led into another important arena – that of roles which would be necessary to conduct the research.

With the possibility of radically ASC being stimulated by the research process itself, I would need to maintain my therapist role, but we could only find out, in action, how increasing skills in my co-researchers would affect the relatively clear cut therapist/client roles we'd previously inhabited. A role of research facilitator would have to be maintained. How doing process work and facilitating an inquiry process would go together was unknown. Presumably, all roles would need to become more conscious and fluid. Hypothetically, as we progressed, responsibility for maintaining these roles would be increasingly shared, as hierarchical models transformed to more collaborative ones.

We ended by anticipating the impact which our new actions might have in relation to our personal lives, other people and systems. One consideration was for Pat and Ann not to publish their actual Christian names. This seemed to be too disidentifying, yet at the same time presented various kinds of difficulties in terms of partners, close associates, colleagues, and actual abusers recognizing them. In terms of professional roles and responsibilites I had concerns as to what the implications could be for me in terms of implementing a democratic process in a hospital setting. We agreed to meet on another occasion to structure our inquiry more concretely.

As I have described, co-operative inquiry involves a number of discrete, coordinated steps. Heron has elaborated a number of interdependent procedures, whose effects, taken together, enhance the validity of the conclusions of a co-operative inquiry (Heron, 1988). Reason (1988) has suggested that an average of five to six procedures are usual in any one inquiry. For us, the following five appearing most relevant and useful.

Research cycling

This process involves the inquirers in moving or 'cycling' to and fro between experiencing and reflecting so that these two processes are in constant interaction with one another. Once the research cycling gets underway, it sets up a two-way positive and negative feedback loop, from ideas to experience, from experience to ideas.

We decided to meet together for six sessions of inquiry, of two and a half hours each, which together would form a complete cycle.

As the focus of this chapter is on beginning research, we considered that reporting on one session together with a consideration of how the data generated could structure further sessions, would give the reader an adequate grasp of our process of learning to collaborate. Also how the process of cycling, both within each session and overall, and of how we began to define important issues would emerge.

For our first meeting, we decided to work experientially with ASC, then reflect together on our action, and finally decide what future action would be needed. In this form of research cycling, some balance is also sought between collective and individual research cycling, for reasons of maximizing autonomy and the divergence of viewpoints. Such action would be likely to include individual reflection on the session, recorded using any mode, for example, logs, personal diaries or drawings; also experimentation with new concepts and behaviours which might emerge, feeding these back, prior to our next session.

Balance of divergence and convergence

Divergence refers to the process in which each inquirer explores a different aspect of the agreed area of inquiry, whereas convergence refers to a collective choice to explore the same aspect in the experiential phase.

At this point, we understood that validity would be enhanced by being divergent and 'loose' in order to get a multi-faceted view. Process workers and experiential researchers need to develop a high tolerance for ambiguity. At best, this process could yield a comprehensive system of inter-related parts: at worst, a disconnected, chaotic aggregate of information (Heron, 1988). In subsequent cycles, we would need to move towards convergence, shape up one aspect of our selected issue as a testable hypothesis and take it through at least two sessions of inquiry.

It was clear, from initial discussions, that each of us were interested in different aspects of process work, art therapy and their relations to ASC. Divergence would allow for us to follow our individual fascinations through at least three sessions to allow a collective 'burning issue' to shape up.

Balancing reflection and experience

Whereas we would be experimenting with ongoing reflection while in the expe-rience phase, validity is enhanced by striking an appropriate balance between experience and reflection. In Heron's ASC inquiry (Heron, 1988), experience and reflection phases were roughly equal. In terms of the radically ASC which we predicted would occur in our inquiry, the process of maintaining a balance of meta-communication that would avoid supersaturation with experience would need to be open to constant monitoring. In relation to practical time constraints, containment and processing of the states, and adequate recording, we decided to try one hour of experiential work, and one and a half hours of reflection. Again,

because of the difficulty we anticipated in retaining the ability to reflect in the ASC, VTR was considered an essential recording tool to assist our reflection.

Facilitation of expression of distress

The very process of inquiry into our human nature and interactions is likely to trigger defensiveness, fear and distress, which could contribute to distortion of the whole process of research. In our context, these issues could be magnified. Triggers could be my changing role in relation to Pat and Ann, exposing radically ASC for the first time in this group, possible restimulation of ASC in reflection periods which also utilize VTR review and loss of ability to meta-communicate in radically ASC.

Aspects of research process most likely to be affected could be management of research process and adequate recording of data, emotional and intellectual edges to reporting certain data, neglect of validity procedures e.g. failure to challenge due to fear of vulnerability, and consensus collusion due to unaware projections.

Authentic collaboration

At the outset the initiating inquirer researcher introduces prospective co-inquirers to both the research method and the areas of inquiry. If authentic initiation has taken place, co-inquirers will move towards ownership of the project in a passionately personal way. At first, it was necessary for me to maintain a high profile in facilitation of the group's work. Signs of increasingly authentic collaboration were indicated in my co-inquirers movement towards participative decision making. As a result of this, a desire to rotate the role of facilitator among ourselves came up for discussion. Taking increasing responsibility for management of research processes, including validity procedures will be a function of ongoing experience.

We are a new group who came together, to explore and share difficult, emotionally charged material. Various level and types of skills exist between us. Ann's longer experience of process work and ability to communicate her processes were rated highly by Pat; conversely, Ann felt extremely inferior to Pat's level of functioning 'in the world', and her academic achievements. In their feelings of inadequacy around these issues, they mirrored each other. These distressing feelings could sabotage full participation of all. In reflection phases we also need to be vigilant for over emphasis of academic skills to the detriment of alternative modes, for example, Ann's graphic fluency.

Members may need to make time, in a formal validity session, to process these issues of imbalance, for instance in educational skill, hierarchies, psychological barriers, use of verbal/non-verbal skills, and to ensure that these interactive dynamics receive adequate attention.

These were some of the major validity dimensions we chose in structuring our initial design. Other measures may be developed as need arises. In all, the undertaking seems an awesome task. In one way or another, we often feel that

the project resembles nothing so much as a hungry wolf, demanding constant feeding and threatening to devour us.

Cycle 1

At the start of this first cycle of inquiry, we agreed simply to meet and discover in action what strategy would emerge through which to explore our purpose. Nothing in the literature of new paradigm research methodology was really informative as to how the role of therapist and research facilitator might interact in our circumstances.

Pat arrived shortly after Ann, shivering and remarking that she felt uncharacteristically cold. Almost immediately, Ann challenged Pat very directly that Pat might be 'scared' rather than cold. Pat then admitted that on the way to the session, she had recognized herself going into an ASC. She had found herself feeling very scared and apprehensive, whereas she had formerly been very excited at the prospect of co-researching.

Figure 9.1 Ann's image

In the course of the session, Ann accessed several states which were foreign to how *she* customarily identified herself. Usually deferring to others, she found herself increasingly assertive. She took over all the art paper, and began to 'model' a free-flowing drawing style, depicting very graphically images of her experience

of rape and violence (Figure 9.1). As she drew, she spoke very directly to Pat of her own experiences of feeling 'not whole and different from other people'.

Observing the authority with which Ann began to work with Pat, and the strong relationship signals between the two, Sheila found herself experiencing a double conflict. The first, between her usual, very active role as process worker with both, and an instinct to 'stay out', to empower Ann, and to allow the delicate relationship process between the two to develop. Staying out, at that time, entailed Sheila paying close attention both to the signals of Ann and Pat, and also to her own. Sheila's second conflict was triggered by her feeling shocked by Ann's confronting Pat, both verbally and graphically, with material which Sheila knew would put Pat right on her edge to seeing and hearing explicit material. Sheila's primary style would have been to support and explore Pat's edges at this point, but she felt a strong impulse to trust these survivors of extremely traumatic experiences to somehow be most useful for one another in a way she could not. At this point, she did not intervene, and continued to observe outer and inner signals.

Ann then pushed art materials towards Pat, who, apparently reluctantly, took up the challenge. Pat had previously explained that she only ever drew 'from her head', believing that all drawings had to be pre-planned – her primary process. Somehow, Ann's modelling of *her* drawing process triggered an awareness in Pat:

> 'Ann did not seem to be drawing from her head. She sketched and moved over the paper in a way that did not seem pre-planned. This was a real breakthrough for me, as I believed that no one could draw without planning it first. I decided to have a go (Figure 9.2). I shut my head off and just went with how I felt. The pen seemed to be led from my chest. I did not know what I would draw, but found myself drawing a door. It is a door I recognized well. I drew with firm, decisive lines and at this stage seemed to be largely unaware that I was not alone.'

In process work terms, Pat had switched from one of her occupied channels, verbal/auditory, to proprioception and movement, which were less occupied by her awareness. Entering this 'new' channel, interacting with the visual image which emerged out of her spontaneous movement, she'd gone right over her edge, and begun to reaccess actual physical pain and hurt of the original assault, and associated distress. But almost concurrently, spatial aspects of the figures she had represented began to strike her.

> 'After the door, I drew a tiny figure (me) and a large figure (the father). I noticed that I had drawn his hands very large and claw like. I felt physically sick, but carried on drawing. I began to feel the hurt from the hands and scribbled them out very firmly. I actually felt the hands doing things to me that I hate. At the top of the paper, I drew two large figures of almost equal size. I was very, very careful to get them the same size. It was to represent me and him, and the equality I feel I am now looking for. When I noticed the figures were very close together I drew a large block of black to separate them. I scribbled red and black between the figures and felt it represented the anger

Figure 9.2 Pat's image

and pain. I now know that I would like the space between the figures to be a bit narrower but to maintain total lack of physical contact. I didn't put hands, because hands *hurt;* I wanted relationship, but no hands.'

At this point, Pat experienced, for the first time, the emotional and cognitive impact of the inequality in her daughter–father relationship. She became extremely distressed. Ann indicated to Sheila that she needed Sheila to come in. Moving between the two, Sheila noted Pat gazing, as if in a trance, at the image, and decided to amplify the process, suggesting that Pat *look* more intently and notice what happened.

Perhaps as a function of being relieved of so active a role, Ann now began to signal distress, drawing away from both Sheila and Pat, moving to the end of the room. Pat spontaneously got up and followed Ann, tentatively holding, and trying

to comfort her. Eventually Ann responded to Pat's touch, also speaking to her. Sheila simply felt into how *she* might best engage, and guessed that both were taking good care of one another's processes.

In a later review session, Ann said

'When she kept looking at the door, I wanted to draw myself hanging on it. She started my process up. I *felt* part of the abuse she was putting on paper. She could have been drawing my picture. We ran along the same path, we both stood in the same place, molested by somebody. I experienced a strong urge to add more horrific detail. I wanted to take the image over as mine, but I didn't want to be intrusive. I needed to meet her there on common ground. She's so intelligent. This is somewhere we could have met...'

In process work terms, could Ann be said to have reached an edge, to be really going for it, being 'intrusive' as a way of making real contact with Pat? Lacking a model for being constructively assertive, she went with her impulse not to hurt.

Later, Ann criticized Sheila for not being there enough as a therapist for her while she worked with Pat, as Ann had been fearful that she would do the 'wrong thing'. To make so few active interventions was, at that time, a source of considerable 'therapist guilt' for Sheila. But subsequent feedback from Ann on the positive side of 'non-intervention' is developing in Sheila much richer feelings around her struggles with role transition. She is studying in greater depth the nature of her intuitive responses, even when they run contrary to collective ethics.

Reflection on action

After this long and distressing session, we sat together to reflect on our action in terms of how this had met our original purpose. One aspect we explored was Pat's art therapy process. She expressed wonder that her experience of an unfamiliar drawing process had represented exactly how she felt, but had never been able to articulate, and that an entirely novel realization of the inequality of her daughter–father relationship had resulted. She reflected that: 'the equality and space in the upper section of the drawing is my blueprint for how I want the relationship to be. It is the contract that I would like to enter into with him, but this time, the terms will be mine.'

Our reflective focus, however, gradually dissolved, as Pat and Ann were gripped by varying degrees of shame and guilt at getting 'lost' in ASC, while, conversely, considering strategies they found helpful in maintaining a degree of awareness and control.

In the beginning stages of research, an issue can present itself very powerfully. In initial discussions there were constant references to the role and function of therapists. In this cycle, we were heading in one direction when suddenly another, highly charged, emotive issue; which Pat and Ann dubbed 'proper therapists', emerged forcefully. Their observations on this style were scathing, their reactions intensely angry. Both had, at times, felt damaged by- and very much at risk during previous therapy.

Reporting the data at this early stage, Sheila feels very vulnerable. It could sound like a 'splitting' mechanism, 'glorifying' the process work paradigm and a pitch against more traditional modes of counselling and psychotherapy, while neglecting their value. Yet not to communicate such a highly charged 'cross-current' would seem like gross distortion of data.

Major themes which emerged centred around inequality in relationships, failure of therapists to participate in ASC, and failure to communicate with ASC in appropriate modes. Bearing in mind that process workers explore what is being talked about in the past, in terms of how this dynamic might be operating in current interactions, we shall need to be alert to these tendencies. One example, to date, is that Ann has stated that Sheila, not being a victim of sexual abuse, can never 'fully *know*', nor appreciate the degree to which ASC render one out of control. The following is a summary of some of the 'unhappy' and 'unhelpful' experiences which for Ann and Pat constitute 'proper therapy'.

There was little sense of authentic, natural human contact. It was felt that these therapists were too invested in 'staying dry'. That they were unwilling to struggle with the task of being really touched emotionally – 'getting wet', that is, participating enough in the turbulence of ASC in order to understand them from within while maintaining sufficient awareness to meta-communicate. There was no sense that the proper therapist experienced, even momentarily, such states, resulting for Ann in the feeling of 'being like someone from outer space, a nut!'

In proper therapy, touch was 'severely circumscribed'. Pat and Ann had major edges around being touched, while at the same time desperately needing to be. Whereas the rationale for models of therapy which exclude touch as, variously, risking invasiveness, extreme dependency, regression, or even erotic involvement, can be appreciated, they might take account also of the following, quite typical, response: 'she put the table between us. I needed her to touch me more than anything else. I felt she really thought I was dirty, untouchable'.

Both co-researchers reacted angrily to what they perceived as fundamental inequality concerned with lack of empowerment in previous therapeutic relationships: 'proper therapists know it all, you are just the patient and a different class of being. They form opinions about you, but never tell you'. Pat criticized Sheila for excluding *her* from discussion with a co-therapist at the time of her therapy, as she concluded from this that something was really seriously wrong with her that had to be hidden.

A major contention was the predominantly verbal, interpretive style of therapy, which was deemed pretty useless with intensely ASC. Being asked 'tell me about it' might not even be heard by a client immersed in an intense visual hallucination! Lacking the presence of a communicator who, in this case, could establish instant contact by visualizing with that client, or otherwise pick up cues in, for example, posture, movement, proprioception, and bring awareness into signals by mirroring, moving with, or offering art materials congruent with the channel in which the ASC is momentarily expressing itself as a possible mode of expression.

Protracted silences, resulting from inability to connect in the language of the ASC provoked feelings of anger and helplessness, often constellating one of the core relationship patterns of some victims of abuse – fulfilling the expectations of others. 'You don't know what is expected of you; you try to work out and do what they want you to do.'

Both Ann and Pat were emphatic that the only useful interventions with their acutely ASC was to go right into them. Pharmacology, whilst being useful to Pat had produced many side effects, one of which was that she was unable to cry when medicated. Ann described the energy of her ASC as impossible to overcome, 'the normal thing that happens to me, difficult, dangerous, but also nature's way of easing my mind.' Yet many therapists were perceived to be either 'freaked out by' or incompetent to deal with ASC. Conversely, those who engaged with ASC at anything other than a palliative level, without appropriate sensori-grounded tools, were considered dangerous: 'she [a previous therapist] used to bring up feelings inside me, and cut them short: I didn't know where I was, and she didn't either. Sometimes I didn't know how I got home. She was lucky I didn't kill myself.'

These reflections raise many interesting research questions. An immediate issue is what to do with such information. What might it mean? Is it an artifact peculiar to this cycle or series of cycles, concerning we three specifically? One tendency for those who would research in a 'chaotic' world may be to over-invest in such an issue, and pre-empt in order to establish some kind of anchor. In this case, the research may be directed, coloured by and constrained in these terms.

Prospective action scientists and process workers strive to remain open to engaging with the unknown, rather than reaching for apparent structure. One option around an issue which is demanding attention would be to 'hold it lightly' in order to continue to explore. We might say 'well, here is this interesting, if explosive, issue: let's just hang out with it and see where it might fit in.' It may then re-emerge, find new forms, elaborate itself enough to form a more inclusive pattern of information, or it may simply be an artefact of this particular cycle.

This process indicates how issues which are centrally important for us may be arrived at, and subsequently shaped up into testable hypotheses. If this issue re-emerges as a recurrent, meaningful pattern, we would have a choice as to whether to recycle it into further cycles, or to reach agreement that this is not what we wish to focus on, and why.

At this point we cannot predict. Some questions we have are whether our inquiry, biased or otherwise, may help in identifying less and more appropriate styles of engaging in radically ASC. Process work stresses that the most creative solutions emerge out of representing as many polarizations of parts in the field as possible, and enable them to express themselves fully. One possible strategy might be to reform our inquiry group to include therapists from other models to represent their responses, failing this, to use our small group to represent and process the roles in question. Let us see...

Video tape recording

As we had predicted, we had encountered difficulties with how to both reflect in action and record inner processes adequately while in the midst of radically ASC. We subsequently decided to use the VTR of our first cycle as a reaccessing tool with which to explore our difficulties.

Pat and Sheila opted for viewing a five minute 'loaded' sequence where Pat was in a very ASC, with Sheila acting as facilitator/therapist. Pat did reaccess that ASC, and found the circumscribed time limit helpful in maintaining a measure of ability to meta-communicate about her process. However, it took a further hour to process her responses.

By contrast, Ann opted to view the entire VTR. As in our sequence of reflection on action, issues of role transition emerged, those of the client/researcher/therapist. However, the most interesting aspect was Ann's achievment of an entirely new perspective on her process parts.

On initial viewing, Ann was highly critical in viewing her secondary 'vulnerable' part from a polarized position of her 'strong' identity. Seeing herself in an ASC, triggered by Pat's image of the bolted door, she criticized this part: 'I didn't realize I was so vulnerable. My control is gone... awful, awful! Now I'm together, I can't think how a picture of a door could do that to me.' But gradually she began to move to a third position, one more of the 'fair observer', a meta-communicator who could reflect on both parts and their interactions, and draw inferences from this.She said: 'Viewing is *painful*.. I only see myself as a strong person. Then on tape, also a person with little control.. it shows me a side that is missing... I should nurture that side more, the vulnerable bit.' Elaborating further, she said: 'I see, hear myself being that strong person, struggling to keep it. *It's an extreme!* Until I saw it, I didn't realize how I switched: one minute that upset, the next, as right as rain! It isn't normal. The parts need to interlock, to shake hands with one another!'

Torbert (1992) refers to this type of shift in knowing in terms of levels of development. As we move through the levels, we no longer totally identify with former patterns of being, although we may still have access to them. The process worker would speak also of a new pattern for behaviour emerging as a result of development of meta-communicative ability, awareness being brought into both poles of her personality, the primary strength, and the secondary vulnerability.

Summary on use of validity procedures and major themes

Even at this early stage there is considerable internalization by all of the group of the concepts and procedures involved, and increasingly shared responsibility for their management.

Cycling – balance of action and reflection

Finding an appropriate balance between experience and reflection needs to be very process specific. Our group was newly formed and plunged immediately into sharing altered states, therefore, the balance between action and reflection needed

to be dictated by these states. It was felt that as the ability to maintain awareness in action improves any imbalance will be redressed.

Reflection was felt to be critical for any forward movement, it also generated much learning and a feeling of engagement with one another. VTR was invaluable in assisting the reflective process and relieved some of the stress of trying to remember whilst in action as well as providing a permanent record of our sessions.

Sheila felt that Ann and Pat's ability to communicate while in action was rather depressed in cycle 1 and some of the continuing work has been to develop this skill further.

We were surprised at the high level of individual research which occurred subsequent to the cycling. Both Pat and Ann were able to continue in the 'research mode' between sessions, Ann by way of her fluent graphic material and verbal reports and Pat, uncharacteristically, by drawing (Figure 9.3), in which she takes over the energy of the 'spiky hands' that hurt, as a way of dealing with the relationship issue concerned.

Figure 9.3 The 'spiky' hands

The way in which data from these sessions will inform the next can be either explicit, or implicit. At this stage, we shall not deliberately focus on specific themes.

Figure 9.4 Practicing outgoing relationships

Figure 9.5 Trapped in an ASC

Divergence/convergence

On reviewing our primary purpose which was to reaccess ASC, assess their effectiveness and use process work tools in order to deal with them, we were extremely divergent. Many issues arose and our individual fascinations led us into various directions at times; however, we were able to share these experiences while still keeping an open mind about the project as a whole.

The secondary issue which arose for us, specifically that of the therapeutic style, was dealt with rather more convergently. Currently, we are holding this issue 'lightly' to see how it might fit into our total pattern. It may become more important than our original purpose and therefore we will need to change direction. This is an example of how the initiating researcher has to constantly be open to reconstrue the original goal.

Divergence could be seen as tantamount to chaos, but process work teaches that, whatever the chaos, a process pattern will eventually emerge.

As we have previously mentioned, in these early stages it is not yet clear how, or on what, we will eventually converge.

Facilitation of distress

This issue touches on the interface between the therapist and the researcher roles. One of the major difficulties we encountered was that Ann and Pat, at various times, experienced flooding of emotions, distress and anger coupled with either a refusal or an inability to use process work interventions at that time. This, alongside the need to record, report and remember important data whilst at the same time taking sufficient care of one another was, in the initial stages, extremely demanding for Sheila. Ann used imagery both to 'practice being more outgoing' (Figure 9.4), and to meta-communicate whilst gripped by an ASC (Figure 9.5). Collectively, our feelings are that we have managed reasonably well in this area.

Experimenting with the role of 'therapist' was new to both Ann and Pat and risky for Sheila. However, the empowerment that this engendered made the risk most worthwhile.

Authentic collaboration – falsification

A large percentage of this chapter has been written collaboratively and sceptics may question its authenticity in terms of the perceived power of the therapist's influence on decision making. We are all aware of this and will continue to concern ourselves with issues of falsification. Indeed, the biggest problem could be for Sheila, as both Ann and Pat have taken such a major role in the research to date.

We are aware that our investment in process work is due to appreciating the effectiveness we perceive it has. Also our gratitude for getting to grips with life threatening states will inevitably colour our perceptions. We will continue to be aware of this.

We have come to value one another's unique contribution to the research project. Whether it is manning the VTR, drawing, talking, challenging or experiencing an ASC, we try to keep constant awareness of each other's personal

vulnerability and take account of this while at the same time taking care not to invalidate any of the data.

Major research themes

Our inquiry, to date, is characterized by ambivalence. Meeting together, relationship issues are emerging as a focus. Our group plunged precipitously into direct confrontations, and exploration of highly charged material without a period of coming to know one another in our primary identities. Yet fear of premature challenge and risk of rejection if radically ASC are 'exposed', seems balanced for Ann and Pat by a sense of shared experience and less denial of the pain, stigma and degradation resulting from early trauma.

In research the research process, increased distress in relation to more rigorous, challenging styles of inquiry into ASC is tempered by increasing ability to meta-communicate whilst in these states, with attendant experiences of increased control and understanding. VTR review is an important vehicle for increasing our perceptual range for 'far out' states, and their eventual integration.

In relation to role transitions – client/therapist/research facilitator, we are experiencing, variously, a mixture of insecurity and excitement. Loss of exclusive therapist–client relationship and anxiety around trying out new skills, balanced by feelings of empowerment and ownership. Although therapeutic skill *is* used directly, whenever needed, the role may, initially, appear weakened. Yet without experimentation at the therapist–research facilitator interface, development of a collaborative versus hierarchical model, and the use of power to create structures which encourage increasing autonomy cannot occur.

We worked towards building a solid 'foundation stone' which might 'underpin' both this and other research projects. We hope that our bias towards process work in conjunction with art therapy, for facilitating therapeutic movement in acute states, and our early stage in operating validity procedures, has not unduly distorted our inquiry. We also hope that any tendencies to consensus collusion may be outweighed by our account of experiences of, and struggles with, inquiry into acute states, and that these will stimulate other professionals to implement research projects that will engage and empower all concerned.

We also have an instinct that this type of research process, in conjunction with the process work model, could be a useful model for therapy with radically ASC.

References

American Psychiatric Association, (1987) *Diagnostic and Statistical Manual of Mental Disorders,* Third Edition, Revised. Washington D.C.: American Psychiatric Association.

Bateson, G. (1973) *Steps to an Ecology of Mind.* London: Paladin.

Cunningham, H. (1988) 'Interactive holisitic research: Researching self managed learning', in P. Reason *Human Inquiry in Action: Developments in New Paradigm Research.* London: Sage Publications.

Heron, J. (1981) 'Experiential research methodology', in P. Reason and J. Rowan (eds) *Human Inquiry: A Sourcebook of New Paradigm Research.* London: John Wiley and Sons.

Heron, J. (1988) 'Validity in co-operative inquiry', in P. Reason (ed) *Human Inquiry in Action.* London: Sage Publications.

Kelly, G.A. (1955) *The Psychology of Personal Constructs Vols 1 & 2.* New York: W.W. Norton.

McClelland, S. (1992) 'Brief art therapy in acute states: A process-oriented approach', in D. Waller and A. Gilroy (eds) *Art Therapy: A Handbook.* Buckingham: Open University Press.

Mindell, A. (1982) *The Dreambody.* Boston: Sigo Press.

Mindell, A. (1985) *Rivers Way: The Process Science of the Deambody.* London: Routledge.

Mindell, A. (1988) *City Shadows: Psychological Interventions in Psychiatry.* London: Routledge.

Reason, P. and Rowan, J. (eds) (1981) *Human Inquiry: A Sourcebook of New Paradigm Research.* Chichester: John Wiley and Sons.

Reason, P. (ed.) (1988) *Human Inquiry in Action: Developments in New Paradigm Research.* London: Sage Publications.

Torbert, W. (1972) *Learning From Experience: Towards Consciousness.* Columbia University Press.

Torbert, W. (1981) 'Empirical, behavioural, theoretical and attentional skills necessary for collaborative inquiry', in P. Reason and J. Rowan (eds) *Human Inquiry: A Sourcebook of New Paradigm Research.* Chichester: John Wiley and Sons.

Torbert, W. (1987) *Managing the Corporate Dream: Restructuring for Long-term Success.* Illinois: Homewood.

Torbert, W. (1992) *The Power of Balance: Transforming Self, Society, and Scientific Inquiry.* London: Sage Publications.

Research as an Act of Creation

Bonnie Meekums

In this chapter, I hope to draw some parallels between the creative process, with particular reference to dance, and that of research. I shall illustrate my ideas with reference to the process involved in a piece of research (Meekums, 1990, 1991) concerning dance movement therapy and the development of mother–child interaction, which made use of illuminative evaluation methodology (Parlett, 1974, 1981; Parlett and Deardon, 1977).

The nature of the creative process

The creative process requires that we find a place in which internal and external reality can interact, to form new gestalts. That place is what Winnicott (1971) referred to as the 'potential space'. In this space, time does not exist as we normally experience it. Dreams, memories and fantasies co-exist; all are present, here and now. The boundaries of the self become permeable as realities mix and merge.

Activity and rest

The dancer Mary Fulkerson takes stillness as her starting point for creative exploration (Fulkerson, 1982). She emphasises the necessity of a receptive attitude of allowing and acceptance in this exploration, and describes stillness as 'a feeling of oneness with the environment', in which she is aware of a presence which she likens to an anchor or a still pool (Fulkerson, 1987, p.20).

Such a notion is both reminiscent of the mystical union with God described by meditators and others for whom inner stillness is a route, and at the same time echos the early union between a mother and her infant, a state of merging described by Winnicott (1965, p. 45) and others. It is as if Fulkerson is describing the moments in between interactions, the quiet times of rest and self-containment, which Winnicott refers to as the state of 'being alone'. The paradox which Winnicott describes is that, whilst alone and in a state of stillness, there is always a (symbolic) presence, and in this state the individual's boundaries become merged with that of the presence.

Milner (1952) proposes that such a merging of boundaries is part of healthy infancy to which the adult can return through aesthetic experience, providing an opportunity to recapitulate the development of object relationships.

Stillness is not a static state, but part of a continuum which includes activity and rest. It is possible to be centred in an attitude of stillness whilst actually moving. The poet T.S. Eliot expresses this point eloquently in his poem 'Burnt Norton': 'At the still point of the turning world...there the dance is,/ But neither arrest nor movement. And do not call it fixity,/ Where past and future are gathered' (Eliot, 1936, p.187).

The rhythmic alternation of the organism between activity and rest has been described both by writers on mother–child interaction (Brazelton *et al.*, 1974; Kestenberg and Sossin, 1979; Stern, 1977) and amongst others a visual artist (May, 1976) and a physicist (Capra, 1975). The dancer Mary Fulkerson describes her use of mental imagery, which exemplifies the process: 'First I see it... Then I think it... Then I forget it... Then it happens' (Fulkerson, 1977, p.94).

All of these writers suggest that it is at the interface of action and stillness that insights and inspirations occur. The idea that creative inspiration often occurs during periods of rest is well documented in the literature on creativity (see, for example, Boden, 1990; Koestler, 1975; Tardif and Sternberg, 1988).

Capra likens the moment of inspiration to the Buddhist concept that the individual's original nature is that of the enlightened Buddha, temporarily forgotten; in the moment of creativity, one's Buddha nature is re-contacted. Of course, such a notion is untestable except in the quality of insights that occur during the process. The central theme, however, apparently described by theorists of several disciplines, is the existence of a dialogue between outward activity and inner stillness. This dialogue appears to be associated both with human interaction and creativity. The paradox lies in that it is in the moments of rest from outward striving and interaction, that the greatest insights, and the greatest feelings of oneness with the universe seem to occur (Fulkerson, 1987; Capra, 1976). Yet, both action and stillness are necessary within a rhythmic framework. Such a notion of rhythmic change between action and receptivity, and the possibility of finding stillness within movement as well as movement within stillness (Fulkerson, 1982; Paxton, 1977), is reminiscent of the description of the Eastern concept of Yin and Yang by Stiskin (1971).

The act of creation incorporates a state of stillness during which insights occur, and which is usually preceded and followed by a state of striving and action. There are some apparent exceptions to this: the dominican scholar Matthew Fox claims that 'To create is always to learn, to begin over, to begin at zero' (Fox, 1983, p.198), which seems to imply that creativity emerges from a void. Picasso once declared 'Je ne cherche pas, je trouve' (quoted in Boden, 1990, p.17). But such claims are untestable. Perhaps the discipline of daily painting was enough prior striving in Picasso's case to allow creativity to flow. The nature of the creative stillness appears to imply a readiness to act. It is not a state of cutting off, but of active receptivity. As one Zen teacher has put it: 'To stop your mind does not

mean to stop the activities of the mind. It means your mind pervades your whole body' (Suzuki, 1973, p.41).

The spiralic process of forming

Boden (1990) expands the notion of activity and rest in the creative process, by referring to Poincaré's four phases of creativity, which were later re-named by Hadamard as preparation, incubation, illumination and verification.

Preparation is the initial stage of striving, which often appears unsuccessful and frustrating. This stage will, for the purposes of this essay, be renamed 'striving'.

During incubation, which may last for minutes or months, the mind is focused elsewhere, but ideas are being combined with a freedom not associated with rational thought.

Illumination refers to the flash of insight, which has the quality of surprise, despite the unconscious work which has been carried out during the incubation period.

Verification, or evaluation, is the stage during which these insights are brought back into the realm of conscious striving. Modifications to the original insight are often made as a result of verification.

To create a dance, whatever the starting point, it is necessary to shape the ideas into a coherent form. Choreography requires some decision–making about the beginning and the end, about points of change and relationship within the piece. Hence, the striving does not stop when insights first occur. The substance from which the dance emerges is a product of the dancer and choreographer's improvisations, their openness and receptivity as they play with images and ideas, the limitations of their bodies including their flexibility and their expanding movement vocabulary, the style of the choreographer and the choreographer's willingness to subtly play with conscious, active decision-making whilst remaining open to possibilities.

The importance of form in the creative process is summed up by Starlady Sandra in Fay Weldon's novel, *Leader of the Band*: 'Get the *form* right, grasp the whole before the detail, and then it will surely add up to more than the sum of its parts...*form* is all: just a pity it needs something to work upon' (Weldon, 1988, pp.9-10, original emphasis).

I propose that Poincaré's four stages are in fact stages in a spiralic process of striving, incubating, illuminating and verification. With each turn of the spiral, the form becomes clearer, until the creator is satisfied with a final product. The initial goal, as Boden (1990) has pointed out, may simply be one of exploration. Each turn of the spiral will clarify or change that goal.

Thus, as a choreographer, I may decide that I wish to make a dance which is a statement about relationships. I strive by setting various choreographic exercises for my dancers, thinking about the piece I am about to make and so on. Then, as I let go and watch the dancers in action (incubating), I see a beautiful image which happens before my eyes, and which I could not have consciously thought of. The

illumination of this moment is exciting, I automatically verify it with my plan for the shape of my choreography, and continue the striving, perhaps changing the dancers' orientation to each other or to the audience, playing with the order of movements and adding in slight touches of my own. Later, while the day's work is incubating underneath my consciousness, and I am cooking the supper, I may see an image before my eyes, which I decide to try out the next day. The spiralic process is essentially one of growth and formation.

Research as a creative process

Rowan and Reason (1981) suggest that the new paradigm researcher needs to aquire a paradoxical awareness: 'To try to learn it is to try to give-up-trying; to concentrate on it is to concentrate on non-concentrating; to grasp it is to let it go' (Rowan and Reason, 1981, p.122). Such a statement echoes Mary Fulkerson's motto of 'First I see it... Then I think it... Then I forget it... Then it happens' (Fulkerson, 1977, p.94), which is discussed above.

Illuminative evaluation and the spiralic process

In the literature on new paradigm research, one author has identified a process which loosely resembles Poincaré's model. Parlett's 'illuminative evaluation' (Parlett, 1974, 1981; Parlett and Deardon, 1977) conforms also to the notion of creativity as exploration. The precise research question may not be formed at the outset. As outlined elsewhere in this volume (Meekums and Payne), Parlett identifies five stages in the process of illuminative evaluation, which are: setting up, open ended exploration, focused enquiries, interpretation and the report.

The stage of setting up appears to correspond to Poincaré's initial stage of striving. There is an initial idea which triggers the exploration, and some decisions are made about how to proceed.

Parlett's next stage implies incubation, although it also incorporates elements of striving. A literature review would form part of this stage.

The stage of focused enquiries implies that something else has happened as a result of the open ended exploration. I am suggesting that this something else is the combined effect of illumination and verification, which, if the spiralic model proposed above is true, will lead to a second stage of exploration. The process of striving, incubation, illumination and verification will occur as many times as is necessary in order to refine the form.

The final form of a piece of research is the report, but before this is possible the researcher must interpret the findings (more striving, incubation, illumination and verification) and check data against existing information, including the literature.

I am therefore proposing that research, when it is seen as a creative act, follows a spiralic process, similar to that proposed by Parlett as a methodology, but incorporating the processes of striving, incubation, illumination and verification on each turn of the spiral. This model bears some similarity to the research cycle proposed by Rowan (1981), although it was independently developed.

Case illustration

Before the researcher can begin setting up a piece of research, he or she must first have an idea for a research project. This idea may in itself constitute an illumination following striving and incubation. I knew that I wanted to do a piece of research for many years before my M.Phil topic came along. I had played with ideas, none of which seemed successful, and then one day, having just started a new job, the idea came to me that I should study the development of mother–child interaction during a dance movement therapy (DMT) programme, using data from my job.

Having decided the general topic, and verified through a literature search that this was not a carbon copy of some-one else's study, but a worthwhile avenue of enquiry, I began a new stage of striving, the setting up of the project. For me, this meant arranging my initial fieldwork. I contacted nurseries, decided on two locations in which to hold mother–toddler DMT groups, devised a referral form, sought referrals and devised an instrument for the initial interview of mothers, which was designed to give the mother's perception of her relationship with the child. I also began to plan how I would run the sessions, and devised ongoing recording methods including videotaping and written records from participant-observation. I decided I would use information from informal conversations with referrers and nursery staff to give an extra dimension to the picture of mother–child interaction for each dyad.

Each decision throughout my research was the result of a painstaking process of striving, incubation, illumination and verification. Not that any of my illuminations were of the order of Kekulé's, when he realised that his dozing vision of a snake eating its own tail held the clue to the structure of the Benzene molecule (Boden, 1990). These were little illuminations, the result of a preoccupation with my work which would not leave my subconscious even when I was engaged in other activities. Sadly, I did not know then that I would become interested in research as a creative process, and I had not identified my model of spiralic forming adapted from Poincaré. I have no records of these illuminations, only of the product of their verification. But I do remember that I did, during my research, examine the data, get up and make a hot drink, write, have a bath, read, go to sleep, do other work – not all in that order, but as and when the other demands of my life dictated. I would frequently find that, after a long period of striving, it was as if the 'after image' of sensori-motor activity was left in my brain, so that ideas would come at grossly inconvenient times including in the bath or at 3 am, and I would be forced to get up and jot down a few notes, to be incorporated into my writing when I next had the opportunity. Thus, I was constantly evaluating what I had done, constantly incorporating new material, making associations and connections, asking new questions, clarifying the form of my research as if I were approaching a figure slowly from a distance, mists ever forming and clearing before my eyes as I did so.

Having set up my research, I began the open ended exploration about which Parlett writes. For me, this meant that I continued to read the literature,

conducted the interviews, looked at the video recordings, recorded the sessions and talked to other workers involved with each family. As a result, I compiled case histories for each dyad. I strived, I watched and waited, new ideas emerged as I examined the data, and I was able to make recommendations for more focused enquiries. These included recommendations about the actual nature of the therapy offered, methodological recommendations and clarification of the research questions. For example, it was decided that twenty sessions would be the best length for a DMT group with this population, as one of the groups in the open ended exploration had run for nine sessions, and there had been very little shift in the mother–child interaction of dyads from that group. The other group had run for twenty-six sessions, there had been some definite shifts, but this process appeared to be completed by about session twenty. Methodological recommendations included the development of a movement observation instrument, and amongst the more focused research questions emerged this one: what constitutes an appropriate referral for DMT with mothers and young children at risk of abuse?

Thus, the focused enquiries began. The fieldwork for this stage was centred on a twenty session DMT group. Refinements to the movement observation instrument were plentiful; there were nine versions of the instrument in all. Again, the process of striving, incubation, illumination and verification was central to this forming process.

Eventually, I arrived at the stage when I began to interpret the results. This was a very exciting stage. The picture of that figure through the mist began to emerge more clearly, as I saw that the mother–child dyads who developed most positively in the DMT group were those who came from families in which the mother functioned more or less well with other children; in other words, when there was a specific failure in the bonding process for that mother and the child who accompanied her in the DMT group. This 'illumination' came as a result of many little illuminations, many little glimpses of the picture, and inevitably raised more questions as I verified my findings in the literature: was there something special about DMT, which had to do with recapitulating very early experiences? If so, what was this something special? We know that moulding (Dulicai, 1977) and rhythmic synchrony (Schaffer, 1977) are important in the bonding process, and these are often elements used in DMT.

I can recall a point in writing the report (Meekums, 1990) when I wanted to stop, I felt overwhelmed with the enormity of it all. This was very near to the end, and I was reminded of the stage in childbirth called 'transition', between the long slow build-up of labour and giving birth (Beels, 1978). Transition can be seen as a moment of anxiety before separation and is qualitatively different from the frustration of the early striving period.

Finally, and partly because I had agreed a deadline with the university, I had to settle on a form to my written thesis. There was always a sense that more could be done. It could be argued that a creative act, no matter how magnificent, is always a potential, and to this end the researcher poses recommendations for

future research. Choreographers may not do the same, but students of dance will study their work and build upon it. No two people look at a piece of dance or read a piece of literature and see it in precisely the same way. And so the creative process repeats.

Summary

In this chapter, I have suggested that research can be viewed as a creative process. I have discussed some of the characteristics of that process, including: the spiralic process of striving, incubation, illumination and verification in the growth and formation of work, and the stage of transition before the final form is reached. The importance of an attitude of active receptivity in the facilitation of insights was emphasised.

References

Beels, C. (1978) *The Childbirth Book.* London: Turnstone.

Boden, M. (1990) *The Creative Mind: Myths and Mechanisms.* London: Weidenfield and Nicolson.

Brazelton, T., Koslowski, B. and Main, M. (1974) 'The origins of reciprocity: the early mother-infant interaction', Chapter 3 in M. Lewis. and L.Rosenblum. (eds), *The Effect of the Infant on its Caregiver.* New York: Wiley-Interscience.

Capra, F. (1976) *The Tao of Physics.* London: Fontana.

Dulicai, D. (1977) 'Nonverbal assessment of family systems: a preliminary study'. *Art Psychotherapy*, 4, 55–68.

Eliot, T.S. (1937) *Collected Poems.* London: Faber and Faber.

Fox, M. (1983) *Original Blessing.* Santa Fe: Bear and Co..

Fulkerson, M. (1977) 'Language of the axis'. *Dartington Theatre Papers*, 1st series nos 12A–12C.

Fulkerson, M. (1982) 'The move to stillness'. *Dartington Theatre Papers*, 4th series, no 10.

Fulkerson, M. (1987) 'Interview with Peter Hulton and Richard Allsopp'. *New Dance*, 40, pp20–21.

Kestenberg, J. and Sossin, M. (1979) *The Role of Movement Patterns in Development*, 2. New York: Dance Notation Bureau.

Koestler, A. (1975) *The Act of Creation.* London: Picador.

May, R. (1976) *The Courage to Create.* London: Collins.

Meekums, B. (1990) 'Dance movement therapy and the development of mother-child interaction'. Unpublished M.Phil thesis, University of Manchester.

Meekums, B. (1991) 'Dance/movement therapy with mothers and young children at risk of abuse', *The Arts in Psychotherapy*, 18, 3, 223–230.

Milner, M. (1952) 'Aspects of symbolism in the comprehension of the not-self'. *International Journal of Psychoanalysis*, 33, 181–195.

Parlett, M. (1974) 'The new evaluation' in *Trends in education, 34, Innovative issues* London, HMSO/DES.

Parlett, M. (1981) 'Illuminative evaluation', in P. Reason. and J. Rowan. (eds), *Human Inquiry, a Sourcebook of New Paradigm Research.* Chichester: John Wiley.

Parlett, M. and Deardon, G. (eds) (1977) *Introduction to Illuminative Evaluation: Studies in Higher Education.* California: Pacific Sounding Press.

Paxton, S. (1977) 'In the midst of standing still something else is occurring and the name for that is the small dance'. *Dartington Theatre Papers,* 1st series, no 4.

Rowan, J. (1981) 'A dialectical paradigm for research', in P. Reason and J. Rowan (eds), *Human Inquiry, a Sourcebook of New Paradigm Research.* Chichester: John Wiley.

Rowan, J. and Reason, P. (1981) 'On making sense', in P. Reason. and J. Rowan (eds), *Human Inquiry, a Sourcebook of New Paradigm Research.* Chichester: John Wiley.

Schaffer, R. (1977) *Mothering.* London: Open books.

Stern, D., (1977) *The First Relationship: Infant and Mother.* London: Open Books.

Stiskin, N. (1971) *The Looking Glass God.* Kyoto: Autumn Press.

Suzuki, S. (1973) *Zen Mind, Beginner's Mind.* New York: Weatherhill.

Tardif, T.W. and Sternberg, R. (1988) 'What do we know about creativity?', in R. Sternberg. (ed), *The Nature of Creativity.* Cambridge: Cambridge University Press.

Weldon, F. (1988) *Leader of the Band.* London: Hodder and Stoughton.

Winnicott, D.W. (1965) *The Maturational Processes and the Facilitating Environment.* London: Hogarth Press.

Winnicott, D.W. (1971) *Playing and Reality.* London: Penguin.

CHAPTER 11

Movement Assessment in Schizophrenia

Laurence Higgens

Introduction

Movement assessment, the observation and analysis of the qualitative aspects of an individual's everyday movement patterns, has long been recognized as an indicator of personality, as unique to the individual as fingerprints and genetic coding (Allport and Vernon, 1933; Plutchik, 1954). Although movement assessment is widely used clinically by dance movement therapists to identify psychological dysfunction and to guide therapeutic intervention, little is known of this work outside the profession and few multidisciplinary studies have applied this expertise in psychiatry or psychotherapy.

This pilot study was inspired by a real clinical problem, that of attempting to understand and help deaf patients referred for inpatient psychiatric care. It set out to investigate the hypothesis that movement assessment has the potential to contribute to the differential diagnosis of schizophrenia, particularly with prelingually deaf patients. In this study, diagnostic predictions based on movement assessment data alone are compared with psychiatric diagnoses made by an experienced medical team.

The literature review argues that movement disorders are one of the few consistent, visible indicators of the schizophrenic condition, and that whilst research into involuntary movement disorders and movement task performance have identified dysfunctions in schizophrenia these have not proved to be diagnostically specific. An approach based on the qualitative aspects of voluntary movement is proposed. This is introduced by a review of studies linking expressive movement with emotional conflict, from the perspectives of muscular tension, psychoanalysis, non-verbal communication and Laban Movement Analysis.

Literature review

The problem

The psychiatric diagnosis of schizophrenia in prelingually deaf persons combines three of the most controversial and intractable problems facing modern medicine:

the uncertain validity and reliability of psychiatric diagnosis in general, our incomplete and fragmented understanding of schizophrenia and the difficulties associated with the psychiatric diagnosis of prelingually deaf patients.

A psychiatric research conference reported '... concordance among the numerous existing psychiatric diagnostic systems is frequently little better than random suggesting that many systems either have limited validity or limited reliability' (Kraemer et al., 1987, p.1101). Even inter-rater reliability within the various systems show wide variations (Brockington, 1986). Recent reports suggest there is still nearly a 1 in 4 chance of being wrongly diagnosed with schizophrenia (Pulver et al., 1988).

The difficulty in achieving concordance between diagnoses made by different observers at different sites reflects the diversity of conceptions concerning the nature of schizophrenia. At the heart of the discord is a fragmentation between the various scientific specialisms which mirrors schizophrenia itself (Scheflen, 1981). The long history of the division between neurological and psychological paradigms in relation to movement disorders associated with schizophrenia has been documented (Rogers, 1985). There is a growing realization that the old distinctions between functional and organic illness are no longer valid, and that the medical model is an inadequate conceptual framework for understanding and treating this condition (Nathan, 1967; Patterson, 1987; Heinrichs and Buchanan, 1988).

Against this background mental health teams must contend with the added difficulties of deafness. Prelingual deafness, that is deafness with onset before spoken language acquisition, has a profound effect on the development of communication skills, emotional maturity, socialization and cognition (Myklebust, 1960; Freedman, 1977; Liben, 1978). The resulting developmental deficits coupled with limited sign language skills and disordered affect can simulate schizophreniform disorders, mental retardation or syndromes associated with brain damage. Psychiatric diagnosis with this population is extremely difficult and in the past resulted in frequent incorrect diagnoses and unnecessary accumulation of deaf patients in psychiatric institutions (Denmark and Eldridge, 1969; Altshuler, 1971; Evans and Elliott, 1981; Misiaszek et al., 1985). These diagnostic difficulties lead to early recognition of the need for more objective measures (Altshuler and Deming, 1967).

The need for more objective and accurate means of assessment has also been recognized by those working with hearing patients (Ascher, 1949; Deutsch, 1947). Dittman (1987), speaking about depressive illness at a recent US National Institute of Mental Health workshop, proposed that patients' body movements, in particular, may provide the cues that improve diagnostic reliability and validity.

Movement disorders in schizophrenia

... a closer understanding of the neurology of schizophrenic motor behaviour holds the promise of advances in differential diagnosis, aetiology, pathogenesis, and treatment (Manschreck, 1986, p.65).

Movement disorders have formed part of the clinical picture of schizophrenia for over a hundred years. In addition to the occasionally dramatic catatonic signs, many motor features are subtle, variable and intermittent. Kraepelin (1919) noted echopraxia, negativism, stupor, stereotypies (stereotyped movements), marked clumsiness, jerkiness or loss of smooth muscular co-ordination, reduced efficiency of fine movements and disturbed gait. Fragmentation, a term first used by Bleuler (1911) to describe schizophrenia, was later employed by Jaspers (1963) to describe a type of motor disturbance in schizophrenia characterised by significantly different degrees of muscle tone in different limbs or body areas simultaneously. The most comprehensive modern descriptions are those by Manschreck (1986) and Rogers (1985).

Apart from description and classification, very little is known about these movement disorders. Manschreck (1986) comments that this is remarkable when it is considered that they offer the possibility of relating observable, measurable behaviour to other aspects of psychopathology, in contrast with the difficulties attendant on the assessment of the delusional, hallucinatory and subjective disturbances of schizophrenia. At least three factors have contributed to this state of affairs: first, the variability of these disorders between patients and over time; second, their confusion with neuroleptic medication side effects; and third, the question of their diagnostic specificity.

Neuroleptic medication accentuates numerous involuntary movement disorders, commonly grouped as acute dystonic reactions, akathesia, drug induced parkinsonism and tardive dyskinesia (Marsden *et al.*, 1986). The introduction of neuroleptic medication for the treatment of schizophrenia, from 1952 onwards gave rise to numerous research studies and a long running debate as to the extent to which involuntary movement disorders were side effects of the medication or features of the illness itself (Rogers, 1985). Whilst most of this research concerned involuntary movement disorders, the contributions by Manschreck and associates (1986) at Massachusetts and Harvard, are of particular relevance to this study as they focused on voluntary movement, building on a substantial literature in experimental psychology linking motor performance with attentional processes and schizophrenic language disorders.

Psychomotor tests have been widely used to identify dysfunctional systems in neurological studies of schizophrenia. In a recent review of 19 studies, Heinrichs and Buchanan (1988) found support for the view that there are three distinct areas of functional impairment in schizophrenia, namely those of integrative sensory function, motor co-ordination and sequencing of complex motor acts. They postulate that the basic mechanisms of sensory input and motor output are not disturbed, rather the impairment appears to be in the higher order functional systems. Other studies support the view that neuromotor dysfunction may be a core schizophrenic process present in both acute and remitted schizophrenics, a vulnerability marker rather than a marker of symptoms (Wohlberg and Kornetsky, 1973; Asarnow and MacCrimmon, 1978; Gunther *et al.*, 1986).

Unfortunately, despite decades of research, psychomotor test batteries have failed to differentiate schizophrenic from brain damaged patients (Goldstein, 1986; Heaton and Crowley, 1981).

The present consensus is that:

1. Involuntary movement disorders are a feature of chronic schizophrenia in the absence of neuroleptic drugs and any coincident, identifiable neurological disorder (Owens *et al.*, 1982; Rogers, 1985; Lund *et al.*, 1991).

2. Some forms of motor disturbance characterise virtually all cases of conservatively defined schizophrenia (Chapman, 1966; Jones and Hunter 1968; Manschreck *et al.*, 1986; Rogers, 1985; McKenna *et al.*, 1991).

3. Movement disorders are a central feature of the schizophrenic condition, demonstrated by correlations between movement disorders, cognitive deficit and negative symptoms (Owens and Johnstone, 1980; Manschreck *et al.*, 1986; Kay *et al.*, 1986; Waddington *et al.*, 1987).

Muscle tension and emotional conflict

Luria's pioneering experiments demonstrated that motor response delay, amplitude and waveform were clearly influenced by external emotional stress, hypnotically induced affective complexes, trauma and neurosis (Luria, 1932). Luria postulated that the *observed diffusion* and *disorganisation* seen in motoric responses reflected a similar process of disruption in cognitive processes.

Jacobson (1967) is best known for his studies of relaxation. He found an association between low muscle tension, diminution of mental activity, lack of rapport, expressionless faces and open but 'not-seeing' eyes. He discovered that emotion comprised responses of virtually the entire organism, and described it as a response to an external situation as the organism represents it and evaluates it through the body. 'Emotion is not only being 'moved' physiologically: *Emotion is the framework in which man apprehends reality... in many respects the most important function of emotion is evaluation of reality*' (Jacobson, 1967 p.125). Jacobson's work suggests an association between the bodily manifestations of flat affect and loss of reality testing observed in schizophrenia.

Studies of severe psychopathology have found that irregularity of motor response was more diagnostically discriminative than degree of muscle tension, although even this measure did not differentiate well between patients suffering from anxiety states and those in acute psychotic states (Duffy, 1962; Malmo *et al.*, 1951).

Psychoanalytic perspectives

That posture and movement contain valuable clues concerning emotional conflict has been recognised from the earliest days of psychoanalysis. One of the most extensive bodies of early work is that published by Deutsch (1947). His 1952

paper reports clinical observations of 32 patients who had been in psychoanalysis from one to four years, from whom thousands of postures were recorded and correlated with verbal analytic material. He comments: '... The integrative function of the ego can be considered as effective when it succeeds in co-ordinating and synchronising the different participants in the postural formation' (Deutsch, 1952, p.198).

Similar comments were made by Wilhelm Reich. In his detailed case study of a schizophrenic patient he links the fragmentation of mental functions with 'weakness in the structure of functional co-ordination' (Reich, 1945, p.446). His view of schizophrenia as damage to early developmental processes is remarkably consistent with some present day neurological theories of the aetiology of this condition (Patterson, 1987). Lowen developed Reich's view of schizophrenia as loss of muscular co-ordination. He commented: 'One does not get a feeling of unity from the body structure. The head does not look as if it is securely joined to the trunk, there is marked splitting of the body at the diaphragm and the lower limbs are not functionally integrated into the body' (Lowen, 1958, p.349). Reich was also a significant influence on Braatoy who investigated the diagnostic potential of respiration patterns (Christiansen, 1972).

Charlotte Wolff (1945) studied 88 psychiatric patients at St Bernards Hospital, London, in work and meal time situations. Wolff found: 'consistency of psychomotor response increases with the severity of a mental malady. The more advanced the disintegration of the personality the more stereotyped and restricted do the gestures become' (Wolff, 1945, p.166). Although no exclusive relationship was found between any individual gesture and a particular psychiatric diagnostic category, Wolff identified five distinct patterns or collections of gestures which did have diagnostic specificity. Wolff's pattern for schizophrenia included: a predominance of withdrawal movements, arhythmical movements, perseverance, stereotyped movements, autistic gestures, general unrest and slow motor speed.

The findings of these early workers have been well supported by modern writers (Izard, 1971; Manschreck, 1986; Heinrichs and Buchanan, 1988).

Criticisms of the naturalistic clinical observations on which psychoanalytic findings were based spurred Mahl (1968) to supplement his own clinical experience with empirical studies. One of these involved observation of clinical interviews with 18 patients at a psychiatric outpatient clinic. An observer in a soundproof room made a record of the movements by audio dictation on to tape, and later generated inferences of leading conflicts, character structure traits, and concerns for 14 of the patients. These were then compared with the outcome of the clinical interview. Of 43 inferences made, 36 were confirmed as correct. The weakness of the study lies in the ill-defined connection between the movement data and the inferences drawn from them.

Non-verbal communication

The 1950s saw a shift in emphasis from the study of the expressive movement of the individual to the patterned processes of interaction involving all participants.

Non-verbal communication research testifies that body movement is a complex, multifaceted phenomena, involving cultural, social, interpersonal, situational and intrapsychic determinants. It is organised in interactive rhythmic patterns which hold the individual within a cultural context whilst maintaining social order. Movement also plays a vital role in both cognitive and emotional functioning and perceptual processes. It seems inconceivable therefore, that psychopathology will not influence non-verbal behaviour in a significant way. Studies have linked body movement with mood, evaluation and status(Dittmann, 1962); anxiety and dependency (Exline and Winters, 1965); speech (Dittmann, 1972; Freedman, 1977); sense of identity (Witkin et al., 1962); and quality of communication (Ekman, 1965, 1982).

Birdwhistell (1970) reports preliminary studies of the mentally ill as finding that the emotionally disturbed display gestures, facial expressions and postural positions that are no different from the repertoire of the remainder of the community. He does, however, find that they display their behaviour for durations, at intensities, or in situations that are inappropriate for such behaviour.

These remarks are echoed by Grant (1972). However, Grant did find that behaviour patterns were biased towards flight and withdrawal and away from patterns associated with assertion. He also found increased rigidity in emotional behaviours and extreme flight responses.

Scheflen has described schizophrenic behaviour in several papers (Scheflen, 1972, 1973, 1981). In his 'Analysis of a psychotherapy transaction' Scheflen (1973) comments on the kinesic immobility and diminution of paracommunicative quality in a schizophrenic patient, corresponding to flattened affect. Scheflen subscribes to the 'double bind' theory of schizophrenia, advanced by Bateson et al.. (1956), describing instances of it when verbal and non- verbal communications are in conflict. He also states that linguistic abnormalities in schizophrenia, such as difficulties in linearity in description, deviations in the sense of spatial order, and violation of the rules of syntactic order, have analogous counterparts in task behaviour. Scheflen (1981) comments on the lack of manners and social graces, lack of respect for other's space, absence of greeting rituals, gaze behaviour abnormalities, courtship behaviour either exaggerated or absent, and a seeming inability to decode non-verbal signals from others, often resulting in confusion, ambiguity and lack of understanding.

Condon and Ogston (1966) in a film analysis of a chronic schizophrenic supported the above findings and found preliminary evidence for self-dysynchrony in that at times the patient's right arm and leg began and ended movement phrases at different times from his speech, head and the left aspect of his body. Unfortunately this loss of self-synchrony is not pathognomonic for schizophrenia, being seen in patients with Huntington's Chorea, aphasia, Parkinsonism, childhood autism and during epileptic petit mal seizure.

Several studies of gestural movement have found an abnormally high proportion of body focused hand movements in schizophrenic and depressed patients

and links with social withdrawal and thought disorder have been hypothesised
(Grand *et al.*, 1975; Freedman, 1972).

Qualitative studies of movement

Plutchik's (1954) review of 89 research papers linking muscular tension, expressive movement, personality and maladjustment found unanimous agreement that expressive movement is a stable characteristic of the individual and can be related to character attitudes.

One of the most extensive investigations were those by Allport and Vernon (1933). Their results, involving some 300 measures from 25 subjects over a period of 11 weeks, supported the dual hypotheses that an individual's expressive acts are self consistent and that this reflects self consistency of personality.

Of relevance for future work on movement assessment scale design is Werner Wolff's (1935) study of involuntary self expression in gait, in particular his findings that self recognition through gait was 'not due to single traits but to the whole movement' (Wolff, 1935, p.334) and that neurotic subjects manifest their state most clearly in the movement transitions between the conclusion of one task and the commencement of another.

Independently of Allport and Vernon, but at much the same time, Rudolf Laban was pioneering a radically new approach to dance through his insight into the inherent psychological significance of the qualitative aspects of movement.

Laban's method of movement analysis is a means of describing how people move, not what they do – a description involving form, rhythm, organisation and sequencing (Laban and Lawrence, 1947). His movement notation system, introduced in the 1920s as Kinetography Laban, has been acknowledged by Birdwhistell (1970) to be one of the most comprehensive systems available, and has undergone continuous use and development to the present day. Laban Effort Analysis involves characterisation of movement by the primary factors space, weight, time and flow.

Laban's contribution far exceeded that of developing the technical means of analysis and notation. He was also concerned with the significance of movement, both in its use as a communicative art form, and as a sensitive indicator of mental state. Central to this aspect of his work is his hypothesis that the four effort qualities in movement are indicators of the psychological functions of thinking, sensing, intuiting and feeling. Laban's discussion of conflicting effort patterns reflecting emotional conflict is in agreement with much of the research on muscular tension and non-verbal communication, cited above (Laban, 1950). Laban also developed an interest in movement assessment of psychiatric patients, including recommendations for treatment plans. In this he was assisted by Marion North who subsequently developed this work in Britain particularly in assessments of hearing and deaf children (North, 1972). North's book includes a comprehensive review of Laban's method of effort analysis and its psychological aspects.

American psychoanalyst Judith Kestenberg has applied Labananalysis (1975) to research relating movement patterns in infants and children. The comprehensive movement observation techniques developed by Kestenberg reveal distinct rhythms characterised by waveform, amplitude, frequency and phase. She relates these to 'object relations' theory and the development of ego defence and coping mechanisms. She finds support for these postulates in the work of Margret Mahler (Mahler *et al.*, 1985).

Siegel (1984) has applied these findings to adult psychiatry, suggesting that characteristic movement patterns can alert the therapist to incompletely resolved developmental issues. She presents a detailed tabulation relating developmental motility to associated developments in object relations, drive differentiation, defences and anxiety level. This is supported by case studies of dance movement therapy sessions with borderline and schizophrenic patients.

Martha Davis remains one of the foremost researchers engaged in the psychological application of Laban Movement Analysis. A Davis movement assessment scale, the Movement Behaviour Assessment Rev., 1988, forms part of the instrument used in this pilot study. This scale is a development of that first used in her 1970 study of 23 hospitalised psychiatric patients. That scale, based on 70 characteristics, was organised according to restrictions and uses of the body, spatial patterns, effort dynamics and composites of these. Expected pathological features defined by Davis were:

1. fragmentation;

2. diffusion;

3. exaggeration;

4. invariant movement patterns;

5. bound active control;

6. flaccidity;

7. mobility and low vitality.

(See Table 11.1 for amplification of this terminology.)

The major finding was a correlation between the presence of fragmentation and more than two hospitalisations and/or a diagnosis of chronic schizophrenia. There was preliminary evidence linking the bound-active control factor with chronic paranoid symptomatology. Davis hypothesises that the first few factors in the scale are features of serious pathology and that the presence of three or more of these in a patient may be a strong indicator of a chronic undifferentiated schizophrenic process. Davis also suggests that therapeutic improvement may be accompanied by decreasing scores on the serious pathology factors.

Discussing these results, Davis proposes that fragmentation may be: 'a reflection of severe personality disorganisation. The rhythms of attention and focus, action and repose, speaking and listening, appear disrupted and chaotic... the patient seemed driven and out of control with parts moving automatically' (Davis, 1970, p.36). Davis suggests that the movement pathology described here might

Table 11.1: Detailed movement pathology: Davis scale items

Subject	Pathology Subtype Observed	Key
		Category 1: Disorganisation
1	11	1* effort flow or weight fragmentation
2	9	3* fingers and palm hyperextended
3	4*, 11	hand fragmented
4	1*, 3*, 7*	4* body fragmentation: movement occurs
5	0	sporadically in different parts during
6	0	a phrase without a coherent sequence
		or fluent connections
		7* different unrelated rhythms performed
		simultaneously in different parts of the
		body, unsynchronised
		9 flow contradiction between body parts
		11 body segmentation: isolated use of one
		part: a pause or clear separation before
		movement of another part
		Category 2: Immobility
1	3, 8*	1* gestural movement only, no postural
2	3	movement in walking or when shifting
3	3, 11, 1 *	position
4	0	3 distal parts only move, whenever sitting
5	3, 11	or standing in place
6	0	8* fixed shape or position held up in the
		air and against gravity for long period
		(30+ seconds)
		11 only one or two position shifts in 20
		minutes or more
		Category 3: Low vitality
1	5	1* very little fluctuation in effort flow,
2	5	changes hard to discern.
3	5, 1*	5 effort qualities observable in only one
4	0	distal part of body: the rest of body is
5	5	non-dynamic
6	0	
		Category 4: Spatial complexity
1	1	1 any spatial complexity (e.g. curved
2	1	transitions) restricted to one body part
3	1	only
4	0	2 two phasic or single directions only
5	2	
6	0	

Subject	Pathology Subtype Observed	Key
		Category 5: Perseveration/fixed invariant
5	3	3 moves strictly in one plane or axis per phrase or with one effort quality per plane/axis continually repeated
		Category 6: Flaccidity or retardation
1	0	1* flaccid, inert, limp trunk tonus, some
2	1*	slumping
3	1*	
4	0	3 flaccid, complete limpness and giving
5	3	in to gravity at end of gestures or upper
6	0	limb actions
		Category 10: Even control/suspension
1	2	2 high degree of bound flow or muscle
2	0	tension maintained throughout the
3	0	entire movement phrase; absence of
4	0	free moments, or release, or giving in
5	2	to gravity within the phrase.
6	0	

Note: Asterisked items are hypothesized to be related to severe psychopathology.

Note: Categories 7, 8, 9: not seen in any subject. Category descriptions reproduced from *Movement behaviour assessment.* Revision 1988. (Davis, 1988).

be a gross form of the lack of self synchrony found by Condon (1968), reflecting disruptions to subtle, complex patterns of both intrapsychic and interpersonal dynamics.

Pilot studies have investigated movement phrases in schizophrenic patients, (Crary, 1984), and the influence of neuroleptic medication on Davis scale factors, (Nichols, 1985). Nichols' results support Davis' finding that fragmentation may be an indicator of chronic schizophrenia. Her results also suggest that neuroleptic medication has a deleterious effect on the movement factors integration, mobility and spatial complexity.

Design of this pilot study
The pilot study attempted to:

1. formulate a movement assessment scale;

2. design a test protocol; and

3. examine their effectiveness in eliciting clinically useful data.

This was seen as the first stage of a larger study needed to test the hypothesis that movement assessment has the potential to contribute to the differential diagnosis of schizophrenia.

The movement scale

The movement scale consisted of two parts. Section one comprised the Movement Behaviour Assessment Rev. 1988, designed by Martha Davis, the result of ongoing development and research by her since 1970. This scale comprises ten categories of movement pathology identified by Davis, in relation to gesticulations, self-related movements, instrumental actions, interactive behaviour, locomotion, and abnormal involuntary movements – Davis (1988).

Space limitations prevent reproduction of the complete scale here, however the Davis movement categories seen in this pilot study are briefly described in Table 11.1 Davis emphasises the following points in respect of the scale:

1. It is essential that it is applied only by observers trained in its use. Although the movement categories can be described in words this is inadequate as observer training.

2. The relationships, discussed below, between scale movement categories and psychological disorders are hypotheses only at this stage. This scale has not been formally validated or tested for reliability.

Section two of the movement scale used in this study was designed by the author, drawing on the literature reviewed above (see Table 11.2).

Subjects

Subjects for the trial were carefully elected from those attending the Supra Regional Deaf Unit at Springfield Hospital, London, in an attempt to match ethnographic variables such as age, sex, culture, cause of deafness, degree of deafness.

Another selection criteria was that the six patients studied should form three groups with two patients in each, as follows:

Subjects 1, 2 Diagnosis: schizophrenia (Clear diagnosis)
Subjects 3, 4 Diagnosis: schizophrenia (Difficult to diagnose)
Subjects 5, 6 Diagnosis: non-psychotic disorder

Original diagnoses were made by the multi-disciplinary team comprising a consultant psychiatrist, clinical psychologist, speech therapist, occupational therapist and nursing staff, all experienced in working with prelingually deaf patients. Assessments were made over a period of weeks with the patient resident on the unit. Reports on family history were used when available.

Table 11.2: Higgens Scale

A. Efforts

	indulging	fighting
space		
weight		
time		
flow		

1. score: 0, 1, 2, for each quality

 key: 0 = never seen, none. 1 = present but reduced.
 2 = normal range. p = passive.

Effort combinations

2. Combinations of 2 efforts: 0, 1, 2

 Note predominant effort combinations:

3. Combinations of 3 efforts: 0, 1, 2

 Note predominant effort combinations:

B. Developmental

4. Note any developmental rhythms seen: oral 0 1 2
 anal 0 1 2
 phallic 0 1 2
 urethral 0 1 2

5. Use of planes: horizontal 0 1 2
 vertical 0 1 2
 sagittal 0 1 2

6. Distinctive body attitude? Type: _____

7. Areas in body of hypertension:

8. Areas in body of hypotension:

9. Splits in body usage or holding: upper/lower
 left/right

 Note others:

C. Phrasing

10. Phrase types seen: impulsive 0 1 2
 impactive 0 1 2
 monotone 0 1 2
 repetitive 0 1 2

11. Are major phrases followed by recovery phrase? Y/N

12. Extent to which clear phrases are used? 0 1 2

D. Interaction

 13. Kinesphere size: small, medium, large,

 14. Interpersonal space preference: small, medium, large,

 15. Interactional synchrony: 0 1 2

 16. Other non-verbal social interactive behaviour present?

 e.g. blocking, defensive postures or positions: 0 1 2

 quasi-courtship behaviour: 0 1 2

 open affiliative positions: 0 1 2

E. Gestures

 Body focused hand movements* *Frequency*

 17.Continuous body touching 0 1 2

 discrete body touching 0 1 2

 continuous hand to hand movements 0 1 2

 (*For definitions see Freedman et al., 1973)

F. Other

 Any other observations or comments on movement.

G. Inferences regarding psychopathology on basis of movement assessment

Protocol

The interview procedure, described below, was explained to each subject and a consent form signed and witnessed. Each patient in turn was video-taped by the author whilst engaged in a 20 minute seated interview with a deaf member of the clinical staff, using sign language. There was no fixed agenda for the conversation, and it generally concerned topics of current interest to the patient. Immediately following this the staff member took control of the video camera whilst the author engaged the patient in a 20 minute movement session.

 The same movement agenda was followed with each patient. It comprised 24 items divided into 5 sections designed to elicit information about (a) body image, (b) spatial clarity, (c) body organisation and co-ordination, (d) ability to perform sequences of movements, and (e) ability to initiate and improvise using an object, in this case a stretch cloth.

 During sections (a) to (c) the patient was asked to follow or mirror simple movements made by the author. These were of the kind used in the warm-up phase of dance movement therapy groups, for example, swing an arm in sagittal circles from the shoulder using light bound flow. They progressed from move-ments using only peripheral body parts to those requiring co-ordination of trunk, head and arms. Section (d) involved simple games first demonstrated by the author, for example, hoop throwing and interactive ball throwing. Communicat-

ing the concept of improvisation to prelingually deaf patients was, as expected, difficult. It was attempted by prior demonstration. Except in the case of one subject who had prior experience of dance movement therapy, it appeared that most patients attempted to reproduce the demonstration.

Data processing

The video tapes were rated for movement by an experienced dance movement therapist, who had no other information about the patients. She was requested to complete both the Davis scale and the author's scale, to comment on which of the patients might be carrying a diagnosis of schizophrenia, and to make any other inferences concerning the patients deficits or needs which might be useful to the clinical team.

Limitations of time and financial resources permitted only one movement rater. This does throw into question the reliability of the data (Davis *et al.*, 1987). The use of an experienced clinical dance movement therapist as rater in this study helped mitigate this factor.

Results and discussion

The results of the pilot study will be discussed with reference to the hypothesis presented at the beginning of this chapter. This will be followed by brief comments on the design of the scales and the protocol. The hypothesis that movement data has the potential to contribute to the differential diagnosis of schizophrenia in prelingually deaf patients was supported by this study. The movement rater made predictions which:

1. successfully identified the two non-psychotic subjects;

2. identified a psychotic disorder in the remaining four in agreement with the medical team;

3. correctly hypothesised a diagnosis of schizophrenia in one subject and severe disorganisation in thinking and organising in another. The rater was reluctant to propose a diagnosis of schizophrenia in the two remaining psychotic subjects on the basis of movement data alone.

These results are presented in Table 11.3. Some of the movement data on which these predictions were based is summarised in Figures 1 and 2.

Inferences regarding psychopathology were drawn on the basis of guidance notes accompanying the Davis scale, Davis (1988), reports linking movements and psychological factors reviewed above, particularly by Davis (1970) and North (1972), and the extensive clinical experience of the movement rater.

The movement pathology revealed by the Davis movement behaviour assessment scale shows several suggestive features. First, all four subjects rated likely to carry a diagnosis of schizophrenia or psychotic illness, showed signs of disorganisation. Figure 11.1 shows that subjects 3 and 4 show serious pathognomonic features (2 scores) while subjects 1 and 2 generally showed less severe features (1 scores). The presence of disorganisation in all four psychotic subjects

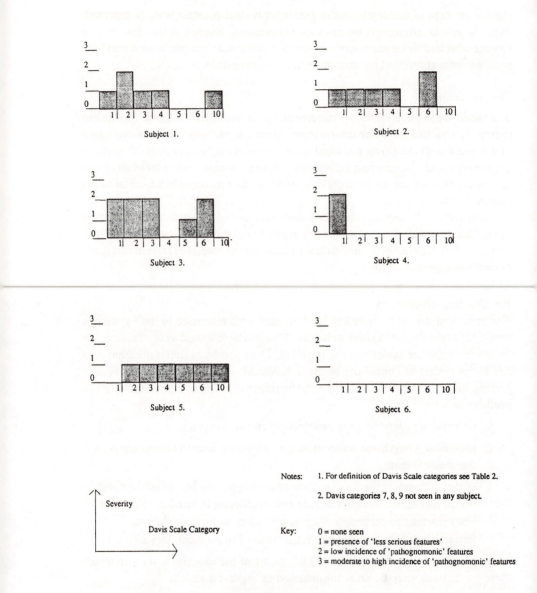

Notes: 1. For definition of Davis Scale categories see Table 2.

 2. Davis categories 7, 8, 9 not seen in any subject.

Key: 0 = none seen
 1 = presence of 'less serious features'
 2 = low incidence of 'pathognomonic' features
 3 = moderate to high incidence of 'pathognomonic' features

Figure 11.1: Davis Scale Movement Pathology

Table 11.3: **Results of a comparison of diagnosis by multidisciplinary team and that based on movement assessment**

Subject	Medical Diagnosis	Movement Raters Assessment
1	Schizophrenia (definite)	disorganisation in thinking and organising
2	Schizophrenia (definite)	psychosis with depressed affect
3	Schizophrenia (probable)	schizophrenia in remission
4	Schizophrenia (probable)	psychosis in remission
5	Neurotic disorder	Communicational disorder. Possible depression
6	Psychopathic personality disorder	psychopathic personality disorder

confirms the early descriptive studies by Bleuler (1911) and Jaspers (1963) and the more recent observations by Davis (1970) and Nichols (1985). Both Davis and Nichols found a link between disorganisation and number of previous hospitalisations, suggesting that this factor is linked with chronicity. In this study subjects 3 and 4 have the longest histories of disturbance, both in excess of eight years, and subject 3 is regarded as a chronic patient by the medical team. However the pattern is not clear cut as subject 2 also has a seven year history of disturbance, yet only scored 1 (less serious features). There are a number of possible reasons for this, one being the temporal variability of movement disorders (Rogers, 1985).

The second item of interest in Figure 11.1 is the distinct cluster of pathology in categories 2, 3 and 4 of the scale, namely; immobility, low vitality, and low spatial complexity. Pathognomonic features (indicated by 2 scores) were present in subjects 1 and 3 and less serious features in subject 2. Davis has hypothesised that these are indicators of serious pathology, i.e. schizophrenic disorders, and major affective disorders, although they are also seen in some organic mental disorders. They are not sufficient conditions for a diagnosis of schizophrenia, as shown by their absence in subject 4 and their presence, in less serious form, in non-psychotic subject 5.

Within each category of movement disorder Davis has identified up to 12 subtypes or manifestations. Those most frequently seen in this study are presented in Table 11.1. Of the 12 subtypes of disorganisation, 6 were observed in this study. However, there was more consistency in the immobility, vitality, and spatial complexity categories. The majority of that pathology concerned the isolation and use of distal body parts (for example arms, legs) with the rest of the body remaining uninvolved and non-dynamic.

Another pattern commented on by Davis (1988) is the association between paranoid psychosis and the movement features of Even Control (Scale item 10) and active forms of holding and control in the Disorganisation and Immobility categories (Scale items 1, 2). This pattern is emerging in subject 1 who shows a

high degree of bound flow of muscle tension throughout entire movement phrases coupled with instances in which a fixed shape or position is held against gravity for long periods.

The rater's hypothesis of paranoid functioning in subject 1 agrees with reports in the medical notes of the patient hallucinating frightening faces, his withdrawal, unprovoked attacks on others, and extremely defensive behaviour in therapy groups.

Returning to Figure 11.1, no subject scored at severity level 3, most subjects displaying a relatively low incidence of features regarded as pathognomonic of serious pathology by Davis. This is consistent with the remitted status of the subjects. If they had been in an acute stage of illness it is hypothesised that there would be a higher incidence of more severe features.

Whilst the '2' scores for disorganisation in subjects 3 and 4 are strong indicators of a severe chronic mental illness, a diagnosis on the basis of the Davis Scale alone would not be justified. In all cases the movement rater drew on information from Section 2 of the movement assessment scale in order to make a diagnosis. Important diagnostic factors in Section 2 proved to be the effort profile, the movement phrases used, and postural information.

The availability of effort dynamics across all subjects are compared in Figure 11.2. Subjects 1, 2 and 3 display deficits in both space and weight dynamics. North (1972) associates the motion factor of space with thinking and cognition, and connects the weight quality in movement with intention, firmness of purpose, and with perception through conscious sensory processes. The deficits in the movement profile of subjects 1, 2 and 3 suggest that they will have difficulties in these functional areas.

Movement researchers and clinicians working within a psychoanalytic framework, Kestenberg (1975) and Siegel (1984), would interpret these profiles as indicative of developmental disturbances during the first and second years of life, manifesting as impairments in the basic sense of self as a separate individual as well as in the movement foundations for cognitive development and ego defences. This would be consistent with some psychoanalytic thinking concerning aetiological factors in schizophrenia.

Subject 4 shows an odd exception to the above pattern. All effort qualities are available, suggesting that well developed coping mechanisms help this patient compensate for the severe disorganisation pathology he is struggling with. This subject achieved a low score for basic effort actions (combinations of 3 efforts), suggesting he is not able to harness these qualities for practical tasks or expressive activities. Subject 6 also shows an apparently healthy profile, however, the movement rater commented on the unusual predominance of basic effort actions over inner attitudes (combinations of 2 efforts). Based on previous clinical experience, this subject's movement profile was correctly linked with a diagnosis of psychopathic personality.

In the effort qualities seen there is a predominance of inner attitudes involving the space effort; 9 compared with only 3 of all other types. Also the space effort

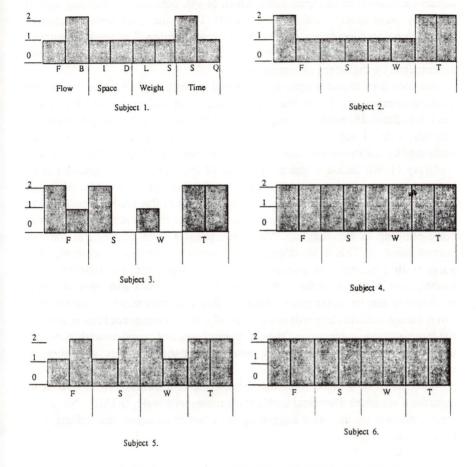

Key: 0 = never seen - 1 = present but below normal range - 2 = normal range

Figure 11.2: Frequency of Efforts

occurs exclusively in its direct form, which North describes as 'fighting against the body using space' (North, 1972, p.233). These inner attitudes are characterised by pointed exactness, precise and narrow attention. The predominance of focused attention may be characteristic of deaf persons and may also have been accentuated by the interview situation.

Another area found diagnostically useful in Section 2 of the scale was the postural information. The flaccid inert torso in subjects 2 and 3 was detected by the Davis Scale. However, a pronounced left to right body lean in subject 4 and left/right split in subject 1 were regarded as important indicators of severe pathology by the movement rater. This was absent in the two control subjects.

Crary (1984) found a higher incidence of impulsive and monotone phrase types in schizophrenics, with a more even distribution in controls. Although relative frequency of phrase types was not counted in this study, impulsive and monotone were the only two categories in which subjects scored a '2' rating, corresponding to frequent use. Monotone phrases were not seen in the two control subjects. This is insufficient data from which to draw conclusions but suggests that quantitative assessment of phrase types may be a factor worth investigating in future studies. Absence of recovery phrases and types of transitions should also be investigated. Other possible indicators which warrant further investigation include the predominant use of a small kinesphere seen in three of the four psychotic subjects, and the complete absence of 'quasi-courtship' behaviours which are equally likely to be related to the social deficits of deafness as schizophrenia.

Subjects 1 to 4 were receiving neuroleptic medication. The Davis scale includes a standard abnormal involuntary movement scale, (AIMS). No scores were recorded by the rater suggesting no gross medication side effects were observable.

Comment on scales and protocol

The study threw into sharp relief that the major shortcoming of the author's scale was the lack of an explicit relationship between the movement data, diagnosis and clinical/psychological implications. The movement rater was required to draw on extensive clinical experience in formulating tentative diagnosis based on the different movement profiles for each subject. Detailed questioning of the rater, after the study, elicited that the 'diagnosis' for each subject was made on the basis of the cumulative evidence of several factors, rather than the presence or absence of a few key parameters. This contrasts with the traditional psychiatric approach which, for example, requires the presence of clearly defined Schneiderian first rank symptoms. The scale in its present form could not be used by other than experienced dance movement therapists, and should therefore more accurately be called an observational check list. Although it is far from being an instrument ready for validation and reliability testing, it is a useful starting point in guiding the observer towards what to look for and record, faced with the enormous volume

of data contained in a 40 minute movement videotape. It is encouraging that most of the factors on the scale were found useful by the rater.

Although the Davis Scale is more developed than the author's in terms of identification and isolation of hypothesized movement pathology, the relationship between the Davis scale and psychiatric categories remains in the form of generalized hypotheses regarding emerging patterns. In the past Davis has resisted making tight connections on the basis that in so doing we might miss or distort the unique contribution movement can make to the understanding of behaviour (Davis, 1970, p.38).

In terms of the protocol used, i.e. the seated interview followed by structured movement session, questions arise as to its effectiveness in eliciting the full range of both movement pathology and adaptive movement range. Both early and contemporary workers in this field have mentioned the importance of eliciting movement data over a period of time and in different contexts (Wolff, 1945; Rogers, 1985). Such questions arise from the finding mentioned above, of a predominance of the Laban space effort in its direct form in the subject's effort combinations. This corresponds to focused attention, to be expected in an interview situation. It will be important to attempt more naturalistic observations in future work.

Conclusions

This study set out to examine the hypothesis that the systematic observation and recording of movement by trained observers has the potential to make a valuable contribution to the differential diagnosis of schizophrenia in prelingually deaf persons. The literature reviewed established both the need for such a contribution and its fe asibility. This was supported by the encouraging outcome of this pilot study in which non-psychotic deaf patients were successfully differentiated from psychotic deaf patients on the basis of movement data alone.

That this differentiation was achieved with patients in remission supports the notion that movement disorders are not symptomatic, but are associated with core dysfunction in schizophrenia.

The implications of this outcome are that movement assessment could make a valuable contribution to the wider problems of:

1. psychiatric diagnostic validity and reliability in both hearing and deaf populations;

2. differentiating the variety of different conditions presently subsumed under the umbrella diagnostic category schizophrenia;

3. identifying individual deficits and needs in patients allowing more focused intervention

The pilot study outcome supports the case for further studies of movement assessment in psychiatry. The complexity of the task demands that these be multidisciplinary team efforts. The following suggestions for further work are offered.

1. The movement observation scale needs considerable development.
 In particular, the observation of movement dynamics, Laban efforts,
 should record patterns and sequences of effort combinations, transitions
 between movement phrases, and shadow or recovery phrases, rather
 than the mere presence or absence of facility with the individual efforts.
 This has been recommended by other authors including Wolff (1935)
 and North (1972).

2. The methodology of movement data collection needs refinement. Future
 studies might examine:

 (a) the protocol for the movement interviews, i.e. to what extent should
 movement be elicited through interviewer participation;

 (b) the influence of context and task performance, for example, meal
 time versus interview versus relaxation time;

 (c) the need for multiple observations over a period of time;

 (d) the influence of the video camera on the subjects and data.

3. The above 'development of an instrument' studies need to be supported
 by validation and reliability trials with both hearing and deaf popu-
 lations, using multiple observers (Davis *et al.*, 1987).

4. Sophisticated means for automated movement analysis are now available.
 For example the 'Selspot' equipment in use at the Institute of
 Neurology in London permits real time recording and analysis of
 three-dimensional movement paths, synchronized with limb
 acceleration and electromyographic measurements. The question of
 whether such equipment can be programmed to detect fragmentation or
 characteristic effort patterns warrants investigation.

Attempting to relate movement dysfunction to ill-defined and non-homogeneous
psychiatric categories may seem ill advised to researchers without an investment
in the medical model. Attempts to do this were regarded as premature by Davis
(1970). As pointed out at the beginning of this chapter, there were clinical reasons
for adopting this approach in this study. However, in terms of furthering under-
standing of the schizophrenic condition, research concerned with careful descrip-
tion and measurement of movement patterns and their relation to specific
psychological dysfunctions may be more productive in the longer term.

References

Allport, G.W. and Vernon, P.E. (1933) *Studies in Expressive Movement. New York:*
Macmillan.

Altshuler, K.Z. (1971) 'Studies of the deaf: relevance to psychiatric theory', *American*
Journal of Psychiatry, 127, 11, 1521–6.

Altshuler, K.Z. and Deming, W.E. (1967) 'Interaction measurements in psychiatric
patients with early total deafness', *Archives of General Psychiatry*, 17, 367–75.

Asarnow, R.F. and MacCrimmon, D.J. (1978) 'Residual performance deficit in clinically remitted schizophrenics: a marker of schizophrenia?' *Journal of Abnormal Psychology*, 87, 6, 597–608.

Ascher, E. (1949) 'Motor attitudes and psychotherapy', *Psychosomatic Medicine*, 11, 228–234.

Bateson, G. Jackson, D.D. Haley, J. Weakland, Jr. (1956) 'Toward a theory of Schizophrenia', *Behavioural Science*, 1, October, 251.

Birdwhistell, R.L. (1970) *'Kinesics and Context: Essays on Body-Motion Communication.* Philadelphia: University of Pennsylvania Press, Allen Lane, Penguin.

Bleuler, E. (1911) *Dementia Praecox or the Group of Schizophrenias.* Translated by J. Zinkin. New York: International Universities Press.

Brockington, I. (1986)'Diagnosis of schizophrenia and schizoaffective psychosis', in P.B. Bradley and S.R. Hirsch (eds), *The Psychopharmacology and Treatment of Schizophrenia.* Oxford: Oxford University Press.

Chapman, J. (1966) 'The early symptoms of schizophrenia', *British Journal of Psychiatry*, 112, 225–51.

Christiansen, B. (1972) *Thus Speaks the Body; Attempts Toward a Personology From the Point of View of Respiration and Postures.* Oslo, Norway: Institute of Social Research.

Condon, W.S. and Brosin, H.W. (1969) 'Micro-linguistic-kinesic events in schizophrenic behaviour', in D.V. Siva Sankar (ed), *Schizophrenia: Current Concepts and Research.* Hicksville, New York: PJD.

Condon, W.S. (1968) *Linguistic-Kinesic Research and Dance Therapy.* Proceedings of 3rd Annual Conference of the American Dance Therapy Association.

Condon, W.S. and Ogston W.D. (1966) 'Sound film analysis of normal and pathological behaviour patterns', *Journal of Nervous and Mental Disease*, 143, 4, 338–47.

Crary, H. (1984) *Exploratory study of Phrasing Patterns in Schizophrenics and its Application to Dance Therapy.* Unpublished pilot study report. Department of Dance and Dance Education, New York: New York University.

Davis, M. (1970) *Movement Characteristics of Hospitalized Psychiatric Patients.* Proceedings of the 5th Annual Conference of the American Dance Therapy Association.

Davis, M. (1988) *Movement Behaviour Assessment: Guidelines for Use and Interpretation.* Seminar presented at Laban Centre, London: November.

Davis, M., Hadiks, D., McCoubrey, C., Sossin, K.M. and Winter, D.D. (1987) 'Observer agreement: movement studies', *Journal of the Laban/Bartenieff Institute of Movement Studies*, 2, New York.

Denmark, J.C. and Eldridge, R.W. (1969) 'Psychiatric services for the deaf', *The Lancet*, 2, 259–62.

Deutsch, F. (1947) 'Analysis of postural behaviour', *Psychoanalytic Quarterly*, 16, 195–213.

Deutsch, F. (1952) 'Analytic posturology', *Psychoanalytic Quarterly*, 21, 196–214.

Dittmann, A.T. (1962) 'The relationship between body movements and moods in interviews', *Journal of Consulting Psychology*, 26, 480.

Dittmann, A.T. (1972) 'The body movement-speech rhythm relationship as a cue to speech encoding', in A.W. Siefman and B. Pope (eds), *Studies in Dyadic Communication*. New York: Pergamon.

Dittmann, A.T. (1987) 'Body movements as diagnostic clues in affective disorders', in J.D. Maser (ed), *Depression and Expressive Behaviour*. London: Lawrence Erlbaum.

Duffy, E. (1962) *Activation and behaviour*. London: John Wiley and Sons.

Ekman, P. (1965) 'Communication through non-verbal behaviour: a source of information about an interpersonal relationship', in S.S. Tomkins and C.E. Izard (eds) *Affect, Cognition and Personality. Empirical Studies*. New York: Springer.

Ekman, P. (1982) *Emotion in the Human Face*. Cambridge: Cambridge University Press.

Evans, J.W. and Elliott, H. (1981) 'Screening criteria for the diagnosis of schizophrenia in deaf patients', *Archives of General Psychiatry*, 38, 787–90.

Exline, R.V. and Winters, L.C. (1965) 'Affective relations and mutual glances in dyads', in S.S. Tomkins and C.E. Izard (eds), *Affect, Cognition and Personality*. New York: Springer.

Freedman, D.A. (1977) 'The influences of various modalities of sensory deprivation on the evolution of psychic and communicative structures', in N. Freedman and S. Grand (eds), *Communicative Structures and Psychic Structures'*. New York: Plenum.

Freedman, N. (1972) 'The analysis of movement behaviour during the clinical interview', in A.W. Siefman and B. Pope (eds), *Studies in Dyadic Communication*. New York: Pergamon.

Freedman, B., Blass, J., Ritkin, A. and Quithin, F. (1973) 'Body movements and the verbal encoding of aggressive affect'. *Journal of Personality and Social Psychology* 26, 72–85.

Goldstein, G. (1986) 'The neuropsychology of schizophrenia', in I. Grant and K. M. Adams (eds) *Neuropsychological Assessment of Neuropsychiatric Disorders. New York: Oxford University Press*.

Grand, S. (1977) 'On hand movements during speech: studies of the role of self stimulation in communication under conditions of psychopathology, sensory deficit and bilingualism', in N. Freedman and S.Grand (eds), *Communicative Structures and Psychic Structures*. New York: Plenum.

Grand, S., Freedman, N., Steingart, I. and Buckwalk, C. (1975) 'Communicative behaviour in schizophrenia', *Journal of Nervous and Mental Disease*, 161, 293–306.

Grant, E.C. (1972) 'Non verbal communication in the mentally ill', in R.A. Hind (ed), *Non Verbal Communication*. Cambridge: Cambridge University Press.

Gunther, W., Gunther, R., Eich, F.X. and Eben, E. (1986) 'Psychomotor disturbances in psychiatric patients as a possible basis for new attempts at differential diagnosis and therapy. II Cross validation study on schizophrenic patients', *European Archives of Psychiatry and Neurological Sciences*, 235, 301–8.

Heaton, R.K., and Crowley, T.J. (1981) 'Effects of psychiatric disorders and their somatic treatments on neuropsychological test results', in S.B. Filskov and T.J. Boll (eds), *Handbook of Clinical Neuropsychology*, New York: Wiley-Interscience.

Heinrichs, D.W. and Buchanan, R.W. (1988) 'Significance and meaning of neurological signs in schizophrenia', *American Journal of Psychiatry*, 145, 11–18.

Higgens, L.G. (1989) 'The Diagnostic Movement Assessment of deaf psychiatric patients', unpublished Masters dissertation. Laban Centre for Movement and Dance, London, U.K: Hahnemann University, Philadelphia.

Higgens, L.G. (1990) 'The diagnostic movement assessment of deaf psychiatric patients', *Laban Centre: Working Papers in Dance Studies*, 3, 58–84.

Izard, C. (1971) *The Face of Emotion*. New York: Appleton-Century Crofts.

Jacobson, E. (1967) *Biology of emotions: new understanding derived from biological multidisciplinary investigation: first electrophysiological measurements*. Springfield, Illinois: C.C. Thomas Publisher.

Jaspers, K. (1963) *General Psychopathology*. Chicago: University of Chicago Press.

Jones, M. and Hunter, R. (1968) 'Abnormal movements in patients with chronic psychiatric illness', in G.E. Crane and R. Gardner (eds), *Psychotropic Drugs and Dysfunction of the Basal Ganglia*. Washington: US Public Health Service Publication No 1938.

Kay, S.R., Opler, L.A. and Fiszbein, A. (1986) 'Significance of positive and negative syndromes in chronic schizophrenia', *British Journal of Psychiatry*, 149, 439–48.

Kestenberg, J. (1975) *Children and Parents: Psychoanalytic studies in development*. New York: Jason Aronson.

Kraemer, H.C., Pryn, J.P., Gibbons, R.D., Greenhouse, J.B., Grochocinski, V.J., Waternaux, C., Kupfer, D.J. (1987) 'Methodology in psychiatric research: report on the 1986 MacArthur Foundation Network I Methodology Institute', *Archives of General Psychiatry*, 44, 1100–6.

Kraepelin, E. (1919) *Dementia Praecox and Paraphrenia* (translator R. Barclay). Edinburgh: Livingstone.

Laban, R. (1950) *The Mastery of Movement*, edited by L. Ullmann. London: MacDonald and Evans.

Laban, R. and Lawrence, F.C. (1947) *Effort*. London: MacDonald and Evans.

Liben, L.S. (1978) *Deaf Children: Developmental Perspectives*. New York: Academic Press.

Lowen A. (1958) *The Language of the Body*. New York, London: Collier Books, Macmillan Publishing Company.

Lund, C.E., Mortimer, A.M., Rogers, D. and McKenna, P.J. (1991) 'Motor, volitional and behavioural disorders in schizophrenia 1: assessment using the modified Rogers scale', *British Journal of Psychiatry*, 158, 323–7.

Luria, A.R. (1932) *The Nature of Human Conflicts: An Objective Study of Disorganization and Control of Human Behaviour* (translated and edited by W.H. Gantt). New York: Liveright.

Mahl, G.F. (1968) 'Gestures and body movement in interviews', in J.M. Shlien (ed), *Research in Psychotherapy* (Vol 3). Washington DC: American Psychological Association.

Mahler, M.S., Pine, F. and Bergman, A. (1985) *The Psychological Birth of the Human Infant. Symbiosis and Individuation.* London: H. Karnac (Books).

Malmo, R.B., Shagass, C. and Davis, J.F. (1951) 'Electromyographic studies of muscular tension in psychiatric patients under stress', *Journal of Clinical and Experimental Psychopathology,* 12, 45–66.

Manschreck, T.C. (1986) 'Motor abnormalities in schizophrenic disorders', in H.A. Nasrallah and D.R. Weinberger (eds), *Handbook of Schizophrenia: Vol. 1: The Neurology of Schizophrenia.* Amsterdam: Elsevier.

Marsden, C.D. (1982) 'Motor disorders in schizophrenia', *Psychological Medicine,* 12, 13–15.

Marsden, C.D., Mindham, R.H.S. and MacKay, A.V.P. (1986) 'Extrapyramidal movement disorders produced by antipsychotic drugs', in P.B. Bradley and S.R. Hirsch (eds), *The Psychopharmacology and Treatment of Schizophrenia.* Oxford: Oxford University Press.

McKenna, P.J., Lund, C.E., Mortimer, A.M. and Biggins, C.A. (1991) 'Motor, volitional and behavioural disorders in schizophrenia 2: the 'conflict of paradigms' hypothesis', *British Journal of Psychiatry,* 158, 328–36.

Misiaszek, J., Dooling, J., Gieseke, M., Melman, H. and Jorgensen, K. (1985) 'Diagnostic considerations in deaf patients', *Comprehensive Psychiatry,* 26,(6), 513–21.

Myklebust, H.R. (1960) *The Psychology of Deafness.* New York: Grune and Stratton.

Nathan, P.E. (1967) *Cues, Decisions and Diagnosis.* New York: Academic Press.

Nichols, V.L. (1985) *Effects of antipsychotic medication on the movement pathologies of chronic schizophrenics* – Masters Thesis. Philadelphia: Hahnemann University.

North, M. (1972) *Personality Assessment through Movement.* Plymouth: MacDonald and Evans.

Owens, D.G.C. and Johnstone, E.C. (1980) 'The disabilities of chronic schizophrenics: their nature and the factors contributing to their development, *British Journal of Psychiatry,* 136, 384–395

Owens, D.G.C., Johnstone, E.C. and Frith, C.D. (1982) 'Spontaneous involuntary disorders of movement', *Archives of General Psychiatry,* 39, 452–61.

Patterson, T. (1987) 'Studies toward the subcortical pathogenesis of schizophrenia', *Schizophrenia Bulletin,* 13, 4, 555–76.

Plutchik, R. (1954) 'The role of muscular tension in maladjustment', *Journal of General Psychology,* 50, 45–62.

Pulver, A.E., Carpenter, W.T., Adler, L. and McGrath, J. (1988) 'Accuracy of the diagnosis of affective disorders and schizophrenia in public hospitals', *American Journal of Psychiatry,* 145, 2, 218–20.

Reich, W. (1945) *Character Analysis.* New York: Simon and Shuster Inc (third edition, 1972).

Rogers, D. (1985) 'The motor disorders of severe psychiatric illness: a conflict of paradigms', *British Journal of Psychiatry,* 147, 221–32.

Scheflen, A.E. (1972) *Body Language and Social Order.* Englewood Cliffs, NJ: Prentice Hall.

Scheflen, A.E. (1973) *Communicational Structure: Analysis of a Psychotherapy Transaction.* London and Bloomington: Indiana University Press.

Scheflen, A.E. (1981) *Levels of Schizophrenia.* New York: Brunner/Mazel.

Shagass, C. and Malmo, R.B. (1954) 'Psychodynamic themes and localized muscular tension during psychotherapy', *Psychosomatic Medicine,* 16, 295–314.

Siegel, E.V. (1984) *Dance Movement Therapy. Mirror of Ourselves. The Psychoanalytic Approach.* New York: Human Sciences Press.

Waddington, J.L., Hanafy, A.Y., Dolphin, C. and Kinsella, A. (1987) 'Cognitive dysfunction, negative symptoms, and tardive dyskinesia in schizophrenia. Their association in relation to topography of involuntary movements and criterion of their abnormality', *Archives of General Psychiatry,* 44, 907–12.

Witkin, H.A., Dyk, P.B., Paterson, H.F., Goodenough, D.R. and Karp, S.A. (1962) *Psychological Differentiation.* New York: Wiley.

Wohlberg, G.W. and Kornetsky, C. (1973) 'Sustained attention in remitted schizophrenics', *Archives of General Psychiatry,* 28, 533–37.

Wolff, C. (1945) *A Psychology of Gesture.* London: Methuen.

Wolff, W. (1933) *Character and Personality,* 2, 168–76.

Wolff, W. (1935) 'Involuntary self-expression in gait and other movements: an experimental study', *Character and Personality,* 3, 327–44.

Emerging Methodology in Dance Movement Therapy Research
A Way Forward[1]

Bonnie Meekums and Helen Payne

Introduction

There is a real pressure to show that dance movement therapy (DMT) is effective (Theeman, 1973; Milberg, 1977), both from the practitioners themselves as well as from outside sources such as the health, social and education services and academic bodies.

This chapter aims to show that approaches such as illuminative evaluation (Parlett, 1974 and 1981) from an emerging paradigm methodology may be a helpful model for dance movement therapy research. We do this by referring in the main to two studies independently undertaken by each of us.

Dance movement therapy research

There is no reliable model for approaches to British research in DMT although those published studies by the authors, for example, Payne (1986, 1988, 1990) and Meekums (1988, 1991, 1992) commented on in this chapter have gone some way towards establishing a base of research.[2] In the literature from North America there have been several types of studies which use either quasi-scientific or case study methodology. This research generally falls into the category Johnson (1984) calls 'conceptualisation', that which uses a particular theory, developed outside the arts therapies, to organise meaning in DMT.

The authors have been involved in three separate research projects which use an emerging/new paradigm methodology to a greater or lesser degree. In the first

1 This chapter is an expansion of a previously published paper entitled *New Paradigm Methodology in Dance Movement Therapy Research* by Helen Payne and Bonnie Meekums of the same title in the Proceedings of the Second Arts Therapies Research Conference, City University, London.

2 For details of further research by the authors please refer to other chapters of this book.

(Payne,1987), young people labelled delinquent participated in a clinical investigation to explore their perceptions of the process of DMT.

In a second Meekums (1990) studied four dyads of mother–child interaction whilst they attended a programme of group dance movement therapy. All the dyads had been referred for DMT following concerns by social workers that the children were at risk of abuse, and that the bond between mother and child was fragile. The researcher gathered data on movement behaviour, information from social workers and maternal reports in relation to the DMT process. Conclusions were drawn concerning appropriate referrals to DMT for this client group and questions raised about the nature of language development during DMT as well as the development of mother–child attachment.

In a third (Payne, 1990), students on a post graduate training course in DMT were invited to collaborate in an inquiry into the nature of their experience in a two year DMT group as part of their training. This was related to any value the group experience was thought to have in the way they eventually practised as a dance movement therapist following graduation.

The old paradigm – a critique
In traditional research a hypothesis is stated, then the design aims to allow this to be tested. The study is pre-ordinate with fixed questions, tests and methods designed in advance. Such studies assume that no change occurs between the early and advanced stages of the research which could potentially affect the research questions. This approach is not responsive to the situation in action and as such restrains the research into, for example, a pre-post test or before and after method.

In order to make any generalized conclusions from such research, large samples are required, and statistics applied to the data to obtain results. This leads to the need for relevant parameters to be strictly controlled or randomized, which becomes expensive in resources and time.

In such research the researcher is divorced from the individual (subject), and the real world of the study environment; the effects of the research on both subjects and researcher are rarely reported. Matching groups of patients/clients are difficult to obtain, and this process is made even more difficult when those clients present with complex special needs, as with those labelled schizophrenic, autistic or delinquent. Equally, not all individuals in a group respond in the same way to DMT as an intervention and DMT is not a repeatable experience as is required in this approach to research. The analysis of change is enormously difficult; where attempts have been made errors in statistics have been shown (White, 1979).

Malcolm Parlett, in Parlett and Deardon (1977), claims that the quasi-scientific approach is for 'plants not people' and points out that innovations do not usually yield hundreds of subjects, making it impossible to do the research properly in the traditional manner. Yet, this form of research is heavily defended. Parlett suggests that this strong defence may be due to the fact that it presents

itself as reliable, objective, quantitative and value-free. Whilst the latter two are highly laudable, it is still possible to achieve the first two when researching innovations in which small samples and complex human factors make a so-called scientific paradigm inappropriate.

Sheldon (1982) criticises experimental group controlled studies because they perpetuate the 'therapist uniformity myth'. Any therapeutic intervention must, in part, be a function of the unique personality and style of the therapist. This is true of the research design and methodology as well, 'As we think so do we act' (Schwartz and Ogilvy, 1979).

Sheldon suggests that qualitative research methods might be most appropriate at the beginning of any evaluation and that there could be a gradual move towards theory testing.

We propose that, just as in DMT practice, the therapist cannot be separated from the process of DMT neither can the person be separate from the research. The notion of controlling for personality factors or for the experience of being in a group becomes irrelevant although these variables may still be of interest to the researcher in an attempt to understand the therapeutic process.

We do not believe that DMT is a repeatable experience like an aerobics class or behaviour modification programme might be. Sessions evolve in response to a complex web of factors which include the present moods of all participants, group dynamics, dyadic interactions and the individual style of the therapist. To prevent interaction between the researcher and the subject might also involve the withholding of pertinent information which could contravene ethical standards.

Bonnie Meekums has had experience as a research scientist studying the effects of anti-cancer drugs on cells 'in vitro' (in test tubes). Equal samples of cells were nurtured for equal durations at the same temperature, and given equivalent amounts of food. The only variable was the drug, or amount of drug administered. Controls, to which no drug was added, were always used to provide a baseline measurement. If human subjects had been used instead of cells the drug or placebo would have been administered and neither doctor nor subject would have known which was which. This is a so-called double blind trial.

There are several features to this very typical research design which deserve closer inspection. These are:

1. The separating out of subject (cells) from its context (body).

2. The homogeneity of the environment.

3. The measurability of input.

4. The measurability of subjects.

5. The use of a baseline measurement.

We will now comment on each of these in turn.

1. In DMT the human subjects can never be isolated from their context. People operate in systems such as the family amongst others. Virginia Satir (1978) suggests that changing one part of the system is rather like

moving one part of a mobile; the rest of the system moves too, though not necessarily in the same way.

2. The DMT programme and environment is not homogeneous. DMT is responsive to the client material and to the therapist. Both therapist and client are changed as a result of the experience.

3. DMT cannot be measured. Physical objects can be measured but what is the length of DMT, apart from counting the number of sessions that is? How much does DMT weigh and if insight is an outcome what is its width? DMT is not like a pill to be swallowed whole to the same extent by each participant. For example, the moods of the therapist and client, the amount of sleep they have had the night before, current life events all might have an effect on the receptivity of client and therapist to the emerging phenomena. Perhaps it is just this need for DMT research to fit neatly into this physical measurement system that has motivated such a focus on movement observation approaches as data for research in the US. If outcome of change is believed to be, for example, an increase in movement range, then we can at least measure this, but perhaps it is the desire to fit into the traditional research approaches that has led to the belief that this is indeed an outcome of successful DMT.

Wilber (1990) draws attention to the concept of measurement in his book *Eye to Eye: The Quest for a New Paradigm*. There is the measurement of extension: the physical world (for example, there are eight letters in the word 'physical'). There is measurement of intention: the mental world which is characterised by meaning, value or inter-subjective understanding; and there is measurement of transcendence, characterised by a subtle form of time which is all encompassing and where time and space are in the eternal moment together, transcending physical or historical time. Wilber goes on to point out that we need to acknowledge that measurement becomes infinitely more meaningless the higher up this spectrum we go and to be careful not to confuse what we mean by measurement of these, 'and the problem with empirical scientism was that, by measurement, it meant the easiest and most objective form of measurement; measurement of extensive gross-realm sensibilities' (Wilber, 1990, p.9).

4. Similarly subjects cannot be measured apart from the fact that ages, gender, socio-economic background and so on may be the same. Human variables are infinite, we are each unique. There is no generalisability that can take account of the particular. 'Science works with concepts which are far too general to do justice to the subjective variety of an individual life' (Jung, 1973, p.7).

5. Lastly, a baseline measurement is a nonsense, particularly when considering the 'double blind' notion used in drugs trials. It is impossible to pretend to administer DMT! And even if one attempts to make human measurement, for example, how attached a mother feels to

her child, it is not very likely that her answers will reveal a reliable baseline measurement until trust is built with her.

Bearing in mind these points, we are proposing that it is virtually impossible to prove the efficacy of DMT (this is not to say we need not address the issue of how efficacious DMT is); the old paradigm obsession with cause and effect becomes untenable due to the limitations of the methodological approach in this context. Some studies have followed the old paradigm approach, such as Lesté and Rust (1984) who limited themselves to the study of anxiety states before and after a course of modern dance. In so doing these studies may miss a wealth of information concerning the process of dance interacting with the individual and the group (Theeman, 1973), to say nothing of potential ripples within the wider system in which the individual lives. There is, therefore, a need for a rigorous research methodology which can address the complexities of DMT within given contexts.

The search for an emerging paradigm

If we acknowledge that there is an interaction between the client and the therapist, and that the therapist's gender, personality, movement behaviour, history and current personal issues, attitudes, values and personal philosophy form an embodiment for the therapeutic techniques, then it must be similarly assumed that the client's attitudes, hopes and expectations and so on play a highly significant role, even if these are unacknowledged and unconscious. This interactive system may be influenced by, for example, the way the session/research is presented to clients and by whom; whether the clients understand the relationship between the researcher and the institution, if indeed there is one; and whether or not information is disseminated to clients on the purpose of the sessions/research. Such aspects will also have an effect on the research and on the intervention planned.

One of the aims of the human potential movement has been to bring together arts and sciences into a new and unified vision of nature and potential of human existence. This integration is important rather than the predominance of one form over the other. All who engage in human inquiry, psychologists, anthropologists, economists, sociologists, therapists, educationalists are finding methods which are more appropriate to the subtleties and complexities of human life.

There are several crucial differences in attitudes and beliefs between the old and emerging paradigms. Reason (1988) refers specifically to three aspects which he considers have made a major contribution to the development of the new paradigm approaches to research:

1. Subjectivity.

2. Participatory and holistic knowing.

3. Knowledge-in-action.

Subjectivity

There has been a recognition that subject and object are connected, as acknowledged by observation scientists in the concept of 'complementarity'; light is both particle and wave depending on one's perception of its being (Capra, 1976). Although there are indisputably fundamental, unchangeable facts about the nature of light, the act and the method of observation can change the perceived nature of light, in that they determine whether light will be seen as particle or wave.

Milner (1977) said 'we must understand subjectivity otherwise the objectivity we aim at will be in danger of fatal distortion'. Until recently it was assumed that science was value-free and neutral and that by using 'scientific' methods, influences of society and the researcher could be avoided. However, literature on the sociology and history of science suggests that science too is a human activity and that scientific knowledge is a social product (Beals, 1970). The new paradigm therefore throws doubt on, for example, the assumption that observation can be carried out without any prior idea as to what will be objectively observed.

Peter Reason, in Reason and Rowan (1981) and Reason (1988), has referred to a quality of awareness in the researcher which he calls 'critical subjectivity'. He urges researchers to use their primary subjective experience as part of any inquiry process by raising it to consciousness. By honouring our individual experience, it can be used in the service of this critical subjectivity. This use of subjective knowledge is also one of the tools of the DMT practitioner who, for example, uses her kinesthetic impressions to alert her to her own counter-transference and thus to the process of the group.

How did we use critical subjectivity in our research? In one project (Payne, 1987) two important ways were (a) to ensure that the therapist's personal process in relation to both the DMT group and the influence she felt from the research process was documented, and (b) to ensure that supervision sessions were written up by both the supervisee and the supervisor which enabled a cross-checking of material contradictions.

Another project (Meekums, 1990) used the therapist's subjective responses to the mother–child dyadic interactions during DMT sessions. These were then cross-checked with video-taped recordings and verbatim notes of interviews with the mothers to compile a composite picture of each dyad.

Participatory and holistic knowing

As a result of the move away from the distance of objectivity in a new paradigm approach there is a move towards knowing based on a participative and dialogical relationship with the world. An important aspect of the current trend towards a more holistic practice is that it requires deeper participation. Holistic DMT requires the body, mind and spirit to become involved. Wholeness implies the participation of all parts. Participation in turn leads to empathy involving responsibility, we cannot truly take part unless we take responsibility. The methodology which clearly illustrates this concept is Heron's (1981) 'co-operative inquiry'. In

this approach, subjects act as co-researchers, as in, for example, the studies of Maruyama (1981) and Stanton (1989).

Aspects of phenomena are understood deeply because they are known within a context of our participation in the whole system, not as the isolated dependent and independent variables of experimental research. This dense knowledge, called by Geertz (1973) 'thick description', is both systemic and descriptive. Theory is then derived from a network or pattern of understanding.

How have we used such an approach in our research? We have both found that the use of co-operative inquiry had a limited application in at least two of our studies, in view of the developmental levels the clients were functioning at, both cognitively and verbally. In Helen Payne's recent study there is more engagement with a co-operative, or collaborative as it is sometimes called, approach. One way to engage with the principle though was to explain clearly the purpose of the research, stressing the need for honest and critical comment. In one study, as an aid to the client's clarification of roles an interviewer was trained rather than the therapist/researcher playing both roles (Payne, 1987).

However, Bonnie found in her study (Meekums, 1990) that when she trained a second interviewer responses were less informative or honest than when conducted by herself as therapist/researcher. In this case the 'therapeutic alliance' was an aid to the authenticity of the inquiry. The usefulness of training a separate interviewer may depend on the nature of the questions being asked. In the case of this study these were of a sensitive nature concerning the mother's relationship with her child. In the case of Payne (1987) it was concerned with the participants' perceptions of the DMT process.

Sometimes it was found helpful to set therapeutic goals together with the client (Payne 1987, Meekums, 1990), as well as involving the staff team in setting general aims for the programme. Video-playback and photographs were also successfully used in these two studies in order to engage clients in self-reflection. Full collaboration is always an ideal to strive for; however, perhaps only part collaboration is possible due to the complex nature of the client group, such as was undertaken with the young offenders in Helen's study. Here some responsibility was taken by them half-way through by deciding, for example, how data was to be collected but such involvement was not possible in the early design or later sense-making stages. Similarly with even less articulate clients it has been found to be difficult to engage them with the concept of collaboration or research, particularly autistic, psychotic and learning disabled clients whose cognitive, communicative and social functioning is severely damaged. In a recent study (Payne, 1990) Helen explored with participants more of an inter-dependent relationship, whereby their voice is heard in the design, data collection methods and analysis. It must however be acknowledged that not all those connected with the research will wish to become involved at all stages of the project. The need to offer client anonymity is an important ethical consideration when engaging clients in clinical research investigations.

Knowledge-in-action

Reason (1988) refers to this idea as being 'about the view that knowledge is formed in and for action rather than in and for reflection' (p.12). This should sit well with DMT practitioners!

The idea seems to be about taking a more practical, grounded approach to knowledge. This may take the form of implementing a solution to a problem as an integral part of the research process. Education and social action can then become more fully integrated with research; this again reflects a less alienated nature in the relationship of the researcher to the research setting.

How did we use this in our research? Bonnie (Meekums, 1990) found the dual role of researcher and therapist helpful in building trust and co-operation with clients. The therapists's perceptions were immediately assessed by the research since she was gaining access to data from the clients on an on-going basis through interviews and participant-observation, something not normally undertaken as part of the DMT programme. As the information was received it was incorporated into the planning of the DMT sessions and shared with the mother since recording was open. The fact that the mothers revealed more painful aspects of their relationships with their offspring as therapy progressed was accepted as normal. One woman complained at initial interview (prior to the DMT programme) that her child was needing to be the centre of attention, was whiny and disobedient. Using the mother's subjective impressions of her son's behaviour as a yardstick this problem appeared to change following implementation of the DMT programme, but only to the extent that the child was able to take turns occasionally for the attention in the family, a factor that could easily have been attributed to maturation. He also was reported by his mother to be more obedient but this was at least in part attributed by the mother to improved hearing following an ear operation. Perhaps more significant was the claim by both the mother and the social worker at initial interview that the child did not like being held. This situation had dramatically changed by the final interview after the DMT intervention. The mother talks about this improvement: 'He'll come and give me a cuddle without me asking...if I ask him to sit near me he'll do it – at one time he'd run off.. my kids are more loving to me. I feel they are mine now rather than just come out of the world'.

New information emerges from this statement which concerns the previous interactions between mother and child. We learn (implicitly)that the mother did not feel as if her children were her own, a fact which may well have influenced the way she asked for or responded to a cuddle. Now we find that she sees all her children as her own and more loving, not only the child attending DMT, indicating a whole family change. We also learn that the child's previous response was to run off when Mother asked for closeness, showing perhaps a desire to put distance between himself and his mother. The mother perceives that this too had changed.

The process of change involved the dance movement therapist, the therapy itself, the mother, the child and the wider family system as well as other group

members. Interactions between all these components of what can be seen as a larger system facilitated an on-going evaluation and modification of the goals for therapy in both the therapy and the research. This was possible even though the mother was initially unable to give words to her deepest problems in the relationship, as she saw them. At the beginning the researcher was unaware of the significance cuddles would have for this particular mother since her complaints were to do with levels of obedience rather than levels of affection. As the therapy opened new possibilities for this mother and child the research was able to respond to this. To have focused solely on obedience would have been to miss the point and the richness of the unfolding in the mother – child relationship. At interview during the half-way stage of the DMT programme the mother's focus had already changed revealing that her child had previously tended to stay in the corner at home but was not now exhibiting this behaviour.

In Helen's study (Payne, 1987) it became obvious that clients' perceptions of the therapy process, elicited from interviews, fed back into the sessions, for example what they felt was happening, what their experience was, the constructs they used to describe the therapist's ideas of what was happening but sometimes provided meaning from unpredicted phenomena. The research process was adapted to the findings at each stage, for example in the preliminary project it was found not to be conducive to the trust-building process to invite form filling as part of the research, particularly when administered by the therapist after DMT sessions.

Illuminative evaluation

This is a methodology which shares some of the same ideas found in a new paradigm approach to research (Parlett, 1974, 1981, 1983). Both authors have adopted it for extensive studies in clinical investigations of DMT. Parlett and Deardon (1977) explain the instances when illuminative evaluation might be the methodology of choice:

1. When the programme goals are complex and difficult to define precisely.

2. When the programme is dominated by local or other 'special' influences.

3. When the programme is not suitable for focalized evaluation designs because of any of the following:

 (a) lack of time;

 (b) a paucity of standardized data;

 (c) uncertainty about the precise questions to be answered.

They emphasize that rather than being a repeatable package, illuminative evaluation is a general research strategy. Parlett likens the work of an illuminative investigator to that of a clinical diagnostician for whom the course of inquiry cannot be charted in advance (Parlett, 1983). The problems define the methods in this approach not vice versa. Parlett does not rule out the use of quantitative data in line with a new paradigm. As in the use of triangulation a fuller picture

can be built up if perceptions from researcher, subjects and others involved in the research are incorporated; in this way light can be shed on problems as they arise, from different angles. By raising awareness in the people involved in the research, discussion about the system under study can be brought to bear on decisions. The approach is responsive to the whole system and to uncertainties, questions and points of view of differing players in the purview of the study. This requires a design which can change during the course of study, the evaluator orchestrating perceptions, analysing data, summarising commonly held positions and collecting suggestions for change. Parlett (1983) stresses that illuminative evaluation bears in mind the importance of the whole interacting system rather than isolating the individual from the whole. In this way phenomena are not taken out of context in order to be explored. He also asserts that the function of illuminative evaluation is not to test hypotheses but to document and understand the intervention. The final report needs to give a historical account of the teething troubles, successes and improvements in a programme and he outlines the systematic stages for achieving this:

1. Setting up.

2. Open-ended exploration.

3. Focused enquiries.

4. Interpretation.

5. The report.

Taking each in turn we offer an outline of what is involved in each stage.

1. In setting up the project there is a need to clarify the scope of the study without closing research doors by defining every variable to be studied. Proper consultation with interested parties is essential at this stage together with reassurance that the aim is not to pass judgement. In a sense the researcher is still setting up the research through to the point of write-up.

2. Open-ended exploration is a long and important stage. It implies total immersion in the programme in order to build a comprehensive picture.

3. Focused inquiry overlaps with the aforementioned stage but is marked by a particular exploration of the emerging themes or theme. Interviews may become more structured for example, or observations more selective.

4. Interpretation goes beyond extensive description; the researcher organises the data using interpretive and explanatory comment, if necessary going back to the source to check data and fill gaps in understanding. This is done by 'progressive focusing', that is, starting with an extensive body of data and reducing it to manageable themes on which to concentrate the next phase of the research cycle. This is essential to avoid data overload

and accumulation of unanalysed material while allowing unpredicted phenomena to emerge.

5. The report must be born in mind throughout the study so that issues of interest to a specific readership can be addressed, though without censorship or loss of autonomy. Here, as during the fieldwork, sensitivity to differing viewpoints is important. The accepted lack of objectivity is at this stage offset by the counter-checking of findings against existing opinion and research.

We have both experienced the use of illuminative evaluation in research and found it to be a most suitable approach. As our inquiry became more focused, a final picture emerged which was a gestalt from several points of view. The incorporation of data from, for example, movement observation, participant-observation, case histories, current life experiences, and client perceptions was found to be extremely important for deriving final conclusions. Unexpected results were also obtained, for example, that clients reported a development in language abilities.

Philosophical links between an emerging paradigm and dance movement therapy

DMT, like all the arts therapies, is concerned with the whole person, as an interacting part of a larger system which includes the therapist/client relationship, the family and the wider society. To attempt a false split, for example, to study the development of eye contact during the DMT session to the exclusion of a wealth of other data would be one way of 'objectifying' research and obtaining more or less reliable 'scientific' data. Yet to the therapist and DMT *per se* this is incongruent, DMT does not work this way. In order to understand the phenomena of DMT it is necessary to adopt such models which harmonise with the object of the study.

DMT in the way we like to think we practise it is a holistic discipline, unpredictable for the most part, changeable, responsive and multi-faceted, scary but exciting! There is a temptation to want to pin down DMT, to want to categorise it and label it to prove some arbitrary measure that it 'works', for example to prove that movement truly does reflect personality and therefore that DMT, in promoting changes in movement, engenders personality changes.

Who can really say whether a therapy works and in whose terms? There is no common yardstick for we are all unique, connected though we are to a universal, archetypal experience. This archetypal aspect of the Self has continually changed its definition of 'scientific investigation' for centuries.

Summary

In summary, the old paradigm, with its positivist, mechanistic and alienating world view is not always suitable for research in DMT if the aim is to truly understand and develop knowledge in the field. It is important not to lose the ideals of rigour and the need for critical and public knowledge. The emerging

paradigm is able to claim validity since the demands for self knowing, self reflection and self criticism are greater than found in the old paradigm.

After some immersion in the new paradigm ideas and a working knowledge of exploring them we would strongly urge potential dance movement therapy researchers to take a long look at integrating these ideas within their own self and inquiry requirements.

References

Beals, R. (1970) 'Who will rule research?' *Psychology Today*, 4, 75, 44–7.

Capra, F. (1976) *The Tao of Physics*. London: Fontana.

Geertz, C. (1973) *The Interpretation of Cultures*. London: Hutchinson.

Heron, J. (1981) 'Experiential Research', University of Surrey Human Potential Research Project and British Post-Graduate Medical Federation, University of London.

Johnson, D. (1984) 'Creative arts therapies as an independent profession', *Arts in Psychotherapy*, 11, 3, 269–72.

Jung, C. (1973) *Memories, Dreams, Reflections*. London: Fontana.

Lesté, A. and Rust, J. (1984) 'Effects of dance on anxiety', *Perceptual and Motor Skills*, 58, 767–72

Maruyama, M. (1981) 'Endogenous research: the prison project', in P. Reason and J. Rowan (eds) *Human Inquiry: A Sourcebook for New Paradigm Research*. Chichester: John Wiley and Sons.

Meekums, B. (1988) 'Dance movement therapy and the development of mother-child interaction: a pilot study'. Proceedings of 4th international conference, Dance and the Child International, Vol 2. Roehampton Institute, London.

Meekums, B. (1990) 'Dance movement therapy and the development of mother-child interaction', M.Phil Thesis, John Rylands Library, Faculty of Education, University of Manchester.

Meekums, B. (1991) 'Dance movement therapy with mothers and young children at risk of abuse', *The Arts in Psychotherapy*, 18, 3, 233–30.

Meekums, B. (1992) 'The love bugs: dance movement therapy in a family service unit', in H. Payne, (ed) *Dance Movement Therapy: Theory and Practice*. London and New York: Tavistock/Routledge.

Milberg, D. (1977) 'Directions for research in dance movement Therapy', *American Journal of Dance Therapy*, Winter, 14–7.

Milner, M. (1977) *On Not Being Able to Paint*. London: Heinnemann.

Parlett, M. (1974) 'The new evaluation', *Trends in Education*, 34, Innovative Issues. London: HMSO/DES.

Parlett, M. (1981) 'Illuminative evaluation', in P. Reason and J. Rowan (eds) *Human Inquiry*. Chichester, John Wiley & Sons.

Parlett, M. (1983) 'Illuminative evaluation', in *International Encyclopedia of Education and Research Studies*, 15. Oxford: Pergamon Press.

Parlett, M. and Deardon, G. (eds) (1977) *The Illuminative Evaluation in Higher Education*. California: Pacific Sounding Press.

Payne, H. (1986) 'Dance movement therapy with adolescents labelled delinquent', in Proceedings VIII Commonwealth and International Conference on Sport, PE, Dance, Recreation and Health, Study of Dance and the Place of Dance in Society, 309–15. Glasgow: E. and F. N. Sponsers.

Payne, H. (1987) Perceptions of adolescents labelled delinquent towards a programme of dance movement therapy. M.Phil Thesis, John Rylands Library, Faculty of Education, University of Manchester.

Payne, H. (1988) 'The use of dance movement therapy with troubled youth', in C. Schaefer, (ed) *Innovative Interventions in Child and Adolescent Therapy*. New York: John Wiley Interscience.

Payne, H. (1990) 'The dance movement therapy group experience as a part of students' learning within a post-graduate training'. Paper presented at conference, Arts Therapies Education – Our European Future, Hertfordshire College of Art and Design, St Albans, October.

Reason, P. (ed) (1988) *Human Inquiry in Action*. London: Sage Publications.

Reason, P. and Rowan, J. (eds) (1981) *Human Inquiry: A Sourcebook for New Paradigm Research*. Chichester: John Wiley.

Satir, V. (1978) *Peoplemaking*. London: Souvenir Press.

Schwartz, P. and Ogilvy, J. (1979) 'The emergent paradigm: changing patterns of thought and belief', Analytical report 7, Values and Lifestyles Programme. Menlo Park, CA: SRI International.

Sheldon, B. (1982) 'A measure of success', *Social Work Today*, 13, 21, 8–11.

Stanton, A. (1989) *Invitation to Self-Management*. Dab Hand Press: Ruislip.

Theeman, H. (1973) 'Research ethics: to do or not to do and if so, how to do', American Dance Therapy Association conference proceedings, eighth annual conference, Kansas.

White, S. (1979) 'Statistical errors in papers in the British Journal of Psychiatry', *British Journal of Psychiatry*, 135, 336–42.

Wilber, K. (1990) *Eye to Eye: The Quest for the New Paradigm*. Boston and Shaftesbury: Shambala.

The Feeling of Sound
The Effect of Music and Low Frequency Sound in Reducing Anxiety and Challenging Behaviour in Clients with Learning Difficulties

Tony Wigram

Introduction

Everyone grows up affected by the stimulating and the calming properties of music and sound. Sound is an integral part of living both in the animal and the human world, as well as the natural world. Over the centuries, music has been utilized for a great variety of functions, ranging from the relaxation and soporific effect in lulling a baby to sleep to the compulsive and forceful feelings generated in encouraging men to kill in battle. More recently though, closer investigation has looked carefully at the influence of sound and music in psychological processes, physiological activity, human behaviour and therapeutic treatment. The emergence of clinical music therapy, music in medicine and the psychology of music has begun to bring to public attention the very significant effects that can be caused by the use or misuse of sound and music.

In terms of the biological importance of music, Spintge (1988) describes the acoustic sense as the most important warning-sense of people. We are always aware of sound, and even during sleep we can perceive alarm signals. As the medium of sound and, as an extension to that, the organisation of sounds into music are essentially communicative. The process of communication throughout the animal and human kingdom is very sophisticated in its effect on our reactions and senses. Pitch, volume and tone quality (timbre) are varied both in speech, vocal sounds and music to convey a multiplicity of different messages. It is with this material and through this process that we can receive and process both the psychological and physiological impact of sound.

Exploration into the psychological processing of music and the associations between people through music has been well documented (Sloboda, 1985; Booth-Davies, 1978; Shatin, 1970). Further or specific investigations into the value of sound and music for particular clinical problems have included their

value in application to developmental therapy for sensory handicapped individuals (Bang, 1980; Darrow, 1993), in the treatment of psychiatric disorders (Priestley, 1975; Bunt *et al.*, 1987; Odell-Miller, 1991). The literature is extensive on the application of music, both in the medical field and in the fields of music therapy and music in special education. The application has varied from psycho analytic to physiological. Music has been used for behavioural programmes, as a palliative treatment and as an entertaining diversion. More recently, the physical effect of sound has been utilized in several studies and through different systems to facilitate the healing process in a variety of physical and psychological disorders. Researchers at Florida State University in Tallahassee have been looking at a combination of vibro tactile and auditory stimuli in a comparative study between the effect of music and the sound of a dentist's drill (Standley, 1991). The development of electro therapy through the use of ultrasound (Forster and Palastange, 1985) has become a standard treatment application for physiotherapists. Moving to the other end of the sound spectrum, recent objective research studies, and accumulated anecdotal reports from treatment in the use of low frequency sound in combination with music, have shown some significant effects on specific physical disorders and disabilities, as well as psychologically based illnesses.

This chapter is concerned with reviewing the application of vibroacoustic therapy (VA), comprising the combination of pulsed low-frequency tones and music to reduce anxiety in patients who have intellectual disability and challenging behaviour, and to reduce self-injurious behaviour in patients with severe intellectual disability. Arising out of developments in the early 1980s (Skille, 1982, 1985, 1987), investigative research began in the late 1980s to explore the effect of VA on a variety of different disorders, including cerebral palsy, oedema, pulmonary disorders, including asthma, cystic fibrosis and emphysema (Wigram and Weekes 1989, 1990; Wigram 1989, 1991; Skille *et al.*, 1989).

Musical structure has wide variants due to cultural influence, and the elements of pitch, timbre, volume, rhythm, melody, harmony and tempo will elicit widely differing responses from individuals from different cultures depending on the composition and structure. There are, however, universal principles that can be brought into play – in particular that low-frequency sound is more comfortable and relaxing, whereas high-frequency sound can raise tension. Rhythmical music is stimulating and can invigorate, whereas non-rhythmical music can be calming and unstimulating. Low-frequency sound is a term used to describe frequencies below 120 hertz (Hz), whereas infrasound is usually understood to be frequencies below 20 Hz.

The equipment used in VA therapy consists of a purpose-built bed or chair with between four and six bass speakers built into it. This unit is connected to a signal unit, amplifier and stereo tape cassette deck which can run the specialised tapes that have been prepared for the treatment programmes.

The treatment process involves lying a client on the bed so that the sound is being felt in the body of the client. The vibration may also be transferred through

a mattress or some other means which can conduct the soundwaves directly to the body. The body vibrates according to the different soundwaves, and at 100 Hz, 2 per cent of the energy is absorbed by the client (Broner, 1978). As one might expect, the soundwaves also have a substantial effect on the autonomic system.

Alongside the development of the music bed, it was necessary to develop taped programmes that would be varied and effective in treating different problems. Cassette tapes were made up with a mixture of music and rhythmical pressure waves which are in harmonic relation to the music. A pulsed tone is created by placing two tones very close together, i.e. 40 Hz and 40.5 Hz. The music used is recorded over a pulsed, low-frequency tone, and is invariably gentle, improvised and without a pronounced rhythm. Music has been written specifically for this therapeutic process, for example an improvisation on the tone E by the Finnish composer, Otto Romanovski. In addition, existing 'New Age' music by composers such as Don Campbell and Steven Halpern has been used. As far as the use of specific tones is concerned, subjective tests have indicated that the most significant frequencies range between 40 and 80 Hz. The lowest frequencies, 40 to 55 Hz will predominantly set up a resonant response in the lower lumbar region, pelvis, thighs and legs. As one moves through the frequency range, so the sound resonates in the upper chest, neck and head (Skille and Wigram 1993).

Study 1: VA therapy for clients with a learning difficulty who have challenging behaviour and are prone to anxiety

Some evidence had already been forthcoming, indicating the effect of VA in reducing levels of stress (Lehikoinen, 1989). Funding became available from the Spastic Society, a department of which was particularly interested in this therapeutic intervention for people living in long-stay hospitals for the learning disabled who have challenging behaviour.

In designing a research study, measuring increases or reductions in anxiety is a complicated process, due in no small part to the ambiguity which surrounds the definition of anxiety. Anxiety can refer to a state, a trait or a process, and the individual's experience of this may be driven by any one of these separately or by a combination. In the dictionary, anxiety is described as 'an emotional condition in which feelings of fear, dread and mental agitation predominate' (*Butterworths Medical Dictionary,* 1978). Freud (1926, 1936) first brought it into the clinical terminology as part of his theory of personality, where he focused on anxiety as a 'global motivational force rather than on the experience of anxiety'. Spielberger (1975, p.137) described state anxiety, where anxiety is an emotional state, as 'subjective, consciously perceived feelings of tension, apprehension and nervousness accompanied by or associated with activation of the autonomic nervous system'. From this point of reference, physiological or motor activity can be looked at to evaluate changes in the state of anxiety. Trait anxiety is viewed as a personality characteristic, where a person will perceive situations as threatening, and as such, respond to those situations with a raise in their anxiety level

(Spielberger, *et al.,* 1966, 1970), whereas state or process anxiety, according to Spielberger (1975, p.121), is a 'complex sequence of cognitive affective and behavioural events that is evoked by some form of stress'. In terms of neurotic anxiety, psychoanalytic theory is concerned with the influence of over-stimulation, where over-stimulation refers to the existence of many impulses, wishes and needs that cannot be gratified, whereas behaviourists consider it to be the result of classical conditioning where anxiety is an internal response that may be learned.

The studies on the effect of music in reducing anxiety both in the acute sector and in the psychiatric field have looked at both physiological and behavioural outcome. Zimmerman *et al.* (1988) undertook a study in a coronary care unit to look at the effects of music on patient anxiety. Dividing 75 patients randomly into two experimental groups, one of which listened to music and the other to white noise, they measured the effect through the state anxiety inventory and by blood pressure, heart rate and digital skin temperature.

They found no significant difference between the two groups in the state anxiety scores or the physiological parameters, but when analyses were conducted of the groups combined, significant improvement in all of the physiological parameters was found to have occurred. Reardon and Bell (1970) undertook a study to look at the effects of stimulative and sedative music on activity levels of severely retarded boys. They found that the subjects were demonstrating lower activity levels during the more stimulating condition. Another study looked at the effects of stimulative and sedative music on cognitive and emotional components of anxiety (Smith and Morris, 1976). A study on the effect of music on anxiety (Hooper and Lindsay, 1989) compared live music in the form of music therapy with recorded music on four female subjects, measuring through pulse rate and a rated scale of behaviour. They found no improvement under the control conditions, whereas the music conditions produced some improvements in the behaviour of the subjects and a decrease in their heart rate, however, the changes in the heart rate could equally have been attributable to other factors.

Finally, Saperston (1989) has developed a Music-Based Individualized Relaxation Training (MBIRT) in a stress reduction approach for the behaviourally disturbed mentally retarded. MBIRT is a behaviour therapy approach where one or more elements of music are incorporated in individualized task specific training strategies. These are designed to elicit and/or shape one or more behaviours identified as necessary in the eventual achievement of a generalized state of relaxation. The assumptions here are that the clients' music preferences should be incorporated to facilitate the process; sedative music is best for facilitating a relaxed psychological and physiological state. The clients' music preferences are based on psychological and physiological factors that can be helpful in interpreting responses to different musical stimuli, and the clients' music preferences can be modified to facilitate more relaxed responding. Earlier studies in American literature (Gaston, 1951; Shatin, 1970; Wascho, 1948) had given some evidence of the value of different component parts of music to make it either stimulative or sedative.

Against this background, the first study described in this chapter looks at the effect of low-frequency sound and sedative music combined on patients with anxiety and challenging behaviour. Physiological and behavioural measures were taken to investigate whether any changes occurred that could support the efficacy of this intervention.

The ethics of research into anxiety

The subjects in this study were residents in a long stay hospital for learning disabled people (formerly known as mentally handicapped). They exhibited a range of behaviours that were difficult to clearly identify as representative of a state of anxiety, but had definitely grown over a period of time into chronic conditions that could be exacerbated in an anxiety rating situation. The problem for the researchers initially was to evaluate the effect of the treatment on a raised level of anxiety. It is unethical to artificially raise anxiety levels, and could be damaging and certainly upsetting.

However, a situation presented itself where the disruption to the routine of life would inevitably cause some elevation of anxiety in this client population. Due to the success of the resettlement programme where patients are moved back into community centres, the hospital contraction necessitated the closure of a ward of 25 middle-aged residents with challenging behaviour, and the process of closure involved moving these patients to other wards in the hospital. Many of the patients in the ward scheduled for closure had lived there for many years. The disruption and uncertainty involved in moving, as well as the problems of forming new relationships with patients on other wards and coping with a different environment was sure to cause anxiety amongst this group. Therefore the study was set up to investigate whether VA would have any influence in helping the patients who were moving cope better with the move and reduce their anxiety.

Design

Ten subjects were referred from the resident group on the ward to take part in the study and were randomly assigned to two groups. All the subjects were female and their ages ranged from 40–65 years. They were all intellectually disabled, some verbal and some pre-verbal. Previous research in VA has indicated that it is the combination of music with a low-frequency tone that has both a physiological and a psychological effect of relaxing subjects or affecting behaviour (including physiological behaviour). Therefore, one group received VA on a treatment unit, consisting of a 30-minute tape of New Age music onto which had also been recorded a pulsed low-frequency tone of 44 Hz. The other group received the same music through a separate pair of loudspeakers positioned on a shelf in the room, without the low-frequency tone. The low-frequency tone of 44 Hz acted as the independent variable, and all other elements in the trials were kept constant to avoid the effect of influencing variables.

The dependent variables were behaviours that were identified in each of the clients individually as indicative of anxiety, and physiological measurements of

heart rate and blood pressure. Each subject was observed, and after discussion with the ward staff three specific identifiable and observable behaviours were chosen that could indicate the level of anxiety in a client. Such behaviours included restless pacing, rocking, picking at clothes, dressing and undressing without any purpose, continuous talking or sitting in foetal position. Baseline measurements were taken in all cases, usually two sessions. Familiarisation of the researchers with their equipment was allowed for, and inter-observer reliability tests were conducted to ensure that the two assistants were measuring to within +/- 10 per cent of each and the more complicated observational measurements were undertaken. During the trials, additional baselines were taken as were consistency checks. The identified behaviours were monitored by observation, and recorded using a portable computer which could count the number of occasions a behaviour occurred and record in seconds the duration of the behaviour. Therefore the data of these observational studies was able to give with great accuracy the frequency of the behaviours and the duration over a period of half an hour of those behaviours. In all cases, sleep was also recorded as a behaviour. Early familiarisation tests entering baseline measurements showed that the independent observers were generally consistent and had well correlated results (+/- 10% once familiar with the procedure).

The subjects in group 1 had six sessions of VA lasting 30 minutes, followed by six sessions of 'after treatment' observation, and the subjects in group 2 had six sessions of the placebo, followed by six sessions of 'after treatment' observation. Blood pressure and heart rate was taken after a five-minute resting period, and at the end of each treatment/placebo session. The researchers then accompanied the subjects back to their ward or day unit and observed their behaviour for a further 30 minutes (after treatment observation). In both groups, the trials were undertaken over a six-week period, with two trials each week. The first six trials were undertaken before the residents were moved from their ward, and the last six trials were undertaken after the move from the ward. The study was intended to evaluate both the effect of the move on the two groups, and the effect of treating one group with VA and the other group with the placebo, so the study was both a 'within subjects' and a 'between groups' design.

The music and the low-frequency tone

The music used in these trials was constant for all the subjects. A piece of 'New Age' music by Daniel Kobialka entitled *Timeless Lullaby* was chosen. The music is electronically produced, and is a very gentle, floating, unrhythmic piece, using conventional harmonic chord structures underneath with a free moving, random melody line, and long sustained chordal structures. The piece is very slow moving, and wanders from root position tonic chords to using sub-dominant and super-tonic overstructures on a tonic base. The timbre of the sounds in the chord structures underneath are very 'string like', and there is also a 'bell like' quality to the tune. The timbre of the electronically produced sound is quite pure and simple, and is a good complement to the pulsed, low-frequency sinusoidal tone

that was put on the tape underneath this music. In this case, the tone was 44 Hz – a low A.

Results

The results give us some indication of the differences between the groups and also within the groups during and after the sessions. As the trials proceeded, it became apparent to the researcher that some of the behaviours that had been initially identified as 'anxiety provoked' were more likely habit-formed, or driven by institutionalised activity. We therefore separated out the behaviours we were monitoring into three discrete groups. Behaviours which were definitely provoked by anxiety (such as temper tantrums, self-injurious behaviour etc); behaviours that were more likely indicative of restlessness, but which also could be indicative of anxiety (pacing around, obsessive movements); and finally, behaviours we identified with hindsight and familiarisation to be indicative of habitual, perseverative or manneristic activity, and not necessarily provoked by anxiety.

Table 13.1: **Mean scores after moving out of their ward on all behaviours (Beh) and sleep (S)**

All behaviours	During Session		After Session	
Total means S = Sleep	Beh	S	Beh	S
Group 1 VA	9.70	19.41	17.02	6.84
Group 2 Placebo	19.07	27.5	20.87	12.00

Table 13.1 shows the difference between the two groups on all behaviours, and represents the percentage of time the behaviour was occurring during the session overall within the group. One can see a greater incidence of the behaviours in the group which was receiving the placebo, and also to a lesser extent after the session when they were being monitored on the ward.

Table 13.2: **Mean scores after moving out of their ward on all behaviours (Beh) except habit-formed behaviours and sleep (S)**

Behaviours	During Session		After Session	
minus habit-formed behaviour	Beh	S	Beh	S
Group 1 VA	8.21	19.41	14.60	6.84
Group 2 Placebo	13.78	27.50	27.50	12.00

Table 13.2 shows only the behaviours that we latterly considered to be indicative of anxiety and restlessness. It shows that the VA sessions had a greater effect in reducing these behaviours both during and after the session.

Table 13.3 **Means of restless and anxiety provoked behaviours (R)(A) and sleep behaviour (S) after moving out**

Restless	During Session			After Session		
behaviour = R Anxiety behaviour = A	R	A	S	R	A	S
Group 1 VA	8.66	6.51	19.41	23.90	6.04	6.84
Group 2 Placebo	12.99	5.68	27.50	52.60	6.35	12.00

Table 13.3 gives in a little more detail the total means for the behaviours identified as indicative of restlessness and anxiety separately. It gives some indication of the after effects of this therapy, particularly in the difference in restless behaviour which is significantly less in the group that had VA.

Conclusions

The trials showed that physiological responses and behavioural responses within the context of this trial (i.e. Pulse/blood pressure (BP) vs observed behaviour) are not directly correlatable. This is a very important conclusion but will require further work before it can be confirmed. Most VA research to date indicates that blood pressure and pulse rate are generally lowered by VA, and some studies have compared the effect with a placebo treatment similar to that described in this chapter. The low-frequency component is significant, and this study adds weight to this.

Two factors lead us to conclude that lowering of blood pressure and pulse cannot be correlated with behaviour. The first is that BP/pulse results show a general tendency to fall throughout the test (for the fully treated group). No significant changes are noted when the clients are relocated. However, behaviours change markedly after relocation. The second is that behaviours in any given client do not have a point to point correlation, i.e. a drop in BP between trials shows near random correlation with a change in behaviour. Similarly for pulse measurements.

The behavioural results show large swings in many cases indicating that external factors were influencing the results. This is largely unavoidable, given the nature of the study. The questions at issue here are whether the external factors obscure underlying trends. This will be discussed later.

Apart from baseline sessions, there were treatment sessions (described as 'during' on the charts) and post-treatment sessions (described as 'after'). All observations lasted for 30 minutes and precise information on rate, frequency and individual events were all recorded.

Pulse and blood pressure

The VA group showed a negative trend of -5 for heart rate, and of -18 for systolic blood pressure (BP). The placebo group showed a positive trend of +4 for heart rate, and +22 for systolic blood pressure. The indication is that repeated VA treatment causes increasing reductions in pulse rate and BP. The control group showed near zero (or slightly positive) trends, the VA group showed negative trends. This accords with previous research (Wigram and Weekes, 1989, 1990). Of note is the surprising result that relocation did not appear to adversely influence this trend for either group. External factors appear to be less important in this. It is very important to note that we have been looking at the amount by which BP and pulse fall over a 30-minute period. The fact that this increases over time with VA (to some maximum which does not appear to have been reached in 12 sessions) gives no indication on rates of restitution (recovery of BP and pulse after the session) and a false conclusion would be that this indicates VA generally lowers blood pressure or pulse rates. What we are seeing is that repeated VA is accompanied by a tendency to larger falls in BP/pulse. More specific work needs to be done to establish any inter-session trends, and further study in this area would be important before any conclusions relating to benefit could be confirmed.

This and previous studies indicate that VA has a similar action on a wide range of people as far as these trends in BP/pulse are concerned. This is becoming a most important positive result, subject to more specific research.

Effect on behaviours

A very substantial amount of data was collected and finding suitable summaries has presented a challenge. Three behaviours were analysed for each client. Percentage occurrences of these behaviours have been charted and the most important observation is that they give markedly 'individual' results, which makes grouping (other than presentation of sets of individuals by group) statistically inadmissible. Most obvious from these results is that the relocation experience caused easily noticed changes in behaviours for most clients. In most cases these tended to settle down after a while. The encouraging sign is that the intuitive expectations seem to be borne out in the observed results. Most important, our measurement techniques were sufficient to capture some of these behavioural changes. This increases confidence in the meaning of the results obtained.

Raw results

The raw results do not show any obvious pattern. Many results show behaviours coming and going during the test with no apparent relationship to point in the

trial or whether VA treatment was given or not. The means and standard deviations for the clients indicate few results which could be meaningfully interpreted as trends. Behaviours changed noticeably at session 7 for many clients. This is the point at which clients were relocated. That this factor is much more noticeable than the effect of the VA treatment is significant because it highlights the importance of external factors in behavioural measurements of this type.

There is much than can be drawn from these results. First, we now recognize that short-term trials (in this case 12 sessions) monitoring behaviour will be very prone to the external influences on behaviour. Subtle effects, which are to be expected from short treatment sessions are prone to being swamped as a result, causing difficulties in measurement. Second, behaviour is modified by the trials alone. One of the difficulties during the trials was that treatment had to be on an unfamiliar site, which itself created anxieties which influenced the results.

There are two possible ways of limiting this effect:

1. Longer adjustment phases (more baseline trials).

2. Trials on a familiar site.

Both have their difficulties. Some method of determining when a client is sufficiently comfortable with the process is needed. The research reports indicate at least six sessions if a new site is required.

Ironically, the one positive result in these trials is that relocation causes significant changes in behaviour patterns, and this worked against us in the way we conducted the trials. Relocation was a good choice for behaviour monitoring. Unfortunately, the hidden elements of relocation (trials in the VA unit) needed to be eliminated by a longer baseline preamble.

Conclusions for behaviour monitoring

The conclusions drawn can be summarized as follows:

1. Any possible effects of VA as a behaviour modifier are subtle compared with external factors. They were not demonstrated by this trial.

2. The technique of monitoring and the information gathered (events and duration) gave a good numerical indicator of observed behaviour. The validity checks and generally well thought out approach to the measurement programme is a firm basis for future work.

3. The original objective of looking at the effects of VA before and after relocation was (in retrospect) very ambitious. Studies to explore the effect of VA under simpler conditions are required first.

4. Research on physiological responses: the initial studies on BP/pulse measurements indicate some progressive action over time. What cannot be established from these studies is any wider implication. Work needs to be done on restitution/recovery responses. At the moment, long-term benefits of VA are largely only supported by anecdotal information and some more controlled research is required.

5. Research on behavioural responses: clearly this will continue to be a difficult task. External influences on behaviour have to be minimized. For handicapped people, adjustment to the trials' environment will be necessarily longer. The clinical environment is often threatening. Simple tasks like taking pulse can generate strong responses (association with injections and other treatments plays a part in this).

6. Preamble trials are required. These should look to ensure that some steady state has been reached in the client/trials/observer relationship. Achieving this will require more observer contact. Familiarisation sessions (all but the explicitly VA related component) should form part of the first phase of any study.

7. Single factor studies only are possible at this stage. For the programme to yield any meaningful results, we must concentrate on monitoring the effect of VA *per se*. Clients should be selected on the basis that little external changes are taking place and that their environment is as stable as possible for the duration of the study. Day-to-day mood changes, and consequent behaviour changes, may still obscure the results. The only way to minimize this will be to continue the study for as long as possible.

Study 2: The effect of vibroacoustic therapy on people with learning disability who display self-injurious behaviour

Reviewing the literature of the last ten years, there has been a considerable interest demonstrated by a multiplicity of research investigations into the causation and treatment of self-injurious behaviour (SIB). SIB is considered to be 'any behaviour, initiated by the individual, which directly results in physical harm to that individual' (Murphy and Wilson, 1985).

Such physical harm is considered to include bruising, lacerations, bleeding (internal or external), bone fractures and breakages, and other tissue damage. Most commonly, self-injury takes the form of hand-to-head banging and head-to-object banging. Other behaviours include: face and finger gouging or picking, where this produces open wounds; self-biting, where this produces bruising, bleeding or even amputation; and self-pinching, where this produces physical damage. SIB occurs in 10 per cent of severely and profoundly mentally retarded institutionalised populations.

Causes

There are various hypotheses on the cause of SIB. First, the learned behaviour hypotheses proposes that people self-injure in order to gain something desirable, often from their careers. As a result of either positive or negative reinforcement, the SIB can be precipitated. For example, positive reinforcement may involve giving a person a cuddle or a pleasant social experience, and as a result behaviour is perpetuated by the individual's desire for that 'reinforcement'. Negative rein-

forcement occurs when the individual displays SIB in order to prevent attention or interference.

Second, organic and pharmacological origins propose that people self-injure from one of two organically determined diagnostic categories. In the case of genetic abnormalities there are two organic syndromes which cause SIB – Lesch-Nyhan Syndrome and de Lange Syndrome. These syndromes are both characterized by biting of the lip or the hand, and it is assumed to be due to the distribution of neuro-transmitters. In these syndromes, it has been suggested (Corbett and Campbell, 1980) that neurological and bio-chemical events, particularly in the lymbic system, cause SIB. In the case of non-genetic abnormalities, one example is the case of otitis media causing head-banging due to internal pain as a result of infection of the middle ear.

Third, self-stimulation hypotheses suggests that tactile, vestibular and kinesthetic stimulation is insufficient, and the individual may indulge in SIB as a means of providing sensory stimulation. It has been suggested (Williams and Surtees, 1975) that SIB can occur during very low levels of stimulation and also very high levels of stimulation. In other words, people may self-injure when they are either bored or when they are over-stimulated.

Fourth, the developmental hypothesis speculates that if head-banging is a normal part of development in infants, problems of SIB occur when the behaviour persists. This theory is related to lack of stimulation, as it may occur in infants lying in bed in a dark room alone without anything to do.

An additional hypothesis is psychodynamic, where it is proposed that SIB may develop in an attempt to distinguish the self from the external world.

Estimates on the prevalence of SIB vary. A study in America (Griffin et al., 1986) found out of a population of 10,000 clients in 13 residential facilities for the mentally retarded in Texas, an incidence of SIB among 13.6 per cent of this population. Of those, 89.8 per cent were found to be severely and profoundly mentally retarded. However, another study conducted through a mail survey of non-institutionalised mentally retarded people in the Federal Republic of Germany found, amongst a population of over 25,000 through 294 facilities, an incidence of SIB among only 1.7 per cent – which is considerably lower than other estimates.

Dependent on the cause, a variety of modalities of treatment have emerged, some successful and some less reliable. The objective of many of the treatment modalities was to introduce a behaviour modification procedure, which could gradually be withdrawn when the incidence of SIB reduced. Some form of restraint is very typical amongst the treatment procedures (Hamad et al., 1983), and commonly appliances have been used to protect the individual and to prevent tissue damage – such appliances included padding, padded chairs and cushions, mittens, elbow splints, capes and helmets (Spain et al., 1984). Other techniques included correction procedures and over-correction procedures (Gibbs and Luyben, 1985) and such interventions as a water mist (Bailey and Pokrzywinski, 1983). Depending upon the cause of the behaviour, differential reinforcement of

other behaviours has also proved effective, except in cases where the individual is undertaking SIB in order to avoid attention.

Many of the studies undertaken have involved very small sample groups; often only a single study design is used.

Treatment procedures and research also focused on the more behavioural methods of intervention, and this study arose out of the possibilities of stimulatory treatment, in particular vibratory stimulation (Bailey and Meyerson, 1970). It is also linked with the possibilities defined in relaxation and desensitisation, where, in a study by Steen and Zuriff (1977), relaxation was found to be effective in reducing SIB, particularly if SIB occurs when the person is tense.

Method

Three subjects were selected for the study, and were treated as individuals in a single case study design. Subject 1 is a 27-year-old man with learning difficulties who self-injures by consistent slapping of his face with one or both hands. When not slapping, he can also be in a state of arousal and tension resulting in hand activity on his body or hand plucking. SIB was particularly noticeable with this young man during any form of intervention, when his anxiety levels seemed to rise.

Subject 2 is a 31-year-old man who also self-injured by banging his head with one or both hands and also by rubbing his head until the hair fell out. In this subject, there is no clear evidence of a reliable antecedent to the SIB, which in itself causes distress for careers.

Subject 3 was an extremely disturbed young lady of 26 years, whose SIB consisted of banging her head against walls, floors and objects. She would also pick at her skin, and her head was so damaged that a large part of the left-hand side of her skull and the rear of her skull was very pulpy.

In addition to SIB, the third subject had extremely difficult behaviours, including kicking patients and staff, biting and scratching patients and staff, pinching and grabbing, which necessitated almost continuous periods of restraint. Subject 1 was frequently restrained by being wrapped in a sheet, and Subject 2 was often equipped with mittens to prevent SIB.

Design

In order to evaluate whether VA had any effect as a stimulatory alternative to self-injurious behaviour, it was decided to treat the subject four times a week over three weeks, using a within-the-subjects design. Baselines were taken by monitoring the behaviours on an HX20 Epsom computer, where different behaviours were assigned to different keys on the keyboard. In this manner, an extremely accurate record of the number of SIB events, together with their duration, was taken, both during the baseline and the subsequent treatments. Subjects took part in sixteen trials, eight where they were given VA and eight where they were played the same piece of music through an ordinary stereo system (without low-frequency sound) in order to facilitate normal relaxation. Subjects 1 and 2 were

observed and their responses recorded using the computers throughout the half-hour period of treatment placebo treatment. In the event that either subject began SIB, it was decided to observe the behaviour for a period of five minutes, following which, if the behaviour still perseverated, the subject would be restrained for ten minutes. Then a further period of five minutes free from restraint followed, and if SIB again perseverated, the subject was restrained for the final ten minutes of the session.

Subject 3 was under continuous light restraint throughout the treatment for reasons of safety, as well as being observed similarly to Subjects 1 and 2.

Behaviours that were monitored

Blood pressure was not taken with these clients, as that would have unduly irritated or upset them at the beginning of the treatment. The following behaviours were recorded for each of the subjects:

Subject 1

U = Unrestrained

R = Restrained

1 = Slapping face while unrestrained

2 = Slapping face while restrained

3 = Attempting to slap face while restrained

4 = Sleep

D = Disaster

5 = Gentle hand stroking

6 = Frenzied hand clasping

Subject 2

U = Unrestrained

R = Restrained

1 = Slapping head while unrestrained

2 = Slapping head while restrained

3 = Attempting to slap head while restrained

4 = Sleep

D = Disaster

5 = Rubbing head on back of chair

6 = Slapping elsewhere

Subject 3

U = Unrestrained

R = Restrained

1 = Banging head while unrestrained

2 = Banging head while restrained

3 = Attempting to bang head while restrained

4 = Sleep

D = Disaster

5 = Resisting restraint

6 = Aggressive behaviour after breaking restraint

The observers recorded a D (Disaster) if one of the subjects became so self-injurious that they were forced to stop recording while they calmed down the subject, or otherwise dealt with the situation.

The music and the low frequency tone

For these trials a tape of classical 'cello music was chosen. Julian Lloyd Webber played a series of pieces, including:

Bailero from *The Songs of the Auvergne* arr.	Cantaloube
'Softly awakes my heart' from *Samson and Delilah*	Saint-Saens
Elegie	Faure
Bachianas Brazileiras No 5	Villa Lobos
Arioso	J.S.Bach
Serenade from *Hassan*	Delius

The music is quite gentle and relaxing for the majority of the tape, and the quality of the rich sound of the 'cello against the supportive background of an orchestral accompaniment lends itself very appropriately for use in VA therapy. The researcher put a tone of 41 Hz on a slow, five-second pulse, under this music. The five-second peaks of the pulsed tone did not interfere rhythmically in any way with the variety of rhythms there were in this selection of classical music, and the lowness of the tone did not appear to conflict with the modality of the various pieces that were played. It appeared to our discernment that frequencies of 44 Hz and below were such a low throbbing tone that they didn't conflict generally with the different modalities of the music. Using frequencies of 50 Hz and above, if the modality of the piece was markedly different from the low-frequency tone, one was conscious of some annoying interval clashes, particularly tritones, major and minor seconds and major sevenths.

Ethical problems

It was apparent before, and became even more apparent during the study, that the ethical problems related to how long one could allow SIB to perseverate before conventional forms of restraint were applied to these subjects. The ethical question the researchers had to consider was that in order to evaluate the effectiveness of the treatment, it was necessary to design a study which investigated whether there was increased or more sustained SIB during the placebo treatment than there was during VA therapy.

Results

The results of these trials showed fairly clearly that Subjects 1 and 2 responded positively to VA and there was a reduction in their self-injurious behaviour during the session, and, in the case of Subject 1, after the session, whereas Subject 3's difficult behaviours and aggression towards the staff made it impossible to be clear about the effect of this treatment on her.

Table 13.4: **Mean duration of positive and negative behaviours (in seconds) in the two conditions**

Subject 1	With VA (Placebo)	Without VA
Negative behaviour		
R + Beh 1 + Beh 3	656.50	807.75
Total	*656.50*	*807.75*
Positive behaviour		
Beh 5	1010.75	800.00
Beh 4 (sleep)	0.00	0.00
Unrestrained – Beh 1 + 6	1193.87	989.00
Total	*2204.62*	*1789.25*

Table 13.5: **Mean duration of positive and negative behaviours (in seconds) in the two conditions**

Subject 2	With VA (Placebo)	Without VA
Negative behaviour		
Beh 1	14.5	90.00
Beh 6	21.62	32.75
Positive behaviour		
Beh 5	917.25	578.25
Beh 4 (sleep)	148.75	0.00

The results show that in a 30 minute (1,800 second) session, there was a proportion of both positive and negative behaviours. Subject 1 indicates that, on average, when we were using VA therapy the accumulated mean scores of restraint, Beh 1 and Beh 3, which we have put together as a total result for negative behaviour, are occurring for less time than when we didn't use VA. Correspondingly, there is more positive behaviour, in particular Beh 5.

When Subject 1 was not being restrained, and we took away the scores accumulated in Beh 1 and Beh 6, we counted this as the positive time period during the session, and this also was better when we were using the VA treatment than when we were using the placebo.

Subject 2 gives a correspondingly encouraging result. In Table 13.5, Beh 1 (face-slapping behaviour) is markedly less with VA, on average, than without, and Beh 6 is also less. His positive behaviours were improved during VA, and there was one occasion when he slept for a large proportion of the session.

Subject 3 had such diverse results, due to the confusion over her aggressive behaviour which was very prevalent throughout the session, that VA had no significant effect on her self-injurious behaviour.

Discussion

Overall, we find the results going in the right direction with both Subject 1 and Subject 2. With Subject 1, we also received anecdotal reports from the ward of a reduction in his self-injurious behaviour on the ward during the period of the trials, and the staff recorded many less incidents of having to use restraint with him. They also recorded that the effect of the relaxation was to improve his bowel movements and reduce the number of times they used enemas. Although one can see some worthwhile effect, the problem of precisely identifying the causes and antecedents to SIB in each of these subjects present uncontrollable variables. The researchers found the problem of having to tolerate more SIB in the placebo trials lessened as the trials progressed, giving some evidence that the environment of the trials was also influential, and as the subjects became more familiar with the treatment, their behaviours lessened. From this we can get an indication of the need for some further studies on the subjects who have self-injurious behaviour. Why the treatment had this particular effect is still, to some extent, an unknown quantity. We are aware of its relaxation effects, but relaxation alone may not prevent self-injurious behaviour. It is possible that with these subjects, where the stimulatory effect of continuous face/head slapping is replaced by a more powerful effect, this could explain the results we were getting and the value of continuing with further investigation.

General conclusion and summary

These two studies have gone some way to evaluating the effect of VA with people who have anxiety problems and people who have self-injurious behaviour on top of existing conditions of learning difficulty. Many of the clients in the study had quite marked behavioural disturbance, deeply ingrained over a long period of time, and they were particularly inaccessible to therapeutic intervention. To that extent, the results are quite encouraging, and indicate to us that there is something substantially significant about the effect of hearing relaxing music and feeling the effect of a low-frequency tone, particularly as it was measured against a placebo effect. These trials certainly give us some evidence for further studies in this area, and if one can have this sort of effect on clients over quite a short period, one is left to speculate on the possible long-term benefits to people who have these particular problems.

In addition, the trials add weight to the other studies and investigations mentioned in the introduction that have been done in VA over the last ten years in Norway, England and Estonia. While everybody will readily acknowledge that sound and music has a physical effect, albeit sometimes arising out of an emotional reaction, this is beginning to break ground in looking at a specific

application of that physical effect to treating particularly severe problems. It offers the possibility of a pleasant and enjoyable form of treatment at a passive level.

References

Bailey, J. and Meyerson, L. (1970) 'Effect of vibratory stimulation on a retardate's self-injurious behaviour', *Psychological Aspects of Disability*, 17, 3, 133–7.

Bailey, S.L. and Pokrzywinski, J. (1983) 'Using water mist to reduce self-injurious and stereotypic behaviour', *Applied Research in Mental Retardation*, 4, 229–41. Oxford: Pergamon Press.

Bang, C. (1980) 'A world of sound and music: music therapy and musical speech therapy with hearing impaired and multiply-handicapped children', *Teacher of the Deaf*, 4, 106–15.

Booth-Davies, J. (1978) *The Psychology of Music*. London: Hutchinson.

Broner, A. (1978) The effects of low frequency noise on people. A review.

Bunt, L., Pike, D. and Wren, V. (1987) 'Music therapy in a general hospital's psychiatric unit – a 'pilot' evaluation of an 8-week programme', *Journal of British Music Therapy*, 1, 2.

Corbett, J.A. and Campbell, H.J. (1980) *Causes of Severe Self Injurious Behaviour*. In Mittler, P. *Frontiers of Knowledge in Mental Retardation, Vol. II Biomedical Aspects* Baltimore: University Park Press.

Darrow, A. (1993) 'Music therapy for hearing impaired clients', in A. Wigram (ed.) *Music and the Healing Process: A Handbook of Music Therapy*. Chichester: Carden Publications.

Forster, A. and Palastange, N. (eds) (1985) *Clayton's Electro Therapy Theory and Practice*. London: Balliere Tindall.

Freund, S. (1926) *Inhibitions, Symptoms and Anxiety*. London: Hogarth Press.

Freund, S. (1936) *The Problem of Anxiety*. New York: Psychoanalytic Quaterly Press.

Gaston, E.T. (1951) 'Dynamic music factors in mood change', *Music Educators Journal*, 37, 42–4.

Gibbs, J.W. and Luyben, P.D. (1985) 'Treatment of self-injurious behaviour. Contingent versus noncontingent – Positive practice overcorrection', *Behaviour Modification*, 9, 1, 3–21.

Griffin, T., Williams, D., Stark, M., Altmeyer, B. and Mason, M. (1986) Self injurious Behaviour: a state-wide prevalence survey of the extent and circumstances, *Applied Research in Mental Retardation* 7, 105–116.

Hamad, C.D., Isley, E. and Lowry, M. (1983) 'The use of mechanical restraint and response. Incompatibility to modify self-injurious behaviour: A case study', *Mental Retardation*, 21, 5, 213–17.

Hooper, J. and Lindsay, B. (1989) 'Music and the mentally handicapped – the effect of music on anxiety', *Journal of British Music Therapy*, 3, 2.

Lehikoinen, P. (1989) *Vibroacoustic Treatment to Reduce Stress*. Unpublished.

Murphy, G. and Wilson, B. (eds) (1985) *Self Injurious Behaviour*. London: BIMH Publications.

Odell-Miller, H. (in press) 'Approaches to music therapy in psychiatry with specific emphasis upon the evaluation of work within a completed research project with elderly mentally ill people', in A. Wigram (ed) *Music and the Healing Process: A Handbook of Music Therapy*. Chichester: Carden Publications.

Priestley, M. (1975) *Music Therapy in Action*. London: Constable.

Reardon, D.N. and Bell, G. (1970) *Effects of sedative and stimulative music on the activity levels of severely retarded boys*. American Journal of Mental Deficiency 75(2), 156–159.

Saperston, B.M. (1989) 'Music based individualized relaxation training: a stress reduction approach for the behaviourally disturbed mentally retarded', *Journal of Music Therapy*. National Association for Music Therapy.

Shatin, L. (1970) 'Alteration of mood via music: a study of the vectoring effect', *Journal of Psychology*, 75, 81–6.

Skille, O. (1982) Musikkbadet – anvendt for de svakeste. Nordisk tidsskrift for spesial pedagogikk nr 4 s. 275–84.

Skille, O. (1985) 'MUBS – ein diagnostisches Hilfsmittel', in Spintge/Droh (eds) *Musik in der Medizin*. Editiones ROCHE 237–50.

Skille, O. (1989) 'Vibroacoustic Therapy', *American Journal of Music Therapy*, 8.

Skille, O. and Wigram, A. (1993) 'The effect of sound and vibration on brain and muscle tissue', in A. Wigram (ed) *Music and the Healing Process – a Handbook of Music Therapy*. Chichester: Carden Publications.

Skille, O., Wigram, A. and Weekes, L. (1989) 'Vibroacoustic therapy: the therapeutic effect of low frequency sound on specific physical disorder and disabilities', *Journal of British Music Therapy*, 3, 2, 6–10.

Sloboda, J. (1985) *The Musical Mind*. Oxford: Psychological Series.

Smith, C.A. and Morris, L.W. (1976) 'Effects of stimulative and sedative music on cognitive and emotional components of anxiety', *Psychological Reports*, 38, 1187–93.

Spain, B., Hart, S.A. and Corbett, J. (1984) 'The use of appliances in the treatment of severe self-injurious behaviour', *Occupational Therapy*, 353–7.

Spielberger, C.D. (ed) (1966) *Anxiety and Behaviour*. New York: Academic Press.

Spielberger, C.D. (1975) 'Anxiety: State-Trait-Process'. In C.D. Spielberger and I.G. Sarason (eds) *Stress and Anxiety Vol. 1*. Washington, D.C.: Hemisphere.

Spielberger, C.D., Gorsuch, R. and Lushene, R. (1970) *State-Trait Anxiety Inventory*. Palo Alto: Consulting Psychologists Press.

Spintge, R. (1988) 'Music as a physiotherapeutic and emotional means in medicine', *International Journal of Music, Dance and Art Therapy*, 75–81.

Standley, J.M. (1991) 'The effect of vibro tactile and auditory stimuli on perception of comfort, heart rate and peripheral finger temperature', *Journal of Music Therapy*, 28, 3, 120–34. National Association for Music Therapy.

Steen, P.L. and Zuriff, G.E. (1977) 'The use of relaxation in the treatment of self-injurious behaviour', *Journal of Behavioural Therapy and Experimental Psychiatry.* 8, 447–8.

Wascho, A. (1948) 'The effects of music upon pulse rate, blood pressure, and mental imagery', in D. Soibelman (ed) *Therapeutic and Industrial uses of Music.* New York: Columbia University Press.

Wigram, A. (1989) 'O Efeito do som de baixa frequencia e da musica no fortalecimento muscular e circulacao, Sao Paulo, Brazil'. International Multidisciplinary Symposium on Music Therapy and the Effects of Sound (The Effect of Low Frequency Sound and Music on Muscle Tone and Circulation – A Physiological Study).

Wigram, A. (1991) 'Die Wirkung von Tiefen Tonen und Musik auf den Muskel-Tonus und die Blutzirkulation', OBM. *Zietschrift des Osterreichiscren Berufsverbands der Musiktherapeuten,* 2–91, 3–12.

Wigram, A. and Weekes, L. (1989) 'A project evaluating the difference in therapeutic treatment between the use of low frequency sound (LFS) and music alone in reducing high muscle tone in mentally handicapped people, and oedema in mentally handicapped people'. Paper (unpublished) to the Internasjonale Bruker-seminar Omkring Vibroakustisk Behandlingsmetodikk in Steinkjer, Norway.

Wigram, A. and Weekes, L. (1990) 'The effect of low frequency sound and music on muscle tone and circulation'. Paper to the Third Research Seminar on Music Therapy and Special Education, ISME 1–4 August.

Williams, C. and Surtees, P. (1975) 'Behaviour modification with children: mannerisms and management', *Therapy.*

Zimmerman, L., Pierson, M. and Manhen, J. (1988) 'Effects of music on patient anxiety in coronary care units', *Heart and Lung,* September 17, 5, 560–7.

Research in Music Therapy with Sexually Abused Clients

Penny Rogers

Introduction

This chapter introduces some of the issues pertinent to any inquiry into the use of music therapy with sexually abused clients. It highlights a number of factors which appear to be common to this client group's manipulation of the medium of music therapy; the symbolic use of the instruments; the preoccupations with mess and containers; the manipulation of boundaries; and guilt. Material from a number of case studies (both adults and children) is used to illuminate many of the points made and comments are made on the implications for the nature and format of an inquiry currently underway in music therapy with this client group.

Many of the issues discussed are pertinent to a range of client groups such as those with eating disorders and substance abuse.

Sexual abuse

During the last decade there has been a rapid increase in the number of cases of sexual abuse seen in child and family psychiatry, social services and other agencies associated with the welfare of children. This growth in the recognition of the issue has been brought about not only by the highlighting of cases of sexual abuse in the media, but also by the increase in public awareness of the damage caused to children as a result of abuse.

Statistics compiled from several studies of child sexual abuse in the general population indicate a conservative incidence of one in ten children. Professor La Fontaine's (1990) study indicates that the majority of cases involve male members of the child's own household or close male kin. Female offenders occur in very small numbers. Baker and Duncan's survey (1985) found that sexual abuse appears to be evenly distributed by region and occupational class. The recent Cleveland inquiry helped raise public awareness with subsequent developments such as child 'helplines' and many other statutory agencies and bodies focusing help on these children. Sexual abuse is not, however, a new problem; it is not the result of a more permissive society; but an age-old problem. Many adults who

were sexually abused as children end up seeking psychiatric help in later life for a variety of reasons.

Organisations involved in the care and protection of children have developed and formalised various systems for dealing with child abuse. Area Review Committees (ARCs) were established as policy-making bodies for the management of child abuse cases; and in 1980 the Department of Health and Social Security issued the 'Child Abuse: Central Register Systems' for the recording of non-accidental injuries to children, amongst which sexual abuse was included. The ARCs were reconstituted as Area Child Protection Committees in 1989, with the focus on the promotion of good inter-agency working.

More recently, the Department of Health issued a 'Study of Inquiry Reports' (1991). This report reviews the lessons of all child abuse inquiries made during the period 1980–89. It highlights the increase seen in the reporting of child abuse during the mid 1980s. It is not known whether or not the actual incidence of abuse has increased. What is certain is that public awareness of the issue has increased, and there is greater recognition of power and gender as factors inherent in abuse. Associated with this has been an increased awareness of the rights and needs of children, with the child being recognised as 'a person, and not an object of concern' – The Children Act, 1991.

The Department of Health has ensured that many of the lessons learned as a result of the inquiry have been made the subject of new policies and guidance through *Working Together*, 1988 and *The Children Act*, 1989 – implemented October 1991. These, with the establishment of Area Child Protection Committees should contribute to the work of all those involved in child protection.

It is also argued that a child's trauma is caused not only by the act of abuse, but also by society's reaction to it (La Fontaine, 1990). Until children perceive such action as being wrong, it is alleged that they may be unconcerned by it. There appears to be little to support such arguments. Firstly there is good evidence that children know it is wrong; the fact that it is a secret arouses suspicions. Secondly, although some survivors recount that they did not know it was wrong, they often state that they did not like it.

In many cases, children cope with abuse by burying it deep in their memory. They are only able to reveal it years later or under therapy. There are children who are so traumatised that they cannot speak, or are so threatened by their abuser that they dare not. Under such circumstances, a child's denial of abuse may not be convincing; but if a child is to be believed when it does disclose abuse, then should it not also be believed when it denies that abuse has occurred!

The power of the secret
The bond joining abused and abuser is the 'secret' which separates them from the external world both physically, emotionally and psychologically. Through the holding of the secret, survivors may begin to perceive themselves as being sexually powerful and may learn to use these feelings as a means of exploitation. Victims thus quickly realise the manipulative power of their own sexuality. Tilman Furniss

(1991) describes how therapists can become drawn into the sexualization and how victims of sexual abuse can be equally hostile to both male and female therapists.

Children keep the 'secret' for a variety of reasons, as discussed earlier and there is often considerable ambivalence in the relationship between abused and abuser. Frequently survivors may wish to protect the abuser in spite of the anger and fear they feel.

One adolescent client spoke in sessions of the warmth received in this distorted and imperfect relationship; 'it's not right, but I had orgasms, I enjoyed the feeling of being special, I wanted his love. Maybe I wanted to be abused. I didn't want to be punished, and at least I was special'.

As adults, they may keep the secret long after the abuse has ceased to occur, with the internalised threatening and punishing abuser still keeping the fears and emotions surrounding the abuse alive.

Denial of the abuse is described by Roland Summit (1983) as the 'child sexual abuse accommodation syndrome'. It is an attempt by the child to make a threatening situation, figure or environment less threatening. It is an attempt to find a method of survival. The use of denial or the 'child sexual abuse accommodation syndrome' is particularly apparent with the survivors of long-term abuse.

The holding of the 'secret' and feeling of receiving love from the abuser may become very important. The survivor of abuse may go to extraordinary lengths to continue to feel 'special' and loved whilst clearly demonstrating an ambivalence towards the continuation of an 'imperfect' relationship in other ways.

Definitions of sexual abuse

It is necessary, at this stage, to define what I mean by sexual abuse. The criteria for registration of cases on the Sexual Abuse register are:

Children under the age of 17 years subject to:

1. Illegal or other sexual activity between parent or custodian and child within the family context (including adoptive and step relationships).

2. Failure of caretakers to protect children from illegal or otherwise inappropriate sexual activity.

These criteria are currently being re-examined. The sexual abuse of children refers primarily to the activities of adults who use children for their sexual gratification. It can also include the abuse of children by older children and adolescents. The activity refers to bodily contact of all sorts: fondling, genital stimulation, oral sex and anal or vaginal intercourse. In some studies of sexual abuse, the meaning is extended to include suggestive behaviour, sexual innuendo or exhibitionism ('flashing'). These behaviours do not include touching, and there is no evidence that they lead to more serious or invasive forms of abuse. There can be little doubt, however, that such behaviours are unpleasant and may have damaging emotional consequences.

For the purposes of this paper, sexual abuse of children will mean sexual activities involving bodily contact with a child or adolescent for the gratification of the adult. It identifies the roles of offender and survivor and recognises the balance of power and impotence within the relationship between abused and abuser. It also acknowledges that any imposed or exploitive sexual touching – even that which is commonly referred to as 'fondling' – is not loving or affectionate but abusive.

Diagnosis

There are considerable problems in diagnosing sexual abuse. Health authorities and social services as well as the police, have needed to devise ways in which to handle sexual abuse cases. One of the main causes of dissention in both the Cleveland inquiry and more recently the Orkney inquiry, concerned the reliability of the diagnoses. Parents often assert that their child has not been abused whilst the professionals involved, doctors, therapists and social workers, assert that the child has been, or is, at risk.

Where a claim is made that a child has been abused, there are often counter-claims by parents that the techniques used to 'acquire evidence' involve bullying by professionals in order to persuade children to confirm that they have been abused. Lack of certainty surrounding diagnoses in the Cleveland inquiry was largely accepted as 'proof' that the original suspicion had been unfounded.

As Jean la Fontaine (1990) remarks: 'We shall probably never know how many of the Cleveland children had been abused; all we can be absolutely sure of is that if they had been, no matter by whom, there is extra pressure on them now never to say so' (p.215).

Many children do not complain of abuse. They remain silent and professional views may rely on medical evidence (as was particularly apparent in the Cleveland cases). For a case to be investigated, there is usually more than one reason (in addition to medical evidence) why there should be concern. The results of sexual abuse can manifest themselves in a host of ways – emotional disturbances, enuresis, language delay, school refusal. In addition the child may develop psychosomatic illnesses or show inappropriate sexualized play. They may represent in their actions what they are unable to say in words.

In many cases of abuse, allegations may not be made because the child concerned is too young to make an allegation; the child may lack the vocabulary and understanding to describe events. Some survivors can be as young as two or three years old, and small children may use words which are capable of more than one interpretation. In addition, the consequences of 'telling' may appear too great to the child. Many children of all ages are terrified of telling, and may have received threats from their abuser regarding the consequences of telling. For older survivors there may be considerable fear, distress and shame associated with the disclosure. It may take many months of therapy for the survivor of abuse to feel able to reveal the abuse. A high proportion of adults who subsequently report abuse in childhood (Women's Research Centre, 1989) state that there was a silent

witness to their abuse (often their mother), who took no steps to intervene. The collusion of others or family members in concealing abuse can add considerably to the stress of disclosure.

In the absence of a clear statement from the victim, there are two means of diagnosing sexual abuse. The first involves a physical examination. Venereal disease in a child is of course a clear indication of abuse, and there are also other infections such as the presence of thrush which may give rise to suspicion. Medical evidence can also consist of injuries (for example, internal bruising) which may not be evident to the naked eye. There may, however, be no physical evidence; traces of semen can be quickly washed away, and much abuse does not involve violence. The clearest disadvantage of medical evidence is that it is not capable of disclosing the exact identity of the abuser, despite, for example, the development of genetic finger printing – DNA (dependent on the presence of body fluids). The validity of this has recently been the subject of many legal arguments (*Guardian*, 11/1/92). If the exact identity of the abuser is not known, then a successful prosecution is impossible under English law.

The second means of diagnosis involves an interview with the child. Recent research in the UK and US has shown that sexually abused children play with dolls in a manner that differs from unabused children (Bentovim *et al.*, 1988). The use of anatomically correct dolls is often utilised in investigating sexual abuse cases. For a child to be interviewed in such a manner requires the belief by the professional that abuse may have occurred (Sgroi, 1982). Equally, it is possible for the doctor or therapist who is unwilling to believe in the possibility of sexual abuse to ignore even obvious signs, or attribute these signs to other explanations. Many complaints about methods of inducing disclosure have come from both the police and defense lawyers. They are concerned about the validity of such interviews and techniques for eliciting information which they have attacked on the basis that children have had 'words put in their mouths'.

There are effects on the child of both methods of diagnosis. For example, it is alleged that attempts to make a child reveal what has occurred are in themselves a form of abuse by adults. The parents in the Cleveland case complained that their children were put through a barbaric ordeal with threats and bullying to get them to 'tell'. The Children's Legal Centre maintains that children should be allowed the right not to 'tell' as long as they understand the consequences of their action. When a child is examined, no matter how carefully and sensitively this is done, it can be perceived by the child as being as invasive and abusive as the initial abuse. If there is potential action by the police, then the child may be required to talk about what happened to her parents, a police woman, a social worker and possibly a therapist. The child may well be aware that as a result of disclosure, the perpetrator of the abuse could be sent to prison; that the family could be broken up; and further that they themselves, may be taken into care. All these possibilities are liable to become sources of anger, self-disgust, guilt, self-blame and fear for the child. This may occur in spite of relief at a changing situation. In many cases, disclosure does not automatically lead to the cessation of the abuse.

There are differences in the approach to diagnosis used by therapists and the social worker or police. It is not the primary aim of the therapist to identify the abuser, whereas the police aim to find the criminal. Research has demonstrated that these distinct aims can produce different attitudes to the offence. Saunders' (1988) study highlights the resultant conflict which may arise in the ensuing management of cases involving social work and judicial system professionals.

The nature of the inquiry

Until recently, I worked in a large mental health unit with children, adolescents and adults amongst my client group. I was the only music therapist working in the unit and was given considerable freedom to develop my clinical interests. Music therapy did not exist in the unit prior to the establishment of the post and there were few preconceptions as to what music therapy entailed. A certain amount of my time was spent talking with other clinicians about music therapy and conducting teaching sessions. Perhaps the most interesting by-product of talking about my work was that it prevented any stagnation of ideas and encouraged me to examine the nature of what was actually happening in sessions, and to question the processes involved. This led to my interest in research.

The efficacy of music therapy cannot be examined if the relationship between therapist and client is ignored. In examining the thoughts and experiences I have in respect of my work with this client group, it is necessary to find a paradigm which:

1. Acknowledges the interaction between therapist and client.

2. Is capable of recognising that all clients are different; and

3. Acknowledges that clients or research subjects will not fit into a neatly labelled subject group. This is particularly true of the sexually abused.

I believe that any research carried out with this client group needs to involve (to a significant degree) the clients themselves in determining what factors are studied. Whilst both client and therapist may believe that the process of engaging in therapy has been of benefit to the client, the client may believe this is simply because a regular time and space were made available in which to explore and acknowledge feelings. In contrast, the therapist may believe that the process of clinical improvisation itself greatly facilitated the therapeutic value of the time spent with the client, and further believe that the non-verbal aspects of the process allow deductions to be made about the client's inner emotional world which would not have been possible without the use of improvisation. Either scenario could be correct, but without the involvement of the client in determining what was important, the research carried out is based exclusively on the subjective perceptions and objectives of the therapist.

A meaningful research design also requires the ability to develop or change; to be 'living' research. This implies the involvement of the subjects or clients in not only the design of any research, but the subsequent evolving questions.

The only research method I know of which allows these possibilities to be explored is 'new paradigm' research. In essence this allows both subjective and objective observations to be made. The basic arguments put forward in favour of new paradigm methods are that orthodox research methods are inadequate when used to study people because they undermine the self-determination of their 'subjects'. When the subject of a study is human, it is important to recognise that she has the ability to choose how she acts, and has the capacity to give meaning to her experiences and to her actions. Orthodox research methods exclude the subject from all choice about the subject matter of the research, all consideration of the appropriate method of inquiry, and the creative thought that goes into making sense of the research.

The essential component of new paradigm research methodology is that it allows the following two points to be incorporated into any research design:

1. It acknowledges the involvement of the subject; their experiences of the study. It thus aims to involve the subject not only in the execution of the study, but the planning and evaluation stages.

2. It acknowledges the impact the researcher has on her subjects. It does not therefore exempt from the study the impact of the researcher's own behaviour.

Innovative research is creative; it lives, grows and expands not only from the input of the researcher but also from the input of the subjects. It can thus be seen as a learning cycle which can be entered from any point. Reinharz (1981) describes it thus:

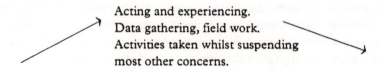

Acting and experiencing.
Data gathering, field work.
Activities taken whilst suspending
most other concerns.

Communication and planning.
Looking at what has been
previously learned.
Posing new questions; new goals.

Reflecting.
Analysis of previous
experience, away from
the clinical field.

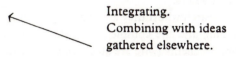

Integrating.
Combining with ideas
gathered elsewhere.

I am utilising such a human inquiry model of research to examine the symbolic use of material by sexually abused clients and the potential of music therapy as a diagnostic tool with this client group. The co-operative inquiry group involves a number of music therapists working with sexually abused ex-clients in the design of the protocol for the research.

The motivations for joining this group are varied for each participant, but each wishes to gain new insights and perspectives on working with sexually abused clients and there is a common desire to provide a better service to this client group and to feel an increased sense of confidence and development of clinical work.

The broad design of the research was presented to a number of clinical practitioners first and their comments formed the basis for the first meeting of music therapists. Subsequently a revision of the research design and a re-focusing of the aims of the inquiry resulted.

The initial meeting was followed by a period of applied research in the field. The results were then fed back to the co-operative inquiry group and the direction of the research subsequently revised. This pattern of inquiry with the presentation of ideas and results to groups of practitioners working in similar clinical fields is analogous to a period of reflection, thinking and planning from which altered *foci* within the research evolve. A cyclic pattern of inquiry with meetings with other music therapists for thinking and planning, followed by periods of on-the-job research in the clinical field is seen to develop, with movement around the cycle from reflection to action and back again. Concentric with this pattern is the involvement of the clients in determining what they saw as of relevance to their treatment in the research. The clients' thus become co-researchers.

The clients are involved retrospectively (approximately six months after their treatment has concluded) and also whilst their therapy is occurring. Retrospective involvement is utilised to attempt to maintain an element of objectivity by the client. If, for example, 'A' understands that my research hypothesis is that music therapy enables clients to express their feelings more quickly through the medium of clinical improvisation – rather than in words; she may attempt to highlight this/demonstrate this within therapy sessions as a bi-product of 'trying to please the therapist'. In contrast 'A' may feel that the most important component of the therapy was the verbal material in sessions but may not report this. Retrospective involvement – through individual discussion and participation in the co-operative inquiry group – is an attempt to avoid the more obvious pitfalls.

Not all clients agree to participate in the co-operative inquiry group whilst engaged in therapy, but for those who feel able, such participation is encouraged. The 'power of the secret' can, however, be a seriously inhibiting factor in involving clients in a co-operative inquiry group; as they may not wish to discuss the very personal process of therapy with others.

Client involvement in the research whilst they are engaged in therapy occurs through the use of diary keeping and the completion of short questionnaires following each therapy session. All clients (who are able) are encouraged to keep a diary of their experiences of the sessions. It is difficult for young children to keep a diary, although guardians are asked to note any reports regarding the therapy spontaneously made by the child. Both diaries and questionnaires are kept apart from the therapy process and are unseen by the therapist until therapy has concluded, unless a client actually brings a diary into therapy. These diaries are used to gain more feedback from clients about their therapy experience. It is

often easier for a client to report in a diary that they felt a session was (for example) a waste of time, than to confront the therapist with that information. Thus the use of the diaries encourages the clients to be open.

The research design comprises many elements:

1. The analysis of audio-visual data (and transcribed audio-visual data) of clinical sessions.

2. The analysis of clients' diary records of sessions. (Unseen by the therapist until therapy is completed.)

3. The analysis of questionnaire's competed by both clients' and clinical staff. (Unseen by the therapist until therapy is completed.)

4. The analysis of the therapist's records (diary) of sessions.

5. The use of a co-operative inquiry group including both ex-clients who have agreed to become involved in the co-operative inquiry group and clinical staff involved in the care of clients on the unit.

6. The use of a co-operative inquiry group of music therapists to inform the research design.

This wealth of data can be analysed both from a single case-study view point and using within and between subject designs.

In conclusion by utilising co-operative inquiry groups, I hope to acknowledge both the involvement of clients and their experiences in all areas of the study. In addition by involving both my clients and my clinical colleagues, I hope to gain a better perspective in determining what areas are important within the therapy.

Application of music therapy

The majority of previous studies of sexual abuse focus not on the therapeutic interventions which the clients receive, but on the prevention and causes of abuse. It is necessary to examine what is known about the relative effectiveness of different treatment strategies, to improve the functioning of individuals and their families once the abuse has been perpetrated or ceased.

Cohn and Daro (1987) suggest that successful intervention requires a comprehensive package of services which address the interpersonal and concrete needs of all members of the family, but with the exception of a few large-scale programmes (Giraretto, 1982), little is known about the suggested success of specific approaches.

In recent years there has been a growing awareness of the prevalence of child sexual abuse and incest. It is still a subject, however, which is often shied away from, particularly in research; possibly because any discussion brings forth feelings of revulsion and disbelief. Whilst there are many personal case histories in the literature, little has been written about work with the sexually abused client (both child and adult) through music therapy. This inquiry makes a first attempt to study the efficacy of music therapy in this field.

Although the use of music therapy with this client group is not well documented, I believe it offers a particularly powerful tool for work in this field. Music therapy by its very nature allows the expression of emotions in a non-verbal and thus non-threatening medium, facilitating the exploration of the underlying issues within a safe environment. In addition it provides a unique and highly effective means of dealing with a client's resistance, denial, and low self-esteem which characterises the immense difficulty in examining the emotional pain associated with the abuse.

Music therapy involves the use of free clinical improvisation through which the therapist examines the relationship between herself and the client, seeking to understand, reflect and interpret (either musically or verbally) therapeutic issues that have particular relevance for the client. Clinical improvisation within the therapeutic environment allows the inner emotional world of the client to be examined and acknowledged.

This form of therapy is very effective in situations such as sexual abuse where verbalisation or disclosure is difficult. The creation of sound (through improvisation) is substituted for verbal dialogue. The pattern of the shared music is then available for analysis and parallels can be drawn between the musical development and the clinical aims of the therapy. The balance between the musical and verbal dialogue may vary substantially from session to session – indeed some sessions may be spent with periods of time in apparent silence. It is possible for the verbally articulate client to avoid expressing the pain of their inner emotional world on a verbal level; but to find those feelings being explored when expressed through the medium of clinical improvisation. The emotions explored are initially externalised through the improvisations which are subsequently discussed with the client. Thus the interaction with the client is done through both music and words. The primary agents of therapeutic change being the client – therapist relationship and the music. By facilitating this communication and expression of emotion, links between behaviour and feelings may be explored. The most valuable role the therapist has is clearly to listen, observe, think and respond.

It occasionally happens that the referred client has no conscious recollection of the abuse and it is through the provision of a therapeutic relationship within which it is safe for the client to express intense emotion that the client is able to acknowledge and make conscious perhaps for the first time as an adult, memories of the abuse.

It is not unusual for disclosure of past sexual abuse to arise after a period of some months or a year of regular sessions in music therapy. It is generally recognised that emotional disturbances may have arisen from sexual abuse which was previously unsuspected by those involved in the care of the client. One of the main developments of the increased media attention given to sexual abuse is the increased awareness amongst professionals that abuse occurs. In tandem with this is the increased sense of confidence amongst the abused, that if they do disclose information, they will be believed.

As highlighted earlier, the results of disclosure can have considerable consequences (such as the breakup of the family unit in the case of children). Thus the client coming into therapy is likely to be defending him/herself against some overwhelming emotional feelings. If disclosure has occurred, the client may experience loss relating to the disclosure and its consequences. Whilst the client may well need to share these feelings within the context of a safe and confidential therapeutic environment, they may be intimidated from doing so by feelings of anxiety, general confusion, guilt and denial.

There is a general misconception that all children want nothing more than for the abuse to cease. This view ignores what many victims see as the positive gains from being abused; for example exclusive attention from the abuser, caresses, hugs and cuddles and the knowledge of a secret which in many cases gave them a sense of power within the family unit. Occasionally victims even report deep conflict and guilt through the mixed emotions of having gained sexual pleasure themselves, particularly through the experiencing of orgasm. It can be seen that such ambivalence causes the victim considerable disquiet.

The use of clinical improvisation allows the client a direct experience of working with their own emotions through their projection on to the instruments. The resulting creations clearly express the confusion and damage which abused clients suffer. Clinical improvisation may be of explicit situations and may be directed by the therapist – for example of the client's emotions during an argument with a family member; the client portraying herself on one instrument and directing the manner of improvisation by the therapist on a second. Conversely, it may be undirected allowing the client to express facets of themselves which they may have been unaware of previously; and allowing contact with otherwise repressed emotions. Improvisations are often characterised by what is perhaps most easily described as a 'mess' or confusion of chaotic sounds. The client may clearly express through the medium of improvisation the ambivalence and mixture of emotions that they are feeling.

The following are two important considerations in the way the therapist may apply music therapy to this client group:

1. The need to use boundaries.

2. Encouragement of the symbolic roles of the instruments.

Use of boundaries

For the trauma of dealing with or acknowledging abuse to be overcome it is essential for the client to feel safe. The maintenance of boundaries can provide such safety. Clients need constant reassurance that they are believed and that the abuse was not their fault. In *Recollecting our Lives* (Women's Research Centre, 1989), an adult survivor explains that belief in the truth of disclosure is critical; especially the mother's belief. 'It is hard enough for children – the offender makes them think it is their fault. It's hard enough to tell. Believe them! I'd take my daughter's word before my husband's any day. Be there for them, support them. It's not their fault. Give them a sense of security'.

The use of boundaries in music therapy is well documented (Heal, 1989). Sessions occur in the same room, at the same time and for the same duration each week (usually 50 minutes, although with very young children sessions may only be scheduled to last for 30 minutes). Sessions are protected from intrusions and interruptions, and holidays are prepared for and their effects taken into account. The same choice of instruments is always available. With the sexually abused child, these kinds of boundaries provide a vital framework.

Clients may frequently attempt to manipulate the boundaries of the sessions and thus test the reliability of the therapist. This may range from a simplistic level (arriving late or asking for extra time at the end of sessions), to more sophisticated testing of the boundaries; testing what can be said to the therapist, imagining the therapist might become angry or reject them.

Sexual abuse often causes the breakdown of 'body boundaries'. The sense of appropriate touching may have broken down to such an extent that the client (whether a child or adult) may express itself in an over sexualized or over-sensualised manner. Such difficulties will quickly become apparent within the therapeutic context. Some clients, particularly children, make approaches in a sexual way, such as seeking to sit on the therapist's lap or undressing at inappropriate times. They may seek a great deal of physical contact with the therapist or conversely constantly isolate themselves.

The respect for a client's physical boundaries is always important, but perhaps particularly so with this client group. The therapist must be sensitive in the way she uses touch and show considerable awareness of the client's need for and use of physical space. Sharing an instrument can be a very intimate form of commu-

Figure 14.1: Child's use of instruments as a physical boundary

nication and may be perceived by the client as being invasive of their space. Alternatively, as therapy progresses, the sharing of instruments can be indicative of an increase in the client's levels of trust and ability to interact.

A nine-year-old boy was initially only able to tolerate being in the same room as the therapist if he completely surrounded himself with the instruments in the form of a protective barrier. He was later able to explore his need to place the instruments in such a manner: saying that he felt safe, and able to concentrate on the music when he had carefully arranged the instruments in this manner. By creating a physical barrier (see Figure 14.1) between himself and the therapist, the child was able to tolerate and seek the levels of intense musical interaction which occurred within the clinical improvisations whilst avoiding the perceived danger of getting too close. As a relationship of trust developed with the therapist, he was gradually able to allow the dismantling of this barrier – initiated at times by himself and at other times by the therapist. The use of boundaries can be particularly valuable for the therapist when a client appears to be regressing as they confront their pain and associated defence mechanisms. Clients who have effectively avoided examining their past, either consciously or unconsciously, may experience considerable anxiety and pain as they begin to recognise their own patterns of behaviour. The client can be left with a heightened sense of vulnerability and exposure which may initially lead to the feelings of depression and isolation becoming worse. If the therapist has anticipated this effect; discussed with the client at the outset of therapy the possibility of this occurring and can reassure the client that they will emerge with an increased sense of 'wholeness', then the anxieties of the client may be lessened. It may happen, however, that the therapist's own anxieties may become greater at this point, leading to the covering of ground more quickly or the temptation to move on to safer subjects. This can detract from the therapeutic process at a crucial point. If the direction of the therapy is diversified for the reasons highlighted above, the client may detect the shift and recognise the therapist's inability to deal with or accept them. This may confirm their own self-image, feelings of self-revulsion and sense of alienation. The therapist's use of boundaries to stay with the therapeutic task, however painful, and the recognition of transference and counter-transference issues are crucial.

In a research context, it may be important that the boundary between the role of researcher and therapist (where this is the same person) needs to be carefully delineated and data from sessions carefully collated for subsequent analysis. Where boundaries are inadequately drawn, the result is chaos; a reflection on the chaos so often previously experienced by the abused where boundaries were not delineated and safe or trusting relationships violated.

In this research project the use of clinical material as data for the research is ongoing, but the involvement of the clients is often retrospective via the co-operative inquiry group. The time gap between being a therapy client and a co-researcher is often a critical boundary. All clients are aware that I am carrying out research and are invited to participate in the research project at the time of

their initial referral to music therapy. If clients were not aware that I was carrying out research, the important component of trust necessary in any therapeutic relationship would be damaged. By implementing a time gap between being a client and a co-researcher, it is hoped that some of the conflicts and ambiguities between the roles of therapist and researcher are acknowledged, but that the therapy process remains as untarnished by the research process as possible. It is important that the clients awareness of the direct focus of the research at any given time is acknowledged, and any resultant behaviour in therapy sessions anticipated.

It may be that the research will develop so that the process of checking out (for the sake of validity) my impressions of the critical moments (musically) and of self-disclosure will happen almost simultaneously not only with external observers (both music therapists and clinicians of other disciplines) my research supervisor and ex-clients, but also with more of those clients currently engaged in music therapy.

The boundaries between the roles of researcher and therapist require maintenance too – I see the role of the therapist as providing a secure environment in which clients can explore their emotions; secure in the knowledge that the therapist can tolerate, deal with and continue to accept all parts of the client – including the 'dirty' bits. The therapist provides a space in which it is safe for clients to explore the damaged parts of themselves. The role of the researcher is to make 'systematic and sustained inquiry, planned and self-critical, which is subject to public criticism and to empirical tests where these are appropriate' (Stenhouse, 1985).

xylophone – mother

handchime – child

Large conga drum – father

– Relational distance

Figure 14.2 Child's use of instruments as symbols

The symbolic roles of instruments

The client may assign symbolic roles to different instruments; for example the same child referred to earlier perceived the conga drum as representative of his father (physically the largest and thus most dominating instrument) the small xylophone as his mother and himself as a beater which was alternatively used to sound either instrument. Sophisticated use of the instruments as symbols will be discussed later, but the clear difficulties that this child had in perceiving the differences amongst adult/child relationships was clearly demonstrated as the instruments and the beater were used to play out a variety of sexual combinations, with beater acting as a go-between. In this way, the child was able to portray his anxieties regarding relationship and generational boundaries in his own home.

The sexually abused child may also exhibit a marked preoccupation with their own genitals, and may frequently masturbate. These children may use the instruments in a very sensual manner, stroking the textures of the instruments or caressing the instruments; often becoming completely self-absorbed. Occasionally beaters may be used to stroke their own bodies.

One small eight-year-old girl repeatedly stroked her own body with the beater during therapy sessions over a period of some weeks. She would use the beater initially to stroke the instrument she had previously symbolically referred to as her father (a large paiste gong). She would later place the beater against her own cheek, stroking her cheek in a sensual slow motion and subsequently kiss and orally explore the beater. The self-absorption exhibited by this child effectively denied my presence completely, leaving me feeling both excluded and unable to break the child's pattern of behaviour. My role at this time was to observe in a non-directive manner, accepting and reflecting back the feelings I saw being expressed.

The symbolic role attached to the instruments may involve many aspects, feelings or emotions. Often clients will use the instruments to tell the story of their family in a form of sculpture (see Figure 14.2). This is particularly true of clients referred by such establishments as Barnardos where the use of life story books is often well known by children. Different instruments may be assigned differing roles or personas. A clear example is a child 'B' who repeatedly used a large conga drum to symbolise his father, a small xylophone to represent his mother and a smaller handchime to represent himself. These instruments were then physically positioned to indicate the strength of the relationships between family members. In addition the way the instruments were played had a clear symbolic meaning; 'B' associated the large conga drum with his father and on one level perceived his father as being very dominating; 'B' then played the conga very gently. A clear distinction between the visual and auditory perceptions of the conga was apparent (the contrast between size of the instrument and the way it was played). This contrast can be subsequently explored. Such an exercise which could be described as the formation of a musical sculpture with the instruments, may happen spontaneously (that is, initiated by the client) or may be directed by the therapist.

Within the research framework, comparisons of symbolic identification with the instruments by clients will be made from detailed annotations of material generated in sessions.

A case example

In this example, themes emerging as common to this population – mess and containers, control, guilt and ambivalence are discussed and commented on, from both a music therapy and research perspective.

An adult client ('A') who had been repeatedly abused by a member of her family was referred for music therapy with the initial diagnosis of depression compounded by eating problems. In addition this client was physically handicapped following an accident three years earlier. She initially presented as a neatly dressed and very tidy person who always arrived for sessions precisely on time and appeared to be very eager to do everything requested and to 'please' the therapist. Musically she was extremely ordered, using only highly structured rhythmic patterns and improvising in a very gentle manner on the xylophone and glockenspiel. In her first session she played a large gong, apparently soothing herself with a monotonous rhythm reminiscent of a heart beat. She ignored any musical overtures or attempts to interact from the therapist, and was only able to tolerate the therapist's presence when it provided a musically safe structure (modal improvisation)[1] which 'held' and 'supported' the tentative explorations the client made on the gong. She was very resistant to using any other percussion instruments and denied strongly that she had any real problems except that she needed to control her weight. She believed that if she could only do that, her depression would go away.

Mess and containers

Over a period of some months in therapy she was gradually able to explore her inner emotional world and her music became more and more chaotic and angry with the use of syncopated rhythms and much use of the drums. The music of the therapist reflected this gradual development, becoming more atonal with the use of much dissonance reflecting the 'mess' and 'chaos' heard in the client's music. In many senses her creative output became more 'messy' as other aspects of her behaviour became more and more apparent. Her preoccupation with her diet and the obvious analogies of taking material into her body was reflected in her preoccupation with putting beaters inside instruments – such as the 'body' of the piano; playing the tubular chimes in a very 'sexualized' manner and hiding the beaters inside the tubes of the chimes, or stroking the surface of the drum in a highly sensual way whilst gazing in a provocative manner at the therapist. The inner reality of her confused feelings became increasingly apparent through her manipulations of the materials provided and in the chaotic nature of her improvi-

1 A technical term for a particular form of musical improvisation.

sations. By exploring with 'A' the nature of her improvisations, 'A' was able to acknowledge the anger and chaos she recognised in her playing and relate this to her feelings about her abuser, subsequently verbalising the abuse.

Control

'A' controlled the course of the improvisations by utilising the most dominating materials available in the therapy room; she would use the piano (physically the largest instrument); large paiste gong (with which she could envelop and drown out any other sound) or large conga drums (which she would attack in an aggressive and continual 'rage of sound'). By exploring 'A's need to control the nature of the musical relationship as expressed in the improvisations, it became clear that 'A' felt there was very little in her environment over which she had any control, and thus her need to 'control' had become focused on her eating habits (leading to anorexia).

The client felt total impotence in her relationship with the abuser in whose home she continued to live and her preoccupation with her eating habits gave her something within her own environment which she could control. This preoccupation with her eating habits served to both deny her sexuality – leading to the anorexia and thus a de-sexualized female form and a belief that she would no longer be attractive to the abuser.

The converse wish of the same client to continue to receive 'love' (her word) from her abuser was also demonstrated in her need to control her eating habits. The abuse she had previously received had ceased when she reached puberty. The client felt rejected and believed her slimmer (older) sisters received more attention from the family member who had abused her. There appeared to be little evidence for this belief, but 'A' sought to emulate her slimmer sisters in the hope that the affection she had previously received through the 'imperfect' but nevertheless existent relationship with her abuser would be reinstated. This client therefore starved herself and was able to simultaneously follow through two patterns of behaviour, the first of which attempted to deny her sexuality and the second which sought to gain the reinstatement of affection from the abuser. These patterns indicate the high degree of confusion and emotional anxiety felt by the client.

Finally, the paralysis which this client exhibited was subsequently revealed to be 'hysterical conversion syndrome' – that is, 'A' was physically capable of movement and could be observed to move the affected limbs in her sleep. This was again indicative of her confusion. Confinement to a wheelchair served to deny her own sexuality and enabled her to fabricate reasons why she was unable to leave the 'supportive environment' of her own home (in which her abuser also lived) as she could not manage on her own. In addition the apparent paralysis resulted in the receipt of 'love' or 'affection' (her terms) from her abuser who helped her in activities of daily living, for example helping her in and out of the car, or going up stairs.

Guilt

Finally I'd like to draw the reader's attention to the important part guilt plays in any acknowledgment of previous abuse. Many victims of sexual abuse perceive themselves as being responsible for the dynamics within their families. In this case example 'A' would constantly try to put right the damage caused within the family unit by accepting all the bad feelings and doing all the cooking, cleaning and washing. All these tasks involved an aspect of cleaning, and were perceived by 'A' as a means of ritually cleansing the family from the effects of the abuse.

Ambivalence

One of the primary problems demonstrated by survivors of sexual abuse is an inability to hold both good and bad feelings. For many, their only experience of a positive relationship in which they received love and affection, was from the abuser. They associate feeling special with this often loved and trusted adult. Ambivalence is felt by the abused as they try to rid themselves of the negative feelings associated with the abuse, whilst retaining a sense of being valued. Therapy is about teasing apart this mixture. In *Working with Children in Art Therapy* Carol Sagar writes: 'In the unconscious world there is always the opposite aspect to the conscious one. In the abuser's unconscious are the abused feelings; in the abused person's unconscious are the abusive feelings and impulses' (1990, p.112).

It is evident that care has to be taken that the potential conflicts between the roles of therapist (good) and researcher (bad – invasive or abusive) are taken into account. There is no obvious reason why someone who is referred for music therapy would want to participate in research – save to please the therapist! Such a motivation could be seen to clearly affect the quality of the therapy and research alliance. In addition, it could be said engaging the client as a co-researcher can be limiting as both researcher and co-researcher may be reluctant to reveal aspects of their experiences to each other, although able to share these with an external consultant (Chesney, 1987). But by facilitating a degree of ownership of the research with the clients it is hoped that such experiences are not avoided and ignored but consciously acknowledged by all involved in the research at all stages of the research.

There are clearly difficulties encountered by the client when they make a commitment to engage in therapy, knowing that data generated from their therapy may be used in a research project. It is quite possible to speculate that if clients were not aware that, for example, videotaped data of their sessions would be analyzed in depth, or an invasive video camera was not in evidence, they would act differently. Clients do 'play to the camera' at times and occasionally they request that this silent witness (the camera) is switched off. On balance, however, clients do usually forget about the camera's presence when fully involved in their therapy and the research data collected can be subsequently used as a further therapeutic tool, for example in enabling clients to observe their own body language more clearly.

The detailed collection of data and analysis of data by clients and clinical colleagues can also be helpful in facilitating acknowledgement of abuse and increased self-knowledge by clients. In this way I have tried to ensure that the research is not only owned by the client group and clinical colleagues, but that it makes a therapeutic contribution to my clients' wellbeing.

These issues of ambivalence, control, guilt, and mess and containers can also be seen to be pertinent to the research design in that many of these factors may only be acknowledged retrospectively by the clients. Such factors may affect research with many other client groups, particularly those with eating disorders (see page 23) or substance abuse.

Conclusion

The use of clinical improvisation in music therapy with victims of sexual abuse is arguably one of the most useful means of therapy this client group can receive. The results of abuse, as we have seen, can manifest themselves in a wide variety of ways. All however demonstrate the invasive nature of abuse towards many kinds of phenomena such as secrecy bound up in lies; affection/love felt as pain; dishonesty with oneself and others; confusion and chaos; or the inability to distinguish between 'good' feelings and 'bad'.

In inquiring into the use of music therapy with this client group, it is apparent that the diverse nature of issues presented by individual clients lends itself to a collaborative research style such as that found in the new paradigm approach. Collaborative research is 'with' people rather than 'on' people, thus all avenues and explorations of what occurs are decided upon democratically. In the research the focus is continually directed into those areas which appear to be most significant for the clients. Validation of the focus of the research is gained by the sharing of results with my colleagues in the co-operative inquiry group.

What is emerging from this research is that there are many factors which appear to be common to this client group's manipulation of the medium of music therapy the need to use boundaries; the development of a symbolic use of instruments; preoccupations with 'mess' and 'containers'; and a willingness to engage in a non-verbal form of expression and exploration. The nature of improvisation is that it finds ways to ask clients questions about their inner emotional world or about the abuse (for example through the use of a 'sound sculpture' depicting family relationships); rather than leaving the onus on the client to 'tell'.

This chapter addressed some of the issues which arise in work with sexually abused clients and commented on their effect on any research. The problem in inquiring into music therapy is in the transition from the 'systematic observing that is being done by every practising analyst who is awake whilst working' (Winnicott, 1965) to preplanned and focused inquiry; combining the roles of therapist and researcher.

References

Baker, A.W. and Duncan, S.P. (1985) 'Child sexual abuse: a study of prevalence in Great Britain', *Child Abuse and Neglect,* 9, 457–67.

Bentovim, A., Elton, A., Hildebrand, J., Tranter, M and Vizard, E. (eds) (1988) *Child Sexual Abuse within the family: Assessment and Treatment. The work of the Great Ormond Street Team.* London: Wright.

Chesney, J. (1987) 'Is psychotherapy research possible?' in *Starting Research in Music Therapy* – Proceedings of the third Music Therapy Conference, City University.

Cohn, A.H. and Daro, D. (1987) 'Is treatment too late? What ten years of evaluative research tell us', *Child Abuse and Neglect,* 11, 433–42.

Department of Health (1988) *Working Together.* London: HMSO.

Department of Health (1991) *Child Abuse. A Study of Inquiry Reports, 1980–1989.* London: HMSO.

Department of Health (1991) *Patterns and Outcomes in Child Placement.* London: HMSO.

Department of Health (1991) *An Introductory Guide for the NHS; the Children Act – 1989.* London: HMSO.

Furniss, T. (1991) *The Multi-Professional Handbook of Child Sexual Abuse: Integrated Management, Therapy and Legal Intervention.* London: Routledge.

Giraretto, H. (1982) *Integrated Treatment of Child Sexual Abuse: A Treatment and Training Manual.* London: Science and Behaviour Books.

Heal, M. (1989) 'In tune with the mind.' In D. Brandon (ed) *Mutual Respect: Therapeutic Approaches to Working with People who have Learning Difficulties.* Surrey: Good Impressions.

La Fontaine, J. S. (1990) *Child Sexual Abuse.* Cambridge: Polity Press.

Reason, P. and Rowan, J. (eds) (1981) *Human Inquiry: A Sourcebook of New Paradigm Research.* Chichester: John Wiley.

Reinharz, S. (1981) 'Implementing new paradigm research: a model for training and practice', in P. Reason and J. Rowan (eds) *Human Inquiry: A Sourcebook of New Paradigm Research.* Chichester: John Wiley.

Sagar, C. (1990) 'Working with cases of child sexual abuse', in C. Case and T. Dalley (eds) *'Working with Children in Art Therapy'.* London: Tavistock/Routledge.

Saunders, E.J. (1988) 'A comparative study of attitudes towards child sexual abuse among social work and judicial systems professionals', *Child Abuse and Neglect,* 12, 1.

Sgroi, S.M. (1982) *Handbook of Clinical Intervention in Child Sexual Abuse.* Massachusetts: Lexington Books.

Stenhouse, L. (1985) In Ruddick and Hopkins (eds) *Research as a Basis for Teaching: Readings from the Work of Lawrence Stenhouse.* London: Heinemann Educational Books.

Summit, R. (1983) 'The child sexual abuse accommodation syndrome', in *Child Abuse and Neglect* 7, 177–94.

Winnicott, D.W. (1965) 'The price of disregarding psychoanalytic research', in D.W. Winnicott (1981) *Home is Where We Start From*. Harmondsworth: Pelican.

Woman's Research Centre (1989) *Recollecting our Lives*. Vancouver: Press Gang Publishers.

Permission to Play
The Search for Self Through Music Therapy Research with Children Presenting with Communication Difficulties

Alison Levinge

'This dear reader is a covering letter. It underlines my belief that it is the stories that matter and how they are told' (Hobson, 1987, p.x).

The story which I am about to tell is not just of my research, but is a story of discovery. The way in which I tell this story will, I hope, reflect something of what it has come to mean. I ask my reader therefore, to suspend if they will their need to know, or their need to be told and allow themselves, if they can, to be carried along by the story. That like 'the patient on the couch, or the child patient among the toys on the floor', (Winnicott, 1971, p.64) I will be communicating a succession of ideas, thoughts and feelings. These may not initially seem linked, but they will reflect what I have come to discover as being at the heart of my research. This is, that the kind of relationship which evolves in the therapeutic setting, is dependent for its effect, more upon the 'how' than the 'what'. For it is 'the manner in which the steps are taken that is more important than the content' (Hobson, 1985, p.35).

I spent nine years of my professional life as a music therapist, working with children presenting with a wide range of difficulties. Suddenly, I found myself at the point where I needed to make sense of it all. It seemed important to formalize my thinking and find a way of placing it within a context which could be understood by others. Taking time to reflect is important in order to develop one's work. However, doing research seemed to me to be in part about making more concrete and accessible, that which initially is private and abstract. I hoped that taking the risk of putting out my ideas and testing them against the work of others, would help me to define my own method of working. Thus the story or journey of my research began.

The process

Before beginning my research, there were two issues which needed to be worked out. First, it was necessary to develop a framework within which I could place my research. Then I had to decide upon a suitable means of recording the material. After some discussion with my professor, I chose the method of descriptive study for presenting my research material, as this was felt to fit most comfortably with the psychodynamic approach to my work I had now developed. My work was with children, whose initial presenting difficulty had been in the area of communication. I was led towards the writings of Donald Winnicott, whose ideas I found most sympathetic and complimentary to the processes which go on in music therapy. His role as paediatrician and later psychoanalyst working with children and adults, had resulted in a wealth of material. In particular, his detailed observations of children which yielded invaluable yet extremely accessible information and connected with what I had already observed going on in music therapy. I decided therefore to choose Winnicott's approach to child development as the framework within which I would examine my work. In particular, his description of the three concepts of play, the holding environment and the Transitional object. When I began to write this chapter, however, I was faced with having to consider what the processes of doing research as a whole were about, as well as what they had come to mean. What I discovered, was that there seemed to be a parallel between what I had identified as the themes emerging in my work with children and certain aspects of how I had gone about my research. I have illustrated this connection, by using a number of Winnicott's ideas, of which the most predominant is his definition of the developmental stages of play. In this chapter therefore, by describing how I did my research, I have also identified and described some of the ideas which I discovered as being central to my work as a music therapist. I shall begin with Winnicott's ideas on the early stages of the mother–infant relationship.

Maternal preoccupation

Observing colleagues embarking upon, or currently involved in, research felt as if I was in the presence of someone in the process of taking vows. The absorption and commitment to the task seemed total and I was reminded of the early state of a motherhood which Winnicott identified and vividly described.

He wrote that when a mother is in the late stages of pregnancy and moving into the first stages of infant care, she is in a state of being 'given over' to the care of her baby in such a way that the baby feels like a part of herself. During this time she experiences changes which, although at first seem physiological, are in fact more related to her emotional state. Winnicott goes on to say, that this state is entirely necessary. For if a mother is to understand and provide for the infant's needs, she has to become almost totally identified with her infant. It is then through this identification that she is able to become literally 'in tune' and adapt to the infant's ever-changing needs. Winnicott named this state, 'maternal preoccupation' (Winnicott, 1956), and I was able to see similarities between the quality

of this early state of the mother and the feelings I started to experience as I embarked upon my research. When I began to examine my work, I gradually became aware that it would be more than just a hobby or interest. Rather, it was to become as the infant to the mother, a total preoccupation. Even when I was not actually involved practically, the research began to fill my mind as well as my time. This state seemed entirely necessary, as well as unavoidable, if I was to give the research a chance of survival and eventual credibility. Being 'given over' to my research would, I hoped, mean that at the end it would be able to stand on its own.

Holding environment

In beginning to parallel the process of doing research with the growth of the infant, I feel that it is essential to include the early stages of development. For it is at this point, that the foundations for successful growth are laid down. In the beginning, the infant is totally reliant upon mother for providing both emotional and physical care. The infant's state at this time therefore, is, as Winnicott termed, one of 'absolute dependence'. Initially, the world of the infant revolves around mother, who must be able to both identify and adapt to the infant's needs. As it is the mother who provides what is required for the infant to grow and develop, Winnicott described this relationship as being the infant's first environment. One aspect of this environment in particular which he felt to be important, was the ability of the mother to hold her child both physically and emotionally. In her arms the infant would be protected and kept warm. Holding the infant in her mind, meant that the mother could think about the infant's needs and present life in manageable doses. By feeling held in both body and mind, the infant would be helped to manage the developmental stages of its life and be able to work towards eventual separation and independence. This concept of a holding environment became one of the three ideas which I later came to explore in my work, but was also one which became an important part of the process of doing research. Like the holding of the infant by the mother, I discovered that I not only needed a physical space to carry out the work, but also a space in my mind in which I could think freely. Providing the right environment both externally and internally, allowed me to feel secure in my surroundings, whilst retaining an open mind in which ideas could change and develop. However, having attended to what I needed from the environment, I realized that this was not enough to make the research actually happen. I now needed to be 'doing' something.

Play

'Doing' is the word Winnicott used to describe play. He wrote, 'that in order to control what is outside one has to do things' and 'playing is doing' (Winnicott, 1971, p.47). For Winnicott, play was part of what facilitated growth and health and was an important means by which we come to manage and make sense of the world. This was the stage I had now reached. I wanted and needed to make sense of my work and in some way take control of my ideas and thoughts. By

observing the way in which other people research, I discovered that part of the 'doing' included gathering concrete evidence or data. This would then be examined, in the light of the original question which the researcher had formulated. I could therefore safely assume that it would also be necessary for me to identify and examine relevant facts within my own work. In a therapeutic relationship however, the facts, or observable behaviour, are only part of a child or adult's story. What gives meaning or sense to what happens between therapist and patient, is the particular way in which these facts are expressed. For, 'Facts lie in how stories are told' (Hobson, 1985, p.xv). Identifying what takes place in a therapeutic relationship must therefore, also include observing how a patient uses the setting, as well as acknowledging the content of what they express. In music therapy it became important, therefore, to create the kind of relationship which would allow a child to freely express themselves, in their own time and their own way. In my research, I had to ensure that the framework which I had chosen did not become a rigid structure. What was important, was that it allowed me the freedom to express my ideas in my own way and the freedom to play with them.

Discovering through play

In music therapy, the relationship is created around and through the music, which both child and therapist literally play together; it is this ability to play which Winnicott identified as leading towards the discovery of self. He felt 'that in playing and perhaps only in playing, the child or adult is free to be creative' (Winnicott, 1971, p.62), and that it was in being creative, that 'the individual discovers the self' (Winnicott, 1971, p.63). What I had come to identify as the essential element of music therapy, i.e. play, now became the essential element of my research. Taking this idea into the process meant that I would not only have to allow myself to freely express my thoughts and ideas, but also that in consequence, I would be led into discovering something of myself. My research had now become a journey of self-discovery.

The objects of play

Focusing on the way in which a child or adult chooses to tell their story connected for me with another of Winnicott's observations of children at play. He described that a child at play, 'gathers objects or phenomena from the external reality and uses these in the service of some sample derived from inner or personal reality' (Winnicott, 1971, p.60). By this Winnicott meant that in play, a child is using the toys or objects in a way which demonstrates something of what they both feel, as well as how they experience, the world. I will summarise one of Winnicott's own case studies in order to explain further.

Edmund was a two-and-a-half-year-old little boy, brought by his mother to visit Winnicott at his clinic. At one end of the room was a table, at which mother and Winnicott sat either side. At the other end was a box of toys. Whilst mother and Winnicott discussed the child's difficulties, Edmund began to play. He eventually discovered the box of toys and pulled out a piece of string. As the

discussion continued, Winnicott noted that Edmund would sometimes use the string to 'make a gesture which was as if he "plugged in" with the end of the string like an electric flex to his mother's thigh' (Winnicott, 1971, p.50). Mother immediately commented, saying that 'Edmund is most clinging, needing contact with my actual breast'. Winnicott saw the string as a symbol or representation of the relationship between Edmund and his mother and that through his play, Edmund's difficulties in separating had been vividly demonstrated. This had been confirmed earlier by mother when she had said, that Edmund would only accept her actual breast and that he 'brooked no substitute' (Winnicott 1971, p.50). Without words, Edmund had been able to display ideas that preoccupied his life and this had enabled Winnicott to gain a wider understanding of how Edmund had perceived the world.

This concept of external objects being used in the expression of something internal, seemed to directly relate to yet another aspect of my research. If I was to be able to place the observable facts which occurred in my therapeutic relationships with the children into a meaningful context, then I needed to be aware of the larger picture. What happens in a therapeutic relationship is to do with all the people present, as therapy is about sharing a dialogue. Therefore, it was impossible for me not to connect the potential material of my research, i.e. that which was in the external world of my work, with my own internal psychological processes. In other words, that by examining the inner and outer world of the children with whom I was working, I automatically became in touch with my own inner material. This material consisted of my own thoughts and feelings about the world developed through my experiences of life. Working with children in particular meant that the part of my inner life which would be in most contact with my external role as a music therapist, would be my own inner child. Any observations which I made must, therefore, include observations of my own feelings and behaviour as the other person present.

Transitional object

An extension of this concept of the use of objects in the writings of Winnicott, is his ideas on what he came to name as The Transitional Object. He described that the space or object which can be located between the mother and the baby, or joins them, is used as a means by which the baby and mother learn to be together whilst at the same time remaining separate. The object chosen by the infant becomes a representation of the mother, which enables the infant to hold on to an idea of her during her absence. In the beginning, this can be the thumb sucked by the baby, changing in later development to objects such as a soft toy or piece of cloth. The transitional object in the story of my research seems to me to have been the material of my work, which was essentially about how the music was used by each child in the therapeutic setting. This materially represented the space or object both between and connecting the two forms of thinking which I had chosen for my research. These were the psychodynamic approach and under-

standing of children as defined in Winnicott's writings and the processes involved in the playing of music together in a therapeutic setting.

Background to the work

My work as a music therapist involved the assessment and treatment of children presenting with a wide range of difficulties. Children between the ages of 0–16 years came to the Child Development Centre, where I was employed as a music therapist. Initially they would be seen for assessment by an appropriate selection of professionals, chosen from the multi-disciplinary team. I saw children who had fairly obvious identifiable physical or mental difficulties and offered music therapy to those whose diagnoses came under the category of cerebral palsy, global delay or other physical difficulties. A large proportion of the children coming to the centre presented with problems which could be understood in the context of a medical model. Certainly, for the majority of the team, the main focus of assessment would be upon the physical representations of these problems. However, there were some children whose difficulties were not easy to categorize or understand. Their predominant symptoms were in the area of communication and language development and often included disturbed behaviour. A child with these kinds of problems, once assessed, would often leave the team feeling confused and puzzled.

It somehow fell to me – or was I being drawn – to try to understand and work with these subtly complicated and puzzling children. During the next few years at the centre, I saw only children who presented with these difficulties. I worked with them individually, seeing them for once weekly music therapy over a period of between one and three years. As therapy progressed, three themes emerged as both central and common to the musical relationship of each child and came to form the basis upon which my research developed. I have already referred to them at the beginning of this chapter, but they were connected essentially with how each child used the musical setting. Through the writings of Winnicott, I was able to identify these themes as having a similar character to those which he named as play, the holding environment and the transitional object.

Play in the music

Unless they were extremely ill or disturbed, Winnicott observed that children naturally play. In music therapy, the toys of play are replaced by a wide variety of what is usually predominantly percussion instruments. Children seem easily drawn into exploring these instruments and making a sound. In doing so, they immediately perform an action which, in turn, creates an opportunity for contact with another. In music therapy, it is through the therapist's use of their own music that the relationship begins to grow. In my therapeutic sessions with these children, I used improvised music to mirror, reflect, support and structure the sounds of each child. This enabled me to develop a connection with their musical play and experience something of how they felt about the world. Just as in Edmund's play with his mother, where he had used the toys in the room to reveal

something of how he perceived the world, so the child in music therapy uses the musical elements of rhythm, pitch, dynamic, duration and tempo to create a feeling of what it is like to relate. As described by Winnicott, there is no specific goal when engaged in play, rather, it is in the actual process that we discover something of ourselves.

In music therapy, there is no need for words. Therefore, the children in my sessions who were having difficulties relating, or were without the use of language, were able to make sounds which I received as a communication. Responding with my own music, I began to build a relationship which continued to develop through the playing of music together. Relating without words seemed to connect with a level of interaction which was developmentally before speech and it is often at this stage of a child's growth that difficulties may arise which can hinder the normal process of development. In Winnicott's writings, we read that he believed that just as there are stages in the physical development of a child, so there is also a developmental process in a child's emotional life. If for any reason this becomes interrupted, then it can lead to later disturbance. These interruptions or traumas may have been unnegotiable at the time and can cause the child to become stuck at a particular stage of development. Through the non-verbal means of playing music together, it was possible to reach the developmental point of relating at which this may have occurred and provide an opportunity for renegotiation and a chance to move on. For example, one child in music therapy played insistent continuous drumbeats, evoking in me a feeling of anger and helplessness at a time when I had been trying to make contact. I realized that these feelings were actually within the child and had occurred in the session when there had been an opportunity for closeness. It was possible to surmise, therefore, that perhaps this was the point in the child's development at which something had become unmanageable. I was later able to use this observation in helping me to understand the child's difficulties.

Holding in the musical environment

Being able to play needs a safe setting and this can be developed by using the music to create what Winnicott termed the holding environment. The mother who helps her infant to manage the physical and emotional changes of life, does so by tuning into their needs. A music therapist can make a child feel safe in therapy by initially meeting their music and playing literally in tune with them. In my sessions, I began by identifying with each child's music and acknowledging the sounds they made. In adapting to their various musical changes, I was able to make sense of their music which at first sounded chaotic and unconnected. This enabled the child to feel heard and ultimately contained. The particular element of music which allows this identification and adaptation to take place is its temporal nature. Using improvisation, I was able to respond and connect with a child's changing moods and different musical elements at any moment. As therapy progressed and they began to feel held by the music, it became possible to begin exploring their difficult and uncomfortable feelings and work towards change.

The transitional object in music

In music therapy, it is easy to see the instruments as the transitional objects. In their sessions, the children were able to use the instruments as a bridge, which both joined us together whilst at the same time kept us apart. However, I think that it is also the music itself which becomes used in this way. Creating music together meant that as well as becoming connected through the sounds, we could remain as two separate 'voices'. Within one session alone, the transitional object could move from being a representation of the original object by the instruments, to the music and even to me as therapist.

Music therapy with David

I shall now end the story of my research by describing the beginning of David's first music therapy session with me. In his story, the three concepts of Winnicott I have previously identified are illustrated and the idea central to my work expressed. In David's music, not only are these two aspects of my research held together, but it is also possible to see something of David's thoughts and feelings being vividly displayed.

David was a lively, loveable, bright-eyed three year old who was to become the first child of my research. In his clinical notes David was described as having language delay accompanied by behavioral difficulties. He was described by his nursery as demonic, with little sense of himself. During assessment David was extremely active and found it almost impossible to focus on one activity for any length of time. His constant restlessness was exhausting and became extremely demanding for both his mother and the nursery staff, who looked after him for three days of the week.

After David's assessment it was agreed that I would see him for one music therapy session per week. In the first session I was immediately struck by a feeling that I was in the presence of a child behaving much younger than his years. This was compounded by the fact that David had developed his own private language which included a wide range of pitches and rhythmic patterns, thus giving it a speech-like quality. In the first moments of the very first session we had together, I was able to see something of what David was feeling: through his behaviour, David seemed to be showing me his view of the world. In beginning to relate to me, David clearly expressed something of how he experienced being with others and this was illustrated in the following series of events.

We had left mother in the waiting area. Presented with a selection of predominantly percussion instruments David began to explore and play them, making a number of single, dynamically loud sounds. He moved quickly from one instrument to another, arriving at the piano, I was prompted to sing and play 'hello'. As if taken over by some intense feeling, David suddenly began to cry, yet even while crying he continued to hit the cymbal and drum alternately. Initially, he was able to be comforted and quickly stopped crying. Then, discovering the guitar, he made a great effort to remove it from the corner, where it was awkwardly placed. David began to pluck at the strings, but after only a short time, burst into

tears once again. The quality of David's cry, however, seemed to me to be that of a child not totally upset, rather, David seemed caught between his desire to explore and his desire for his mother.

I decided to ask mother to join us. She sat opposite me at the other side of the room, where she remained for the rest of the session. We briefly discussed David's difficulty in separating, and it was decided that mother and I would work together on helping David feel comfortable about being away from her.

With mother present in the room, David continued to explore the instruments, now playing a wider range of sounds. He moved quickly from one instrument to another, spending only a short time on each. David's musical expressions were more definite, but unsustained, often directed towards his mother. My role, as the therapist, was now very much in the background, sitting at the piano. It seemed that my only way of safely making contact with David was through music. So I began to make musical invitations on the piano. These took the form of short musical statements, which in some way echoed or mirrored something of the quality or character of David's musical play.

At this stage of our relationship, I felt that it was important to David that my musical invitations were carefully placed and structured: if my phrases were sudden or too lengthy David may have experienced them as intrusive. If they had been too brief or unpredictable, David may have felt unable to connect with them. Throughout these musical exchanges, mother made continuous comments, either praising, encouraging or instructing David to be careful.

Gradually, David began to respond and his musical explosions began to be directed towards me. The music changed from being my invitations and affirmations of David's music, to David's imitations and responses to mine. We were creating a language together. This language started to develop from the music David and I had played together. What we discovered in the very first moments of our musical time together, was a space to play, to be creative. We moved away from an uncomfortable place where relating and communicating seemed awkward and difficult, to a place where we both felt safe enough to explore. Winnicott named this place 'The playground'.

Until now, David's music felt at times to be chaotic, unstructured and disconnected. Yet it was interesting, and I feel significant, that this was not the feeling I had later when I examined this section on the video taped recording. I was therefore left to wonder if in fact what I had felt at the time had actually been part of David's own inner world of thoughts and feelings. What David enabled me to feel and experience, was in fact part of his own story. What emerged through David's use of the music was that in some way, he did not feel held: that the world was not a safe place for him to be. His body expressed this idea even more vividly when he literally dropped himself over the xylophone. It seemed that even his body could not hold him.

As this session moved on, David allowed himself to be fully held in the music. He now came to join me at the piano. Our music developed into a duet which led from dissonant, heavy chords into a waltz. At this time David physically, musically

and now emotionally moved from being in a space with mother to being in a space with me. As we entered the waltz, David's whole body moved as if he was totally held in the music. I noticed that he had now become co-ordinated and more focused.

However, the original conflict re-emerged, and David made an attempt to move away from the music and back to mother. I observed that there had seemed to be a relationship between the music David and I played well together, which had continuity and flow and his need to interrupt this experience. David's tripping and falling were, I felt, a rupture to our togetherness and in the following sessions this emerged as a significant theme.

What had already been revealed through the musical relationship, was a vivid representation of the beginning of David's own story. This little boy's experience of his mother had been confusing. Mother had found it difficult to set boundaries and at times her own feelings and thoughts had been unmanageable and uncontainable, often spilling out into her relationship with David. His inability to hold himself, both physically and emotionally, seemed to reflect part of David's experience of being with his mother. This was translated directly into our musical relationship. Without words it had been possible to recreate David's early experience of relating. Music therapy had been able to provide another opportunity for David to renegotiate this stage of development and hopefully to move on.

In conclusion

Our musical time together had seemed to mirror what I had come to discover in the larger process of doing my research. That once I had been able to let go of my expectations in the therapy and in my research, the conditions became right for growth. Providing the right environment for David had allowed him room to grow and develop from being a child in a dependent and undifferentiated state, into one who could begin to live and act in his own right. He had used the instruments both as a means to connect us together and as a way of maintaining a safe distance. Ultimately, I had been forced to let go of my own agenda and had to allow David to reveal his own. If I was to understand him, then it was important that David could express himself in his own way and in his own time. The relationship had to evolve freely, without me assuming the end result. I had needed to trust that by providing a 'good enough' environment or setting, David would be able to reveal something of himself. By being able to play together, I had gradually come to understand David's difficulties and been able to help him begin to manage relationships in a different way.

In doing my research I often found myself having to let go of the need to know and allow the process of discovery to carry me along. The interplay between my ideas, my observations and my feelings was constant, and took place in the space called 'doing research'. This was the playground in which I struggled, played, explored and ultimately came to discover my ideas. The psychodynamic approach to my work with the children who came for music therapy became the basis upon which I developed my research model. Whatever I observed or came to under-

stand, became a stepping stone to the next discovery. In putting my trust in the process of doing therapy or doing research, I had learned to play and in learning to play I had discovered something of myself as well as of the children. However, play was only part of the journey. Having allowed myself to freely explore the material contained within each child's session, the next step was to translate this into a recognizable and accessible form. I identified the individual themes which had occurred within each child's musical play, and used them to relate to the original specific ideas chosen from Winnicott's writings. A set number of sessions of each child's therapy was written in descriptive form over a period of one year. By placing the ideas of Winnicott together with the themes from each child's music therapy, my aim was to create a different framework within which it would be possible to understand the processes of music therapy. Attempting to reach a conclusion automatically seemed to raise further questions. Just as it had been difficult to end my therapy with David, so it became difficult to end my research. For me, doing research had been in part about trying to find answers, as I had in part hoped to find them in the therapy with the children. However, in both processes, as in the creative activity of play, I discovered that there are no final answers, only the journey of finding out.

References

Hobson, R.F. (1985) *Forms of Feeling (The Heart of Psychotherapy)*. London: Tavistock.

Winnicott, D.W. (1956) *Primary Maternal Preoccupation*. London: Tavistock.

Winnicott, D.W. (1965) *The Maturational Process and the Facilitating Environment*. London: Hogarth.

Winnicott, D.W. (1971) *Playing and Reality*. London: Tavistock.

Part III

Directory of Arts Therapies Research

Part III

Directory of Arts Therapies Research

Directory of Arts Therapies Research

Helen Payne

This directory is the result of two calls for research details in 1988 and 1992 through each of the four professional Associations. Many thanks to all those arts therapists who responded by submitting details of their research projects. Any project omissions are due to a lack of information.

It should not be seen as a comprehensive list, but a step towards collating research completed and currently being undertaken in all four professions.

The directory is in four sections: art therapy, dance movement therapy, dramatherapy, and music therapy. Each is divided into three distinct categories, in date order for historical purposes:

1. Research by degree.

2. Research projects with independent sponsorship.

3. Studies submitted as part of taught post-graduate courses.

Both completed and current research is referenced, together with any relevant publications. All studies which were personally submitted by the researcher or student have been included. Others thought to be relevant and which were registered research studies at an institution for higher education in the UK are mentioned where details were known. The same format has been followed for all four sections.

Please contact the training institutions' libraries for further studies completed on Post-graduate Diploma and Masters taught courses.

Supervision

Supervision can be obtained from those institutions listed where the projects were either registered or undertaken. In some cases names of supervisors have been included where they were supplied.

Research may be carried out by degree (M.Phil/PhD) registered with any institution of higher education or university where academic supervision is provided; or by independent sponsorship, or as part of a taught course where a basic introduction to research methods will normally be learned. In addition,

those arts therapists who have conducted research may be willing to act as academic and clinical supervisors to those beginning projects.

Note: Hertfordshire College of Art and Design (HCAD) is now The University of Hertfordshire, School of Art and Design, 7 Hatfield Road, St Albans, Herts AL1 3RS.

Sponsorship

Sponsorship for independent research could be sought by contacting those sponsors listed in the directory. Employers may also be willing to sponsor a project. Arts therapists familiar with research may be able to offer help with the formulation of research proposals.

Art therapy: completed research

Research by degree

Henzell, J. (1980) 'Image making and the mentally ill. A critical examination of the theories and models underlying its study and uses'. M.Phil (CNAA) Birmingham Polytechnic. Copy in library, School of Art and Design, University of Hertfordshire. (Philosophical and historical study.)

Dubowski, J. (1983) 'An investigation of pre-representational drawing activity of certain severely retarded subjects'. PhD (CNAA) University of Hertfordshire. Copy in library, School of Art and Design. (Comparative study.)
 Publications:
 Dubowski, J. (1982) 'Alternative models for describing the development from scribble to representation in children's graphic work'. Proceedings of Conference 'Art and Dramatherapy' April, School of Art and Design, University of Hertfordshire. (Developmental psychology.)
 Dubowski, J. (1984) 'The development of children's graphic art work', in T. Dalley (ed) *Art as Therapy.* London: Tavistock.

Males, J. (1986) 'Art therapy as an approach to change in mental handicap'. PhD, University of Surrey. Copy in library. (Evaluative.)

Waller, D. (1990) 'History and development of art therapy towards professionalism (1940–1982)'. D.Phil, University of Sussex. (Historical and case study. Process model of professions.)
 Publications:
 Waller, D. (1984) 'A consideration of the similarities and differences between art teaching and art therapy', in T. Dalley (ed) *Art as Therapy.* London, Tavistock.
 Waller, D. and James, K. (1984) 'Training in art therapy', in T. Dalley (ed) *Art as Therapy.* London: Tavistock.
 Waller, D. (1987) 'Art therapy in adolescence: a metaphorical view of a profession in progress', in T. Dalley *et al., Images of Art Therapy.* London: Tavistock.
 Waller, D. (1986) 'The professional development of art therapy in Britain', *Ballet International,* 9, 9.
 Waller, D. (1991) *Becoming a Profession: The History of Art Therapy in Britain 1940–1982.* London: Routledge.
 Waller, D. and Gilroy, A. (1992) *Art Therapy: A Handbook.* Buckingham: Open University Press.

Schaverien, J. (1990) 'Transference and countertransference in art therapy: Mediation, interpretation and aesthetic object'. PhD (CNAA) Birmingham Polytechnic. Copy in Department of Art, Margaret Street, Birmingham B3 3BX and School of Art and Design, University of Hertfordshire. (Philosophical and discursive study.)

Publications:

Schaverien, J. (1985) 'The picture within the frame'. Proceedings from Conference 'An International Review of the Arts in Therapy', Goldsmiths College, University of London.

Schaverien, J. (1987) 'The scapegoat and the talisman: transference in art therapy', in T. Dalley *et al.* (1987) *Images of Art Therapy.* London: Tavistock.

Schaverien, J. (1987) 'The child within: reflection, repair and transference'. Proceedings from Conference 'Image and Enactment', School of Art and Design, University of Hertfordshire. Copy from college.

Schaverien, J. (1989) 'The picture within the frame', in A. Gilroy and T. Dalley (eds) *Pictures at an Exhibition: Selected Essays on Art Therapy.* London: Routledge.

Schaverien, J. (1991) *The Revealing Image: Analytical Art Psychotherapy in Theory and Practice.* London: Tavistock/Routledge.

Schaverien, J. (1993) 'Retrospective review of pictures data for research in art therapy', in H. Payne (ed) *Handbook of Inquiry in the Arts Therapies: One River, Many Currents.* London: Jessica Kingsley Publishers.

Gilroy, A. (1992) 'Art therapists and their art'. D.Phil, University of Sussex. (Survey and interview.)

Publications:

Gilroy, A. (1988) 'Art therapists and their art – are there any firm criteria for distinguishing between images made in a "therapeutic" context and those made in an "art" context'. Proceedings from Conference 'Art and Therapy' held in association with the exhibition 'Through the Looking Glass', Midland Arts Centre, Birmingham. Copy available from author.

Gilroy, A. (1989) 'On occasionally being able to paint', *Inscape*, Spring.

Independent research projects

Waller, D. (1975) 'Naive artists or naive critics?' Sponsor: Leverholme.

Publication:

Inscape, 1, 14. (Sociological study.)

Dalley, T. (1977) 'An investigation into the efficacy of art therapy in psychiatric treatment'. Sponsored by Rank Xerox Research Fellowship, School of Art and Design, University of Hertfordshire. (Evaluative, experimental study.) Copy available from author.

Publications:

Dalley, T. (1979) 'Art therapy in psychiatric treatment: an illustrated case study'. *Art Psychotherapy*, 6, 4. (Case study.)

Dalley, T. (1980) 'Assessing the therapeutic effects of art: an illustrated case study'. *Art Psychotherapy*, 7, 1. (Case study.)

Holtom, R, (1977) 'Measuring change attributable to art therapy'.

Publication:

Inscape, 17 (Survey.)

Waller, D. (1980) 'Body image disturbance as observed in paintings by persons with eating disorders'. Sponsors: Goldsmiths College and Guys Hospital, Lewisham Mental Health Centre Project. (Evaluations of group using Personal Construct Theory.)

Publications:

Proceedings of Conference Gilbert and Irene Champernowne Trust, Hawkswood College Stroud, Gloucester. Sponsors: Guys and Lewisham Community Health Centre Project. (Evaluations of group using Personal Construct Theory.)

Waller, D. (1981 and 1983) 'Art therapy and eating disorders'. Proceedings of Art Therapy Symposium and International Conference of the British Psychological Society 1983 and Proceedings of 8th World Congress of Social Psychiatry, Zagreb, 1981.

Males, J. (1983) 'An examination of methods used in art therapy with mentally handicapped adults'. Sponsor: Small Grants Committee, DHSS.

Waller, D. (1983) 'Art therapy within the psychiatric services in Bulgaria'. Sponsor: World Health Organisation.
Publication:
Proceedings of Conference 'The Institution', School of Art and Design, University of Hertfordshire. Copy in library.

Waller, D. (1983) 'Art therapy in Bulgaria: Parts 1 and 2'. Sponsor: World Health Organisation.
Publications:
Inscape, Spring and Autumn 1983.

Waller, D. (1989) 'Musing cross culturally', in A. Gilroy and T. Dalley (eds) (1989) *Pictures at an Exhibition: Selected Essays on Art Therapy.* London: Routledge.

Waller, D. (1992) 'Different things to different people: Research with art in psychotherapy'. *The Arts in Psychotherapy,* 19.

Waller, D. (1992) 'The development of art therapy in Italy: Some problems of definition and context'.
Publication:
In *Inscape,* Winter 1992.

Males, B. and Stott, J. (1984) 'Art therapy for people who are mentally handicapped'. Sponsor: DHSS.
Publications:
Chapter in T. Dalley (ed) (1984) *Art as Therapy.* London: Tavistock.

Males, B., Males, J. and Stott, J. (1985) 'An examination of the methods used in art therapy with mentally handicapped adults'. Proceedings of Conference 'An International Review of the Arts in Therapy', University of London, Goldsmiths College.

Maclagen, D. (1986) 'Between psychoanalysis and surrealism: Grace Pailthorpe and Reuben Mednekoff'. (Historical and evaluative.)
Publication:
In Proceedings of Conference 'Surrealism in England 1936 and After' held in association with exhibition of same name. Copy with author.

Luzzatto, P. (1987) 'The internal world of drug abusers. Projective pictures of self-object relationships'. (Pilot study, experimental.)
Publication:
British Journal of Projective Psychology, 32, 2, 22–33.

Greenwood, H. and Leyton, G. (1987) 'An outpatient art therapy group'. (Case study, considers the use of humour in art therapy groups with psychotic patients.)
Publication:
In *Inscape,* Summer 1987.

Greenwood, H. and Leyton, G. (1988) 'Taking the piss'. Pending Publication, *British Journal of Clinical and Social Psychiatry.*

Edwards, D. and McNab, D. (1988) 'Private art therapy'. (Survey.)
Publication:
In *Inscape,* Summer 1988.

Schaverien, J. (1989) 'Transference and the picture: art therapy in the treatment of anorexia'. (Case study.)
Publication:
In *Inscape,* Spring 1989.

Perry, P. (1991) 'Art therapy with Fonthill'. Sponsor: Salisbury Health Authority in consultation with David Purkis, Principal clinical psychologist, Old Manor Hospital, Wilton Road, Salisbury SP2 7EP. (Evaluation of aims and objectives of art therapy with resettlement patients in day care. Rating scales used by participants to measure outcome.)

Waller, D. (1992) 'A European perspective on art therapy training'. University of London. Sponsor: Central Research Fund.

Waller, D. (1993) *Group Interactive Art Therapy: Its Use in Training and Treatment.* London: Routledge.

Gheorrhieva, J. (1990) 'Establishing a new psychosocial intervention in the Bulgarian NHS: The case of art therapy.
Publication:
In *Inscape*, Spring 1990.

Studies submitted as part of a taught post-graduate course

Waller, D. (1972) 'A personal appraisal of art therapy'. Submitted in part fulfilment of requirements for MA, Royal College of Art. Copy in library. (Historical.)

Byrne, P. (1977) 'Art in art and psychopathology'. Submitted in part fulfilment of requirements for DAE, Birmingham Polytechnic, School of Art Education. Copy in library. (Exploratory.)

Liebmann, M. (1979) 'A study of structured art therapy groups'. Submitted in part fulfilment of requirements for MA (CNAA), Birmingham Polytechnic, School of Art Education. (Survey and interview.)
Publications:
Liebmann, M. (1981) 'The many purposes of art therapy'. *Inscape*, 5, 1.
Liebmann, M. (1984) 'Art games and group structures', in T. Dalley (ed) (1984) *Art as Therapy.* London: Tavistock.
Liebmann, M. (1986) *Art Therapy for Groups*. London: Croom Helm.
Richardson, B. (1980) 'Introducing art as therapy to a terminal care unit'. Submitted in part fulfilment of requirements for MA (CNAA), Birmingham Polytechnic, School of Art Education. (Descriptive, heuristic.)

Case, C. (1981) 'The expression of loss in art and play therapy'. Submitted in part fulfilment of requirements for MA (CNAA), Birmingham Polytechnic, School of Art Education. Copy in library. (Case study.)
Publications:
Case, C. (1981) 'Problems with bereavement with maladjusted children'. Proceedings of Conference 'Art Therapy and the Mentally Handicapped', School of Art and Design, University of Hertfordshire. Copy in library.
Case, C. (1983) 'Working through the grief process with children'. Proceedings of Conference Third International Congress of AEDES, Madrid, Spain.
Case, C. (1986) 'Hide and seek: a struggle for meaning – art and play therapy with bereaved children', *Inscape*, Winter.
Case, C. (1987) 'A search for meaning – loss and transition in art therapy with children', in T. Dalley *et al. Images of Art Therapy*. London: Tavistock.
Synman, E. (1981) 'The symbolic image: an exploration of the symbolic image in art as therapy with reference to C.G. Jung'. Submitted in part fulfilment of requirements for MA (CNAA), Birmingham Polytechnic, School of Art Education. (Exploratory case study.)

Levens, M. (1983) 'Magical control of the body and psychic cannibalism'. Submitted in part fulfilment of requirements for MA (CNAA), School of Art and Design, University of Hertfordshire. Copy in library.

Donnelly, M. (1983) 'The origins of pictorial narrative and its potential in adult psychiatry'. Research Diploma project. Copy with author, Art Therapy Department, Gloucester House, Southmead Hospital, Bristol. (Experimental.)

Schaverien, J. (1984) 'Word and image in art psychotherapy'. Submitted in part fulfilment of requirements for MA (CNAA), Birmingham Polytechnic, School of Art Education. Copy in library and School of Art and Design, University of Hertfordshire. (Philosophical.)

Nowell-Hall, P. (1985) 'The use of art therapy within a therapeutic community'. Submitted in part fulfilment of requirements for MA (CNAA), Birmingham Polytechnic, School of Art Education. Copy in library and School of Art and Design, University of Hertfordshire. (Illuminative evaluation methodology.)
Publication:
Nowell-Hall, P. (1987) 'Art therapy: a way of healing the split', in T. Dalley *et al* (1987) *Images of Art Therapy.* London: Tavistock.

Whitehurst, A. (1985) 'Images and words'. Submitted in part fulfilment of requirements for MA (CNAA), School of Art and Design, University of Hertfordshire. Copy in library. (Evaluative.)

Driscoll, C. (1986) 'Problems of human interaction within a large organisation with particular reference to the practice of art therapy'. Submitted in part fulfilment of the requirements for MA, School of Art and Design, University of Hertfordshire. Copy in library.

Pope, M. (1986) 'Anita: An investigation into meaning of symbolic and metaphoric self expression in images produced by a young woman'. Submitted in part fulfilment of requirements for MA (CNAA), School of Art and Design, University of Hertfordshire. Copy in library. (Case study.)

Teesdale, C. (1986) 'Thunderclouds and rainbows: art therapy, homelessness and other issues'. Submitted in part fulfilment of requirements for MA, Royal College of Art. Copy in library. (Descriptive case study.)

Thomson, M. (1986) 'Art, the instrument of change'. Submitted in part fulfilment of requirements for MA (CNAA), School of Art and Design, University of Hertfordshire. Copy in library. (Historical.)

Killick, K. (1987) 'Art therapy and schizophrenia: a new approach'. Submitted in part fulfilment of requirements for MA (CNAA), School of Art and Design, University of Hertfordshire. Copy in library. (Evaluative and case study.)

McGregor, I. (1987) 'Anomalous drawing ability in children'. Submitted in part fulfilment of requirements for MA (CNAA), School of Art and Design, University of Hertfordshire. Copy in library. (Descriptive.)

Clare-Barker, N. (1987) 'The construction of the self: an art therapy approach to the use of body image'. Submitted in part fulfilment of the requirements for MA, School of Art and Design, University of Hertfordshire. Copy in library.

Danvers, P.F. (1987) 'An approach to the understanding of the use of pictures in therapy through the theories of visual perception'. Submitted in part fulfilment of requirements for MA, School of Art and Design, University of Hertfordshire. Copy in library.

Greenman, B. (1987) 'What does an understanding of transitional periods in the artist's image making process contribute to an understanding of the image making process in art therapy'. Submitted in part fulfilment of requirements for MA (CNAA), School of Art and Design, University of Hertfordshire. Copy in library. (Phenomenonlogical observation of art process.)

Wetherall, J. (1989) 'A two-way bridge: questions relating to creative experience and the nature of imagination and its uses in art therapy'. Submitted in part fulfilment of requirements for MA (CNAA), School of Art and Design, University of Hertfordshire. Copy in library. (Discursive, philosophical.)

Chow, H.C. (1990) 'Structured art therapy for a disturbed child: using a repertory grid technique as an assessing tool'. Submitted in part fulfilment for M.Ed, University of Edinburgh. (Evaluative.)

Ashby, M. (1990) 'Art therapy and the concept of passive trauma in children'. Submitted in part fulfilment of requirements of MA (CNAA), School of Art and Design, University of Hertfordshire, St Albans. (Theoretical, discursive.)

Art therapy: current research

Research by degree

Henzell, J. (1982–) 'Art, aesthetics and psychotherapy'. PhD registered at University of Sheffield. (Epistemological study.)

Publications:

Henzell, J. (1985) 'The patient and Dr Procustus'. Proceedings from Conference 'An International Review of the Arts in Therapy', University of London, Goldsmiths College. Copy from author.

Henzell, J. (1988) Paper based on PhD research. Proceedings from Conference 'Art and Therapy' held in association with exhibition 'Through the Looking Glass', Midlands Arts Centre, Birmingham.

Rees, M. (1984–) 'Ethological constructs of territoriality and dominance hierarchy and their implications for the practice of art therapy'. PhD (CNAA), registered at School of Art and Design, University of Hertfordshire.

Hogan, S. (1987–) 'Conformity and expressionism', PhD registered at the University of Sydney, Power Department of Fine Art, Australia. (Historical and theoretical.)

Publications:

Hogan, S. (1987) 'Art therapy in the community, mental health in transition', Richmond Fellowship Conference Report, University of Stirling, Scotland.

Hogan, S. and Gunn, M. (1987) 'Towards a model of art therapy in the community in Scotland', *Alba Journal of National and International Contemporary Art from Scotland*, Talbot Rice Arts Centre, 6, 19.

Hogan, S. (1988) 'New approaches to mental health, the mandala art therapy project', Link-up ECSS (Edinburgh), summer edition.

Hogan, S. (1988) 'Metaphor in art therapy', *Alba Journal of National and International Contemporary Art from Scotland*, Talbot Rice Arts Centre, 8, 27–30.

Hogan, S. (1989) 'Letter from Australia, the development of art therapy', *Inscape*, Spring, 24–5.

Hogan, S. (1989) 'Art and psychoanalysis, interview with Peter Fuller', *Alba Journal of National and International Contemporary Art from Scotland*, Talbot Rice Arts Centre, 2, 18–22.

Hogan, S. (1989) 'Doing it metaphorically', *Art Monthly Australia*, November, 25, 28.

Hogan, S. (1992) 'The cultural melting pot: multi-culturalism in Australia', *Australian Journal of Arts Administration*, Deakin University, January edition.

Hogan, S. (1992) 'Representations of women and the development and strategies of the feminist movements', *The Arts in Therapy*, ADE Conference Papers, La Trobe University, Victoria.

Edwards, D. (1991–) 'An inquiry into the supervision of art therapists', PhD registered at the University of Sheffield. (Interview, questionnaire, single case study.)

McClelland, S. (1991–) 'Art therapy and acute states'. PhD registered at the University of Bath. Supervisor: Dr P. Reason. (Collaborative inquiry.)

Independent research projects

Dalley, T. (1976–) 'The efficacy of art therapy in psychiatric treatment'. Experimental study begun under auspices of Rank Xerox Research Fellowship at School of Art and Design, University of Hertfordshire. (Some material to be analysed and written up.)

Schaverien, J. (1982–) 'Anorexia nervosa: a case study of art therapy and transference'. (Case study.)

Maclagen, D. (1984–) 'Between psychoanalysis and surrealism: Grace Pailthorpe and Rueben Mednekoff'. Sponsor: Leverhulme. (Historical and evaluative.)

Edwards, M. (1985–) 'The pictorial material of patients of C.G. Jung 1917–1950'. Sponsor: C.G. Jung Institute. (Historical and evaluative study of images in Jung's picture archives, cataloguing and organising material.)

Waller, D. (1985–) 'Cross cultural issues in art therapy training and practice'. Sponsor: World Health Organisation. (Longitudinal and anthropological study in Bulgaria, Yugoslavia and Italy.)

Teesdale, C. (1986–) 'Conditions of service of art therapists'. Sponsors: British Association of Art Therapists and MSF. (Survey.)

Greenwood, H. (1987–) 'The use of art therapy in a community setting with people suffering from psychotic illness'. Sponsor: Stanley Royd Hospital, Wakefield, West Yorkshire. (Descriptive case study.)

Donnally, M. (1988–) 'A method of evaluating art therapy'. Sponsor: DHA.

Vasarhelyi, V. (1989–) 'The self image of children with kidney transplants'. Sponsors: Child Psychiatry and Renal Unit, Guys Hospital. (Descriptive, case study.)

Schaverien, J. (1991–) 'Gender, transference and counter-transference', in *The Revealing Image: Analytic Art Psychotherapy in Theory and Practice*. London: Routledge.

Chow, C.H. (1991–) 'To be or not to be'. Sponsor: Tung Wah Group of Hospitals, Yau Tze Tin Memorial Hospital, Siu Hong Court, Ten Mun, New Territories, Hong Kong. (Case study.)

Toolan, P. (1991–) 'Music therapy and its effect on the incidence of communicative interaction in people with a range of mental handicaps'. Sponsor: Prudhoe Hospital, c/o Arts Therapies Department, Northumberland, Steering Group: Dr T.B. Berney, Consultant Psychiatrist and Mr S. Noone, Senior Clinical Psychologist. (Experimental single case (A-B) design, replicated in 6 cases, behavioural indices presenting in time-sampled videotape recordings of therapy analysed by independent observers, inter- observer reliability calculated. Trends in data tested for significance with statistics).

Milavic, G., Boronska, T., Fenton, M., O'Leary, C., Liebovitz, G. Carmel and Sharpe, V. (1992–) 'The nursery project'. Sponsors: Cecily Northcote Trust, Greenwich Social Services, based at Chevering Road Child and Family Consultation Service, Greenwich. (Evaluative.)

Dance movement therapy: completed research

Research by degree

Payne, H.L. (1987) 'The perceptions of male adolescents labelled delinquent towards dance movement therapy'. M.Phil, University of Manchester, Department of Physical Education, Oxford Road, Manchester. Supervisor: Dr P. Sanderson. Copies in John Rylands Library, University of Manchester and School of Art and Design, University of Hertfordshire. (Three studies examining the process of a DMT programme. Uses Parlett's illuminative evaluation technique from new paradigm research methodology and records and makes sense of the young peoples' perceptions of a DMT programme as implemented. Quantitative methods, survey methods and the evolution of an interviewing method are also elements of this research. Implications for DMT practice, research and training.)

Publications:

Payne, H.L. (1985) 'Results of preliminary fieldwork study on the evaluation of dance movement therapy with male adolescents'. Proceedings of the 11th Triennial Congress of the International Society for the study of Art and Psychopathology 'An International Review of the Arts in Therapy', Goldsmiths College, University of London.

Payne, H.L. (1986) 'Dance movement therapy with male adolescents labelled delinquent – a pilot study'. Proceedings, VIII Commonwealth and International Conference on Sport, Physical Education, Dance, Recreation and Health – 'Dance: the Study of Dance and the Place of Dance in Society'. London: E. and F.N. Spon.

Payne, H.L. (1987) 'An adolescent's perceptions of dance movement therapy', Proceedings of Conference 'Image and Enactment in Childhood', School of Art and Design, University of Hertfordshire.

Payne, H.L. (1988) 'The practice of dance movement therapy with male adolescents labelled delinquent – research findings and implications for dance movement therapy'. Proceedings of Conference 'Dance and the Child International', Dance Department, Roehampton Institute, Roehampton Lane, South West London.

Payne, H. L. (1988) 'The use of dance movement therapy with troubled youth. Final fieldwork results', in C. Schaefer (editor) *Innovative Interventions in Child and Adolescent Therapy.* Chichester: John Wiley Interscience.

Payne, H.L. (1992) 'Shut in shut out: dance movement therapy with children and adolescents', in H.L. Payne (ed) *Dance Movement Therapy: Theory and Practice.* London: Tavistock/Routledge.

Meekums, B. (1990) 'Dance movement therapy and the development of mother–child interaction'. M.Phil, Department of Physical Education, Faculty of Education, University of Manchester, Oxford Road, Manchester. Supervisor: Dr P. Sanderson. Copy in John Rylands Library. (New paradigm and semi-quantitative methodology. Goals compared to information derived from movement observation. Examines maternal and worker perceptions of DMT in small groups of mothers and toddlers identified as being at risk from abuse.)
Publications:

Meekums, B. (1987) 'A time to dance'. *Family Service Unit Quarterly,* 40, 1–5 (reprinted in SCAN, Journal for the Social Care Association).

Meekums, B. (1987) 'New dance and family dance therapy', *New Dance Magazine,* Summer, 41, 6–8.

Meekums, B. (1987) 'Bond of hope', *Yorkshire Artscene,* November, 14.

Meekums, B. (1988) 'Dance therapy and the development of parent- child interaction'. Proceedings of Dance and the Child International Conference, Roehampton, London.

Meekums, B. (1988) 'Dance therapy in family social work'. Leeds Family Service Unit.

Meekums, B. (1989) 'Back in touch: video and manual on parent–child relationship building through dance'. Leeds Family Service Unit.

Meekums, B. (1992) 'The love bugs: dance movement therapy in a family service unit', in H.L. Payne (ed) *Dance Movement Therapy: Theory and Practice.* London: Tavistock/Routledge.

Independent research projects

Payne, H.L. (1978) 'Movement therapy as applied to a group of children with emotional disturbance and moderate learning difficulties with special reference to relationship'. Sponsors: St Lukes Special School and Hertfordshire Education Authority. Copy with author. (Single case study research approach based on a pilot study, evaluations of cases are presented in the context of a historical and theoretical overview of movement therapy. Correlations are made between the level of emotional disturbance, movement pattern profiles and relationship factors. Pre-post test, outcome study.) Unpublished research study presented at the (1978) American Dance Therapy Association conference, Seattle, USA.

Payne, H.L. (1979) 'Movement therapy in a special education setting'. Sponsors: St Lukes Special School and Hertfordshire Education Authority. Copy with author. (Outcome study which examined a programme of movement therapy with a group of underactive and a group of overactive children in a special school for moderated learning difficulties.)
Publications:

Payne, H.L. (1979) 'Movement therapy with the special child'. Proceedings of Conference 'Current Developments in the Curriculum for Children with Special Needs', Cambridge Institute of Education, Shaftesbury Road, Cambridge. Copy in Institute library.

Payne, H.L. (1981) 'Movement Therapy for the Special Child', *British Journal of Dramatherapy,* 4, 3.

Payne, H.L. (1983) 'Movement and dance for the special needs child'. Sponsor: Schools Council, Lloyds Bank, Durham Education Authority. (Action research, collaborative with special education teachers and lecturers, educational psychologist, school and college based.)

Payne, H.L. (1983) 'Moving towards dance movement therapy', *Laban Guild Magazine,* 71, pp.22–5.

Kirby, M. (1984) 'Sherborne movement – an evaluation of Veronica Sherborne's work in movement for the mentally and multi- handicapped'. Sponsor: the Carnegie United Kingdom Trust. Copies of report available from the Faculty of Education, Bristol Polytechnic, Redland Hill, Bristol BS6 6UZ. (A descriptive study which uses questionnaire and interviews with Sherborne and others using her approach. Video-tapes report programmes of work. The study attempts to show the development of the Sherborne approach.)

Meekums, B. (1986) 'Assessing the quality of mother–baby interaction using techniques drawn from dance movement therapy'. Copy with author. (Comparison of two case studies.)

Studies submitted as part of a taught post-graduate course

Payne, H.L. (1977) 'To examine the value of movement therapy in improving relationship for a number of emotionally disturbed children. Submitted in part fulfilment for Certificate in Movement and Dance with reference to special education, Laban Centre, Laurie Grove, New Cross, London SE14 6NH. Copy with author. (Experimental pilot study. Methods include Stott's Bristol Social Adjustment Guide and teacher perceptions which are correlated with movement patterns, diagnosis and behaviour. Short-term movement therapy in a special school (EBD).)

Payne, H.L. (1980) 'Body image boundary and its relationship to social adjustment, self concept and self actualisation (as measured by movement patterns) in a group of ESN (M) children'. Sponsor: London Borough of Waltham Forest. Submitted in part fulfilment of the requirements for Advanced Diploma in Education of Children with Special Needs, Cambridge Institute of Education. Copy in library and with author. Supervisor: Dr A. Bowers. (Quantitative statistical study, examined the relationship between body boundary scores (Barrier and Penetration dimensions) as tested by Holtzman's Inkblot Test; Lipsett self concept scores, self actualization as measured by videotape analysis of movement patterns and posture/gesture merger and social adjustment scores in a group of 25 children educated in an ESN (M) department of a large special school.)

Melville-Thomas, R. (1984) 'Movement patterns of cancer patients'. Submitted in part fulfilment of requirements for MA, Hahnemann University, US. Copy in library, Laban Centre, Laurie Grove, New Cross, London SE14 6NH.

Liebowitz, G. (1985) 'The use of dance and movement in the therapy of schizophrenia'. Submitted in part fulfilment of requirements for MA, Antioch International University, 115–117 Sheperdess Walk, London N1 7QA. Copy at centre for British Studies. (Phenomenological approach.)

Broillet, F. (1987) 'Dance movement therapy and self esteem in a group of adolescents with moderate learning difficulties'. Submitted in part fulfilment of requirements for MA, Hahnemann University, Philadelphia, USA.

Fresko, T. (1987) 'A study investigating the movement patterns of non-psychotic suicidal patients'. Submitted in part fulfilment for MA, Hahnemann University, Philadelphia, USA. Copy with author and at Laban Centre for Movement and Dance. (A preliminary single case comparative study.)

Scott, R. (1988) 'An investigation into the outcomes of dance and movement in the curriculum of children with emotional and behavioural difficulties'. Submitted in part fulfilment of requirements for Post-graduate Diploma (CNAA) Children with Special Educational Needs, Oxford Polytechnic, Wheatley Campus, Wheatley, Oxford OX9 1HX. Copy in library and with author. (Five forms of movement/dance with eight groups of pupils in different settings. Methods include observations, questionnaires, tape recordings of interviews and sessions, Eisner's educational objectives and Abbs' model for the aesthetic field. Assessment in relation to education in and through dance, evaluation in relation to curriculum areas, personal and social development and creative and aesthetic experiences.)

Webster, J. (1987) 'A comparison of functional and dysfunctional adoptive families: a non-verbal assessment'. (Pilot study.) Submitted in part fulfilment of requirements for MA, Hahnemann University, USA. Copy at Laban Centre for Movement and Dance.

Best, P. (1990) 'Disabling strokes: self loss and movement coping styles'. (Pilot study.) Dissertation submitted in part fulfilment of the requirements for MA, Hahnemann University, Philadelphia, USA. Copy at Laban Centre for Movement and Dance.

Higgins, L. (1991) 'The diagnostic movement assessment of deaf psychiatric patients'. (Pilot study.) Dissertation submitted in part fulfilment of the requirements for MA, Hahnemann University, USA. Copy at Laban Centre for Movement and Dance.

Dance movement therapy: current research

Research by degree

Payne, H.L. (1988–) 'The student as client: a dance movement therapy group in the context of training dance movement therapists in a higher educational setting'. PhD registered at Department of Curriculum Studies, Institute of Education, University of London, 20 Bedford Way, London WC1 OAL. Supervisor: Dr Helen Simons. (Explores the perceptions of students whilst engaged in a DMT group as part of their training, and examines any value such a group experience has on their eventual practice. A naturalistic research methodology is employed together with a collaborative style. World survey.)

Publications:

Payne, H.L. (1990) 'Dance movement therapy as an integral experience in a post graduate course of study'. Proceedings of Conference 'Arts Therapies Education: Our European Future', School of Art and Design, University of Hertfordshire.

Totenbier, S.L. (1992–) 'A comparative analysis of C.G. Jung's psychological types and Rudolf Laban's efforts designed to lead to the formulation of a theoretical model for the practice of dance movement therapy'. M.Phil/PhD (CNAA) registered at the Laban Centre for Movement and Dance, Laurie Grove, London SE14 6NH. (Interviews with experts on effort study, sample study of movement assessments and Myers-Briggs Types Indicator correlations leading to theoretical model for DMT evaluated by questionnaire and interview with qualified practitioners.)

Independent research projects

Payne, H.L. (1987–) 'Dance movement therapy in child and family therapy'. Sponsor: East Herts Health Authority. Project Advisor: Dr J.A. Causton. (Evaluates a short-term programme of individual dance movement therapy with adolescents. Parents, staff and young people are invited to participate in the evaluation. Some material still to be analysed.)

Payne, H.L. (1992–) 'An evaluation of movement psychotherapy with women suffering from eating disorders'. Sponsors: Research section, the Institute for the Arts in Psychotherapy, St Albans. (Collaborative with women and researcher/therapist and assistant. Videotape recordings of sessions and personal journals will be analysed by the co-researchers during and after the therapy programme.)

Studies prepared for submission as part of a taught post-graduate course

See dissertations and long essays filed in libraries at University of Hertfordshire, School of Fine Art and the Laban Centre for Movement and Dance.

Dramatherapy: completed research

Research by degree

Jennings, S. (1987) 'Drama ritual and transformation'. PhD, University of London. Copy in library. (Anthropological study, fieldwork with Tamiar tribe of Malaysia as context to understanding ritual healing processes within dramatherapy.)

Independent research projects

Jennings, S. (1987) 'Dramatherapy with weight related infertility'. Sponsor: the Academic Unit of Obstetrics and Gynecology, The London Hospital, Whitechapel, and Newham General Hospital. (Pilot study collaborative design. Dramatherapy intervention. Pre-post test.)

Jennings, S. (1988) 'Dramatherapy as an intervention in unexplained fertility'. Sponsor: the Academic Unit of Obstetrics and Gynecology, The London Hospital, Whitechapel. (A Pilot study. Pre and Post test, Dramatherapy intervention.) Copy with author.
Publications:
Jennings, S. (1987) 'Metaphors of violence'. Proceedings of International Congress for Group Psychotherapy, Zagrab.
Jennings, S. (1988) 'Rights or rites?' *Journal of Holistic Medicine*, November.
Jennings, S. (1989) 'Infertilisation: a hypothesis for infertility'.
Jennings, S. (1989) 'Isolation in fertility symptomatic withdrawal'.
Jennings, S. (1989) 'Anorexia disguised as infertility: the Newham example'.
Jennings, S. (1989) 'The mask as a birthing experience'. Unpublished articles, copies with author.
Jennings, S. (1989) 'Not iron bars a cage'. Proceedings of the International Congress on Stress in Times of Peace and War, Tel Aviv.
Jennings, S. (1989) 'Legitimate grieving?' Proceedings International Congress on Death and Dying, Athens.
Jennings, S. (1989) 'Dramatherapy as a complementary therapy before, during and after assisted conception'. Sponsor: the Academic Unit, London Hospital. (A comparative study with couples.)
Taylor, J. (1988) 'Creative arts in therapy'. Sponsor: Anglo-Israel Association, 9 Bertock Street, London W1.

Studies submitted as part of a taught post-graduate course

See dissertations and long essays in institution's libraries where Post-Graduate Diploma and MA dramatherapy courses are offered.
Young, M. (1985) 'The use of dramatherapy in the treatment of eating disorders'. Submitted in part fulfilment of requirements for Post Professional Certificate in Dramatherapy, College of Ripon and York St John, Lord Mayors Walk, York. Copy in library. (Theoretical overview, examines causes and dramatherapy models.)
Publication:
Young, M. (1986) 'Use of dramatherapy methods for working clients with eating problems'. *Journal of Dramatherapy*, 2, (Spring).
Dokter, D. (1990) 'All the world's (going through) a stage: an anthropological perspective in dramatherapy training and practice'. Supervisor: Dr R. Little. (Interviews and participant-observation, informant's perceptions from questionnaire analysis.) Submitted in part fulfilment for MSc University of London.
Publications:
Dokter, D. (1990) 'Cultural aspects of dramatherapy training and practice: A common European home'. Paper presented at 'Arts Therapies Education: Our European Future', School of Art and Design, University of Hertfordshire. Copy with author.
Dokter, D. (1993) 'Dramatherapy across Europe: cultural contradictions', in H.L. Payne (ed) *Handbook of Inquiry in the Arts Therapies: One River, Many Currents*. London: Jessica Kingsley Publishers.

Dramatherapy: current research

Research by degree

Grainger, R. (1986–) 'The use of dramatherapy in the treatment of thought disorder'. M.Phil (CNAA), Huddersfield Polytechnic, Queensgate, Huddersfield HD1 3DH. (Longitudinal cross experimental design. Pre-post test.)

Publications:

Grainger, R. (1987) 'Education in dramatherapy' in D. Milne (ed) *Evaluating Mental Health Practice.* London: Croom Helm.

Grainger, R. (1990) *Drama and Healing.* London: Jessica Kingsley Publishers.

Grainger, R. (1986–) Working titles: 'Implicit religion and health' or 'Psychotherapy as implicit religion'. PhD, Trinity College, Bristol. Sponsored by Network for the study of Implicit Religion. Supervisor: Canon Dr Edward Bailey, Winterbourne Rectory, 58 High Street, Winterbourne, Bristol, BS17 1JQ. Action methods.

Publications:

Grainger, R. (1979) *Watching for Wings.* London: Longman and Todd.

Grainger, R. (1986) 'Alienation and infection'. *Contact,* 89, 1.

Grainger, R. (1986) 'Hospitals', in *A Workbook in Popular Religion.* Dorchester Partners.

Grainger, R. (1988) 'Reflections on hospital religion', *Contact,* 95, 1.

Jones, P. (1991–) 'Meaning in dramatherapy'. M.Phil/PhD registered at Exeter University.

Publication:

Jones, P. (1982) 'The active witness', chapter in H.L. Payne, (ed) (1993) *Handbook of Inquiry in the Arts Therapies: One River, Many Currents.* London: Jessica Kingsley Publishers.

Dokter, D. (1992–) 'Ritual and cultural processes in arts therapies healing'. M.Phil/PhD registered at University College, London, Department of Anthropology. Supervisors: Dr R. Little and Dr E. Schaeffelin. (Descriptive case study and/or comparative study.)

Winn, L. (1991–) 'Towards a model of dramatherapy in the treatment of post traumatic stress disorder'. M.Phil registered at the University of Exeter, Drama Department. Sponsor: Mental Health Unit, St Lawrence's Hospital, Bodmin, Cornwall.(Evaluation, co-operative inquiry involving clients, dramatherapists actors and students. Semi-structured interviews.)

Winn, L. (1993) *Post Traumatic Stress Disorder and Dramatherapy.* London: Jessica Kingsley Publishers.

Independent research projects

Jennings, S. (1989–) 'The nature of dramatherapy'. Sponsor: Research Division, The Institute of Dramatherapy. (Experiential, collaborative study.)

Jennings, S. (1989–) 'Dramatherapy and eating disorder'. Sponsor: Research Division, The Institute of Dramatherapy. (Case Study.)

Jennings, S. (1989–) 'Dramatherapy with perpetrator-victim cycle'. Sponsor: Research Division, The Institute of Dramatherapy. (Pilot study.)

Music therapy: completed research

The Association of Professional Music Therapists, Chestnut Cottage, 38 Pierce Lane, Fulbourn, Cambridge CB1 5DL have a Research Register with further details of these studies.

Research by degree

Bunt, L.G.K. (1985) 'Music therapy and the child with a handicap: Evaluation of the effects of intervention'. PhD, City University, Northampton Square, London EC1V 0HB. Copy in library. Supervisors: Dr Hilton Davis, The London Hospital, Dr. Hugh Jolly, Charing Cross Hospital and Professor Malcolm Troup, City University. (Three studies researching the outcome of music therapy with children attending pre-school nurseries and special schools, links hypothesized between processes in developmental child psychology and music therapy.) Sponsors: Music Therapy Charity Ltd, the City University, National Medical Research Fund.
Publications:

Bunt, L.G.K. (1986) 'Research in Great Britain into the effects of music therapy with particular reference to the child with a handicap', in Evan Ruud (ed) *Music and health.* London: J. Chester.

Bunt, L. (ed) (1986) 'Music therapy in psychiatry'. Proceedings from a conference organised by the Bristol Music Therapy Centre and held at Glenside Hospital, Bristol. Copy with author. Sponsor: Emperor Fine Arts Trust, London.

Bunt, L. (1987) 'Music therapy – an introduction', *Psychology of Music,* 16, 1, 3–9.

Bunt, L., Clarke, E., Cross, I. and Hoskyns, S. (1988) 'A discussion on the relationships between music therapy and the psychology of music', *Psychology of Music,* 16, 1, 62–70.

Bunt, L. and Hoskyns, S. (1987) 'A perspective on music therapy research in Great Britain'. *Journal of British Music Therapy,* 1, 1, 3–6.

Bunt, L., Pike, D. and Wren, V. (1987) 'Music therapy in a general hospital's psychiatric unit – a "pilot" evaluation of an eight week programme'. *Journal of British Music Therapy,* 1, 2, 22–7.

Oldfield, A. (1986) 'The effects of music therapy with a group of profoundly handicapped adults'. M.Phil, City University, Northampton Square, London EC1V OHB. Copy in library. (Compares music therapy and play in two groups. Analysis of videotapes.)
Publications:

Bolton, A. (now Oldfield) and Adams, M. (1983) 'An investigation of the effects of music therapy on a group of profoundly mentally handicapped adults'. *Research News: International Journal of Rehabilitation Research,* 6, 4, 511–2.

Oldfield, A. (1985) 'Practical methods of evaluation for music therapists working with the mentally handicapped'. Proceedings of the 5th World Conference of Music Therapy, Genoa, published (in Italian) by Italian Society for Music Therapy.

Oldfield, A. (1985) 'A music therapy project with a group of profoundly mentally handicapped adults'. British Society of Music Therapy, October.

Oldfield, A. and Adams, M. (1989) 'The effects of music therapy on a group of profoundly mentally handicapped adults'. Submitted for publication, *Journal of Mental Deficiency Research.*

Oldfield, A. (1990) 'The effects of music therapy on a group of profoundly handicapped adults'. *Journal of Mental Deficiency Research.* 34, 107–25.

Oldfield, A. (1990) 'A study of the way music therapists analyse their work'. Proceedings of the Second Arts Therapies Research Conference, April 1990, City University, London.

O'Dell-Miller, H. (1989) 'Clinical work with the elderly mentally ill'. M.Phil, City University, Northampton Square, London EC1V OHB. Sponsor: Fulbourn Hospital, Cambridge. Supervisors: Linda Powell-Proctor, Malcolm Adams and Leslie Bunt. Copy in library. (Statistical study. Time sampling observation method. Compares music and reminiscence therapies efficacy.)

Pavlicevic, M. (1990) 'Music in communication: improvisation in music therapy'. PhD, Department of Psychology, University of Edinburgh, 7 George Square, Edinburgh EH8 9JZ. Copy in library. Supervisors: Professor Colwyn Trevarthen; Dr David Lee, Dr Raymond Monelle, University of Edinburgh. (Develops a theoretical basis for defining and evaluating inter-personal processes in music therapy and was used to evaluate musical engagements between music therapist and adult psychiatric patients in two experimental studies.)
Publications:

Pavlicevic, M. and Trevarthen, C. (1989) 'A musical assessment of psychiatric states in adults'. *Psychopathology,* 22, 325–34.

Pavlicevic, M. (1990) 'Dynamic interplay in clinical improvisation'. *Journal of British Music Therapy.* 4, 2, 5–9.

Pavlicevic, M. (1991) 'Inter-personal processes in clinical improvisation', in T., Wigram, B. Sapperston and R. West, (eds) (1993) *Music and the Healing Process: A Handbook of Music Therapy.* Chichester: Carden Publications.

Pavlicevic, M. and Trevarthen, C. *Music Therapy and the Rehabilitation of Chronic Schizophrenics* (submitted for publication.)

Independent research projects

Hoskyns, S. (1982) 'An investigation into the value of music therapy in the care of patients suffering from Huntington's Chorea'. Sponsor: Association to Combat Huntington's Chorea, Hinkley, Leicestershire. Copy from charity office. Advisors: Malcolm Hibberz and Graham Fawcett. (Outcome study on short-term music therapy).

Publications:

Hoskyns, S. (1981) 'An investigation into the value of music therapy in the care of patients suffering from Huntington's Chorea'. Association to Combat Huntington's Chorea.

Hoskyns, S. (1982) 'Research note on the above project', *The Lancet,* May.

Hoskyns, S. (1982) 'Huntington's Chorea: striking the right chord'. *Nursing Mirror,* 154, 22, 14–7.

Cosgriff, V., Sutton, J., Hamil, R. and Crozier, E. (1986) 'A combined speech therapy and music therapy approach with Parkinson's Disease'. Sponsor: Belfast Branch of Parkinson's Disease Society. Supervisor: Dr M. Swallow.

Publication:

Hamil, R. and Crozier, E. (1986) 'A combined speech and music therapy approach with Parkinson's Disease'. *Speech Therapy in Practice.*

Selman, J., Simon, R. and Sutton, J. (1987) 'An intensive, combined art therapy and music therapy approach with Parkinson's Disease in a residential setting'. Sponsor: Parkinson's Disease Society, London. Supervisor: Dr M. Swallow. (Case study.)

Sutton, J. (1987) 'Music therapy as an individualised treatment: Parkinson's Disease'. Sponsor: Parkinson's Disease Society, London. Supervisor: Dr M. Swallow. (Case study.)

Lawes, C. and Woodcock, J. (1989) 'An evaluation of music therapy for people with learning difficulties and self-injurious behaviour'. Sponsor: Psychology and Music therapy Departments, Turner Village Hospital, Turner Road, Colchester, CO4 5JP. (Single case study.)

Hooper, J. (1990) 'Music and the mentally handicapped: the effect of music on anxiety'. Sponsor: Strathmartine Hospital, Dundee DD3 0PG. (Controlled case studies examining the effect of music on four mentally handicapped women suffering from anxiety and agitation.)

Publications:

Hooper, J. and Linsey, B. (1990) 'Music and the mentally handicapped – the effect of music on anxiety', *Journal of British Music Therapy,* 4, 2, 19–26.

Hooper, J. and Lindsey, B. (1991) 'Improving the quality of life through music – a case study', *Mental Handicap* (in press).

Hooper, J. (1991) 'Music hath charms', *Nursing Times,* 87, 37, 40–1.

Hooper, J. (1991) 'The therapeutic potential of recreational musical activities'. Sponsor: Strathmartine Hospital, Dundee DD3 OPG. (Single subject reversal design to examine the effects of music on a range of anxiety related behaviours.)

Publications:

Hooper, J. and Linsay, B. (1991) 'Recreation and music therapy: an experimental study'. *Journal of British Music Therapy,* 5, 2, 10–3.

Pavlicevic, M. (1991) 'Putting music therapy on the map: is music therapy a useful intervention in the rehabilitation of chronic schizophrenics who are day hospital attenders?' Collaborator: Professor Colwyn Trevarthen (joint grant-holder), University of Edinburgh. (Pilot study compared three matched groups of subjects: 15 chronic schizophrenics, 15 unipolar depressed patients and 15 non-clinical controls, in a one-off music therapy session. Results suggest capacity to interact with therapist in related to the subject's clinical state, rather than to their musical experience. The main study examined whether music therapy might be useful to enhance the rehabilitation of chronic schizophrenics. In contrast to a matched group of 20 patients who did not attend individual music therapy sessions, the 21 subjects who attended ten weekly sessions showed a significant improvement in Musical Interaction Rating (MIR) scores and in formal psychiatric measures. These results suggest that music therapy may have a role to play in the rehabilitation of chronic schizophrenics.) Sponsor: Scottish Home and Health Department, Biomedical Research Committee Research Grant.

Studies submitted as part of taught post-graduate course

Fenwick, A. (1986) 'The provision for music in special schools within a metropolitan authority'. Submitted in part fulfilment of M.Ed, University of Birmingham, Edgbaston, Birmingham B15 2TT. Supervisors: Professor Gullford and Brian Fraser, Faculty of Education, University of Birmingham. (Provision for music in nine special schools of a metropolitan education authority for children with special educational needs was examined in detail, and the work of the music therapy team (which included the researcher) outlined.) Sponsor: Birmingham LEA.
Publication:
Collaborator on booklet *Music Therapy in the Education Service*, APMT Publication.

Rogers, P. (1989) 'The processing of musical and verbal information in short-term memory with reference to the theories of cerebral dominance in schizophrenia and Baddeley's model of working memory'. Collaborator: Dr Norman Smeyatsky, Senior Registrar, Homerton Hospital, Homerton Road, London E9. Submitted in part fulfilment for MSc, Birkbeck College, University of London, Russell Square, London WC1. Supervisor: Professor Glynn Humphreys. (Compared the performance of a group of schizophrenic subjects with groups of normal and depressed subjects on a number of auditory short-term memory tasks. Results support the hypothesis that schizophrenia is partly a dysfunction of the dominant cerebral hemisphere, finds the extant theorem on working memory inadequate and suggest that a separate 'musical loop' co-exists with the Articulatory Loop.)
Publications:
Rogers, P. (1991) 'The processing of musical and verbal information in a schizophrenic', T., Wigram B. Sapperston and R. West (eds) *Music Therapy and the Healing Process: A Handbook of Music Therapy.* Chichester: Calden Publications.

Music therapy: current research

Research by degree

Muller, P. A. (1986–) 'Music therapy and autism: the effects of maternal involvement in therapy'. Collaborator(s): Mrs Auriel Warwick, Music Therapist and Dr Tim Williams, Clinical Psychologist, Div. Clinical Psychologist, West Berks Health Authority. M.Phil/PhD registered at the University of Reading, Building 3, Earley Gate, Whiteknights, Reading RG6 2AL. Supervisors: Dr Elizabeth Gaffan, Dr Charlie Lewis. (To investigate the effects of music therapy on autistic children and whether the involvement of mothers in therapy enhances effects and facilitates generalization. The order of the two conditions was counterbalanced. A range of social interaction behaviours such as approach, requesting and negative behaviours by mothers and children were assessed, as well as avoidance and stereotypic behaviour by the children alone.) Sponsor: Economic and Social Research Council.

Publications:

Muller, P. A. and Warwick, A. (1987) 'The linking of two disciplines in research: psychology and music therapy', in *Starting Research in Music Therapy*. Proceedings of The Third Music Therapy Day Conference held at the City University, London.

Gaffan, E.A., Lewis, C.N. and Muller, P. (1990) 'Autistic children: the influence of maternal involvement in music therapy'. Poster Presentation for the IVth European Conference in Developmental Psychology, University of Stirling, Scotland.

Van Colle, S. (1987–) 'Music therapy intervention with cerebral palsied children'. M.Phil/PhD registered at University of Reading, Department of Music, 35 Upper Redlands Road, Reading, Berkshire RG1 5JE. Supervisors: Dr T. Williams and Dr R. Samuel. (Ethological method, transcribing videotapes.)

Pavlicevic, M. (1987–) 'Emotional communication through musical improvisation'. M.Phil/PhD registered at University of Edinburgh. Supervisors: Professor Colwyn Trevarthen, Dr Raymond Monelle and Dr David Lee. (Case study.)

Hoskyns, S. (1986) 'Group music therapy with adult offenders: an investigation of changes in self-perception and action'. PhD, registered at City University, Northampton Square, London EC1V OHB. Supervisors: Dr L. Bunt, Department of Child Health, University of Bristol and Dr Hilton Davies, Department of Academic Psychiatry, London Hospital, London E1. (Survey methods: questionnaire and interview. New paradigm methodology. Rating scales for videotape analysis and music therapy grid developed.) Sponsor: Music Therapy Charity and J. Paul Getty Jr. Charitable Trust.

Publications:

Hoskyns, S. and Bunt, L. (1987) 'A perspective on music therapy research in Great Britain', *Journal of British Music Therapy,* 1, 1, 3–6.

Hoskyns, S. and Clarke, E.C. (editors) (1987) *Starting Research in Music Therapy*. Proceedings of Third Music Therapy Research Conference, February, City University, London.

Hoskyns, S. (1987) 'Productive and counter-productive issues for therapist and researcher'. Paper from *Starting Research in Music Therapy.*

Hoskyns, S. (1988) 'Studying group music therapy with offenders: research in progress'. *Psychology of Music,* 16, 1, 26–41.

Hoskyns, S. (ed) (1988) The Case Study as Research Proceedings of Fourth Music Therapy Research Conference, February, City University, London.

Hoskyns, S. and Bunt, L. (1988) 'A review of music therapy research in Great Britain', *Complementary Medical Research,* 3, 1, 47–54.

Lee, C (1988–) 'The structural analysis of therapeutic improvisatory music: process evaluation of music therapy with people carrying the virus HIV and AIDS'. PhD registered at City University, Northampton Square, London EC1V OHB. Supervisors: Dr L. Bunt and Dr P. Reason. (An examination of the 'elements of communication' within therapeutic improvisation. Three studies researching the musical process of music therapy with people carrying the virus HIV and AIDS working individually, in groups and with near-death clients. Hypothetical links to be discussed and compared with regard to the central analytical design of process, its effects on outcome and the ensuing implications for music therapy.) Sponsors: Nordoff-Robbins Music Therapy Centre.

Publications:

Lee, C.A. (1989) 'Structural analysis of therapeutic improvisatory music', *British Journal of Music Therapy,* 3, 2, 11–19.

Lee, C.A. (1991) 'The efficacy of music therapy for people living with the virus AIDS'. BSMT publication and paper by same title (1990) *European Journal of Humanistic Psychology,* XVIX, 1(Jan).

Lee, C.A. (1990) 'Structural analysis of post-tonal therapeutic improvisatory music'. *British Journal of Music Therapy,* 4, 1, 6–20.

Lee, C.A. (1990) 'Endings'. Foreward in *British Journal of Music Therapy,* 5, 1.

Lee, C.A. (1989) 'The arts therapies researcher: possibilities for shared ideological avenues'. Paper in Gilroy *et al.* Proceedings of the First Arts Therapies Research Conference. City University, London.

Van Colle, S. (1988–) 'Music therapy process with cerebral palsied children: connections with psychoanalytic models, particularly those of Winnicott and Bowlby'. M.Phil/PhD, registered at The University of Reading, 35 Upper Redlands Road, Reading RG1 5JE. Supervisors: Dr Rhian Samuel and Dr Tim Williams, University of Reading. (Descriptive study of processes arising within an interactive music therapy framework exploring the concept that music therapy promotes individuation. Videotape of clinical work (50 sessions) undertaken by the researcher with two groups each of four severely and multiply handicapped cerebral palsied children. Analysis involves manual and computerised systems and draws on ethological methodology.) Sponsors: R.S. Nathan & Co and The Music Therapy Charity.

Wigram, T. (1988–) 'The effect of low frequency sound and music on muscle tone, circulation, blood pressure, heart-rate and electrodermal activity'. M.Phil/PhD registered at Department of Psychology, Royal Holloway and Bedford New College, London University, Egham Hill, Egham, Surrey. Supervisors: Dr Barbara Kugler, Harper House, Children's Service. (Explores the effects of a system of treatment called vibro-acoustics originated in Norway. This deeply penetrating sound vibration has relaxing effects on muscle tissue. Controlled trials using a within subjects (repeated measures) design. Results measured by means of a range of movement and electrophysiological measures.) Sponsors: The Mental Handicap Unit, North West Herts District Health Authority and London University.

Publications:

Wigram, A. (1987) Report on a two-day conference on the effective use of vibro-acoustic therapy (Levenger, Norway). Printed by Viibrosoft. Huvdingv. 98 7700 Steinkjer.

Wigram, A.L. and Weekes, L. (1989) 'A project evaluating the difference in therapeutic treatment between the use of low frequency sound and music, and music alone in reducing high muscle tone in multiply handicapped people and Oedema in mentally handicapped people'. (Unpub) Paper given at an International Seminar on Vibro-acoustics. Steinkjer, Norway.

Wigram, A.L. and Weekes, L. (1989) 'Vibro-acoustic therapy: the therapeutic effect of low frequency sound on specific physical disorders and disabilities'. *Journal of British Music Therapy*, 3, 2, 6–10.

Wigram, A.L. and Weekes, L. (1989) 'Collaborative approaches in treating the profoundly handicapped'. *Pediatric Physiotherapy Newsletter*, 51, 5–9.

Wigram, T. (1993) 'The feeling of sound', in H. Payne (ed) *Handbook of Inquiry in the Arts Therapies: One River, Many Currents*. London: Jessica Kingsley Publishers.

Levinge, A. (1989–) 'What does it mean to play music together with children presenting with non-physically based communication difficulties?' M.Phil, Department of Education, University of Birmingham, Edgbaston, Birmingham B15 2TT. Supervisor(s): Professor G. Upton, Department of Education, University of Birmingham and Mr Adam Phillips, Principal Child Psychotherapist, Department of Child and Family Psychiatry, Charing Cross Hospital, London. (This research aims to describe in words the processes involved in the playing of music together, with six children presenting with non- physically based language and communication disorders. Three ideas central to Winnicott's thinking will be used to create the framework within which the themes and processes will be described. These are the ideas of (1) holding, (2) play, (3) transitional object.)

Publications:

Levinge, A. (1986) 'What is music therapy?' Paper published by the Bristol Psychotherapy Association.

Levinge, A. (1989) 'Music therapy in pediatric care'. *Community Pediatrics*. Butterworths.

Levinge, A. (1990) 'The use of I and me: music therapy with an autistic child'. *Journal of British Music Therapy*, 4, 2, 1.

Levinge, A. (1993) 'Playing together', in H. Payne (ed) *Handbook of Inquiry in the Arts Therapies: One River, Many Currents*. London: Jessica Kingsley Publishers.

Sutton, J. (1989–) 'Parallel development of music and language in speech and language disordered children'. M.Phil/PhD registered at the University of Ulster, (Jordanstown) Shore Road, Jordanstown, N. Ireland. Supervisors: Dr Nan Hill, Consultant Pediatrician, E. Health Board, Northern Ireland; Dr Kevin Tierney and Hilary Bracefield, University of Ulster. (Study of speech and language with musical development isolating significant musical components common to both in language disordered children and infants attending a well baby clinic. An investigation of remediation, assessment, implications regarding language disorder, identification and cause.) Sponsor: DHSS grant; Clinical Medical Research Award.
Publications:
Cosgriff, V. and Sutton, J. *et al.* (1988) 'Music therapy and speech therapy in group setting with Parkinson's disease – a one-month intensive study'. *Speech Therapy in Practice.*
Sutton, J. (1987) 'Music therapy and art therapy with Parkinson's Disease: a two-week intensive study'. Unpublished paper. Copy with author.
Sutton, J. (1987) 'Music therapy as individualised treatment for Parkinson's disease. A 3-month study of work with three individuals'. Unpublished paper. Copy with author.
Rogers, P. (1991–) 'Music therapy and sexual abuse'. M.Phil/PhD registered at City University, Northampton Square, London. (Collaborative inquiry.)
Publications:
Rogers, P. (1991) 'Working with sexually abused clients using a psychodynamic approach'. Paper presented at 5th Music Therapy Research Conference. City University.
Rogers, P. (1992) 'Music therapy research and sexually abused clients'. *BSMT Journal*, 6, 2.

Independent research projects

Cartwright, J. (1989–) 'A study of the diagnostic potential of non-directed early music improvisation with newly admitted psychiatric patients in the hospital setting'. Book publication pending: *The Music has Spoken for Us – Clinical and Diagnostic Music Therapy in Adult Psychiatry.* (Analysis of tape recordings. Collating symptoms revealed in music with psychotic/neurotic disorders.)

Pavlicevic, M. and Trevarthen, C. (1989–) 'Putting music therapy on the map: is music therapy a useful intervention in the rehabilitation of chronic schizophrenics who are day hospital attenders?' Sponsored by Scottish Home and Health Department, Biomedical Research Committee. (Pilot outcome study. Comparing three groups.)

Sutton, J. and Hill, N. (1989–) 'Parallel development of music and language in speech and language disordered children'. Sponsor: Eastern Health and Social Services Board (N. Ireland). (Medical Research Award. Evaluative and comparative study).

Studies prepared for submission as part of a taught post-graduate course

Streeter, E. (1979) 'A theoretical background to the interpretation of rhythmic skills, with particular reference to the use of music therapy as an aid to the clinical assessment of pre-school handicapped children'. Submitted in part fulfilment for MA, Department of Music, University of York, Heslington, York. Supervisor: John Local. (Explores how rhythm is part of the infant's experience. Background to the fact that musical rhythmicity relates to other areas of development and therefore might be used as a catalyst for therapeutic intervention.) Sponsor: Inner London Education Authority.
Publications:
Streeter, E. (1981) 'Towards a theoretical understanding of rhythmic responses in music therapy'. BSMT Conference Paper.
Streeter, E. (1993) *Making Music with the Young Child with Special Needs – A Guide for Parents.* London: Jessica Kingsley Publishers.

Heal, M. (1988–) 'Observational studies and the application of psychoanalytical ideas to work with children, young people and their families'. Prepared in part fulfilment for MA, Polytechnic of East London, affiliated to The Tavistock Clinic, 120 Belsize Lane, London NW3 5BA. Supervisors: Valerie Sinason, Principal Child Psychotherapist, and Dr A. Hyatt-Williams, Lecturer in Psychoanalytic Theory, The Tavistock Clinic, London. (A psychoanalytically-informed approach in music therapy. Excerpts from a two year mother–infant observation compared to descriptions of client behaviour during individual music therapy sessions, observed similar or different characteristics provide a model for thinking about possible unconscious meanings clients communicate.)

Publications:

Heal, M. (1989) 'Psychoanalytically-informed music therapy in mental handicap: two case studies'. A paper presented at the 5th International Congress: Music Therapy and Music Education for the Handicapped, Developments and Limitations in Practice and Research, Nogdrinzken, The Netherlands, August 23–27.

Heal, M. (1989) 'In Tune with the Mind', in D. Brandon (ed) *Mutual Respect: Therapeutic Approaches to People with Learning Difficulties*. Surrey: Mood Impressions Publishing Ltd.

Heal, M. (1991) 'A comparison of mother–infant interactions and the client-therapist relationship in music therapy sessions'. To be included in: Wigram, T., Sapperston, B. and West, B. (eds) (1993) *Music Therapy and the Healing Process: A Handbook of Music Therapy*. Chichester: Carden Publications.

Lawes, C. (1988–) 'Effects of music therapy in reducing self- injurious behaviour with people with severe learning difficulties'. Collaborator: John Woodcock, Head IV Music Therapist, Turner Village Hospital, Polytechnic of East London, Romford Road, Stratford, London E15 4LZ. Prepared in part fulfilment for MSc in Clinical Psychology. Supervisor: Dr Mary Boyle, Lecturer in Clinical Psychology, Polytechnic of East London. (The effectiveness and generality of music therapy evaluated for four severely mentally retarded adults who exhibited self injurious behaviour. Findings revealed that there was no reduction in self injurious behaviour nor an increase in communication skills, but that variation in self injurious behaviour was significantly associated with the functions it served for each person.)

Publications:

Lawes, C. and Woodcock, J. (1991) 'Music therapy and people with severe learning difficulties who exhibit injurious behaviour'. To be included in: Wigram, T., Sapperston, B. and West, R. (eds) (1993) *Music Therapy and the Healing Process: A Handbook of Music Therapy*. Chichester: Carden Publications.

Dunachie, S. (1989–) 'An investigation of the undirected improvisations of mentally handicapped adults'. Undertaken in part fulfilment of the requirements for MA, Psychology Department, Keele University. Supervisor: Dr J. Slobada. Sponsor: Lea Castle Hospital, Wolverley, Kidderminster. (The improvisations of a sample of mentally handicapped adults at a keyboard compared with those of pre-school children at different stages of development. Viewed in relation to subject's developmental levels in general terms (i.e. mental age equivalent) and specifically, their levels of linguistic functioning). Sponsor: Regional Health Authority.

Ritchie, F. (1991–) 'Ethological study of music therapy with people who have severe learning difficulties and display challenging behaviour'. Prepared in part fulfilment of MA, University of Keele, Staffordshire. Supervisor: Dr John Hegerty. (Individual clients receive weekly two half-hour music therapy sessions for one year. Videos and observation of each session will be documented. Conclusions drawn as to the changes that the clients have been perceived to make during the music therapy sessions and directly after the sessions when the clients have returned home.) Sponsor: North Warwickshire Health Authority; West Midland's Regional Competitive Bursary Scheme.

Collated by Helen Payne
May 1993

Part IV

Reflections

Part IV

Reflections

Reflections

Helen Payne

The story of this book seems to have been an in-depth, searching journey which has resulted in the arts therapies finding ways of creating meaning in the research process. The chapters reflect, variously, objectivism, the search for lawful relationships between causes and effects (and quantification as the preferred mode of representing those relationships), and subjectivism, the search for meaning in specific episodes or events, together with an emphasis on the investigator's own internal frame of reference, self-searching, intuition, and the method of qualitative analysis. In examining each of these approaches arts therapists may be able to discuss integrating them as a way to harness their usefulness in understanding the complexities of the arts therapy process.

By letting go and falling into their river of inquiry the arts therapies can swim from an old consciousness into a new steam of consciousness. By swimming into a new, unknown current, with all its jarring, uncomfortable and refreshing effects, the arts therapies practitioner can value her own experience and become more self-aware. In inquiry, as in therapy, we are letting go of the known and diving into an unknown current. This is a challenge which is both personal and professional. As the practitioner learns to inquire, so she actively discovers and explicates, transforming herself and her profession into a new world of knowledge and wisdom. This requires total honesty, maturity, integrity, and a passion to know and understand our world of practice. It may be demanding in time and energy and necessitate a substantial immersion into one core idea; it may entail risk in that old wounds could be opened or beliefs overturned. As a professional group, in undertaking such a journey of inquiry, the arts therapies can become connected with a new creative source and develop new frameworks for understanding and knowing.

The emerging approaches to inquiry illustrated in the book challenge several notions of both the research process and the arts therapy process. In particular, they model and stress that research and therapy processes may mutually enhance and transform one another, yielding further learning for the field and for the inquirers. The nature of knowledge and its relation to a knowing entity is thereby explored together with a growing recognition of the inter-dependency of the arts

therapies. Each has something to contribute to each other and can no longer afford to proceed in isolation from one another. This book embodies this belief.

The chapters demonstrate an inter-linking of knowledge. Just as the tree and the moss can survive without each other, the mutuality which results from their participation together makes for a greater complexity and richness of experience, both to each other and to our world. By working together to mature towards inter-dependence the arts therapies can accomplish far more than any one of the arts therapies alone can. Now that each arts therapy has true independence resulting in public victories there is a foundation for successful inter-dependence – they can communicate, co-operate and work together towards inquiry and act as a collaborative team, as is demonstrated by the way practitioners have contributed to this book and the participatory editing process.

Finally, as I write this reflection piece, I am reminded of an author who spoke about taking the first printed copy of his book in his hands and, tossing it into the fire, page by page, he warmed his belly on a cold night. The contributors, by inquiring and then writing about what they know, can let go of it and begin to learn afresh what they know. This process is often of a reflexive nature and can take people into their next current of inquiry.

This book takes the first step towards seeking to understand the arts therapies; thus presented it seeks to be understood.

Contributors' Biographies

Ditty Dokter, MSc, RDth, IPC (WPF) was born and lived in Holland before coming to Britain to study dramatherapy. She now works as a senior lecturer at The University of Hertfordshire and as a dramatherapist and group psychotherapist in the NHS and private practice. She is a member of the Arts Therapies Research Committee. Her previous experience includes intermediate treatment, people with learning difficulties and psychiatry. Her research interest is in the cultural aspects of the arts therapies.

David Edwards, BA (Hons), RATh, is currently employed as Course Leader for the Post-graduate Diploma in Art Therapy, University of Sheffield. David was employed as an art therapist full time with Wakefield Health Authority, as a locum with Chesterfield Community Mental Health Team and as a locum counselor. He has served on the Council of the British Association of Art Therapists, the editorial board of *Inscape*, the Association Journal, and the representative for Art Therapy on the NHS Training Authority's Professional Advisory Committee. He has also contributed to a wide range of books and articles on art therapy and has a main research interest in the clinical supervision of art therapists.

David Fontana, PhD, is a reader in educational psychology at the University of Wales and full professor in the School of Child Education, University of Minho, Portugal. He is a qualified teacher of English and drama and as a psychologist takes a keen interest in the therapeutic use of the arts. Much of his work centres on psychological counselling and psychotherapy and he is author of a number of books on psychology and education including *Psychology for Teachers, Managing Stress, Social Skills at Work* and *Your Growing Child from Birth to Adolescence*.

Laurence Higgins M.Eng, MCAT, was born in New Zealand and travelled extensively in South East Asia and India. Whilst working as an engineer in London he participated in dance and psychotherapy courses and completed a dance movement therapy training in 1989. He works as a dance movement therapist at Springfield Hospital and teaches on the Laban Centre's training course in dance movement therapy. He was a council member of the Association for Dance Movement Therapy and a representative on the Standing Committee of the Arts Therapies Professions.

Phil Jones, MA, is senior lecturer in the Graduate Arts Therapies Programme at Hertfordshire College of Art and Design, teaching on both the Post-graduate Diploma and MA courses in dramatherapy. He was Director of Artsreach Arts in Education project at Jackson's Lane in North London and has researched into anthropology, psychology and theatre. He has lectured widely in this country and in Greece, The Netherlands, Ireland and the US and is currently undertaking a PhD at the University of Exeter.

Alison Levinge, LGSM (MT), RMTh, Cert. Ed, began teaching music in mainstream education before becoming a music therapist with children and adults. She held the music therapy post at the Child Development Centre at Charing Cross Hospital for nine years where she worked closely with Dr Hugh Jolly. She now works in the Psychotherapy Day Unit and in-patient acute wards of a psychiatric hospital. Having completed studies at the Tavistock Institute she is currently writing up her M.Phil thesis linking her clinical practice in music therapy with some of Winnicott's ideas.

Sheila McClelland, M.Ed, RATh, is a lecturer in art psychotherapy at the University of London and senior art therapist at the Princess Royal Hospital. She is trained as a personal construct psychotherapist and as an art therapist in Birmingham and New York City. She has also been studying and practicing process work for four years. Her current interests include developing professional skills in working in acute psychiatry particularly implementing a model of process oriented psychology and in empowering people by their developing research and process work skills. Publications include a chapter in a forthcoming Open University book *Art Therapy in Great Britain* entitled 'Working briefly with acute states'.

Bonnie Meekums, BSc (Hons), Dip. Theatre, M.Phil, is one of the pioneers of dance movement therapy in this country. Following a performance career in dance she developed her practice including five years as dance movement therapist in a Family Service Unit. She is currently employed full time in a psychiatric hospital, a member of the International Board of the *Arts in Psychotherapy Journal*, and documents her research interest in the development of child and mother interaction in her chapter in H. Payne (ed) *Dance Movement Therapy: Theory and Practice*, the first UK book on dance movement therapy, published by Tavistock/Routledge in 1992.

Brenda Meldrum, lived for some years in Nigeria, where she and her husband formed a theatre group and built a theatre. On her return to England she took two degrees in social psychology at the London School of Economics and worked as a research psychologist at the Thomas Coram Research Institute. She teaches psychology at LSE, works in a youth theatre and is training director of the South London Theatre Centre where she works with young people. She is acting treasurer for the British Association of Dramatherapists and is a trainee dramatherapist with the Institute for Dramatherapy.

Helen Payne, Cert. Ed (PE), PG.Dip, M.Phil, is a dance movement therapist, trainer, consultant and accredited psychotherapist in private practice in St Albans. She is Director of the Institute for the Arts in Psychotherapy where a DMT apprenticeship training scheme has been developed. Foremost leader in her field she has extensive experience in special education, child and adolescent psychiatry and in hospitals for adults. A co-founder and past chair of the Association for Dance Movement Therapy she also initiated and led the first nationally validated, DES supported, post-graduate training at The Univeristy of Hertfordshire where she still teaches. Her books include *Creative Movement and Dance in Groupwork,* Winslow Press. Currently completing her doctorate at the University of London she is now developing further research with women with eating disorders.

Penny Rogers, PG Dip (MT), MSc, RMTh, originally trained as a cellist before continuing her studies at the Guildhall School of Music and Drama where she gained her diploma in music therapy. Since then she has worked extensively in the mental health field and gained a masters degree in cognitive neuro-psychology. Previous research studies include an examination of the processing of musical information by schizophrenics. She lectures regularly both in the UK and abroad, recently returning from a second lecturing visit to Estonia. She is now working as research fellow in music therapy at City University, London carrying out doctoral research into the use of music therapy with survivors of sexual abuse.

John Rowan is a fellow of the British Psychological Society, and has been running research projects since 1963. In 1977 he founded the New Paradigm Research Group, which led to the publication of *Human Inquiry: A Sourcebook of New Paradigm Research* (Wiley, 1981), co-edited with Peter Reason, which has now been through six reprints. He is on the Governing Board of the UK Council for Psychotherapy, representing the Humanistic and Integrative Psychotherapy Section. He practises Primal Integration, which is a holistic approach to therapy, and teaches, supervises and leads groups at a number of different centres. His latest book is *The Transpersonal in Psychotherapy and Counselling* (Routledge, 1993).

Joy Schaverien, DFA (Lond), MA, PhD, RATh is an analytical art therapist, psychotherapist and supervisor in private practice in Leicestershire and London. She worked for many years as an art therapist in NHS psychiatry and psychotherapy and then taught art therapy at Advanced and Masters levels at The University of Hertfordshire College of Art and Design. She lectures and conducts art therapy workshops in Britain and abroad. Her PhD research was published as a book *The Revealing Image: Analytical Art Psychotherapy in Theory and Practice,* by Routledge in 1991. Her current research interests include gender and transference in analytical art therapy.

Lucilia Valente, PhD, trained in Portugal as a teacher of the creative arts and has extensive experience at working with adults and children with special needs. With David Fontana she has published a number of articles and book chapters on the therapeutic use of drama. She is Professor and Head of Creative Arts Department, University of Minho, Portugal.

Tony Wigram, BA, PG Dip (MT), BSc (Psychol), R.MTh, studied music therapy with Juliette Alvin at the Guildhall School of Music and Drama and is currently undertaking his doctorate at RHBNC, London University. A former Chair of the Association of Professional Music Therapists he is currently Chair of the British Society for Music Therapy and Advisor to the Department of Health, co-ordinator of the European Music Therapy Committee and Chair of the Courses Liaison Committee. He lectures in music therapy, learning disability and child assessment in England, Spain, US and Estonia and is head of the music therapy department at Harperbury Hospital and senior music therapist at Harper House, Hertfordshire.

Useful Addresses

The Arts Therapies Research
 Committee
c/o Helen Payne (Chair)
1 The Wick
High Street
Kimpton
Herts SG4 8SA

The Association of Dance and
 Movement Therapy
c/o Arts Therapies Department
Springfield Hospital
Glenburnie Road
Tooting Bec
London SW17 7DJ

The British Association of Arts
 Therapists
11a Richmond Road
Brighton
Sussex BN2 3RL

The British Association for
 Dramatherapists
30c Bank Street
Kincardine
Fife
Scotland FK10 4LY

The British Society of Music
 Therapists
25 Rosllyn Avenue
East Barnett
Herts

The Council for Professions
 Supplementary to Medicine (State
 Registry)
Park House
184 Kennington Park Road
London SE11 4BU

The Institute for the Arts in
 Psychotherapy
1 Beaconsfield Road
St Albans
Herts AL1 3RD

The National Council for
 Psychotherapy (UKCP)
167 Sumatra Road
London NW6 1PN

The Professional Association for
 Music Therapy
68 Pierce Lane
Fulbourn
Cambridge

The Standing Committee of Arts
 Therapies
c/o Vera Vasarehlyi (Chair)
Bloomfield Clinic
Guy's Hospital
London Bridge
London SW

Subject Index

Name Index

Music Therapy in Health and Education
Edited by Margaret Heal and Tony Wigram
Foreword by Anthony Storr
ISBN 1 85302 175 X pb

'...the selected papers give a graphic description of the overall nature of the work of music therapists...written in a fluid and easy to read manner... For the occupational therapist, whether interested in music therapy or not, there is much to gain from the increased awareness of the clinical and research work of another therapeutic discipline... The majority of the papers are based on case studies and well illustrate the common ground of the making of the therapeutic alliance...this book gives a good overview to music therapy practice and is presented in an interesting and lively fashion.'
— British Journal of Occupational Therapy

'...these papers give new insights into music therapy and research as each practitioner espouses a different form of evaluation... I have found this collection of papers immensely stimulating...the work presented shows such extraordinary variation from highly complex thought and techniques through to equally compelling directness and simplicity.'
— Journal of British Music Therapy

'The scope of successful treatments spans the clinical spectrum, from tackling eating disorders to the reduction of self-injuring behaviour...this absorbing book gives a good idea of the present state of the art and the future paths open to this emerging application of music-making.'
— BBC Music Magazine

'Covering a wide range of clients and their problems, it provides fascinating insight into the diverse ways that music therapy is used to meet the needs of almost any situation... This book provides an invaluable music therapy text book and for those outside the discipline the editors, Margaret Heal and Tony Wigram, have succeeded in their aim 'to reflect the breadth and scope of music therapy practice in the world today'.'
— Mencap News

'...the book has encouraged me to see a role for music therapy within the traditional composition of the multi-disciplinary team in the mental health field...'
— Psychiatric Bulletin

'...provides a tremendous international digest of a variety of clinical work and research today... a fascinating book which would provide anyone with a feel for the huge variety of situations, techniques, challenges, and thinking in the practice of music therapy today.'
— Music Education

Jessica Kingsley Publishers
116 Pentonville Road, London N1 9JB

Persona and Performance
The Use of Role in Drama, Therapy and Everyday Life
Robert J Landy
ISBN 1 85302 229 2 hb
ISBN 1 85302 230 6 pb

This book, by one of the world's leading dramatherapists, demonstrates how the concept of role connects the areas of dramatherapy, theatre and everyday life, and provides a detailed model for a role-based form of therapy. Based on a central assumption that well-being depends on the individual's capacity to manage a complex and often contradictory set of roles, it examines the origins and development of the role metaphor both in drama and the social sciences; discusses how role can be used as a form of therapy, using detailed clinical case studies both of an individual and a group; and provides a comprehensive taxonomy of theatrical roles drawn from repeated types throughout the history of Western dramatic literature, arguing that an understanding of these will enhance an understanding of the dramatic nature of healing through role.

With references drawn from art and the social sciences, theatre, popular culture and personal experience, *Persona and Performance* will be essential and inspiring reading for all people interested in the use of drama and theatre as therapy.

Robert J Landy is Associate Professor and Director of the Drama Therapy Program at New York State University and Founder and Director of the Institute of Dramatherapy, New York City.

Music Therapy, Remedial Music Making and Musical Activities for People with a Developmental Disability
F W Schalkwijk
ISBN 1 85302 226 8 pb

'...succeeds in conveying a picture of music therapy which is both clear and very moving in its sensitivity to the clients and therapists he describes...this book should become essential reading for people with an interest in adults and children with developmental difficulties, and for music therapists, particularly students and those at the start of their career. It addresses the fundamental but crucial issues of making an informed and careful choice about the form of treatment most likely to be helpful to the client.'
— British Journal of Guidance and Counselling

'The book will be of interest not only for the definitions of musical activities, remedial music-making and music therapy it provides but also for the survey of clinical methods in the Netherlands presented. The book provides some valuable material on the psychology of developmental disability and draws attention to the particular significance of low self-esteem. For music therapists working in an education setting, it provides a thought-provoking discussion of methods and objectives which may facilitate the identification of therapeutic-/educational aims and techniques.'
— Education in the North

Jessica Kingsley Publishers
116 Pentonville Road, London N1 9JB

Storymaking in Education and Therapy
Alida Gersie and Nancy King
ISBN 1 85302 519 4 hb
ISBN 1 85302 520 8 pb

'This is an essential and wonderful book for anyone interested in working with stories in education or therapy... It is a true discovery.'

– Dr Ofra Ayalon, Haifa University

'This is a lovely book... Buy it.'

Nursing Times

'This is in essence a 'How to' book replete with instructions for achieving personal growth and facilitating creativity in just about every avenue of expresion...This book contains many exciting and compelling ideas'.

– The Arts in Psychotherapy

'The book contains a rich variety of thought provoking and inspiring material...a core text for dramatherapists to acquire.

– Dramatherapy

Storymaking in Bereavement
Dragons Fight in the Meadow
Alida Gersie
ISBN 1 85302 176 8 pb
ISBN 1 85302 065 6 hb

'This is an erudite, imaginative book by an author who is deeply involved in her topic and is an enjoyable and absorbing read.'

–Nursing Times

'This book is beautifully written. It is immensely rich in its use of story, metaphor and literary allusion to illustrate the process of grief and healing...moving and deeply compassionate.'

– Counselling

Movement and Drama in Therapy
A Holistic Approach
2nd edition
Audrey G. Wethered
Foreword by Chole Gardner
ISBN 1 85302 199 7 pb

'[Readers] may find, in these pages, a theory connecting the inner world with practical daily living... I wish this book every success. I hope it will reach many people and light sparks, answer quests, strengthen endeavour and broaden horizons.'

–from the Foreword

Jessica Kingsley Publishers
116 Pentonville Road, London N1 9JB

Dramatherapy with Families, Groups and Individuals
Waiting in the Wings
Sue Jennings
ISBN 1 85302 144 X pb
ISBN 1 85302 014 1 hb

'Not only is it extremely well written, but the theoretical models and issues outlined are worked through with the use of detailed and clear examples... deserves to be widely read by specialists and non-specialists alike...'

— Counselling

'She shows an impressive knowledge of myths and dramatic literature and demonstrates their therapeutic validity. The case examples are wonderful.'

— Dramascope

'This is a clear, well-written text that reflects a drama therapist who is clinically astute and well-grounded in drama, theatre, and ritual processes ... There is no doubt that Jennings is a trailblazing pioneer whose journey makes ours a little easier.'

— The Arts in Psychotherapy

Post Traumatic Stress Disorder and Dramatherapy
Treatment and Risk-Reduction
Linda Winn
ISBN 1 85302 183 0 pb

'This publication will be purchased by trainers and those new to this kind of work for its lucid approach to defining PTSD and the situations where it may be found. Parts of the book would be useful to people involved in personnel or management as information for those working alongside a therapist or dramatherapist or those involved in establishing or promoting such a therapeutic approach. It has helpful chapters on prevention, debriefing and supervision which are applicable to an institutional context.'

— British Journal of Guidance and Counselling

'Although written for a specialized minority, the book is clearly presented, so that the reality of what is being described is brought home to those of us who are strangers to PTSD and its clinical problems. For people who are involved in drama it is completely fascinating, however, because it shows how essential dramatic awareness is to our mental well-being.'

— Radius

Jessica Kingsley Publishers
116 Pentonville Road, London N1 9JB

The Metaphoric Body
A Guide to Expressive Therapy
Through Images and Archetypes
Leah Bartal and Nira Ne'eman
Foreword by Professor Harris Chaiklin
ISBN 1 85302 152 0 pb

'...a *tour de force*...a series of exquisite exercises which translate the philosophical ideas into practical and clearly understood directives for activities that are immediately experienced in the body. This work is useful to anyone engaged in education, the creative arts, and the art therapies. It is useful for all ages and all people and all time. In a word this volume is practical. Dear reader, you are about to embark on an exciting adventure.'
—from the Foreword

Art Therapy in Practice
Edited by Marian Liebmann
ISBN 1 85302 057 5 hb
ISBN 1 85302 058 3 pb

'This book ... offers a valuable contribution to the dissemination of information about the practice of art therapy ...fascinating reading.'
— Counselling Psychology Quarterly

Symbols of the Soul
Therapy and Guidance Through Fairy Tales
Birgitte Brun, Ernst W Pedersen and Marianne Runberg
Foreword by Murray Cox
ISBN 1 85302 107 5 hb

'the book...has many of the best qualities of fairy tales. Its descriptive style is lucid and simple. It contains many pointers and signposts which provoke the readers curiosity. There is transparency and verbal economy... Because it links the 'once upon a time' world with greater access to that of everyday, [the book] is highly recommended.'
—from the Foreword

'This is a wide-ranging, eclectic look at the profundity of fairy tales and their ability to draw clients into a secure space in which they can explore their own feelings and preoccupations through the story form. The authors draw on their clinical experiences and describe a number of case studies throughout the text.'
— Contemporary Psychology

'...much to please the followers of Bettelheim and his classic text in this area...people interested in myth, narrative and archetypes will find much to enjoy...a useful collection for anyone interested in using story in therapy.'
— British Journal of Psychotherapy

'There are a number of valuabe aspects to this book...the introductory chapters and the discussion of therapy with emotionally deprived children are clear and worth reading.'
— British Journal of Psychiatry

Jessica Kingsley Publishers
116 Pentonville Road, London N1 9JB

Art Therapy with Offenders

Edited by Marian Liebmann
Foreword by Stephen Tumim
ISBN 1 85302 171 7 pb

'If the Prison Service is to fulfil its stated duty "to help prisoners lead law-abiding and useful lives in custody and after release," this book must be one of the more important guides on how to achieve it. ...art therapy with offenders seems both necessary and desirable at this stage of regime development, and each chapter in this book provides fresh ideas for it.'

—from the foreword

'Each chapter stands in its own right, and authors set out very clearly what they intend to say. Each work setting is vividly described, giving the reader a sense of what it must feel like to work in such settings... There is a wealth of information on the 'nuts and bolts' of establishing oneself in an institution, inviting referrals, setting up a group sessions, making contact with clients, introducing them to the medium and documenting the process of therapy... I felt these accounts to be as useful to music therapists as art therapists, and relevant to therapists setting up work with any client group, not just offenders...I found so much to stimulate and inspire me, and little to criticise... This book demonstrates the value of art therapy with offenders.'

—Journal of British Music Therapy

'The foreword by Judge Stephen Tumim sets the scene for a thoroughly good book... It is in essence a practical and pragmatic series of essays offering new horizons about art as a vehicle for the understanding and addressing of offending behaviour... Each contributor whilst adding their own dimension appears to reflect a common thread. A book of reference as well as ideas...those involved in the training of prison and probation staff would do well to find a place for this book on their reading list. What it is not, is a book for the Art Teacher alone. It has much more to offer.'

—AMBOV Quarterly

'*Self and Society* readers will find this superb book a valuable contribution to in-depth work in their therapy and with themselves...brilliant and beautiful collection of papers and illustrations.'

— Self and Society

'...a valuable insight into how the setting for therapeutic work shapes its from and potential... There are interesting contributions from art therapists working with adolescent sex offenders.'

—Assoc for Child Psychology and Psychiatry Review and Newsletter

'An extensive reading list adds to the value of this comprehensive book as a resource for work with offenders.'

— Readings: A Journal of Reviews and Commentary in Mental Health

'The reader is easily able to understand the material that the authors present...a very readable book...of interest to health professionals wanting to know more about the value of art therapy with offenders and the impact of the environment on the delivery of therapy.'

—Australian Occupational Therapy Journal

Jessica Kingsley Publishers
116 Pentonville Road, London N1 9JB

Play Therapy with Abused Children
Ann Cattanach
ISBN 1 85302 193 8 pb

'...a welcome addition to the sparse literature in this area. I would recommend the book to anyone working in this field but especially to beginners...This is a well presented, clear and easy-to-read book, providing a balanced mixture of factual information and case material.' — *British Journal of Occupational Therapy*

'This is a book which is shocking at times but extremely valuable.' — *Nursery World*

'Her accounts of the way in which play is used to make sense of traumatic experiences are full of insight and often moving. All aspects of the work are covered... This is an exceptional volume...goes far beyond a mere text book.' — *Therapy Weekly*

Art Therapy and Dramatherapy
Their Relation and Practice
Sue Jennings and Ase Minde
ISBN 1 85302 027 3

'The creativity of the authors is testified to by their production of a new form. In addition to being a 'how to' manual for art and dramatherapy, this book is a melange of autobiography, anthropology, psychoanalysis, case reports, cross-cultural analysis, art reproduction, poetry, literary quotation, and mythology.' — *The Lancet*

'There is energy, creativeness and richness of imagery in this book... The book is well referenced and relevant theoretical concepts are explained. ...there is some very good sound advice...on many different issues.' — *Inscape*

'...this book would enrich any occupational therpay department library.' — *British Journal of Occupational Therapy*

'will prove useful to both beginning and advanced art therapists... The authors, whose passion for their work is obvious, are creative and generous in providing a text rich in methodology for arts therapists interested in expanding their practice.' — *American Journal of Art Therapy*

'...the links between theory and practice are shown in detail...this book will be useful to students and exponents of these therapies alike.' — *Nursing Times*

'This is a well researched study for the serious therapist. But it is also intelligible and stimulating for the non-specialist...there is a generous sprinkling of black and white illustrations well placed within the text to which they closely relate... It is a reference book for inspiration as well as information.' — *Reform*

'...an interesting book, relevant to those of us who work in multi-disciplinary contexts or who wish to do such collaborative work. The scope for collaborative inter-disciplinary work is evidenced in part 2 with examples of work greatly adding to the coherency and purpose of the book in its entirety.' — *Counselling*

'This book is an excellent and concise summation of the notions of dramatherapy and a detailed guide to it's application... Jennings's book will appeal to a broad multi-disciplinary readership, with many of the notions encountered of great interest and value for the developing and practising psychiatric nurse. Further, this represents an excellent resource book for those who are engaged in dramatic activities with clients, peers or students.' — *Australian Journal of Mental Health Nursing*

Jessica Kingsley Publishers
116 Pentonville Road, London N1 9JB